Mediated Ethnicity

New Italian-American Cinema

EDITED BY

Giuliana Muscio
Joseph Sciorra
Giovanni Spagnoletti
Anthony Julian Tamburri

JOHN D. CALANDRA ITALIAN AMERICAN INSTITUTE

QUEENS COLLEGE, CITY UNIVERSITY OF NEW YORK

D1382984

Originally published as
Quei bravi ragazzi
©2007 Marsilio Editori
Venice, Italy

STUDIES IN ITALIAN AMERICANA
VOLUME 2

John D. Calandra Italian American Institute
Queens College, CUNY
25 West 43rd Street, 17th floor
New York, NY 10036

ISBN 0-9703403-6-2
ISBN 978-0-9703403-6-8
Library of Congress Control Number: 2010928581

Book design: Lisa Cicchetti
Cover photograph: Lucia Grillo and Maria Teresa Attisani in *A pena do pana* ©Calabrisella Films

We dedicate this book to the memory of Piero Tortolina (1928-2007)
who taught us to love American cinema. – G.M., G.S.

CONTENTS

Mediated Ethnicity

Joseph Sciorra & Anthony Julian Tamburri
JOHN D. CALANDRA ITALIAN AMERICAN INSTITUTE
QUEENS COLLEGE, CITY UNIVERSITY OF NEW YORK

We at the John D. Calandra Italian American Institute, Queens College, CUNY are pleased to present this English translation of *Quei bravi ragazzi*, Giuliana Muscio and Giovanni Spagnoletti's edited collection of critical essays on Italian-American cinematic culture.[1] This book situates Italian-American cinema within a larger socio-cultural context by addressing topics ranging from music to the family, from prejudice to religion. This holistic approach provides opportunities to explore the diverse ways in which immigrants and their descendants shaped meaning through artistry in a strange and sometimes estranging environment.

The original publication is part of increasing Italian scholarly inquiry on, and popular curiosity about, Italian-American history and culture.[2] This attention is witnessed in numerous academic conferences exploring emigration, Italian-American authors found in translation (e.g., Helen Barolini, Louise De Salvo, John Fante, among others), and the proliferation of Italian museums dedicated to emigrant experiences. These initiatives come at a time when Italy has become a site for immigration and the country attempts to better understand its own history as an emigrant nation.[3]

[1] Giuliana Muscio and Giovanni Spagnoletti, eds., *Quei bravi ragazzi, Il cinema italoamericano contemporanei* (Venice: Marsilio Editori, 2007). The anthology takes its title from the Italian translation of Martin Scorsese's film *Goodfellas* (1990). We, in turn, have redubbed the book with a title we believe better expresses its collective ideas for an Anglophone audience.

[2] Examples of this work include but are not limited to: Martino Marazzi, *Misteri di Little Italy: Storie e testi della letteratura italoamericana* (Milan: Franco Angeli, 2001); Francesco Durante, *Italoamericana: Storia e letteratura degli italiani negli Stati Uniti, 1776-1880* (Milan: Mondadori, 2001) and *Italoamericana: Storia e letteratura degli italiani negli Stati Uniti, 1880-1943* (Milan: Mondadori, 2005); Simone Cinotto's *Una famiglia che mangia insieme: Cibo ed etnicità nella comunita Italoamericana di New York, 1920-1940* (Turin: Otto Editore, 2001); and Stefano Luconi, *Little Italies e New Deal: La coalizione rooseveltiana e il voto italo-americano a Filadelfia e Pittsburgh* (Milan: Franco Angeli, 2002).

[3] Mark I. Choate, *Emigrant Nation: The Making of Italy Abroad* (Cambridge: Harvard University Press, 2008) and Donna R. Gabaccia, *Italy's Many Diasporas* (Seattle: University of Washington Press, 2000).

The Italian publication was issued in conjunction with the 43rd annual Mostra Internazionale del Nuovo Cinema (International Exhibit of New Cinema) in Pesaro, Italy, known in English as the "Pesaro Film Festival," under Spagnoletti's artistic direction. In June-July 2007, the festival featured a retrospective entitled "Contemporary Italian-American Cinema" — co-sponsored by the Calandra Institute (Queens College) and curated by film scholar Giuliana Muscio (University of Padua) — that focused on the work of Italian-American directors who followed the American "auteur renaissance" of the 1970s that included Michael Cimino, Francis Ford Coppola, Brian De Palma, Martin Scorsese, and others. Nancy Savoca's low-budget, award-winning film *True Love* (1989) heralded a new era of feature-length "independent" films offering alternative narratives to mainstream Hollywood fare.[4] The Pesaro Film Festival acknowledged the contributions of this new generation by screening features, shorts, and documentaries depicting thoughtful, engaging, and powerful stories of Italian Americana. The festival included an all-day conference with directors and scholars of Italian-American studies discussing Italian-American history, culture, and cinematic artistry.

This book builds on the growing scholarship on Italian-American cinematic experiences. A simple Web search of "Italian Americans" and "film" reveals a profusion of university course offerings on Italian-American film culture by departments and programs as varied as cinema studies, American history, ethnic studies, literature, and cultural studies. A number of books have broadened our understanding of various aspects of Italian-American film culture.[5] Among both authored books and edited collections that deal with an overview of the aesthetic panorama, this volume is number nine in both English and Italian with regard to book-length studies on Italian-American cinema.

[4] Edvige Giunta, "The Quest for True Love: Ethnicity in Nancy Savoca's Domestic Film Comedy," *MELUS: The Journal of the Society for the Study of the Multi-Ethnic Literature of the United States* 22 (Summer 1997): 75-89.

[5] Robert Casillo, *Gangster Priest: The Italian American Cinema of Martin Scorsese* (Toronto: University of Toronto Press, 2007); George De Stefano, *An Offer We Can't Refuse: The Mafia in the Mind of America* (New York: Faber & Faber, 2006); Fred Gardaphé, *From Wiseguys to Wise Men: The Gangster and Italian American Masculinities* (New York: Routledge, 2006); and Ilaria Serra, *Immagini di un immaginario. L'emigrazione italiana negli Stati Uniti fra i due secoli (1890-1924)* (Verona: CIERRE Edizioni, 1997). Scholars such as Giorgio Bertellini, Carlos E. Cortés, Dawn Esposito, Edvige Giunta, Ben Lawton, Laura E. Ruberto, John Paul Russo, Pasquale Verdicchio, Robert Viscusi, and others have contributed to the growing literature in essay form. See the online bibliography "Italian Americans in the Movies: A Bibliography of Materials in the UC Berkeley Library" at http://www.lib.berkeley.edu/MRC/italianambib.html.

Lee Lourdeaux's *Italian and Irish Filmmakers in America: Ford, Capra, Coppola, and Scorsese* (1990) analyzes three Italian-American directors and one of the greatest Irish-American directors.[6] The book focuses on a range of topics: Hollywood's stereotypes of Irish and Italians as police, priests, politicians, and gangsters in movies in the 1920s; Ford's portrayal of Irish America; Capra's comedies as social commentaries about the Anglo-American ethic; Coppola's themes of conflict between Italian America and Anglo America; and Scorsese's articulation of Catholic Italian America and mainstream culture. Throughout, Lourdeaux underscores the importance of the directors' ethnic heritage and their Catholicism, and provides an excellent comparison of the Irish and the Italians, especially in its positioning of Frank Capra as a bridge between the two ethnic groups.

Paola Casella's *Hollywood Italian* (1998) is a film encyclopedia of sorts and could serve as an introductory reading to orient a reader unfamiliar with Italian-American cinema.[7] The book is divided into sections that consist of chapters and sub-chapters dedicated to many films. Each section is introduced by a short chapter on cultural history, as well as the specific film history pertinent to that section; and the bibliography lists more popular than academic sources. The book is thus most useful for finding quick, general information, much less suitable instead for scholarly research.

Pellegrino D'Acierno's "Cinema Paradiso: The Italian American Presence in American Cinema" (1999) offers a detailed and theoretically sophisticated history of the genre; yet, this long, book-like essay is also accessible to the theoretically uninitiated.[8] D'Acierno's readings of films by Coppola, Scorsese, and Capra invite the reader to re-consider these films. His analysis of Coppola's *The Godfather*, for example, underscores the filmmaker's skill at romanticizing the outlaw figure — the film "trap[s] the spectator in an imaginary identification with the outlaw" (573) — and simultaneously critiquing that same figure through his portrayal of Vito Corleone as a monster at the end of his life. This valuable essay may not be that easy to find because it is in a volume published in the late '90s.

[6] Lee Lourdeaux, *Italian and Irish Filmmakers in America: Ford, Capra, Coppola, and Scorsese* (Philadelphia: Temple University Press, 1990).

[7] Paola Casella, *Hollywood Italian: gli italiani nell'America di celluloide* (Milan: Baldini & Castoldi, 1998).

[8] Pellegrino D'Acierno, "*Cinema Paradiso*: The Italian American Presence in American Cinema." *The Italian American Heritage* (New York: Garland, 1999) 563-690.

The collection, *Screening Ethnicity*, edited by Anna Camaiti Hostert and Anthony Julian Tamburri (2002), includes essays by scholars from the United States, Italy, and France.[9] The book gathers an array of critical voices from various theoretical perspectives. Organized around three sections — "Specific Themes, Multiple Voices"; "The 'Bad Boys' of Italian-American Cinema"; and "Different Voices, Different Tones" — the essays explore issues such as gender, race, structural narrative, "mafia" as an Italian-American theme, and, in addition to the so-called masters, cover such filmmakers as Abel Ferrara, Nancy Savoca, Quentin Tarantino, and Stanley Tucci. The collection closes with an essay on three shorts (fiction, music video, documentary), and a conversation between folklorist Joseph Sciorra and Annabella Sciorra, an actor of the post-boomer-generation. Some essays subsequently developed into larger projects: Casillo's essay on Scorsese is now part of a book on the director, *Gangster Priest* (2007); Tamburri's closing essay is a preview of a study he then published in 2002, *Italian/American Short Films & Videos*.

This book, in fact, *Italian/American Short Films & Videos: A Semiotic Reading* (2002), is dedicated to the short film.[10] Divided into three sections, the book examines two "fictions," two "narrative" music videos, and two documentaries. In each case, one film is an explicit articulation of the director's Italian-American heritage, while the other constitutes a more implicit expression of the director's ethnicity. The study demonstrates that it becomes the reader's task to invest the films' physical signs with Italian American meaning.

Giuliana Muscio's *Piccole Italie, grandi schermi* (2004), a study of the first fifty years of United States cinema, examines the representation of Italians and Italian Americans.[11] In five chapters, Muscio traces both the activities of the cinematic world and the socio-political phenomena in which these aesthetic activities took place. Her first chapter discusses the roots of this cinema — from the stage to the screen. Chapter two focuses on the figure of the Italian and the Italian American in film from 1895 to 1940, analyzing various types of "Italian" characters represented, culmi-

[9] Anna Camaiti Hostert and Anthony Julian Tamburri, eds. *Screening Ethnicity: Cinematographic Representations of Italian Americans in the United States* (Boca Raton: Bordighera, 2002).

[10] Anthony Julian Tamburri, *Italian/American Short Films & Videos: A Semiotic Reading* (West Lafayette: Purdue UP, 2002).

[11] Giuliana Muscio, *Piccole Italie, grandi schermi, scambi cinematografici tra Italia e Stati Uniti 1895-1945* (Rome: Bulzoni, 2004)

nating in the gangster figure. The remaining three chapters deal with the development of representations of the Italian and Italian American in film in both the United States and Italy. The result is an original bilingual and bicultural analysis.

Peter Bondanella's *Hollywood Italians* (2004) juxtaposes stereotypical roles of Italian Americans in United States society with their portrayals in United States cinema.[12] As his subtitle signals (*Dagos, Palookas, Romeos, Wise Guys, and Sopranos*), these portrayals include primarily immigrants, boxers, Latin lovers, and Mafiosi. Bondanella insists that these classifications demonstrate the Italian and Italian-American dedication to admirable values such as the preservation of family and hard work. Much of his book centers around the gangster figure, a representation that, while indeed ubiquitous, may be doing more harm than good for a historically informed understanding of the history and place of Italian Americans in United States culture. Bondanella would like to see the Italian American favorably ensconced in American society, despite negative portrayals. In fact, he points to *The Sopranos* as a prime example of how Italian Americans have moved into mainstream society. Furthermore, Bondanella also sees in *The Sopranos* a more satisfactory representation of Italian Americans in so far as the characters portray a plethora of individuals: mobsters, psychotherapists, teachers, lawyers, and, of course local, regional, and national law enforcement agents.

Our book, *Mediated Ethnicity*, then brings up the rear, so to speak, of what has been published of a general nature on Italian-American cinema to date. It does so by gathering a series of voices representing a kaleidoscopic viewpoint both in the Italian and North American worlds of Italian-American cinema studies. We are confident it will continue to make a contribution to the overall conversation; these may take the form of larger studies that spring forth from the essays in the collection, as well as the reactions to some of the ideas already expressed in this volume.

Issues surrounding stereotyping, defamation, and "negative" images, as they pertain to Italian Americans and film, have loomed large in the public consciousness. The gangster genre has caused vehement outcry from self-appointed spokespeople for the imagined community called "Italian American." From the release of *Little Caesar* (Mervyn LeRoy, 1930)

[12] Peter Bondanella, *Hollywood Italians: Dagos, Palookas, Romeos, Wise Guys, and* Sopranos (New York: Continuum, 2004).

and *Scarface: The Shame of A Nation* (Howard Hawks, 1932), to Coppola's *Godfather* trilogy and Scorsese's brutal portrayals of mob life, to the passel of other less talented endeavors, celluloid and cathode gangsters have caused interminable *agita* for this sector of the community. Spike Lee's "Italian-American" trilogy — *Do the Right Thing* (1989), *Jungle Fever* (1991), and *Summer of Sam* (1999) — has also come under similar attack for its depiction of racism among New York Italian Americans. National membership organizations including the Order Sons of Italy in America (OSIA) and the National Italian American Foundation (NIAF) regularly scrutinize the media for depictions deemed negative and issue missives denouncing said images.[13] These anti-defamation campaigns, which literary scholar Anne Paolucci characterizes as "misplaced fervor," have been primarily self-serving and ultimately unmitigated failures.[14]

The Italian-American *prominenti* (elites) continue to offer the fractious pantheon of "positive role models" and inspirational stories of ethnic success, e.g., war heroes, sports figures, doctors, lawyers, and CEOs, as antidotes to alleged media stereotypes. This project of ethnic boosterism-cum-therapy, a psychosocial *commedia* of uplift from disesteem and victimhood, illustrates the cautious and uncreative ways that "Italian American" is pre-conceived and enacted.[15] All too often, attempts to produce films with decidedly "positive images" of Italian Americans have resulted in insipid storylines, one-dimensional characters, stilted dialogue, and lack of dramatic tension.

Recently, critical analysis of anti-defamation rhetoric and efforts has emerged from within the field of Italian-American studies. Literary scholar Robert Viscusi argues for a discursive approach to cultural products that moves beyond mere protest on the part of what he calls "official Italian America":

[13] See OSIA's "Articles on Italian American Stereotyping" at the website http://www.osia.org/ public/commission/only_a_movie.asp; NIAF's "Image & Identity" at http://www.niaf.org/image_ identity/default.asp; and the Italian American One Voice Coalition's "Speaking out with one voice against negative stereotyping" at http://www.onevoicecoalitoin.org. See also Dean Tomasula's blog "Italian-Americans Against Media Stereotypes" at http://iaams.blogspot.com.

[14] Anne Paolucci, "Preserving the Future Through the Past," *Italian-American Perspectives*. (New York: Griffon House Publications, 2007) 1-39.

[15] See historian Robert F. Harney's work on the "ethno-psychiatric uses of history" by Italian community leaders and intelligentsia in North America in their attempts to assuage "ethnic self-disesteem" in "Caboto and Other Parentela: The Uses of the Italian Canadian Past," *From the Shores of Hardship: Italians in Canada*, Nicholas De Maria Harney, ed. (Welland, Ontario: Éditions Soleil, 1993) 4-27.

The Godfather and *The Sopranos* are the most widely influential works of narrative that Italian America has yet produced. Their very successes call for the best critical and historical understanding that critics can bring to bear on them. Their enormous popularity and prestige does not rest simply on an uncritical use of criminal stereotypes (and indeed, these stereotypes are themselves complex historical facts that call for patient analysis and unraveling). Stereotypes alone do not produce the impact that these narratives have had. *The Godfather* and *The Sopranos* are, for good or ill, works of art. To respond to them with less than full critical attention amounts to a serious failing, one that leaves Italian Americans unprepared to deal with the cultural situation they in fact occupy.[16]

In his essay about the Italian-American elite's involvement with fascism, historian Philip Cannistraro takes a long term view to understanding seventy years of unsuccessful anti-defamation campaigns. He answers his rhetorical question, "Why has this effort to defend the ethnic community failed so completely?" by stating, "The answer lies in the nature and history of the ruling elite of the ethnic community":

Throughout the Italian American experience, the *prominenti* have consistently endorsed a closely-linked agenda of "patriotism" and Americanization, which has essentially meant supporting the coercive efforts of American society designed to strip Italian immigrants and their descendants of their history, culture, and their identity. The dual focus of *prominentismo* has always been to promote the separate, self-agrandizing [sic] interests of their own particular elite rather than of the community as a whole, and to stress what Italian Americans are not.[17]

Journalist George De Stefano provides one of the most astute readings of anti-defamationist activists' often hyperbolic and unsubstantiated statements by examining how class, race, and power is constructed and enacted in the United States:

[16] Robert Viscusi, *Buried Caesars and Other Secrets of Italian American Writing* (Albany: State University of New York Press, 2006) 1, xvi-xvii.

The theme of representation has also been explored by the Charles and Joan Alberto Italian Studies Institute's all-day conference "Real Stories: Discrimination and Defamation in the History of Italian Americans" held at Seton Hall University on December 4, 2004, and in Steven Fischler's documentary film *Beyond Wiseguys: Italian Americans and the Movies* (2007).

[17] Philip V. Cannistraro, "The Duce and the Prominenti: Fascism and the Crisis of Italian American Leadership." *Altreitalie* 31 (July-December 2005): 76-86.

But those Italian Americans who are so worked up over gangster stereo-
types, so caught up in yes, their victimology, never seem to consider
why Italian American stereotyping elicits less concern than racism, anti-
Semitism, or homophobia. Racial minorities, Jews, and gays get more
sympathy because they experience far more bias, stigma, and outright
decimation than do Italians.[18]

It was with this desire for intellectual and cultural engagement that the
Calandra Institute partnered with the Mostra Internazionale del Nuovo
Cinema to co-sponsor the retrospective in Pesaro in 2007 and the follow-
ing year in New York City. It is our hope that by translating and publish-
ing this book we contribute to the ongoing discourse about the mediated
ethnicity of Italian Americans in keeping with our mission of conducting
critical inquiries in the public sphere.

In 2006, the Calandra Institute began a new direction in its relationship
to Italian-American cinematic culture. Instead of engaging in anti-defa-
mation initiatives in opposition to cinematic and television works deemed
"insulting" as it had done in the past, the Calandra Institute embraced its
mission as an academic research institute to conceptualize and organize
scholarly inquiry into the subject in a series of public forums and events.
In April 2006, as Associate Director of Academic and Cultural Programs, I
organized the Calandra Institute's "Mediated Ethnicity: Italian Americans
and the Cinematic Experience," a symposium with scholarly presenta-
tions, discussions with film directors and actors, and film screenings. The
symposium offered a serious examination of Italian-American film cul-
ture, including its social, aesthetic, political, and economic aspects. It was
also designed in support of directors and actors who have given us beau-
tiful, provocative, and sometimes disturbing films to enjoy and contem-
plate.

In September 2006, the Calandra Institute inaugurated "Documented
Italians," a monthly documentary film and video series that includes di-
rectors discussing their respective works with scholars. The series title

[18] De Stefano, 2006, 313. See also Libero Della Piana's "Are Italians the New Anti-Racist Front?"
RaceWire blog, October 2004, http://www.arc.org/racewire/041006l_piana.html.

Author Bill Tonelli and anti-defamationist gadfly has made trenchant and humorous observations in
print and online about the doings of "ethnic activists and other touchy types," which have only
further fueled their ire. See Bill Tonelli, "A 'Sopranos' Secret: Given the Choice, We'd All Be
Mobsters," *The New York Times*, March 4, 2001, AR 21, and online exchange on the list serve H-ItAm.
Most revealing is the reaction to Tonelli's writing found on the Web site "Tonelli: The Enemy
Within," Sicilian Culture Website, http://www.sicilianculture.com/news/tonelli.htm.

playfully problematizes the intriguing status of Italian Americans in film. As a folklorist/anthropologist and the series curator, I am less interested in Italian-American authorship, per se, although many of the presented films are, in fact, made by Italian-American directors. The documentary format seems to allow the possibility to explore the diversity of Italian-American experiences and narratives in ways that Hollywood seems unwilling or unable to produce. These stories, to name but three, have included the feisty 103-year-old Mary Mirabito in Justin Alex Halpern's *Nine Good Teeth* (2003), Camilla Calamandrei's *Prisoners in Paradise* (2003) about Italian World War II POWs in the United States, and Edward DeBonis and Vincent Maniscalco's attempt at a Catholic wedding in Abigail Honor's *Saints and Sinners* (2003). The documentary, far from being an unfiltered slice of reality, is imbued with the director's point of view made evident through camera angles, edits, interview styles, selection of subjects, etc. [19]

The mediated ethnicity of Italian Americans is a rich and untidy array of stories, styles, perspectives, images, and voices subject to varied responses and interpretations. This publication contributes to the continuing and increasingly transnational conversation and investigation of Italian-American cinematic culture.

A HEART-FELT THANKS!

This book is the result of a large team of translators, editors, and, in this last case, one page designer. It is truly a collaborative effort. There were, for example, a number of essays originally written in Italian that were translated into English for this collection. Translation, as we all know, is always a challenging enterprise; the literal simply does not suffice. On occasion, one must indeed engage in twists and turns of the target language in order to render the original idea in a faithful manner. In our case, in a few instances, the Italian proved to be most challenging. But after a number of readings and consultation among the United States editors and translators, we believe we have come forth with a natural-sounding text overall, one that is loyal both in tone and content to the original Italian texts.

[19] See Muscio's article "Italian American DOC" on page 240 for what appears to be the first essay in print on documentary films about Italian-American subjects. See also Ilaria Serra's "Creare una memoria collettiva: le donne e i documentari italoamericani," Oltreoceano. Scrittura migrante. Parole e done nelle letterature d'oltreoceano. Silvana Serafin, ed. 2 (2008): 86-92.

That said, then, we need to thanks a series of individuals who have worked on this project over the past year or so. Our translators are all listed after their respective essays; we thank them for their concerted effort in transforming the Italian into faithful English renditions of those essays. Similarly, we are most grateful to Dr. Maria Grace La Russo, one of our colleagues at the Calandra Institute, who read the complete manuscript on a number of occasions as it went through its multiple transformations. She also completed the index that is included at the end of this volume. Lisa Cicchetti, Calandra's in-house book designer, added her editorial skills to the mix and, as well, created the volume's cover and page template, making the reading all the more pleasurable. Olivia Cerrone, in turn, provided a reading of the penultimate page proofs; Rosangela Briscese proofed the final manuscript; and Paolo Giordano, in the end, compiled the initial version of the book's index of names.

MEDIATED ETHNICITY: NEW ITALIAN AMERICAN CINEMA

Introduction

Giuliana Muscio
UNIVERSITY OF PADOVA

How does one write Italian Americans?* The spell check on computers automatically writes it with a dash, that which in America is called a hyphen. It corresponds to a multicultural approach that emerged in the 1970s, according to which ethnic origins are represented by this "dash," and all Americans are transformed into "hyphenates": Hispanic-Americans, African-Americans, and Italian-Americans. The dash indicates that there are Americans with different cultures since the qualifier is an adjective: Americans yet with another cultural origin. They are Americans who are a little different but, in essence, primarily American. A complex culture such as the Italian American one, which has long resisted assimilation, behaves, however, in a less linear way, and ultimately refuses the concept embodied by that dash. It transforms the dash into a slash /, an indication of otherness, as theorized by Anthony Julian Tamburri.

We do not know how to write this word because we do not know its implications. If the spelling is meant to be a graphic representation of cultural history, we propose five different ways of spelling it. Each corresponds to a different phase in assimilation by Italian emigrants to the United States: Italian Americans (1870-1929), Italian-Americans (1930-1941), Americans (1942-1959), Italian Americans (1960-1990), and today's American Italians (a difficult wording). To each corresponds, and in no way automatically, a different connection between émigré Italian entertainment and American cinema.

The starting point can only be these two separate words, Italian Americans. The approximately six million Italians who emigrated to North America were bearers, as postulated by Emilio Franzina, of a weak na-

* For editorial reasons, the term "Italian American" has been written without a hyphen in all of the essays in this collection, except for those written by Emanuele Pettener, Anna Camaiti Hostert, and Anthony Julian Tamburri, where it is written with a slash, in accordance with their theoretical positions.

tional identity. They suffered discrimination in their homeland, both be-
cause of the anti-emigration sentiments of Italy's leadership, as well as the
anti-Southern Italian prejudice that underlies the entire issue. This pre-
judice was fed by a racial one that developed at the time within Italian
positivism, according to which Northern Italians were deemed Caucasians,
while dark-complexioned Southern Italians were suspected of having
African blood. It was a suspicion that American immigration officials
appropriated by issuing two different visas to the two groups. Italians
were thus separated upon entry, one group on the path to quick assimi-
lation, the other to exclusion.

As clearly emerges from the essays by Stefano Luconi and Giorgio
Bertellini, this entwining of a racial issue with an ethnic-cultural one had
significant consequences on Italian immigration in the United States.

The condition of Southern Italian émigrés in North America, and con-
sequently their sense of identity, was burdened by a nexus of negations
and exclusions. They were despised both in Italy by the large landowners
who were losing an over abundant (and thus cheap) supply of laborers,
and in America where their dark complexion and very different customs
alarmed the WASP community. Issues of race (a word one has trouble
voicing if applied to ourselves) and of virulent prejudices attack a com-
munity with a weak identity (Italy had only recently become a unified
nation and the social conditions of Southern Italians most certainly did
not encourage a feeling of belonging). To support legislation restricting
immigration, the American popular press (and cinema immediately there-
after) grabbed hold of these prejudices, and created inflammatory media
myths about Southern Italian immigrants, depicting them as instinctive,
passionate, violent and belonging to the Mafia. Many essays have been
written on the negative stereotypes that emerged, of note: Fred Gardaphé
on the eternal equation Italian-Mafia, and John Paul Russo, Ilaria Serra,
Jaqueline Reich, and Alessandra Senzani on the various manifestations of
these stereotypes. We lay this process at the feet of American xenophobia,
but Italians are not without blame; Italian emigration is denigrated and
demonized because Italian institutions and intellectuals have *never* come
to its defense.

This entwined cultural veto resulted in angry non-assimilation; the
Italians, or rather, Southern Italians, did not abandon their dialect (we are
not speaking of standard Italian, which they often did not know), the
importance of family, and their culinary and religious traditions. Non-

assimilation preserved their culture within their North American homes. Just as beliefs under threat gather strength in catacombs, so every family had a secret recipe, a collective legend, a mythological origin. This process had very positive implications. The émigrés, for example, gave birth to a vivacious and varied world of entertainment by maintaining the traditions of Italian popular theater, from adaptations to sketches, from classics to neo-realism. Immigration officers also made this possible by giving unrestricted access to those Italians who declared themselves musicians and actors, thus granting them a legitimacy that has never diminished (see Emelise Aleandri's essay on Italian theater in New York).

This history is articulated through five generations of cinema. The first is the forgotten one of actors who left "Little Italy" for Hollywood, such as Cesare Gravina who worked with von Stroheim, Frank Puglia who debuted in Griffith's *Orphans in the Storm* (1922), and directors such as Robert Vignola and Frank Borzage. Supreme among them was Rodolfo Valentino—a star phenomenon that seems to contradict American anti-Italian sentiments during the 1920s, when Sacco and Vanzetti were tried and sent to the electric chair solely because they were Italian anarchists. The Valentino cult embodies the love-hate relationship Americans have for Italians. Italians are beloved when they evoke the Italy of art, music and entertainment, but hated when they become a badly smelling mass invasion (the "different" odor of the emigrant is still today used as justification for exclusion). The contradiction resurfaced with Enrico Caruso, as it did with Valentino. Both were very successful émigrés and both were the victims of poisonous attacks by the American press, which accused them of homosexuality. The machismo embodied by Italian American gangsters, boxers, and policemen in today's media is none other than a reverse manifestation of the sex and identity phobias of the past.

In the 1930s the political interests of the Fascist regime for "Italians abroad" (emigrants is a term the regime refuted, as it would have revealed the country's precarious social and economic conditions), and the New Deal's openness to ethnic diversity, which caused a retreat of the two identity prejudices, resulted in the use of the dash and of the term Italian-Americans. The second Italian American cinema generation is the "hyphenated" one of the 1930s which, in acknowledging diversity, created its own cultural industry that ranged from newspapers to radio, from records to movies. With the advent of talkies there was a crisis in the non-assimilated community, as Hollywood spoke only English, and Italian

cinema was barely beginning to speak. The community reacted by drawing on the wealth of immigrant theater and Italian American radio. It began producing Italian American movies by filming Farfariello, the famous sketch artist, setting *Santa Lucia Luntana* in New York (see Giuliana Bruno's essay) and approximately twenty other sound versions of Neapolitan movies, musical shorts, and native adaptations. This production is proof of ample progress in immigrant culture that has never been documented, despite the fact that ours is the second ethnic cinema, after Yiddish cinema, in terms of numbers of movies produced in the United States. During these same years, Italian American literature, which, until then, had been written in Italian, takes on both the English language and American culture, and in the case of John Fante (see Emanuele Pettener's essay), reaches as far as Hollywood. It is a passage that confirms emigrant culture's propensity for modern communication, and is quite different from the regressive and conservative nostalgia hypothesized by Italian intellectuals.

Just when a modern Italian American culture was beginning to emerge, the war violently interrupted the virtuous circle: Italians became enemies of their new homeland. And so they stopped speaking Italian, Americanized their last names, and threw away or hid any trace of their cultural tastes, such as records and books in Italian. For an entire generation, from World War II up until the 1960s, Italian connotations were suppressed in favor of almost total assimilation, assuaged by Frank Sinatra's success. After the war, however, actors of Italian ancestry were vindicated by the affirmation of neo-realism. They were seen in imported imitations such as *Marty* (Delbert Mann, 1955), in which, together with the Italian American Ernest Borgnine, Esther Minciotti, who came from the world of émigré theater, also appeared. This is, in fact, the moment when Italian cinema, with its social commitment and artistic-cultural focus, affirmed itself worldwide and, in so doing, triggered a co-option mechanism within the community.

The 1960s saw changes in the social arena — the civil rights movement and aspirations for multicultural tolerance — and in cinematic aesthetics — the notion of Italian *cinema d'auteur*, and a cinema that was freer, conceptually from the point of view both of production and creativity. One clear result was the arrival of Francis Ford Coppola and Martin Scorsese, which constituted both the "rebirth of Hollywood" and the affirmation of Italian American culture, two components now inextricably fused. The

coinciding of these two phenomena—i.e., the affirmation of the Italian American community and the emergence of a "new American cinema" (and its many directors of Italian descent)—did not receive the attention it deserved in the Pesaro Festival's ample bibliography devoted to the rebirth of American cinema in 1979. The 2007 edition, therefore, allows for investigation of a possible relationship between these two elements.

In the 1970s, a new generation of directors that includes Brian De Palma, Joe Dante and Michael Cimino emerged. Their movies, however, do not seem to deal with Italian American characters or themes to the extent that Coppola and Scorsese did. In fact, if one carefully analyzes their filmography, one realizes that it is only a first impression. In almost every one of De Palma's movies there is at least one Italian American character or actor. De Palma directed *Wise Guys* (1986), written by George Gallo, with Danny DeVito and Joe Piscopo playing the role of the two gangsters, and Mimi Cecchini, a child of entertainers who began her career in the émigré theater, in the role of the grandmother. He also directed *The Untouchables* (1987) and *Snake Eyes* (1998), in which the Italian American Nicolas Cage played the role of the corrupt policeman, Rich Santoro.

De Palma plays a key role in the Hollywood strategy of ethnic interchangeability, particularly in the case of *Scarface* (1983), where he transformed the Italian gangster Tony Camonte in Hawks' film into the Cuban Tony Montana (played however by the Italian American Al Pacino). The interchangeability of Italians with Hispanics, common in Hollywood, has been associated in the past with pressure made by Italian censors who changed the names of Italian characters if portrayed negatively; it makes ethnic recognition more difficult. In *The Untouchables*, for example, despite the presence of the Italian American actor Robert De Niro playing the role of Al Capone (the most famous of all Italian American gangsters), Andy Garcia in the role of the Italian policeman Giuseppe Petri (a kind of Petrosino), and a cast of characters elegantly dressed in Giorgio Armani, one does not see the type of stereotypes associated with godfathers and their confederates. And so, De Palma seems to us to be less identified with our idea of Italian American culture. An opposite path is that taken by Michael Cimino. His *The Deer Hunter* (1978) is heavily ethnic, but not set in an Italian American environment, while he boasts of his origins with his romantic portrayal of the Mafia with *The Sicilian* (1987).

In the 1980s, the Marshall siblings, Garry and Penny (Marsciarelli), and Chris Columbus burst onto the scene; their respective sitcoms and feature films have barely any trace of their cultural origins. It is also Abel Ferrara's moment, with his dark and weighty Italian American cinema. In turn, Quentin Tarantino follows in the early the 1990s, although his connotations are much less ethnic.

From the 1970s to today, therefore, there have been many movies directed by Italian Americans using Italian American actors, or those that have dealt with Italian American gangsters, criminals and more or less corrupt cops with explosions of violence, sensuality and drugs, all in a primarily male world with its codes of honor. The result has been a peculiar synthesis of gangster movies and film noir, following in the footsteps of *The Godfather* (Francis Ford Coppola, 1972), which can also include both the Yakuzas and the Chinese mob. In exploiting the romantic and at times cultured potential (at least from a musical stand point) that the association with gangsters of Italian origin offers—namely, the ethical-psychological complexity and the anti-social rebellion that the urban Italian criminal has always represented in American cinema beginning with *Little Caesar* (Mervyn LeRoy, 1930), and *Scarface, Shame of a Nation* (Howard Hawks, 1932)—this cinema has reaffirmed in a strong, almost inextricable manner the Italian American stereotype of urban violence and the Mafia. What separates a gangster movie set in an Italian American environment from one connected to other cultures is, however, the role of the family. It is a small consolation, but family, be it of blood ties or business, constitutes the Italian American element; the cuisine and the social and ritual rites of marriages and funerals then follow.

These cultural traces in the cinema of Scorsese, Coppola, De Palma, and Ferrara in the 1990s have been discussed by Robert Casillo, who has noted their gradual fading away as being in concert with what has been called "the decline of ethnicity." In this cinema, more than Italian Americanicity, one feels the presence of the homeland, the point of return, journeys, and flashbacks that narrate the departure from and ties with the mother (native) land, with its music (pop and opera), as discussed by Simona Frasca, and its flavors. Vito Zagarrio, in his essay, retraces some of the most emblematic moments of this Italian nostalgia, in style as well as movie plots. The connection between Italianicity and Italian Americanicity, which is a given in the United States, is not as obvious for us in Italy.

The degree of closeness of this cultural kinship is still an unresolved matter.

In contemporary American cinema, numerous mainstream Italian American directors have given life to Italian American characters. Penny Marshall, for example, gave us Madonna's baseball player. And yet what people remember are a few titles associated with the troublesome equation of Italian = Mafia. It is only by investigating independent movie productions and the less well traveled path of shorts and documentaries, as done by Tamburri and Muscio in their essays, that one discovers a different or differently portrayed Italian American (or American Italian) culture. Curiously, it is in the work of the "Dir-Actors," of which Anton Giulio Macino writes, that one finds concentrated an interesting part of this minor American cinema, one that deals with another Italian American. In fact, when discussing contemporary American cinema, we encounter an extremely significant phenomenon: the very large number of actors of Italian origin and the substance they give to every type of role, from romantic lead to comedian: Robert De Niro, Al Pacino, Leonardo DiCaprio, Nicolas Cage, Steve Buscemi, John Travolta, Sylvester Stallone, Stanley and Michael Tucci, Susan Sarandon, John Turturro, Nick Turturro, Aida Turturro, Ray Liotta, Christina Ricci, Vincent Gallo, Marisa Tomei, Annabella Sciorra, Mary Elizabeth Mastrantonio, Vincent D'Onofrio, Rene Russo, Joe Pesci, Ben Gazzara, Vincent and Joe Spano, Joe Mantegna, Ralph Macchio, Linda Fiorentino, Danny Aiello, Paul and Mira Sorvino, Vincent Gardenia, Gary Sinise, Danny DeVito, Chazz Palminteri, Talia Shire, Joe Pantoliano, and Robert Loggia. And let us not forget television stars such as David Caruso, Nicholas Colasanto, and, above all, James Gandolfini. The list would not be complete without Dan Castellaneta (Homer Simpson's voice) and the popular Jay Leno (his father is from Avellino).

In music we have Madonna, Bon Jovi, Cindy Lauper, and Bruce Springsteen. American media culture is therefore often embodied by persons of Italian ancestry. Without resorting to clichés that too easily associate Italians with entertainment, it could be argued that their presence is not pure coincidence, but rather due to the self-portrayal these actors give of their culture of origin when they move from in front of the camera to behind it. A case in point is John Turturro with his trilogy: *Mac* (1992), *Illuminata* (1998), and *Romance & Cigarettes* (2005). All three have a working-class Italian American setting, centered around female and male charac-

ters tied to the debate on genre roles that a macho stereotype such as that of the Italian American has given rise to, particularly during the past ten years. Turturro's search for his roots brought him back to Naples, to act in Eduardo De Filippo's *Questi Fantasmi* (*Souls of Naples*), but in English translation. One could not find a clearer exemplification of a journey that seems to overcome Italian Americanicity, in order to directly link Americanicity with the strongest cultural tradition of Italian performance.

The Italian American retrospective proposed by Pesaro 2007 contains very few godfathers; instead, one finds many families and couples that grapple with roles and values (sentimental as well as ethical and professional) that are in crisis everywhere, but which the community considers still very important. What emerges are directors such as Nancy Savoca and Marylou Tibaldo-Bongiorno, who are independent, feminist, and political. As discussed by Anna Camaiti Hostert (with regard to gender) and George De Stefano (with regard to sexuality), these directors analyze, with irony and a few low blows, the Italian American families where it has become increasingly difficult—especially for men—to deal with the economic, social, and racial complexity of the America in which they live. Many of these directors have studied cinema at college: Tom Di Cillo and Nancy Savoca at New York University, and Joe Greco at Florida State University. Almost all of them view their community of origin in a disenchanted, even critical, though not self-denigrating way.

Reaganism, in fact, saw some of the Italian American community transform itself into part of the silent (and according to Spike Lee, sometimes racist) majority, with Rambo-Sylvester Stallone in the lead. The cinema of Italian American directors instead reacts against this simultaneously defensive and aggressive position. It narrates the contradictions of this phase by dealing with the war between the sexes and the crisis of the patriarchal family, but does it with a focus on social stratification that is absent in Hollywood. Their movies show how the hardships caused by the economy and the workforce are always faced with stubborn dedication to the job well done—a value that distinguishes the community. It is expressed in a phrase that all Italian Americans sooner or later end up saying, as a defense against being associated with the Mafia: that their money and their jobs were earned with the sweat of their brows. Mac says it, but De Niro also says it as the father in *A Bronx Tale* (1993).

The movies, in the retrospective, tell of families, but without sentimentalism. They show bricklayers, mechanics, and a lower middle class

trying to deal with an increasingly cruel economy. They live in Abel Ferrara's degraded New York and, more frequently, in the suburbs, in New Jersey or Rhode Island. Signs of Italian Americanism are not strong. As John Paul Russo notes in his essay, only non Italian American directors still use the stereotype of the *mafioso*, music-loving, fat, woman-izer, and superstitiously religious Italian American. Nowadays, this stereotype goes by the name of "Guido," a word that harks back in a trouble-some way to the derogatory term "guinea," that was used in the past to denote the community. The Guido is a muscular, working class, suburban bully. He has a hairy chest showing through his undershirt and a gold chain and cross around his neck, dark pomaded hair, and looks some-where between The Fonz (the type's first representation), John Travolta, and one of Tony Soprano's bodyguards. Macho, racist, violent, and at-tached to his mother, the Guido maintains past stereotypes alive in American media. Recently he has found a mate, the "Guidette." She chews gum, wears too much makeup, is a hairdresser, shows too much of her abundant cleavage, but respects her parents and is basically a good girl. Faced with this typology, as expounded upon and renewed in the *Sopranos*, Italian American cinema proposes less negative, but in no way self-indulgent versions. In fact, its ironic, reflected image is, at times, quite merciless. In *Little Kings* (2003), Tibaldo-Bongiorno tells the story of three brothers with more or less healthy sexual appetites; in turn, Nancy Savo-ca depicts a young Italian woman whose fiancé is markedly immature. And behind the preparation of food there is often the kind of philosophy of life preached by *Big Night* (1996), a cinema that connects body and soul in a much richer way than in WASP culture. It is an unexpected cinema that analyzes family and social relations in conflict.

One could say that small independent productions cannot afford spectacular sets and that intimacy therefore becomes a necessity. But we are far from tranquil sitcom family life. What we have is, in fact, the com-plete opposite. No wonder the most innovative television series is cen-tered on the Soprano family. In *Desperate Housewives*, as noted by Silvia Giagnoni, one of the most troubled housewives is Italian American.

Within the span of a century, the Italian American community has moved from the lowest level of society to the Oval Office, if it is true that a future President of the United States could be "sheriff" Rudolph Giu-liani. Luconi tells us that "according to data from the latest federal census completed in 2000, the achievements of Italian Americans in education,

employment, and income are even higher than the national average. For example, 28.9 percent of the members of this ethnic group have some sort of university degree, compared with 24.4 percent of total United States population. Similarly, 38.3 percent of total Italian Americans are professionals or managers, while only 33.6 of those who are employed throughout the country have these qualifications. Finally, the average annual income of a family of Italian origin is $51,246 compared with the national average of $41,994."

This consolidated community, therefore, has no need to boast or show off. At times, it is still caught in the trap of fighting against Mafia stereotypes, not understanding that the true turn around was actually done by *The Godfather*, when it made this world fascinating because it is Italian American, and Tony Soprano, above all, continues to do so.

The Italian American media have come of age: they make us identify with these characters. They make them fascinating and/or likeable while at the same time, making fun of them or criticizing them with an almost Brechtian dose of irony and detachment.

The census cited by Luconi also shows an increase of about seven percent in the number of US residents who, compared to the 1990 census, claim Italian ancestry. It is a sign that belonging to the community is considered a plus. This fact is associated with another current trend: an increase in requests for an Italian passport in order to obtain dual citizenship. Having achieved a high level of social legitimacy, the community has no need to ascribe to a total Americanicity, but can reclaim its Italian origins since they no longer denote shame but, to the contrary, pride and identification with glamour.

As Anna Camaiti Hostert acutely observes, "[t]hese characters are no longer victim to any type of exclusion, segregation, or discrimination from the cold Anglo-Saxon world. Furthermore, they feel they have contributed to positive changes because they have an overriding set of values that makes them and the world around them richer and better. Their emotions and passions, the things that once made them second-class citizens, now make them and the society around them better. They are able to articulate their feelings without repressing their sensuality. They are also able, especially after they confronted each other, to reach an interior equilibrium that contributes to improve the relationships among individuals, demonstrating a reversal of their roles and of their ethnic subaltern position."

The Italian American component of contemporary cinema is not only an indication of quality, it also has a positive function in its totality, both because of the connection it maintains with emotions — and we could say this is a given — but also because of its strong reliance on the culture of the ancestral country, and most of all, on its cinema.

I believe that, at the very least, one achievement of the Pesaro 2007 Italian American retrospective, as well as of this collection, is to have revealed the richness of this culture and the pride with which it is expressed, whereas we, in Italy, still associate Italian Americans with poverty and the shame of emigration. They enable us to see the success of our cousins in America as they manifest their desire to come back to, and most certainly not leave, the family, despite the treatment received in the past.

Translated from the Italian by Maria Enrico

DEFINING ITALIAN-AMERICAN CULTURE

Italian Prejudice against Italian Americans

Emilio Franzina
UNIVERSITY OF VERONA

Despite the vast expanse of literature that has recently been dedicated to an analysis and, even more, the public use of anti-Americanism as an instrument of political struggle on both sides of the so-called "clash of civilizations,"[1] it is surprising that no mention, even peripherally, has been made of the relationship between a generically negative notion of the United States and the trans-Italian (or European) emigration over the last two centuries. This could be reasonably explained by the fact that, from a certain moment forward,[2] emigrants leaving for the new world notoriously retained the dream — the mirage, or rather the "myth" — of America,[3] thus producing an "irresistibility" of the country's tangible, far-reaching advantages. Nevertheless, there is considerable evidence of feelings of malice and "anti-Americanism" in the field of emigration studies, and such phenomena deserve to be further examined, perhaps in conjunction with other possibly related "anti-" sentiments of the time. For instance, there were indeed critical if not defamatory opinions of the "Southernness" of those Italians who arrived in the United States between the 1800s and 1900s.

[1] Pietro Craveri e Gaetano Quagliarillo, eds., *L'antiamericanismo in Italia e in Europa nel secondo dopoguerra* (Cosenza: Rubbettino, 2004). The theme is quite vast and very much researched, not only from a cultural viewpoint (see, for example, Russel A. Berman, in *L'antiamericanismo in Europa. Un problema culturale* [Cosenza: Rubbettino, 2007]), but also, as principal rationale, through a detailed historical analysis that identifies correctly as the major anti-American modern era that period between the two World Wars. In tune, that is, for Italy, even with the Fascist stand against the barbarization of the emigrant co-nationals in the United States (in any event, with regard to these issues, for close to twenty years we have had at our disposal an excellent examination by Michela Nacci, even with regard to the French case. See her two books, *L'antiamericanismo in Italia negli anni Trenta* (Turin: Bollati Boringhicri, 1989); *La barbarie del comfort. Il modello di vita americano nella cultura francese del Novecento* (Milan: Guerini e Associati, 1996).

[2] Victoria De Grazia, *L'impero irresistibile. La società dei consumi americana alla conquista del mondo* (Turin: Einaudi, 2006).

[3] Claudia Dall'Osso, *Voglia d'America. Il mito americano in Italia tra Otto e Novecento* (Rome: Donzelli, 2007).

This is not a totally incomprehensible case of omission or amnesia. In many ways, both anti-Americanism in and of itself (and for that matter, anti-Southernness),[4] and, more importantly, its frequent application, look towards objectives that are political in character. Just to cite an example, the criticism against anti-American positions and its supposed subjects (a criticism that is often bitter, but moreover somewhat unfounded and used as a pretext), and the defenders of America and its "manifest destiny,"[5] reveal their blatantly ideological origins.

The prefix "anti," as has been pointed out, presupposes views that are "totalitarian." Whoever takes on "anti" positions is irremediably against visions of the world or reality that are opposite to his, which inevitably provokes the same inverse reaction in the person who is being attacked, generating an endless cycle of hatred and incomprehension that in the long term alters and confounds any possibility of rational discussion.[6] This not only demonstrates that "anti-ism" is ideological in nature, but that it is also subordinate to highly symbolic forms of political communication aimed entirely at disqualifying an adversary. Therefore, we should not take this road, or deliberately place ourselves on such a steep, slippery plane with our analysis. In any case, in the context of migration this is not bound to happen in full simply because the fiercest statements of "anti-Americanism,"[7] often in the same discussion, would be contra-

[4] Vito Teti, *La razza maledetta. Origini del pregiudizio antimeridionale in Italia* (Rome: Manifesto-libri, 1993); Nelson Moe, *Un paradiso abitato da diavoli. Identiti nazionale e immagini del Mezzogiorno* (Naples: L'Ancora del Mediterraneo, 2004).

[5] On "Manifest Destiny" in the United States there exists, as is well known, ample literature since the writings of Albert K. Eirnberg (or, closer to us, those by Sam W. Hayes and Christopher Morris), however, one need only consult the work of Anders Stephanson, *Manifest Destiny: American Expansionism and the Empire of Right* (New York: Farrar, Straus & Giroux, 1995) and Walter A. Mc Dougall, *Promise Land, Crusader State: The American Encounter with the World since 1776* (New York: Houghton Mifflin, 1997).

[6] Though with some reservations, see narrative summary by Barry Rubin and Judith Colp Rubin, *Hating America: A History* (New York: Oxford University Press, 2004).

[7] Gianfausto Rosolo, "Mito americano e "cultura" religiosa degli emigrati italiani oltreoceano," in Sebastiano Martelli, ed., Il sogno italoamericano. Realta e immaginario dell'emigrazione negli Stati Uniti (Naples: Cuen, 1998) 208-215 e 220-224; and Emilio Franzina, "L'Amerique," in M. Isnenghi, ed., *L'Italie par elle-méme. Lieux de mémoire da 1848 á nos jours* (Paris: Editions de la Rue d'Ulm, 2006) 450-456. The quote from Rosoli's essay leads us to note *en passant* how a theme would be foreign to the issue, which we cannot discuss in detail at this juncture, or better the coexistence, even in the Catholic and ecclesiastic arena, even since the end of the nineteenth century (see the correspondence between Leone XIII and Cardinal Gibbons, in the books of priests and missionaries in the United States, etc.), of two different tendencies, one filo- (Ornella Confessore, *L'americanismo cattolico in Italia* [Rome: Studium, 1984]) and the other anti-American. Both had their bishops and a decent following even at the popular and migratory levels since the 1930s (see Silvio D'Amico, *Scoperta dell'America cattolica* [Florence: Bemporad, 1927] and G. Formica, *Il Congresso Eucaristico internazionale di Chicago*, New York, 1928), colliding, as usual, on the dangers and advantages of the American way of life from an

dicted or counterbalanced by positive assertions such as the above-mentioned American "myth."

This was, for instance, the case of Francesco Perri, who, after a cycle of literary and para-literary writings that appeared in Italy between the nineteenth and twentieth centuries, suggestively and persuasively asserted in 1928 that America had always been both good and bad for emigrants. Discussing an imaginary, yet very realistic town in the south of Italy, Pandore, literally emptied by emigration to the United States, Perri cited examples that argued both for and against the choice to emigrate. In fact, in Pandore, and in nearby towns, many were able to improve their quality of life thanks to emigration:

> Vincenzo Mantica repaired his home. Ciccio Musolino, who had left as poor as Job, had a house built for himself with a pretty little lodge painted yellow, and had a wax-surface tablecloth on his kitchen table, with a painted image of the Brooklyn Bridge and a giant Madonna the returned emigrants call liberty. And Americans have a thousand other luxuries in their homes; lots of unused domestic gadgets. One even brought back an egg-beater, another a machine to make maccheroni. Those who came back from America gave the impression that they knew how to live a life that was different from their old one, more comfortable, more content. But it wasn't all roses! Some of the emigrants came back sick, afflicted by some mysterious illnesses that no one in the country had ever seen. Others had been maimed and couldn't even get any insurance money for their injuries. Peppe Cùfari only received two thousand lire for all the fingers he lost on his right hand. What could they do, these poor illiterate peasants, who couldn't even write a few lines to their families?[8]

Examples, even non-literary ones, are almost infinite (for instance, proletarians' private writings or the folk songs about "'Merica" and Christopher Columbus),[9] and they certainly would not erase an intrinsic ambivalence. There are other examples to follow, but it would be expe-

ethical-religious viewpoint and therefore proceeding by far the debates and polemics followed up to the end of World War II, or even to 1968 (see, among the many filo-American critics non exempt, like these, from apparent political exaggerations, Massimo Teodori, *Maledetti americani. Destra, sinistra e cattolici: storia del pregiudizio antiamericano* [Milan: Mondadori, 2002]).

[8] Francesco Perri, *Emigranti* (Milan: Lerici, 1976 [1928]) 43-44.

[9] Emilio Franzina, "Le canzoni dell'emigrazione," in Piero Beviacqua, Andreina De Clementi, and Emilio Franzina, eds., *Storia dell'emigrazione italiana. I Partenze* (Rome: Donzelli, Roma, 2001) 549-551.

dient first to examine the genesis of anti-Americanism in Europe's so-
called "departure areas" of the 1880s in relationship to widespread, al-
most generalized, repulsion by today's middle class for the America that
was once the destination of peasant and proletariat classes. This is not an
exclusively Italian phenomenon. Nevertheless, it is easily recognizable,
and it reaches its irascible and sharp points in Italy.

A summary representation from myriad period sources reveals the
demonization of peasants and laborers, accused of deserting the fields
and, at best, ridiculed for their gullibility. On the other hand, targets of
such accusations often appropriated the implicit classist reasoning of the
arguments, and they provided ample evidence of this in their letters. As
they were departing from Italy, they emphasized in their songs the re-
venge they would exact in abandoning the mother country. The meek
peasants of Hapsburg-ruled Trentino that was part of the Austro-Hun-
garian Empire, not unlikely the subjects of the Italian Kingdom, would
sing: "When we'll be in 'Merica/The newfound land/We'll hand over the
shovel/to the nobles from Tirol." That was enough to reinforce in the
eyes of "signori" all over Italy the notion that the responsibility for this
unwelcome and surprising state of affairs was with those trans-Atlantic
countries and their illusions about property and jobs.[10]

If it was not America's fault, then whose was it? America as "fabri-
cator" of formal and informal enticements,[11] nevertheless, keeps a low
profile, faintly visible in the negative campaign waged for twenty years
until the beginning of the twentieth century by the land-owning class and
its newspapers, which do not discriminate among the various parts of the
"new world" chosen by the emigrants. The mechanism is simple and easy
to decipher: by abandoning *en masse* their native, mostly rural, lands, the
peasants contribute to a decrease in population and consequently cause
salaries of agricultural workers to rise, to the great annoyance of the land-
owning ruling class that is backed by the intellectual class.

In the "anti-emigration" literature and journalism, to which I have al-
ready dedicated a good deal of attention,[12] the main points of "ruralist"
criticism (with moralistic overtones) are intertwined with lower-class

[10] Andreina De Clementi, *Di qua e di là dall'oceano. Emigrazione e mercati nel Meridione (1860-1930)*
(Rome: Carocci, 1999).

[11] Amoreno Artellini, "Il commercio dell'emigrazione: intermediari e agenti," in Bevilacqua, De
Clementi, Franzina, *Storia dell'emigrazione italiana*, 293-308.

[12] Emilio Franzina, *Dall'Arcadia in America. Attivita letteraria ed emigrazione transoceanica in Italia (1850-
1940)* (Turin: Edizioni della Fondazione Giovanni Agnelli, 1996).

prejudice. Indeed, this correlation leads to, on the one hand, the rapid transformation of the "satire of the peasant" into the "satire of the emigrant," and on the other hand, to new complaints about those, such as Americans, who have lead astray the souls of the "poor people," to the point that they have been de-naturalized and stripped of their "natural attitudes."[13]

Precarious, partial, or unreliable knowledge of a continent, constructed by many people and their understandable expectations, foments the most catastrophic and pessimistic prophecies of the anti-emigration front, with the reactivation of anti-American sentiments of the past. In predicting for emigrants a grim future full of problems related to their new environment, work, interpersonal relations, etc., derived from the irreducible and almost ontological difference of newly-erected or provisional dwellings, the critics of ruralism re-appropriated a patrimony of ideas and preconceptions, which were consolidated and often already metabolized for decades within the culture of Europe's old regimes.

It is worth noting that, already in the eighteenth century, biased confusion and prejudices easily lent themselves to theories about the nature of the "new world" and its original inhabitants. Much of this is based on the fact that at its inception, the exodus of peasants for at least twenty years privileged South America as destination (Brazil and Argentina in particular), as well as Spanish-speaking areas in the Pacific. This led to imprecisions and misjudgments, impermeable to the eighteenth- century debates and theories on the nature of the "new world" and its original inhabitants.[14] The degenerative seventeenth-century theories centered around events and experiences of older Spanish and Portuguese empires across the Atlantic. However, they also included criticism of localized cases in the Northern part of the new continent. South America, at first, did not jibe with the image, which later became current and prevalent, of America understood essentially as the United States or North America. To North America, one was thus able to ascribe the stigma of a biological minority, and later, the negative characteristics of a culture in formation, consumed in the materialism and vulgarity of both individual and collective behavior.

[13] Emilio Franzina, *La grande emigrazione. L'esodo dei rurali dal Veneto durante il secolo xix* (Venice: Marsilio, 1976).

[14] Antonello Gerbi, *La disputa del Nuovo Mondo. Storia di una polemica (1750-1900)* (Milan: Ricciardi, 1955).

When emigrants were foretold of a disastrous future in their roles of pioneers, linked to the remoteness of the destination points, notions of *wilderness* or *savagerie* were negatively emphasized. This was not without basis given the misfortunes encountered by some Northern Italian peasants, often at the hand of cruel, "savage" indigenous populations or even African Americans still subject to a regime of slavery (in Brazil for instance until 1888).[15] It was said that these kinds of contacts would irremediably damage the emigrants whose decline, certified by phenomena such as "caboclization,"[16] constituted the final, pernicious outcome of a hopeful initiative for the betterment of the original (European) life and work conditions. In the journey from Brazilian forests to urban outskirts of large North American cities, the discussion and panorama do not vary much, as the wilderness becomes of a cultural and moral nature.

The recovery of these eighteenth-century notions, from Buffon, who mercilessly expounded on the congenital aridity of American society ("The heart of Americans is ice cold, their society is cold, their empire is cruel"), to Talleyrand, who stigmatized what he perceived as American society's limitations, including the proliferation of far too many religious confessions and even the abysmal level of its food and eating traditions, was a prelude to certain salient points in a criticism that, with Alexis de Tocqueville, became political. His observations about the democratic republican regime prevalent in the new world (tyranny of the majority, grave risks of populism, dictatorship, etc.)[17] made seventeenth-century notions available for reuse when Italian migration shifted to the United States at the end of the 1800s.

The cliché of the U.S. as the country of choice for talentless and anonymous men, commoners without a history and consumed by a single-minded aspiration for wealth, was already in place. This was in opposition to the European tradition modeled on an aristocratic spirit, which was almost always entangled with the aristocracies of power and the possession of land. These perspectives were the least adept at understanding

[15] The reference does not obviously concern the Italian immigration experience in North America, or at least it is concerned with the those cases studied until now of southern Brasil at the end of the nineteenth century; see, Piero Brunello, *Pionieri. Gli italiani in Brasile e il mito della frontiera* (Rome: Donzelli, 1994).

[16] To become "caboclos" means to be indefinite, indefinable, and regressed to rudimentary levels of civilization, a concept reinforced by racial mixing and mixed marriages with blacks and indios.

[17] Corrado Vivanti, "Introduzione" to Alexis De Tocqueville, *La democrazia in America* (Turin: Einaudi, 2007) v-liv.

(or appreciating) the nascent logic of the all-inclusive market and the secularization of consciences induced by pragmatism and technology. These two factors together—a practicality freed from the excesses of bureaucratic procedure and continuous technological innovation—formed a civil and economic model of development that encompassed and almost resolved the contradictions of capitalist modernity or, in a word, the American model.

The landowners' age-old, anti-peasant polemic against emigrants was being attenuated, rebutted, reabsorbed, or defeated by the facts. However, the facts did not diminish the intellectual's or the literati's objections to that model, understood as American. Many of them, in fact, undertook voyages of inspection across the ocean, with the pretext that they were looking to offer a positive portrait of the emigrant situation and of those who left in search of fortune, or more likely in search of greater freedom, better quality of life, and work conditions. This was a voyage that was conveniently and adequately remunerated by editors and newspapers desirous of offering their readers a "believable" image of America and of the emigrants' "painful" attempts at integration.

These accounts of immigrant experience—a few of which dealt with Latin America, such as Adolfo Rossi's and Dario Papa's—were condensed in books and pamphlets of a certain substance, although repetitive and monotonous. They were monotonous in substance, implying (even from the most balanced authors like Giuseppe Giacosa) that the United States was, in all likelihood, the country of the future, yet, at the same time, a country in which Italian immigrants would rapidly suffer linguistic, cultural, and spiritual impoverishment.[18] These emigrants were no longer just, or simply Southern agricultural proletarians, but rural and urban residents from all regions of the South seeking further still Latin American destinations (albeit in relative decline), but with a preference for the United States, which was enjoying an impetuous economic and political growth, particularly after 1898, as it emerged as an imperial power. All of this visibly embittered the anti-American positions of noted and less noted intellectuals, including those better informed on the United States, such as Prezzolini and Ojetti, Preziosi and Allemand Bernardy (or Villari

[18] See Giuseppe Massara, *Viaggiatori italiani in America (1860-1970)* (Rome: Edizioni di Storia e Letteratura, 1976).

and Pecorini).[19] They did not cease to exhibit hostile diffidence and subtle contempt for the mass society in which many immigrants would lose "their nature" and be forced to integrate. These immigrants were understood from the beginning to be "Southern brutes," hardly representative of a superior, and high, "Italian tradition." This attitude lasted from the beginning of the century until World War I, when recriminations against America were temporarily attenuated.

Not by chance, they would end up amassing in the degraded ethnic neighborhoods of "Little Italy," which soon became more than a physical place, the symbolic place *par excellence* of the Italo-North American.[20] As with the *cortiços* and *conventillos* in Brazil and Argentina,[21] the Little Italies were portrayed as the training grounds of the immigrants' bitter experiences, marked by intolerance and xenophobia that resulted even in homicide.[22] This was further marked by the tribulations of menial and stigmatized jobs. For those who intended to remain in America, it would take more than one generation to achieve the material success the immigrants longed for, and that represented their true goal.

Meanwhile, there were those who practiced a sort of transoceanic commuting, although they were in the minority. Not only did they contribute to the considerable fluxes of the so-called temporary emigration, harbinger of some repatriations and incremental returns (especially to the South), but also to a different and more positive phenomenon of integration into North American society. But Italians treated them as carriers of unwelcome contaminations. By the late 1900s, Italian filmmakers like the Taviani Brothers of *Good Morning Babilonia* (1987, by Paolo and Vittorio Taviani) paid attention to immigrants, albeit Italians from Central

[19] Their recriminations against America were only temporarily silenced with the United States' entrance into World War I in 1917 to join Italy and its allies. It was a coincidental paradox that the infamous Literacy Act was approved by Congress (see Betty Boyd Caroli, "The United States, Italy and the Literacy Art," *Studi Emigrazione* 41 (1976): 3-22 and Emilio Franzina, "La chiusura degli sbocchi emigratoria," in *Storia della società italiana*, Part V, vol. XXI, *La disgregazione dello Stato liberale* [Milan: Nicola Teti Editore, 1982] 125-189) which would become the basis for post-war restrictions established in the 1920s that were, above all, anti-Italian (see also, Catherine Collomp, *Entre classe et nation. Mouvement ouvrier et immigration aux États Unis* [Paris: Belin, 1998]).

[20] Emilio Franzina, "L'Italy," in *Una patria espatriata. Lealtà nazionale e caratteri regionali nell'immigrazione italiana all'estero (secoli XIX e XX)* (Viterbo: Settecittà, 2007 [Quaderni dell'Archivio storico dell'emigrazione italiana, n. 2] 119-138).

[21] Emilio Franzina, *Gli italiani al nuovo mondo. L'emigrazione italiana in America (1492-1942)* (Milan: Mondadori, 1995).

[22] Emilio Franzina e Gianantonio Stella, "Brutta gente. Il razzismo antitaliano," in Salvatore Lupo, ed., *Verso l'America. L'emigrazione italiana e gli Stati Uniti* (Rome: Donzelli, 2005) 213-242.

Italy. Nevertheless, the "southernization" of the fluxes was an imposing and decisive force, creating stereotypes that would last over time. In the early 1900s, the large majority of immigrants were from the South, sharing social, "ethnic," and geographical characteristics. This led to generalizations that fit perfectly with the widespread racism on both sides of the ocean. If not their social composition, than certainly the "ethnic" one present in the first decades of the 1900s, conferred embarrassing and embarrassed ideas to interpretative authenticity shared with the racism rampant on both sides of the ocean.

The distinction between "Northern Italians" and "Southern Italians" was already present in the national political discourse in Italy[23] and was not amiss (with more or less the same motivations) at the start of the mass exodus to Latin America countries, like Argentina and Uruguay.[24] This was refined by way of language, religion, and culture, and it was sanctioned according to statistical data. In the United States, there were two separate tallies for Southerners and Northerners at the point of entry. The latter were preferable, based on the proximity to Central and Northern Europe. First came the people of Piemonte, Veneto, and Lombardia (up to the 45° parallel), with some oscillation for Emilia, Umbria, and Toscana. It was commonly believed that the character of Northerners reflected a strong work ethic, a tendency for order, political conformity, etc.[25] Southerners, on the contrary, were included in the Mediterranean and Southern European ethnic group, associated with the worst suspicions of (low) work ethic and (inherent) unruliness. Moreover, certain behaviors and life practices in the "Little Italies" and elsewhere would give cyclical confirmation to these stereotypes in the eyes not only of the authorities and

[23] And not only in this one (see Claudia Petraccone, *Le due civiltà. Settentrionali e meridionali nella storia d'Italia dal 1860 al 1914* [Bari: Laterza, 2000]) even if, according to some scholars (e.g., Paolo Macry, "Se l'unità crea la divisione: immgini del Mezzogiorno nel discorso politico nazionale," in Loreto Di Nucci e Ernesto Galli della Loggia, eds., *Due nazioni. Legittimazione e delegittimazione nella storia dell'Italia contemporanea* [Bologna: Il Mulino, 2003] 62-92), this would then be at the base of a more recent Italic "divisiveness," for which it would be allowable, at least for us, to maintain various reservations.

[24] Fernando Devoto, "Gli italiani in Uruguay nel secolo XIX, in Fernando Devoto et al., *L'emigrazione italiana e la formazione dell'Uruguay moderno* (Turin: Edizioni delia Fondazione Giovanni Agnelli, 1993) 17-18, and *Storia degli italiani in Argentina* (Rome: Donzelli, 2007) 62-64 (not much different was the situation in Brazil up to the mid-1880s; see, Emilio Franzina, "I 'taliani' della Serra gaucha," in AA.VV., *Terra Natal Terra Nova / Paese Natio Zweite Heimat. O futuro das tradiçoes italiana e alema no Rio Grande do Sul* [Porto Alegre: Est Publications, 2002] 15-42).

[25] Gabriella Gribaudi, "Images of the South," in David Forgacs and Robert Lumley, eds., *Italian Cultural Studies: An Introduction* (New York: Oxford University Press, 1996) 73-87, and John Dickie, *Darkest Italy: The Nation and Stereotypes* (Houndmills: Macmillan, 1999).

American public opinion, but also — perhaps to a larger extent — in those of their compatriots back home in the publishing and academic arenas.

One of the most vicious, cultural paradoxes is that, on the cusp of the nineteenth and twentieth century, many of the in-vogue theories about race, including those fated to contribute to some of the worst restrictive and xenophobic campaigns in the U.S., originated with scientific studies conducted in Italy at the time of King Umberto I.[26] The teachings of Cesare Lombroso's "positivist" school and its adherents or competitors, from Sergi to Niceforo, had elaborated the framework for ideas that would become progressively more complex and radical.[27] Within this context, the reprisal of the age-old concept of "Latin decadence" formulated by Ferrero (Lombroso's son-in-law,) was inadvertently connected to that of the "Two Italies," whereby the "second," the South, would almost end up gobbling up the first, automatically annexing it and assimilating it. This would happen many times in real life, as, for instance, in the famous film *The Italian* [1915] (originally called *The Dago*), where the protagonist and victim, Beppo, is not a Northern Italian laborer but a Venetian gondolier. The director, the "great supporter of Americanism,"[28] Thomas Ince, applied the equation: Italy = the South, which arose from its possible immigrant history: emigrant = Southerner (and Southerner = Neapolitan).[29] By virtue of the same process of approximation and generalization, host countries would often confuse (though, again, not reflected in official statistics) Northern Italians with the "brown men" from the South. In any event, the latter were the protagonists of a mass emigration, barely acknowledged by sociologists and anthropologists such as Angelo Mosso and Zino Zini. The operation of discrimination took place primarily at their arrival in the United States, where they became targets of Italians

[26] Peter D'Agostino, "Craniums, Criminals and the Cursed Race: Italian Anthropology in American Racial Thought, 1861-1924," *Comparative Studies in Society and History* 2 (2002): 319-343. Even if the country of immigration, in which the diffusion of positivistic ideas with regard to race was more strident happened to be Argentina at the beginning of the twentieth century [see, Eugenia Scarzanella, *Italiani malagente. Immigrazione, criminalità, razzismo in Argentina* [Milan: Angeli, 1999]).

[27] Claudio Pogliano, *L'ossessione della razza. Antropologia e genetica nel xx secolo* (Pisa: Edizioni della Normale, 2005).

[28] Giuliana Muscio, *Piccole Italie, grandi schermi. Scambi cinematografici tra Italia e Stati Uniti, 1895-1945* (Rome: Bulzoni, 2004) 116.

[29] Besides the Argentine and Rio de la Plata case of the "Napolitano/Papolitano" that contained within itself the same negative stereotype of the Southerner, one must note for the United States the strong influence of Sicilianization in the consolidation of common anti-Southern locations within a precise regional hierarchy of the South (see, Giuseppe Calasso, *L'altra Europa. Per un'antropologia storica del Mezzogiorno d'Italia* [Milan: Mondadori, 1982]).

from other regions and even compatriots and meek clergymen (from the Catholic Church), who were themselves divided into Northern and Southern priests.

Sometimes, there were curious entanglements between "popular" anti-Americanism, in America, and the Italian anti-Southern attitudes. An example comes from a letter of great interest to us, written without second thoughts by an emigrant from Piemonte, an emigrant who, later in the years when the doors of immigration had been closed, became an unwilling ethnic scapegoat with sacrificial/symbolic roles of great relevance. The letter precedes, by about ten years, the episode that associated him to his companion-in-misfortune, the Southerner Nicola Sacco from Apulia.

In a somewhat famous letter written by Bartolomeo Vanzetti, dated January 12, 1911, sent from Meridan, Connecticut to his sister Luigia, (a letter that, incidentally, this writer uses in his lectures on "sung history,") together with the self-portrait of a *wobbly* Italian from the early 1900s, swept in the fury and discrimination of the *red scare*, we find, scattered about, almost all the basic elements of an anti-American (and anti-Southern) discourse that has come down from the high-minded realm of intellectual argumentations, to the level of convictions and opinions held by many "common men," experts on America and emigration:

> Dear sister [. . .] now I'll tell you a bit about America. The account of my adventures would be too long, I'd have enough to fill a book, so I'll limit myself to giving you a brief summary. As you might have understood from my first letters, when I first arrived in America [1908] a tremendous crisis overtook these parts. I had the fortune of finding work in hotels and for ten months, I encountered no misfortunes. I worked with Caldera for two months, and after eight months in a French restaurant where I learned the language a little. But, because of my temperament, I couldn't stay . . . I left New York and went to the countryside. There I worked the land, did some deforestation work, bricklaying, and work in stone quarries. I worked in a store that sold fruit, candies and ice cream and then putting in telephones. . . . [Now] I have the strong hope of finding a good job, because a friend of mine, an old man from Piemonte, is doing his best to find me one. In the country, I gained strength and health. I call it the country, but the town where I work has a population of about 30, 000. It has a public library, a high school, night school, many parks and little lakes that surround it. There isn't a nationality that I

haven't encountered here. I suffered quite a bit finding myself among foreigners, indifferent and at times hostile. I had to suffer injustices and derision from people who, had I known a fraction of English, I would have kicked their faces into the dust. Here, public justice is based on force and brutality, but not that the foreigner, and in particular the Italian, should dare to enforce it with energetic means; for him there are the police batons, prisons and the penal code. Don't think that America is so civil, though there are no qualities missing in the American people and more yet in the cosmopolitan population, if you take away their dollars and the elegance of their dress, you'll find semi-barbarians, fanatics and delinquents. No country in the world hosts so many religions and religious extravagances like the holy United States. Here, he who makes money is good, it doesn't matter if he steals or poisons. Many have and are making a fortune by selling their dignity, spying on and persecuting their own compatriots. Many reduce morality to a level lower than that which nature bestowed on animals. Even though here every cult is free, the Jesuit mode triumphs. And the saintly doctrines of Europe, conscious and wise, are a long way from illuminating these places and populations. In this Babylonia, I have always preserved myself in the original and old way, and cowardice and lowliness have never gotten the best of me [. . .]. In general I have been favorably viewed, as much by Italians as by Americans, and even by Blacks. Never has anyone taken me for anything other than what I am [. . .]. I'll have you know that there is a multitude of young Italians, of the Southern Italian type, that never works: they're always amusing themselves and dressing elegantly. They belong to the Black Hand and live off the fruits of their crimes. This is because so much of the time many of the Italians in America are ignorant. I frequent only honest and intelligent people. For two years, I have been going to English school and I'm starting to have less trouble with the language; rare are the things I don't understand, it is only difficult for me to respond. I have faith only in myself, in my will, honesty and strength, if fate will continue to maintain them. I hope to win [. . .][30]

We view here the influence of an accelerated political acculturation and evident anticlerical opinions that, in the originally fervent Catholic Vanzetti, must have been born in America. However, it is not hard to pick

[30] Included as an appendix to Aldous Sellers e Arthur Brown, *Il caso Sacco e Vanzetti* (Rome: Editori Riuniti, 1967) 48-50.

up in his words the result of his concrete immigrant experience as a "Jack-of-all-trades," in addition to readings that, even in the radical microcosm of anarchists and socialists, that he frequented, must have included robust feelings of anti-Americanism (and, when among Northern Italians, some anti-Southern feelings too).[31]

The reference to too many religions and "religious extravagances" that the United States harbored, or the references to relations with "Blacks," are reminiscent, on one hand, of the maxims of Talleyrand, and, on the other, of the inescapable facts of a "racial" situation in which, the Italian immigrants from the South, would end up finding themselves, for once, at ease. The differences and "extravagances" of the popular religiosity, loud and choreographed, of the majority of devotees living in the "Little Italies," evoked reproaches. Moreover, the immigrants cultivated with a vague sense of guilt Counter-Reformist devotions, that were in part, as the Irish and Catholic Americans maliciously implied, "pagan" and reflective of Mediterranean superstitions—as Leslie Fiedler put it, "between papalism and lust." In this context, Southern immigrants very soon, as Vanzetti did not hesitate to condemn, had to deal with the consequences of an illegal and criminal drift that—in all honesty—was typical of many members of their group. From the end of the 1800s to the 1940s, they were often active in hardly commendable dealings (and on an increasingly wider scale) as members of the Black Hand, Mafia, or organized crime, which gave life, inevitably, to the labels that would come to characterize the Italian immigrant, even in American cinema—labels that would remain constant from the "first decade of the nineteenth century," or, in a way, from the dawn of seminal movies like *Black Hand* (Wallace McCutcheon, 1907) and *The Cord of Life* (David W. Griffith, 1909).[32]

Yet, seen from a different angle, even that drift seemed to contribute to the adaptation to American modernity,[33] a process capable of generating, in other ways and in different fields, "virtuous" and very visible commercial phenomena of entrepreneurship (from gastronomy to the "Italian" restaurant business, to the very "Neapolitan" theatrical and musical entertainment industry that flourished particularly in New York and

[31] Arnaldo Testi, "L'immagine degli Stati Uniti nella stampa socialistà italiana (1886-1914)," in Giorgio Spini, ed., *Italia e America dal Settecento all'età dell'imperialismo* (Venice: Marsilio, 1976) 313-348.

[32] Gian Piero Brunetta, "Emigranti nel cinema italiano e americano," in Sebastiano Martelli, ed., *Il sogno italoamericano,* 147.

[33] Humbert Nelli, *The Business of Crime: Italians and Syndicate Crime in the United States* (Chicago: University of Chicago Press, 1976).

San Francisco between the 1910s and 1940s, as we are now well aware, thanks to growing research on the subject).[34]

Southern immigrants were helped in their assimilation by the existence of a "color line," certainly precarious in the Old South, which was still capable of securing for them an intermediate status[35] within the hierarchy of American races. As has been observed by many, Italians gleaned some advantages from being co-opted as subordinate, as the "rearguard," to the group of the "best," thanks to an identification that was more "racial" (white) than ethnic (Italian). This was according to a logic that could turn out to be rather contradictory, or that could be indeed turned upside down in Italy, but that the U.S. favored, even if only over the long term, the subsequent evolution.

Whereas in the 1930s the "classic" cinematographic gangster genre with *Scarface* (Howard Hawks, 1932) and *The Marked Woman* (Lloyd Bacon, 1937) presented a stigmatized image of Italians, the final decades of the last century saw the mythicization of godfathers and the like by the hands of many and more recent Italian American "cantors of the criminal epic" (such as Coppola, De Palma, Scorsese, Turturro, De Niro, Savoca, etc.). Often setting their stories in the 1950s, they suggest a different interpretation of the phenomenon, in which, paradoxically, dynamics and themes have been pointed out as plausibly "American" — an interpretation that has been accepted for some time by the specialists such as Affron, Brownlow, Tomasulo, Gardaphé, Muscio, etc. It is perhaps with them that the old stereotypes have been remixed ("like in a game of mahjong," as Brunetta suggested), leading to — at least in recent times — a prevalently positive image of the Italian American. This is also possible "thanks to the representation of policemen, honest lawyers, store owners, employees, students, cooks, restaurateurs, perfectly integrated within American society," and along the lines of a discussion (now not only literary, or cinematographic — one only needs to think of the sagas of politicians like Giuliani, Pelosi, etc.) in which the results of a completed parabola are reflected, visible to everyone. This took place when it became clear that

[34] The relevant bibliography (food culture and gastronomic entrepreneurship, theater and paraliterature, music and the record industry, etc.) has become quite vast, and while it is not the place to go into detail here, some names do come to mind: from Simone Cinotto to Donna Rae Gabaccia, from Dominic Candeloro to Emelise Aleandri, from Francesco Durante to Martino Marazzi, from Bénédicte Deschamps to Simona Frasca, etc.

[35] Jennifer Guglielmo and Salvatore Salerno, eds., *Are Italians White?: How Race is Made in America* (New York: Routledge, 2003).

"the process of integration and the opening of many possible roads for the Italian American attracted by the sirens of the American dream, and the possibility of giving worth to his reasons and geniality, does not only occur with a machine-gun or revolver in hand." Jerre Mangione's heroes of Mont'Allegro and John Fante's of "Little Italy" — Brunetta opportunely remarks — "were transferred onto the screen some decades later, reclaiming more firmly, their representation, indicating that 'Sicilian connections' don't lead only to the rediscovery of Mafiosi godfathers."[36]

In light of this, the uncertainties and intermittent interpretations of those who look at the history of anti-Americanism and anti-Southern prejudice are a little surprising, particularly in Italy, where renewed, but perhaps too superficial an attention has been given to the close nexuses that bind these prejudices to emigration abroad and its consequences over time. Among these, at some point we will need, without engaging in polemics, to update the contribution that Italians, as immigrants, made to the material construction of present-day America and to the creative "invention" of its stratified and prismatic identity.

Translated from the Italian by Eleonora Mazzucchi

[36] Gian Piero Brunetta, "Emigranti nel cinema," 145.

Anti-Italian Prejudice in the United States: Between Ethnic Identity and the Racial Question

Stefano Luconi
UNIVERSITY OF ROME "TOR VERGATA"

Scholars have long suggested that Italians retained their ethnicity and parochial sense of regional identity as a result of the historical timing of Italy's unification and the small village dynamic of "campanilismo." The immigrants who left Italy for the United States during the mass migration between the late 1870s and the early 1920s initially resisted acquiring a full-fledged sense of national identity. Indeed, even after settling in their adoptive society, Italians were delayed in bringing a cohesive ethnic minority to life and thus remained divided along the lines of different geographical origins. This fragmentation resulted, on the one hand, from the survival of those regional rivalries that had already taken root in their country of origin and, on the other, from the preservation of the habits, lifestyle, and religious and social traditions, as well as the dialects of each area in their homeland.[1]

Nevertheless, neither the Anglo-Saxon population of the United States nor the members of other ethnic groups were generally able to grasp the regional differences that separated Italian newcomers, and that, at times, would pit Italian immigrants against each other. The more sophisticated distinctions usually failed to go beyond a discussion of the differences between Northern and Southern Italians, and were based on rudimentary, pseudo-scientific notions which, paradoxically, drew upon the eugenic theories of Italian anthropologists such as Giuseppe Sergi and Luigi Pigorini, or upon the thesis of sociologist Alfredo Niceforo that supported the presumed inferiority of the inhabitants of the South with respect to their northern counterparts in the peninsula. Following such classifica-

[1] Luigi Manconi, "Campanilismo," in *Bianco, rosso e verde: L'identità degli italiani*, ed. Giorgio Calcagno (Rome and Bari: Laterza, 2003) 36-42; Frances M. Malvezzi and William M. Clements, *Italian-American Folklore* (Little Rock, AK: Augustus House, 1992) 25-35.

tions, it was usually argued that, as they were similar in characteristics to the Anglo-Saxon and Scandinavian populations, Northern Italians could manage to integrate themselves with greater ease into their adopted land, while Southern Italians were inassimilable and, therefore, their presence on U.S. soil was not welcomed for fear that they would introduce disruptive elements that could lead to the break-down of American society in the long run or irreversibly modify its basic features. Sloping foreheads, stocky builds, and olive skin tones were among the characteristics that would shroud the Southern Italian immigrants in doubt as to whether they could be considered part of the "white race." The intermixing of "African blood" over the course of centuries would prove problematic in the positioning of certain individuals within the standard of the Caucasian race, even for Congressional legislators in Washington. In 1922, an Alabama court acquitted an African American defendant of the charge of violating the state's miscegenation laws on the grounds that it could not be proved that his partner belonged to the white race since she was Sicilian.[2]

The distinction between Northern and Southern Italians lasted for a relatively short time. The restrictive immigration legislation of the 1920s put it to an end. It determined that all Italians were undesirable and limited their flow, regardless of their specific places of birth in the native country, in order to preserve the Anglo-Saxon fabric of United States society from any contamination from the Mediterranean. Since most Italian immigrants had come from Southern Italy during the late nineteenth century, the negative judgment that lumped together all the natives of these particular regions was quickly extended to include all the inhabitants of the peninsula. In 1890, testifying before a Congressional Committee on immigration, the foreman of a construction company stated, without mincing his words, that an Italian was not a "white man" but rather a "dago."[3] Italians as well as Hispanics were included in this disparaging term. Nonetheless, in this instance, the epithet referred to an individual who was classified as being "in between" the Caucasian and African races. Nearly a quarter century later, the Italian Ambassador to

[2] Bénédicte Deschamps, "Le racisme anti-italien aux Etats-Unis (1880-1940)," *Exclure au nom de la race* (*États-Unis, Irlande, Grande-Bretagne*), ed. Michel Prum (Paris: Syllepse, 2000) 59-81; Peter R. D'Agostino, "Craniums, Criminals, and the 'Cursed Race.' Italian Anthology in U.S. Radical Thought," *Comparative Studies in Society and History* 72.2 (April 2002): 319-43.

[3] Humbert Nelli, *From Immigrants to Ethnics: The Italian Americans* (New York: Oxford University Press, 1983) 3.

the United States disconcertingly acknowledged that his compatriots held a middle ground between whites and blacks in the U.S. public opinion.[4] After all, from the 1880s to the eve of World War I at least thirty-four Italians were victims of lynching, namely they fell prey to extralegal and summary justice that was generally reserved for African Americans as punishment for presumed crimes committed against the white community.[5]

The source of prejudice against Italian immigrants was not only the color of their skin, but their religious affiliation as well. As most Italian immigrants were Roman Catholics, they were considered potential agents for the diffusion of papal power in a Protestant land. The American Protective Association, a radical Protestant organization founded in 1887, promoted intolerance towards Catholics and advocated barring Italian immigration to the United States.[6] As with eugenics, some Italians even fed the suspicions of the U.S. public opinion with regard to their own compatriots. In fact, among the first to launch alarming warnings about the presumed hegemonic goals of the Vatican in North America was Alessandro Gavazzi, a former Barnabite from Italy, who seized the opportunity of apostolic nuncio Gaetano Bedini's trip to the United States in 1853-54 to denounce the papal designs on the country.[7] Italians did not even find solidarity among their fellow Catholics from different ethnic backgrounds. The Irish clergy monopolized the Catholic hierarchy in the United States until after the end of World War II. The Irish pastors were unable to realize the multifaceted religious customs of their parishioners who had recently arrived from the various regions of Italy, and extended to all Italian newcomers their own censure of the behavior of Southern Italian immigrants, whose emphasis on the cult of saints and constant invocations of the latter's intercession verged on superstitious paganism. Besides such unorthodox religious practices, what fanned the flames of the hostilities of the Irish clergy was the outright refusal of Italian parishioners to make donations to support the Church, in part because of the dire poverty in which they lived, and in part because the Church in Italy was maintained by the State rather than by the parishioners. Consequent-

[4] Edmondo Mayor des Planches, *Attraverso gli Stati Uniti: Per l'emigrazione italiana* (Turin: Utet, 1913) 144.

[5] Patrizia Salvetti, *Corda e sapone: Storie di linciaggi degli italiani negli Stati Uniti* (Rome: Donzelli, 2003).

[6] Thomas J. Curran, *Xenophobia and Immigration, 1820-1930* (Boston: Twayne, 1975) 93-108.

[7] Matteo Sanfilippo, *L'affermazione del cattolicesimo nel Nord America: Elite, emigranti e Chiesa cattolica negli Stati Uniti e in Canada, 1750-1920* (Viterbo: Sette Città, 2004) 55-76.

ly, in the late nineteenth century, Italians still found themselves having to fight so that they could obtain Italian national parishes and pastors of Italian descent. When their requests were not honored, they sometimes found themselves confined by the Irish clergy to attend services sitting in the back pews or even relegated to the church basements.[8]

These prejudices also ended up isolating Italians within the labor movement. On the one hand, the American Federation of Labor (AFL), the leading labor organization between the mid-1880s and the New Deal, accused them of jeopardizing the few achievements of U.S. workers because Italians allegedly accepted lower wages than those union representatives had agreed on, and even supposedly benefited from strikes called by other ethnic groups to get work as scabs. On the other hand, bringing up a charge that paradoxically contrasted with the previous one, the AFL held Italian immigrants up to public scorn as dangerous members of radical organizations—such as the Industrial Workers of the World (IWW), a labor union formed in 1905 and inspired by anarchism—which were considered the product of foreign ideologies and being inconsistent with the values of American society. Therefore, the AFL attempted to prevent Italian American workers from joining the unions by imposing high membership fees that remained outside the reach of many immigrants who, for the most part, were unskilled laborers earning incomes lower than the average skilled workers. Specifically, the lack of specialization on the part of the bulk of Italian Americans was the primary reason for their discrimination at a time when the AFL emerged as the voice of the collective interests of skilled workers, who feared losing their jobs to the benefit of the Italian immigrants. The fear of being replaced was the result of increasing prejudices against the members of this ethnic group. Yet, it was not the supply of labor from rural areas in Italy that reduced the employment of skilled workers, rather—especially following the introduction of the assembly line—the automation of the factory processes, which increased the demand for unskilled labor in U.S. manufactures. Similarly, what led Italians to join radical labor unions such as the IWW

[8] Rudolph J. Vecoli, "Prelates and Peasants: Italian Immigrants and the Catholic Church," *Journal of Social History* 2.3 (Spring 1969): 217-68.

was not their alleged subversive orientation, but the fact that they were ostracized by moderate organizations such as the AFL.[9]

In contrast to the supposed characteristics of balance and self-control in the behavior of Anglo-Saxons, Italian immigrants were also charged with impulsiveness, an inclination to violence and passion, a lack of discipline, and the inability to conceive collective interests outside the small circle of the family. United States sociologist Edward C. Banfield noted this family dynamic as "amoral familism" in a village in Calabria in the 1950s.[10] As far back as 1880, the *New York Daily Tribune* contended that "Italians are the most quarrelsome people on the face of the earth. [...] Nearly all of them carry stilettos and if they get into a fight they never hesitate to use them. Recently many of them have begun to carry pistols."[11] An editorial that appeared in *The New York Times* stated that "the violent passions of the Italians and their readiness to resort to deadly weapons for the settlement of trivial quarrels make them troublesome neighbors."[12] Similarly, the following year the magazine *United Service* reported widely that "every Dago has a stiletto up his sleeve."[13] Not only coeval articles in newspapers and magazines, but also the earliest movie productions helped spread these stereotypes. In their melodramatic overtones, films such as *The Cord of Life* (David W. Griffith, 1909), *At the Altar* (David W. Griffith, 1909), *In Little Italy* (David W. Griffith, 1911), and *The Coming of Angelo* (David W. Griffith, 1911), or even *The Italian* (Thomas Harper Ince, 1915), were full of Italians ready to resort to nothing less than explosives to take revenge on rivals or on women who had rejected them.

In terms of overemphasizing the presumed aggressive and brutal nature of Italians, the media in particular have contributed to spreading the common belief that immigrants are tied to organized crime. The figure of the Italian American gangster emerged from the beginning with episodes from the late nineteenth century about criminals of Italian origin, who extorted money from their fellow countrymen and committed other crimes

[9] Rudolph J. Vecoli, "The Italian Immigrants in the United States Labor Movement from 1880 to 1929," in *Gli italiani fuori d'Italia. Gli emigranti italiani nei movimenti operai dei paesi d'adozione (1880-1940)*, ed. Bruno Bezza (Milan: Angeli, 1983) 257-306.

[10] Edward C. Banfield, *The Moral Basis of a Backward Society* (Glencoe: Free Press, 1958).

[11] "Two Sides of Italian Life," *New York Daily Tribune*, July 27, 1880, 2.

[12] Editorial, *The New York Times*, May 16, 1893, 4.

[13] Landreth Burnet, "*Italian Laborers*," *United Service* 12.3 (September 1894): 241.

in their "Little Italies," but the stereotype was exaggerated and general-ized by the stir caused by popular novels such as *The Heart of a Stranger: A Story of Little Italy* (Anne Christian Ruddy, alias Christian McLeod, 1908),[14] or movies beginning with *The Black Hand* (Wallace McCutcheon, 1906), whose title referred to an alleged Italian American criminal organi-zation that extorted money from members of its ethnic community. The effectiveness of this repetitious and persuasive campaign was already confirmed in those years by Italian journalist Giovanni Preziosi. After visiting the United States in the early twentieth century, Preziosi noted with bitterness that "there wasn't an American who didn't talk about the 'Black Hand' as a strong, sinister, and well-organized criminal society that lives and operates in the slums of the city, the countryside, or wher-ever there are dollars to steal and revenge to be taken until the end."[15] It was, however, the era of Prohibition that cemented the stereotype of the Italian American "mafioso." The reason was not so much the actual in-crease in criminal activities related to the illegal sale of alcohol and the bloody conflicts over the control of this market, as much as the attention that these events were given in the press and in successful movies in-spired by the criminal underworld such as *Night Ride* (John Stuart Robert-son, 1929), *Little Caesar* (Mervyn LeRoy, 1931) and *Scarface* (Howard Hawks, 1932).

In the interwar decades, the stereotypes and forms of prejudice indis-criminately affecting Italian Americans, regardless of the latter's place of origin in the motherland, helped immigrants and their children develop an awareness of their common national origin. At the same time, the alleged achievements of the Fascist regime and, above all, the prestige that Italy gained on an international level after the establishment of Beni-to Mussolini's dictatorship, stimulated the ethnic pride of Italian Ameri-cans and their identification with their nation of origin. The broad-based consensus for Fascism among the members of the "Little Italies" can be explained in terms of ethnic redress that offset in part decades of discri-mination rather than as ideological allegiance. It is no coincidence that the popularity of the regime with Italian Americans reached a climax at the time of the 1935-36 war on Ethiopia, when the proclamation of the Em-pire seemed to position Italy as one of the major world powers, and to re-

[14] Christian McLeod, *The Heart of the Stranger: A Story of Little Italy* (New York: Revell, 1908).

[15] Giovanni Preziosi, *Gl'italiani negli Stati Uniti del Nord* (Milan: Libreria Editrice Milanese, 1909) 120-21.

fute once and for all — also in the eyes of the U.S. public — the belief in the presumed inferiority of her people, including immigrants to the United States as opposed to individuals of Anglo-Saxon origin.[16]

Nevertheless, in the long run, the national identity gained by Italian Americans in the 1920s and 1930s proved to be the harbinger of new prejudices related to their ethnic origin. At the outbreak of World War II, especially after Italy's declaration of war on the United States on December 11, 1941, the U.S. population of Italian descent was the victim of widespread suspicion that it would operate as a fifth column at Mussolini's beck and call. As early as June 1940, *Fortune* magazine had already warned against the presence in the United States of Italians who would then act as "enemy soldiers within our borders," and for about a year since the start of hostilities between Rome and Washington, unnaturalized Italian citizens were classified as enemy aliens, a legal status that restricted their civil rights and freedom of movement within the country. General John L. DeWitt, head of the Western Defense Command in the United States, wished to deport Italians en masse from the Pacific coast, but only obtained the authorization for selective relocation and internment of those who appeared to be more sympathetic to the Fascist regime, and therefore a real threat to national security.[17] However, even immigrants who had obtained U.S. citizenship and Italian Americans who had been citizens by birthright lamented discrimination in various forms, such as being fired from their jobs and lack of access to federal and state relief programs because of their Italian ancestry and the ensuing doubts about their loyalty to their adopted homeland, while the United States was at war with their native country. Nevertheless, these additional manifestations of intolerance pressed Italian Americans to wipe away the last vestiges of their sense of provincialism and consolidate their identity based on national origin that had already emerged in the prewar decades.

On the other hand, the war years witnessed the emergence of a new racial identity for Italian Americans. The substantial influx of African Americans from the southern states to the northern cities to replace workers who had been enlisted in the U.S. armed forces provoked hostility

[16] Stefano Luconi, La "diplomazia parallela": Il regime fascista e la mobilitazione politica degli italo-americani (Milan: Angeli, 2000).

[17] "The Foreign Language Press," Fortune 20.5 (November 1940): 108; Guido Tintori, "Italiani enemy aliens: i civili residenti negli Stati Uniti d'America durante la seconda guerra mondiale," Altreitalie 28 (January-June 2004): 83-109.

from the working class of European origin that was frightened by the prospect of new competitors on both the job and housing markets. These fears, and the racial tension that stemmed from them, produced urban riots—among which the bloodiest took place in Detroit and New York in 1943—and a series of hate strikes to prevent the employment or promotion of African Americans to positions from which they had been theretofore excluded.[18] Faced with the growing polarization of U.S. society along color lines, Italian Americans definitively abandoned the "in-between" racial status that had characterized them since the end of the previous century, and began to see themselves as part of the white race. Using words that are emblematic for their racist implications, Paul Pisiciano, a New York architect of Sicilian descent, recalled:

> . . . there were riots in Harlem in '43. I remember standing on a corner, a guy would throw the door open and say, "Come on down." They were goin' to Harlem to get in the riot. They'd say, "Let's beat up some niggers." It was wonderful. It was new. The Italo-Americans stopped being Italo and started becoming Americans. We joined the group. Now we're like you guys, right?[19]

The fact that Italian Americans have had to share the implicit racism of U.S. society against the black population to fully achieve integration within their adopted country did not exempt them from further prejudices.[20] Their full participation in demonstrations to protest against racial integration of the public schools in Boston, or in working-class neighborhoods in Brooklyn, made them a paradigmatic example, however appalling, of the latest racist resistance of the working and lower middle-classes of European descent. Prominent figures such as Frank Rizzo—the mayor of Philadelphia known for using violent methods against the African American civil rights movement in the 1970s—became the symbol of a narrow-minded Italian American conservatism which was nevertheless

[18] Dominic J. Capeci, Jr. and Martha Wilkerson, *Layered Violence: The Detroit Rioters of 1943* (Jackson: University Press of Mississippi, 1991); George Lipsitz, *Rainbow at Midnight: Labor and Culture in the 1940s* (Urbana: University of Illinois Press, 1994) 69-83.

[19] Studs Terkel, *"The Good War": An Oral History of World War II* (New York: Pantheon, 1994) 141-42.

[20] David A. J. Richards, *Italian American: The Racialization of Ethnic Identity* (New York: New York University Press, 1999).

After progressively reshaping their own sense of ethnic allegiance, based on national ancestry, into a broader racial identity as whites of European descent since the end of World War II, most of the descendants of the late nineteenth- and early twentieth-century immigrants have nowadays fully integrated themselves in U.S. society, and have achieved a stable position within the middle and upper classes. This status has made them impervious to the negative consequences of deplorable stereotypes and prejudices on their own individual and collective lives. Indeed, according to data from the latest federal census completed in 2000, the accomplishments of Italian Americans in education, employment, and income are even higher than the national average. For example, 28.9 percent of the members of this ethnic group have some sort of university degree, as opposed to 24.4 percent of the total U.S. population. Similarly, 38.3 percent of Italian Americans are professionals or managers, while only 33.6 of those who are employed throughout the country have these qualifications. Finally, the average annual income of a family of Italian origin is $51,246 compared with the national average of $41,994.[29]

This same 2000 census reported a roughly seven-percent increase from 1990 in the number of U.S. residents who claimed Italian ancestry.[30] According to several commentators, themselves of Italian descent, this increase demonstrates that Italian American ethnic identity is increasingly vital and more significant than any sense of belonging based on racial affiliation.[31] In fact, this hypothesis offers a far-fetched interpretation. The question posed by the census was specifically meant to ascertain the country of origin of the individuals surveyed, certainly not their ethnic identity. Actually, the latter is expressed not by means of the mere identification of the native country of one's ancestors, but through a pattern of attitudes and behaviors that—in the case of Italian Americans, as shown in the preceding pages—in recent times have shown a progressive detachment from their Italian roots and the development of a sense of belonging within the white race. Moreover, the fact that in 1997 a descendant of Italian immigrants, Frank DeStefano, was listed as a local leader

[29] William Egelman, "Italian Americans, 1990-2000: A Demographic Analysis of National Data," *Italian Americana* 24.1 (Winter 2006): 9-19.

[30] U.S. Bureau of the Census, *Profile of Selected Social Characteristics: 2000*, table QT-02, 2002, www.factfinder.census.gov, consulted June 20, 2002.

[31] Richard Annotico, "Italian Americans and the 2000 Census," posting to online discussion list at H-ItAm, June 18, 2002, www.h-net.msu.edu/itam, consulted June 20, 2002; Vecoli, "Negli Stati Uniti" 55, 85-6.

in Long Island, New York, of one of the most racist and xenophobic organizations in U.S. history, the Ku Klux Klan, demonstrates that ethnic prejudices against Italian Americans have now been largely overcome and that the members of this minority group are now accepted as an integral part of the "white" component of U.S. society.[32]

Translated from the Italian by Giulia Prestia

[32] "KKK Cancels Mass Recruiting Drive," *Newsday*, July 19, 1997, A22.

John Fante and the Others:
The Strange Destiny of Italian/American Writers[1]

Emanuele Pettener
FLORIDA ATLANTIC UNIVERSITY

"In tutti i libri di italo-americani che scrissero in inglese non ci fu forza artistica sufficiente a penetrare veramente entro la corrente del gusto americano. Vorrei anzi dire che gli scrittori stessi non lo tentaron nemmeno" (298).[2] Giuseppe Prezzolini writes in 1963 that there are six "narratives" we can consider as the most important from an artistic point of view, as well as for their success in the United States: *Son of Italy* by Pascal D'Angelo (1924), *The Grand Gennaro* by Garibaldi Lapolla (1935), *Olives on the Apple Tree* by Guido D'Agostino (1940), *Dago Red* by John Fante (1940), *Mount Allegro* by Jerre Mangione (1942), and *Maria* by Michael De Capite (1943).

> Ora che anni son passati dalla loro pubblicazione, si vede più chiaramente che nessuna ha sopravissuto: non restano che come *documenti* . . . "Ecco gli italiani", pare che dicano tutti, rivolgendosi agli altri americani come se mostrassero gli animali d'un giardino zoologico: "Vedete: non son così cattivi o così stupidi come paiono, anzi siete voi che avete avuto un po' di cattiveria o almeno di stupidaggine nel considerarli." Nei libri di questi pseudoromanzieri la vicenda è quasi assente . . . e l'elemento autobiografico prevale . . . Oltre la fame, i motivi che più sovente ricorrono in questi romanzi autobiografici tendenti allo studio sociolo-

[1] For my use of the slash, see Anthony Julian Tamburri's *To Hyphenate or Not to Hyphenate? The Italian/American Writer: an Other American.* In this study, Tamburri calls into question the mainstream concept of the hyphen and all of its connotations. His suggestion to turn the hyphen on its side is a call for the "closing of the ideological gap" (47), as he states, to contrast the marginalization imposed by the dominant culture and to think beyond the divisive characterization of the hyphenated subject.

[2] "In all the books by Italian-Americans who wrote in English there was not sufficient strength to truly penetrate the American taste. I would even say that those writers did not even attempt to do it" (My translation). This passage and the following one are taken from "Il Contributo Italo-Americano all'America" in Giuseppe Prezzolini's *I Trapiantati.*

gico, sono il conflitto fra l'emigrato e l'America, fra la prima generazione venuta dall'Italia e la seconda educata in America . . . " (299-300).[3]

Prezzolini ignores (or he decides to ignore) novels such as *Wait Until Spring, Bandini* by John Fante (1938) and *Christ in Concrete* by Pietro Di Donato (1939) among others. In addition to his general observations (*Dago Red* is a collection of short-stories, *Son of Italy* and *Mount Allegro* are autobiographies), Prezzolini speaks of these texts as if they were documents that simply demonstrate how much Americans are irritated by Italian Americans, without indicating that at least four of these narratives — though all of them have an autobiographical taste — are explicitly *fiction*.

The superficiality with which Prezzolini defines these authors suggests a couple of things: first Italian intellectuals have always looked at these writers with arrogance, considering them as sentimental amateurs who unburden themselves by writing — perhaps this is the same arrogance with which we Italians, generally, continue to look at Italian Americans. A few examples: the first Italian anthology of Italian/American writers was only published in 2001, edited by Francesco Durante.[4] Furthermore, in the departments of American literature of Italian universities, Italian/American literature enjoys little prestige. In addition, David Baldacci and Lisa Scottoline had to publish their first novels translated in Italian with a pen name (Ford and Scott), hiding their ethnic origins since their Italian publishers obviously thought that Italian/American authors would not attract Italian readers. Finally, many authors who have been

[3] "After many years since their publication we can more clearly see that none of them has survived: they remain only as *documents* . . . 'Here are the Italians,' everyone seems to say, speaking to the other Americans, as if they were showing beasts of a zoo: 'See, they are not so bad or so stupid as they look. On the contrary, you have been a little naughty and foolish to consider them like this.' In the books of these pseudo-novelists the plot is almost absent . . . and the autobiographical element prevails . . . Besides hunger, the themes that most often appear in these autobiographical novels that tend to be sociological works are the conflict between the immigrant and America, between the first generation who came from Italy and the second generation educated in America . . . "(My translation).

[4] In the United States, the first anthology of Italian/American writers was published in 1949, edited by Olga Peragallo (ironically a student of Prezzolini): *Italian-American Authors and their Contribution to American Literature*. Among the other anthologies following Peragallo's work, I would include: *The Italian-American Novel: a Document of the Interaction of two Cultures* by Rose Basile-Green (1974); *The Dream Book* by Helen Barolini (1985); *From the Margin*, by Fred Gardaphé, Paolo Giordano and Anthony Julian Tamburri (1991); *The Voices We Carry: Recent Italian/American Women's Fiction* (1994) by Mary Jo Bona. The scholars of this field keep doing hard work to analyze and expand the development of Italian/American literature. I would quote at least *Italian Signs, American Streets* (1996) by Fred Gardaphé, *A Semiotic of Ethnicity* (1998) by Anthony Julian Tamburri, *Claiming a Tradition: Italian American Women Writers* (1999) by Mary Jo Bona, *Writing with an Accent* (2002) by Edvige Giunta, and *Buried Caesars, and Other Secrets of Italian American Writing* (2006) by Robert Viscusi.

recognized and honored in the United States, have not been translated and published in Italy: for example, Tony Ardizzone, Salvatore La Puma, Rita Ciresi (all of them winners of the prestigious Flannery O'Connor Award), Josephine Gattuso Hendin (American Book Award 1986 with the novel *The Right Thing to Do*), and Tina De Rosa (author of the 1980 novel *Paper Fish*, by now a classic of Italian/American literature).

Another observation: Italian/American literature – that literature in which the Italian/American element is substantial – has always been a *niche* literature and has never became part of mainstream American literature. Was Prezzolini not completely wrong? Did Italian/American writers always make the congenital mistake of gazing at their ethnic navel?

Cinema too, unless the Mafia is involved,[5] does not seem interested in these stories of immigration, integration, rejection and recovery of one's own roots: some titles that come to mind are: *Give Us This Day* (Edward Dmytryk, 1949) from Pietro Di Donato's novel *Christ in Concrete*; more recently, *Household Saints* (Nancy Savoca, 1993) from the novel with the same title by Francine Prose (who is not Italian/American); and the intriguing film, *Riding in Cars with Boys* (Penny Marshall, 2001) from Beverly Donofrio's autobiography.

According to Helen Barolini, author of the novel *Umbertina*, "what American authors of Italian descent lack are important literary critics among them who write for national publications, not only for specialized magazines."[6] One might readily think of Gay Talese, author of the best-seller *Honor they Father* (a mafia story, of course). Contrary to possible expectations, on the main page of *The New York Times Book Review* on March 4th, 1993, he wrote an article that stirred up a hornet's nest with the provocative title, "Where are the Italian American Novelists?" It would have been sufficient to look around a little. Talese ignored (or decided to ignore) a plethora of texts produced over the course of a century. Beside those already mentioned, I would list some novelists and poets, apologizing to those whom I have inadvertently left out: Luigi Ventura (his collection of short stories, published in 1886, could be the first example of Italian/American fiction, even if some scholars might disagree, precisely because Ventura's short stories had been written in French); Dorothy Calvetti Bryant; Emanuel Carnevali (the *maudit* of Italian/American

[5] Americans' attraction for Italian Mafia is parodied by Giose Rimanelli in *Benedetta in Guysterland*, American Book Award 1994.

[6] From my "Interview with Helen Barolini" published in the on-line magazine *Vibrisse*.

literature, whose *Il Primo Dio* was published in Italy by Adelphi in 1978 and *Racconti dell'uomo che ha fretta* by Fazi in 2005); Diane Cavallo; John Ciardi; George Cuomo; Antonio D'Alfonso; Emanuel di Pasquale; Anthony Giardina; Sandra Gilbert; Dana Gioia; Daniela Gioseffi; Arturo Giovannitti; Ralph Lombreglia; Kenny Marotta; Carole Maso; Ben Morreale; Joseph Papaleo; Jay Parini; Mario Puzo; Giose Rimanelli; Felix Stefanile; Joseph Tusiani; Anthony Valerio; Angelo Valenti.[7]

In these past recent years, Italian readers had the opportunity to discover some of these authors, thanks to the publishing house, Avagliano, which has translated, among others, *Golden Wedding* by Joe Pagano and *Astoria* by Robert Viscusi (American Book Award 1996); and to the publishing house, Il Grappolo, which translated writers such as the above-mentioned D'Angelo, Giovannitti, Di Donato, and others. The legitimate hope of these small publishing houses is to find the goose that lays the golden egg: which was the case in the 1990s for the publishing houses, Marcos y Marcos and Fazi, with the overwhelming success of John Fante.

John Fante's story is well known. He was rediscovered as a writer in the 1980s (he died in 1983) and, by the end of the century, two books, a collection of essays, and a biography were dedicated to him and his works in the United States.[8] But, whereas in the United States Fante is still a relatively unknown writer, not widely read and recognized only by a few diehard fans, in Europe (especially in France, Italy, and Germany) Fante's popularity is astounding. In his father's country, Fante's works are discussed in conferences and at round-table meetings; a literary festival is dedicated to him every year; most of his books, now published by Einaudi, are prefaced and praised by the most celebrated contemporary Italian writers; and Mondadori has published a truly elegant cased edition entitled *Romanzi e Racconti* in its most prestigious series, "I Meridiani," a series that privileges only the classics and that now includes Fante's (almost) complete works.

But why do so few people know John Fante in the United States? Why such success in Europe? Why so late?

[7] I have listed writers in which the Italian/American element is clearly visible. With regard to other writers who could belong to an Italian/American tradition for biographical reasons, Italian/Americanicity is a matter of interpretation: I'm thinking of Don DeLillo, for example, among the novelists, and Lawrence Ferlinghetti, Diane Di Prima, and Gregory Corso among the poets.

[8] *John Fante: A Literary Portrait* (2000) by Richard Collins; *John Fante: His Novels and Novellas* (2000) by Catherine J. Kordich; *John Fante: A Critical Gathering* (1999) edited by Stephen Cooper and David Fine; and *Full of Life: A Biography of John Fante* (2000) by Stephen Cooper.

Besides the vagaries of the unfathomable fortune, besides Fante's bio-
graphical misadventures, besides the fact that having an Italian surname
is not helpful, as previously noted, I will suggest two other possible ex-
planations, deeply intertwined with them. First, the absolute absence in
John Fante's works (with the exception of *Full of Life*) of any moral, poli-
tical, religious, philosophical, social message. Fante, in his novels, does
not teach any lesson about life, does not give any answer about life; not
only that, he does not impose any point of view on his readers. Second,
this absence of a truth, of any truth, is due to Fante's refined use of hu-
mor, as defined by Luigi Pirandello in his essay *L'umorismo*. This very
sense of humor is the other reason for which Fante has been forgotten for
a long time, and is still not as recognized as he deserves in the United
States.

Let me attempt a sociological reflection; the United States is a roman-
tic country, believing in *absolute* values, in *Truths* with the capital T.
Bookstores' shelves are packed with inspirational books teaching how to
become the best in one's own field, whatever the field; Hollywood and
Oprah Winfrey offer incontrovertible truths from the screens, and they do
this in a *sentimental* way: America is a sentimental country infused with
the rhetoric of pathos. The most incorruptible truth is the American Dream,
the power of the individual, the confidence that a man can achieve any
dream just with and only through his own force of character and hard
work — an idea that Italians find ridiculous. Since humor undermines and
subverts the foundations of any truth, we can see how it could be difficult
to be appreciated by most Americans, especially when it lays bare the
foundations of the American Dream, as happens in Fante's novels. In
Fante's works, the American Dream exists and is vivid only for the
immigrant, who arrives in America dreaming of streets paved with gold,
but it proves fallacious when the process of *Americanization* begins; there
is no American Dream for the Americans of Fante's novels. Not only, but
the American Dream is soley reputedly romantic and pure, only evident-
ly springing from the individual power of one's own imagination. But,
actually, it is a second-hand dream, of imitative nature, a wish that is
born out of the competition between the dreamer and a rival who had
that dream before him, a competition that is much more important than
the dream itself.[9]

[9] In Fante's novels, we find the perfect application of Renè Girard's theory of his 1961 *Mensonge
Romantique, Verité Romanesque*. Girard theorizes that the great innovation of the novel, as a genre,

Here is an example of Fante's humor. In *Ask the Dust*, Arturo insults Camilla Lopez by calling her a filthy little greaser; he feels good and thus claims his Americanicity:

> I was an American, and goddamn proud of it. This great city, these mighty pavements and proud buildings, they were the voice of my America. From sand and cactus we Americans carved an empire. Camilla's people had had their chance. They had failed. We Americans had turned the trick. Thank God for my country. Thank God I had been born an American! (*Ask the Dust*, 44)

Arturo's pathetic boast makes us laugh but Fante's humor is subtler than what it seems and could go unnoticed. Arturo celebrates "we Americans" (antithetically to those who are not Americans, according to Arturo: the immigrants) through the cities, the pavements, the buildings . . . that had been built by the immigrants! And among them, Arturo's father, a bricklayer.

It is not just by chance that Fante has been so successful in France, the country that adopted reason as a goddess, and in Italy, a country of skeptical and disillusioned people; and it is not the case that such a success has come in the heart of the postmodern era, in a time of crushed ideals and ideologies, in a time unable to recognize any truth and exalting the power of humor.

I would underline that *Full of Life* (1952) is an exception in Fante's production: this is his only novel where absolute values — values of family and faith — are offered (imposed) to readers; therefore, Fante does not use humor anywhere in this novel; and as a consequence *Full of Life* was Fante's only best-seller during his lifetime. A movie with the same title, directed by Richard Quine in 1956, was produced from *Full of Life*, cheesy and successful like the book.

consists in an anthropological discovery; our desires are always triangular, they are always imitations of someone else's desires that are, in turn, imitations of someone else's desires, in an infinite chain. That is, human beings are unable, according to Girard, to long for an object directly, but they need the presence of another subject (the "mediator") desiring the object, so that their desires can arise from the admiration, envy, sense of competition they feel toward this subject. Thus, this subject becomes more important than the desired object itself, and the disappearance of the competitor means the disappearance of desire. Girard studies the form of this triangle in the most important works of all time, from Cervantes to Stendhal, to Flaubert, to Dostoevsky, to Proust, etc. Girard's goal is to unmask the *mensonge* of the Romantic Age, and especially of romantic critics, who asserted that desires are always spontaneous, *romantic*, that they originate from the subject toward the object without any mediation.

Two other movies have been inspired by John Fante's novels: *Wait until Spring, Bandini* (1989) and *Ask the Dust* (2006). *Wait until Spring, Bandini* is a honest movie that partly recovers the bitter and harsh spirit of that novel. Directed by Dominique Deruddere, it is well interpreted by Joe Mantegna (as Svevo Bandini) and Faye Dunaway (as Effie Hildegarde); Ornella Muti as Maria Bandini does a good job too, but she is too beautiful for that role. The movie focuses more on the relationship between Svevo and Effie than on Arturo and Rosa, neglecting what in the novel has a symbolic taste: the *American* Effie accepts and takes cares of the *Italian* immigrant Svevo who — even if he desires her (he desires to be accepted by America more than anything else) — at the end of the story rejects her to return to his *Italian* family, to his *Italian* roots. Svevo's son, the *Italian/American*, Arturo, craving to be considered one hundred percent American and therefore despising his Italian roots, falls in love with a girl with a similar degree of Italianicity, Rosa Pinelli. But she rejects Arturo and is pushed into the snow, probably the cause of the pneumonia that will kill her. So Arturo, unconsciously, kills Rosa: he kills *Italy*. Beside this, the movie reproduces clearly the sufferance of the immigrants, but neglects their dreams, their hopes, and their optimism thanks to which, as the title suggests, though all misadventures, both Svevo and Arturo keep waiting for spring.

Whoever has loved John Fante's masterpiece *Ask the Dust*, its prodigious humor and its melancholy, its warm Latin prose, has a too deep-rooted prejudice to face objectively the movie with the same title; the problem is that whoever watches the movie *before* will never go to read the novel *later* — so ridiculous is Robert Towne's transposition. It is not so important that the director has modified plot and characters, this is his right to tell his own story; what comes forth, unfortunately, is that this movie confirms that all the worst stereotypes about Hollywood may in fact be true. In fact, the first half of the movie reproduces rather faithfully Fante's book, and especially charming is the Los Angeles of the 1930s (curiously enough, the movie was filmed in Cape City, South Africa). Fante's novel has a very simple plot, almost non-existent: the young Arturo Bandini, the son of Italian immigrants, arrives in Los Angeles from Colorado to become a writer and he falls in love with a Mexican waitress, Camilla Lopez. He succeeds in becoming a writer, but he fails in his love for Camilla, who disappears in the desert at the end of the novel, as if she were Arturo's last reverie.

Ask the Dust, indeed, is a sort of panegyric to Arturo Bandini: his extraordinary dreams; his feverish frenzies for fame and women; his endless imagination; his alternating machismo and impotence; bragging and self-pity; euphoria and desperation—in a word, his "hunger."[10] Arturo is an excessive character, and Fante is not worried about such characterization; he is not worried if Arturo looks ridiculous, especially because Arturo is twenty-years old and a twenty-year-old, specifically one with Arturo's background of misery and humiliations, is by nature excessive, full of contradictions, ridiculous. Excesses and contradictions cease to be such if we attenuate, shade, and/or soften them. This is Towne's first mistake: he wants to stage Fante's Arturo, but he softens him, he "politically corrects" him, he censors him. He gives rationality to Arturo's rages and shames, making them less crazy, more acceptable: Towne makes Arturo a character who can be accepted by a large audience.

Towne's second mistake is to give the role of Arturo Bandini—who is short, squat, full of complexes and terrified by women—to Colin Farrell, a tall young man with a sculpturesque body and delicate star-like features. Farrell tries to look goofy, clumsy and embarrassed when he approaches Camilla (Salma Hayek). Salma Hayek herself is infinitely less aggressive and difficult to deal with than Fante's Camilla, who is a wounded tiger, feverish, scorbutic, humiliated and furious—wonderful. In the novel, Arturo and Camilla bite each other, like two children, like two animals, and love is impossible; in the movie Arturo and Camilla fall in love, they become adult and gloomy lovers, they go to live at the beach, they adopt a dog, he patiently teaches her how to write, she gets sick and dies of tuberculosis, not before recommending Arturo to be kinder with people in the future.

Fante, a poor Italian/American novelist, became rich working as a screenwriter. He hated Hollywood that, according to him, had stolen his soul: watching this movie, how can we say he was wrong?

[10] *Sult* (1890), that is *Hunger*, by Knut Hamsun, was Fante's favorite novel. Fante's prose is strongly inspired by this novel, especially *The Road to Los Angeles*.

Works Cited

Barolini, Helen. *Umbertina*. New York: Seaview, 1979.

————. *The Dream Book: an Anthology of Writings by Italian American Women*. New York: Shocken Books, 1985.

Basile-Green, Rose. *The Italian-American Novel: a Document of the Interaction of two Cultures*. Madison, NY: Farleigh Dickinson University Press, 1974.

Bona, May Jo, ed. *The Voices We Carry: Recent Italian/American Women Fiction*. Montreal: Guernica, 1994.

————. *Claiming a Tradition: Italian American Women Writers*. Carbondale: Southern Illinois University Press, 1999.

Boyle, Kay. *The Autobiography of Emanuel Carnevali*. New York: Horizon Press, 1968. [Prior source for *Il Primo Dio. Poesie Scelte. Racconti e Scritti critici*. Milano: Adelphi, 1978.]

Carnevali, Emanuel. *A Hurried Man*. Dijon: Three Mountains Press, 1925 (Italian translation: *Racconti dell'Uomo che Ha Fretta*. Roma: Fazi, 2005.)

Collins, Richard. *John Fante: a Literary Portrait*. Tonawanda/NY: Guernica Editions, 2000.

Cooper, Stephen, and David Fine, eds. *John Fante: a Critical Gathering*. New York: Associated University Press, 1999.

Cooper, Stephen. *Full of Life: a Biography of John Fante*. New York: Farrar, Straus, and Giroux, 2000.

D'Agostino, Guido. *Olives in the Apple Tree*. New York: Doubleday, 1940.

D'Angelo, Pascal. *Son of Italy*. New York: Mcmillan, 1924.

De Capite, Michael. *Maria*. New York: The John Day Co, 1943.

De Rosa, Tina. *Paper Fish*. Chicago: The Wine Press, 1980.

Di Donato, Pietro. *Christ in Concrete*. Indianapolis: Bobbs-Merrill, 1939.

Donofrio, Bverely. *Riding in Cars with Boys*. New York: Penguin, 1992.

Durante, Francesco, ed. *Italoamericana. Storia e Letteratura degli Italiani degli Stati Uniti*. (1776-1880), vol 1. Milano: Mondadori, 2001.

————. ed. *Italoamericana. Storia e Letteratura degli Italiani degli Stati Uniti*. (1880-1943), vol 2. Milano: Mondadori, 2005.

Gardaphé, Fred L. *Italian Signs, American Streets. The Evolution of Italian American Narrative*. Durham: Duke University Press, 1996.

Girard, Renè. *Mensonge Romantique et Verite' Romanesque*. Paris: Grasset, 1961.

Giunta, Edvige, ed. *Writing with an Accent: Contemporary Italian American Women Authors*. New York: Palgrave, 2002.

Fante, John. *Wait until Spring, Bandini*. New York: Stackpole Sons, 1938.

————. *Ask the Dust*. New York: Stackpole Sons, 1939.

————. *Dago Red*. New York: The Viking Press, 1940.

————. *Full of Life*. Boston: Little, Brown, and Co, 1952.

————. *The Road to Los Angeles*. Santa Barbara, CA: Black Sparrow Press, 1985.

Hamsun, Knut. *Sult*. Copenaghen: Gyldendal, Copengahen, 1890.

Gattuso Hendin, Josephine. *The Right Thing to Do*. Boston: David Godine, 1988.

Kordich Catherine J. *John Fante. His Novels and Novellas*. New York: Twayne Publishers, 2000.

Lapolla, Garibaldi. *The Grand Gennaro*. New York: The Vanguard Press, 1935.

Mangione, Jerre. *Mount Allegro*. Boston: Houghton Miffin, 1943.

Pagano, Joseph. *Golden Wedding*. New York: Random House, 1943.

Peragallo, Olga. *Italian-American Authors and their Contribution to American Literature*. New York: S.F. Vanni, 1949.

Pettener, Emanuele. *Intervista con Helen Barolini*. www.vibrissebollettino.net.

Pirandello, Luigi. *L'Umorismo*. Lanciano: Carabba, 1908.

Prose, Francine. *Household Saints*. New York: St.Martin's Press: New York, 1981.

Rimanelli, Giose. *Benedetta in Guysterland*. Toronto: Guernica, 1993.

Talese, Gay. *Honor thy Father*. New York: Ballantine Books, 1971.

_____. "Where are the Italian-American Novelists?" New York Times Book Review, March, 14, 1993: 1+

Tamburri, Anthony Julian, Paolo A. Giordano and Fred L. Gardaphé, eds. *From the Margin. Writings in Italian Americana*. West Lafayette, IN: Purdue University Press, 2000.

Tamburri, Anthony Julian. *To Hyphenate or Not to Hyphenate? The Italian/American Writer: an Other American*. Montreal: Guernica, 1991.

_____. *A Semiotic of Ethnicity: In (Re)cognition of the Italian/American Writer*. Albany/NY: SUNY Press, 1998.

Ventura, Luigi Donato and S. E. Shevitch. *Misfits and Remnants*. Boston: Ticknor and Company, 1886.

Viscusi, Robert. *Astoria*. Toronto: Guernica, 1995.

_____. *Buried Caesars, and Other Secrets of Italian American Writing*. Albany, NY: SUNY Press, 2006.

The Gangster Figure
in American Film and Literature

Fred L. Gardaphé
QUEENS COLLEGE, CALANDRA INSTITUTE, CUNY

The gangster, as the public knows him today, is a strange mixture of fact and fiction that has emerged in response to the evolution of corporate capitalism in the early-twentieth century. Although criminal gangs had long occupied American cities, the Prohibition Act of 1920 and the desperate poverty brought on by the Great Depression in the 1930s provided opportunities for individual crime leaders to emerge and thrive.

During the late 1920s and early 1930s, the exploits of gangsters such as Al Capone, John Dillinger, "Baby Face" Nelson, and "Pretty Boy" Floyd became national news, fueled fictional accounts, and captured the popular imagination. These real-life gangsters rose above ordinary criminals by committing their crimes with bravado; they were all blatant transgressors of the boundaries between good and evil, right and wrong, and rich and poor. As corporate capitalism promoted consumerism and widened the gap between rich and poor, Americans became infatuated with the gangster, a man of humble origins, who affects stylish dress and fancy cars, defying the boundaries separating social classes.

Al Capone's rise to iconic status came during America's "Roaring Twenties," a time of excess and changing morality stimulated by a booming economy. At the same time, reactionary religious and social activist forces then exerted enough pressure to lead Congress to pass the Volstead Act, legally prohibiting the production and sale of alcoholic beverages. This created a ripe opportunity for smart street thugs to thrive in the resulting black market. A legend in his own time, Capone became a symbol of contemporary power; right or wrong, Capone's actions told Americans that crime didn't just pay, it paid handsomely. His legend became the basis for many of the gangster films of the 1930s.

Fictional versions of the fascinating characters began to appear in American films during the late 1920s and early 1930s. Early films often

portrayed gangsters as degenerate and overly feminized men losing their independence in the new capitalist society, but later films recast them as men who wielded power through sexuality and guns. Films such as Mervyn Leroy's *Little Caesar* (1930) and Howard Hawks' *Scarface* (1932) established a lasting association in popular culture between the gangster and particular ethnic groups: Jewish, Irish-American, African-American, Asian-American, and — especially — Italian-American.

More than an urban evolution of the western outlaw, the gangster came into American culture at a time when great change was occurring in American society, and he has remained there in one form or another ever since. Critic Richard Gambino noted in 1975 that "the mafioso rivals the cowboy as the chief figure in American folklore, and the Mafia rivals the old American frontier as a resource for popular entertainment" (277). Robert Warshow also saw this connection, but in a more fragile vein:

> The Western film, though it seems never to diminish in popularity, is for the most of us no more than the folklore of the past, familiar and understandable only because it has been repeated so often. The gangster film comes much closer. In ways that we do not easily or willingly define, the gangster speaks for us, expressing that part of the American psyche, which rejects the qualities and the demands of modern life, which rejects 'Americanism' itself. (100)

Warshow goes on to say, "What matters is that the experience of the gangsters as an experience of art is universal to Americans" (100).

The cinematic images of masculinity associated with these ethnicities stereotyped and marginalized these groups. This marginalization was amplified in the 1960s and 1970s when, amid growing feminist criticism of conventional understandings of manhood, the ethnic gangster embodied the masculine qualities under attack. Through books such as Mario Puzo's *The Godfather* (1969), Gay Talese's *Honor Thy Father* (1971). and William Kennedy's *Legs* (1975), and especially through the films of Francis Ford Coppola, Martin Scorsese, and Brian De Palma, the American ethnic gangster of fiction eventually became more rounded, more thoughtful, and less inclined to act violently. These more recent depictions represent the efforts of ethnic groups to take control of their own stories, and they also reflect advances in cultural analysis made by feminist critiques of masculinity.

The gangster's actions also reflected changing notions of manhood. Historians, such as David Ruth, have suggested that the gangster figure helped shift ideal masculinity away from traditional qualities, such as honor, to traits such as violence, independence, and the ability to exploit the social system (3). These aspects of the gangster have captured the public imagination from the 1930s to today. Whether a distilled version of the Italian stereotype, an imitative performer of gangsta rap, or a newly sensitized Mafia man à la Tony Soprano, the gangster continues to reflect cultural perceptions of what society considers to be true manhood.

Through filmmakers Francis Ford Coppola, Martin Scorsese, and Brian De Palma, and writers Mario Puzo, Gay Talese, Frank Lentricchia, Don DeLillo, Louisa Ermelino and Anthony Valerio, most of us have come to know the American gangster as a more rounded figure, a man who thinks before he acts, one who rarely pulls the trigger of a gun. From Puzo's *The Godfather* to Frank Lentricchia's *The Music of the Inferno*, Italian American culture has taken hold of the figure of the gangster and elevated it from a common criminal to a god of sorts, that can help us understand much about ourselves and our societies. It is my contention that the gangster, in the hands of Italian American artists, becomes a telling figure in the tale of American race, gender, and ethnicity, a figure that reflects the autobiography of an immigrant group, just as it reflects the fantasy of a native population.

For the sake of discussion, I propose three stages of development of the Italian American gangster figure within American popular culture, and each stage reflects a different function for the gangster and a new direction pursued by its creators. The first is the early use of the gangster as minstrelsy, a way of performing Italian culture in an effort to control the perceived threat to mainstream American culture posed by differences introduced by a wave of Italian immigration. This stage began with films based on Al Capone and faded with the Vietnam War, but revives whenever a non-Italian puts on the "Mafioso" mask to perform the gangster. A second stage began when Italian Americans started to use the figure of the gangster as a vehicle for telling their own stories of being Italians in the United States. The third stage started when Italian Americans began to parody, and in doing so renounce, the gangster figure as representative of their culture, as a means of gaining control of the story.

During the first stage of representation, the gangster figure emerged when the nation was shifting from an agrarian to an industrial based

economy; this was also a time when immigration to the United States was
at its highest, and xenophobia was rampant. Italian immigrants encoun-
tered a great deal of discrimination from established Americans, leading
to the development of negative stereotypes. Recent work on blackface
minstrelsy can be applied to the study of the gangster, to help explain the
rise of the figure in American entertainment in its first stage of develop-
ment, for it is not long after the waning of the blackface minstrel show in
the late nineteenth century that the Italian replaced the African as a sub-
ject of imitation in popular culture. Eric Lott, in his study *Love and Theft*,
writes: "The black mask offered a way to play with collective fears of a
degraded and threatening — and male — Other, while at the same time
maintaining some symbolic control over them" (25). This is precisely
what happened to Italians in the gangster films of the 1930s. Another
dimension that the gangster figure shares with the black-face figure is
overt sexuality. Lott notes: "Bold swagger, irrepressible desire, sheer bo-
dily display: in a real sense the minstrel man *was* the penis, that organ
returning in a variety of contexts, at times ludicrous, at others rather less
so" (25-26). Again, Lott provides a key perspective: "What appears to
have been appropriated were certain kinds of masculinity. To put on the
cultural forms of 'blackness' was to engage in a complex affair of manly
mimicry" (52). It is this mimicry of masculinity that is the greatest func-
tion of the gangster figure.

Early gangster representations, enacted by Jewish actors such as Ed-
ward G. Robinson in *Little Caesar* and Paul Muni in *Scarface*, also convey a
sense of projected fantasy: "Minstrel characters were simply trash-bin
projections of white fantasy, vague fleshly signifiers that allowed whites
to indulge at a distance all that they found repulsive and fearsome" (149).
This minstrelsy stage, as it applies to Italian Americans, is notable for its
distortion, if not disfigurement, of Italian culture, ostensibly for plot
purposes, but actually as a means of maintaining power over the attrac-
tion of the foreign, including the repression of women in Italian culture
and the replacement of the mother–son paradigm with the father–son pa-
radigm. This aspect is actually picked up and utilized in the second stage
by Italian-American artists. This first stage also distorts the communal as-
pect of Italian culture, replacing it with the American stress on indivi-
duality.

The gangster figure also functions as the scapegoat for the obsessive
desire for self-advancement, and unresolved class conflicts are played out

in the films. He also serves as a guide to the underworld, taking audiences to places that they might never go on their own. Other themes surrounding the early depictions of the gangster include the disintegration and destruction of the family, the substitution of a "false family" — the gang — for the real family, and a son of the New World rebelling against a father from the Old World. In the wake of the success of these early gangster films, however, came stricter Hollywood censorship and World War II, both of which contributed to decreased interest in gangster storylines. When the gangster returned to popularity in the second stage of development, he would have his greatest impact through the work of Italian-American artists.

The second stage of the gangster's development begins with Mario Puzo's novel, *The Godfather,* and the three films based on it. At this stage, the Italian-American artist uses an accepted and profitable public vehicle, (the gangster film), to tell a story that is personal. The mother–son paradigm employed by Puzo in his novel *The Fortunate Pilgrim* (1964) is exchanged for the father–son paradigm in *The Godfather* (1969). Puzo added a preface to the last reprinting of *The Fortunate Pilgrim* in which he admitted that he had modeled Don Vito Corleone after his mother. This is repeated in most of the films that derive from the Puzo/Coppola oeuvre, and also in the work of Martin Scorsese.

The highly romanticized depiction of the gangster in *The Godfather,* both Puzo's novel version and Francis Ford Coppola's three films, has much to say about how Italian-American culture fares. As a culture hero, Puzo's gangster is a romantic type. *The Godfather,* as many critics have pointed out, tries to explain many things: American capitalism, American imperialism, Italian traditions, and more. But along with those themes, *The Godfather* looks at the changing notion of American masculinity as it has been affected by changes of the 1960s, the rise of feminism, and the fall of the traditional American He-Man. For it was after this period that Americans learned that the strength of a man was more than muscles, that the Marlboro man could die of cancer, and that fathers didn't always know best. Against this tempest of change stand the Corleone dons, tragic and violent versions of Peter Pan, upholding all that was traditionally manly for men who were afraid of becoming feminized.

The films of Martin Scorsese counter the romantic view of the gangster in Coppola's *Godfather* films through Scorsese's use of techniques derived from the French New Wave, Italian neorealism, and cinema verité. Scorsese

grew up on Mulberry Street in Manhattan's Little Italy. His own experiences, combined with journalistic accounts, helped him create the composite characters of the gangsters in his films. Scorsese's gangsters grow up in the streets, away from the watchful eyes of fathers who work, and mothers who, if they don't work, stay home and remain nearly invisible. These gangsters start off as rough boys who continually try to prove their manhood. *Mean Streets* (1973), *Goodfellas* (1990), and *Casino* (1995) together established Scorsese as the maker of gangster films par excellence. In each film, Scorsese achieves a striking sense of realism which comes from the sources of his stories: *Mean Streets* was based on his own life experience, and *Goodfellas* and *Casino* on nonfiction books by Nicholas Pileggi. Scorsese's films all move chronologically, following the rise and fall of the gangster. In this way, they reflect the reality of the documentary rather than the romanticism of fictional drama. Scorsese's gangsters are shown as men trapped forever in an immature stage—physically adult, but behaving like boys. Because Scorsese has chosen this simple realization of the gangster figure, he has not presented a way for us to imagine a gangster-free masculinity. This absence of an alternative presentation of masculinity persists in his films, even to *Gangs of New York* (2002) and *The Departed* (2006). The films of Scorsese serve as models for many subsequent gangster films: Michael Cimino's *Year of the Dragon* (1985) and *The Sicilian* (1987), Abel Ferrara's *The Funeral* (1990), Quentin Tarantino's *Reservoir Dogs* (1993), and Michael Corrente's *Federal Hill* (1994).

The third stage brings the parody or renunciation of the earlier figures by Italian Americans and reinvents the figure of the gangster as a figure through which American culture is criticized. In terms of film and video, this stage begins with David Chase's television series, *The Sopranos*, which became to America of the new millennium what *Dallas* was to the 1980s. This hit series signals a major change, both in what the gangster represents and in what is happening to the American way of life. The original American gangsters represented a traditional, patriarchal sense of manhood that came from an old European model. Violence was used to acquire and sustain honor, and for this type of gangster, the swarthy, "European-looking" Italian offered instant identity with the type; after all, America has regularly compared itself to Europe to determine its difference.

Chase's *The Sopranos* joins the fiction of Italian Americans such as Giose Rimanelli's *Benedetta in Guysterland*, Anthony Valerio's *Lefty and the Button Men*, Frank Lentricchia's *The Music of the Inferno*, Louisa Ermelino's *Joey Dee Gets Wise*, and Don DeLillo's *Underworld*, in creating a different future for the gangster figure in American culture. Chase, the creator and executive producer of the hit series *The Sopranos*, conceived the program in the tradition and spirit of the traditional U.S. gangster film, but he executed it as a commentary on both the genre and contemporary life in the United States. He gives new life to the gangster figure by setting him back down in the suburbs, where today over 60 percent of Americans live in the United States. Hardly an episode of *The Sopranos* passes without some nod to, or comment on, an earlier classic depiction of the gangster. In the first episode, there are cutaways to Al Capone and head shots of famous actors playing gangsters (Humphrey Bogart, Dean Martin, and Edward G. Robinson), as the character of Christopher Moltisanti shoots a rival. Over time, the gangster has become a marker of ethnicity and manliness in contemporary American life, and Chase uses the gangster figure as a vehicle for his own commentaries on both ethnicity and manliness.

To Tony Soprano the history of organized crime is poetry, an art that comforts him, as it gives him a sense of being connected with a past. He has mythologized the actions of past gangsters, as though his father belonged to some type of gangster-hood golden age. Tony becomes philosophical whenever he contemplates these myths, but the more he thinks about them, the more he sees that they are only constructions that shatter easily. By utilizing the strong mother–son dynamics of Italian culture through his creation of strong women characters who influence Tony's actions, Chase moves the gangster figure toward a higher level of maturity than previous artists.

The movie *A Bronx Tale* (1993), Robert De Niro's directorial debut, was adapted from a one-man show written and performed by Chazz Palminteri. On the surface, the film might seem stereotypical in its portrayals, but Palminteri's gangster, based on a real man he knew in his youth, is a more rounded character than most previous gangster figures. The film thus is more a father–son story than the portrait of a gangster. The story involves two periods of young Calogero Anello's life, at the ages of nine and seventeen. Calogero is growing up in the Bronx under the influence of his father and a local gangster, who both try to shape his sense of masculinity.

More often than not, the gangsters created by playwright Richard Vetere appear in a humorous light, revealing the absurdity of gangster behavior as a model for contemporary masculine behavior. *Gangster Apparel* is Vetere's first and only play dealing directly and exclusively with the gangster figure. The two-act comedy features two characters, Louie Falco and Joey Pugg, small-time hoods who get a chance to kill somebody for the mob. Louie is a slick, fancy dresser who, as the writer's note says, "believes that style is more important than substance." Joey, his partner, is a slob who thinks nothing of how he dresses. The play deals with how the two of them confront the surfaces and depths of the gangster life. Vetere parodies the many gangster characters who have come before his, but unlike more obvious gangster parodies and comedies — *The Freshman* (1990), *My Blue Heaven* (1990), *Jane Austen's Mafia* (1998), *Analyze This* (1999), and *Analyze That* (2002), none of which were created by Italian Americans — his play attempts to say something serious about the gangster, and therefore it offers a fresh way of looking at the plight of the gangster figure. At the end of the play, while Louie is admirable for his prowess and his ability to see trouble coming and deal with it, it is Joey who proves that a wiseguy becomes a wise man, when he begins to use his intellect to move beyond the limitations of a life lived only on the surface. For Vetere, a wise man is one who can change when he needs to. Vetere continued to use the gangster figure in a number of other plays, most obviously in *The Classic* (1998) and the book he wrote for the musical *A Hundred Years into the Heart* (2004).

The American artists of Italian descent whose works have been discussed in this essay have used the gangster figure to reflect various notions of what it means to be a man in American society. Those notions have shifted from the very narrow, tough, macho version of masculinity seen in Puzo's novel and Coppola's film *The Godfather*, to the more varied and fluid versions presented by Frank Lentricchia, Louisa Ermelino, and many contemporary dramatists, poets, and novelists. Mario Puzo's version in *The Godfather* humanized the gangster figure. However, Vito and Michael Corleone remained staunchly macho, even in the face of increasing rights for women. Scorsese's gangsters reinforced this notion and firmly established the Italian-American gangster as the prototype for a post-feminist masculinity that remained untouched by social and political developments stemming from the Women's Rights Movement of the 1970s. Both the romanticization and the realization of the gangster in

American popular culture set up the Italian-American male as one of the last survivors of old-fashioned macho masculinity. However, the strong, silent type of man who settled scores with his fists instead of diplomacy became politically incorrect. When Tony Soprano asks his psychiatrist, "What ever happened to the strong silent type played by Gary Cooper?" in the first episode of *The Sopranos*, he is asking a question that his very presence in the media answers. It is through the reinvention of the gangsters created by David Chase, Giose Rimanelli, Frank Lentricchia, Louisa Ermelino, Anthony Valerio, Richard Vetere, Chazz Palminteri, and many others, that new possibilities are available for the old stock characters. Ultimately, the power of the gangster figure shifts from reinforcing macho masculinity to freeing the power of the writer, the creator, the artist to question the status quo.

Works Cited

DeLillo, Don. *Underworld*. New York: Scribner, 1997.

Ermelino, Louisa. *Joey Dee Gets Wise*. New York: St. Martin's Press, 1991.

Gambino, Richard. *Blood of My Blood*, New York: Anchor, 1975.

Lentricchia, Frank. *The Music of the Inferno*. Albany: SUNY Press, 1999.

Lott, Eric. *Love and Theft: Blackface Minstrelsy and the American Working Class*. New York: Oxford University Press, 1993.

Puzo, Mario. *The Fortunate Pilgrim*. New York: Random House, 1997.

————. *The Godfather*. New York: Fawcet 1969.

Rimanelli, Giose. *Benedetta in Guysterland*. Toronto: Guernica Editions, 1993.

Ruth, David. *Inventing the Public Enemy: The Gangster in American Culture, 1918-1934*. Chicago: University of Chicago Press, 1996.

Valerio, Anthony. *Lefty and the Button Men*. Philadelphia: Xlibris, 2000.

Vetere, Richard. *Gangster Apparel*. Woodstock, IL: Dramatic Publishing Company, 1996.

Warshow, Robert. "The Gangster as Tragic Hero," in *The Immediate Experience: Movies, Comics, Theatre and Other Aspects of Popular Culture*, Cambridge, MA: Harvard University Press, 2001.

Italian-American Immigrant Theatre

Emelise Aleandri

In America before the eighteenth century, except for the dance rituals of Native Americans, little if any entertainment was performed among any new immigrants because of the tremendous hardships of the struggling inhabitants. During the eighteenth and early nineteenth centuries, Italians immigrated not only because of the political and religious pressures in Italy, but also because of America's continuing need for Italian workers and craftsmanship. Eventually, that need would extend to music and musicians and other types of entertainers. A reference to the first Italian musical curiosity of note appears in an advertisement in New York City's 1746 *Evening-Post*. At the house of Wood Furman, one could, for two weeks, see exhibited by John Brickell, "the Italian Mountebank, or fomous [sic] Quack." As early as 1757, and possibly before, traveling Italian musicians performed classical music, held concerts, and established music schools. Among these musical pioneers were two Philadelphians: composer John Palma (1757) and Giovanni Gualdo, composer and teacher of the mandolin, violin, flute, guitar and harpsichord (1767 to 1769); and in Williamsburg, Virginia, Francis Alberti—a teacher of violin, harpsichord and other instruments—taught vocal and music lessons to Thomas Jefferson's future wife Martha.

Journalist Pasquale De Biasi, in Guglielmo Ricciardi's *Memoirs*, notes a performance specifically for Italians in 1765: Mr. Galluppi, Mr. Seminiani and Mr. Giardini presented a *commedia-ballata* (comedy ballet or dance comedy or "ballad opera"). In 1768, two Piedmont brothers, who had been engineers for the King of Sardinia and performed for the royal family of Spain and for the Duke of Gloucester, appeared at the Ranelagh Gardens on Broadway at Thomas Street, and demonstrated an "elegant set of fireworks" at the Southwark Theatre in Philadelphia. In 1769, a "magnificent set of fireworks" by the two brothers took place in New York City at the Vauxhall Gardens on Trinity Church property at Greenwich Street, between Warren Street and Chambers Street, on the shores of

the Hudson River. The fireworks displayed many themes, a few of which were: rockets, Chinese fountains, Italian candles, illuminated colored wheels, stars, snakes, a Marquis tent, the sun, the moon, the globe, a Chinese looking-glass, diamonds, flowers, triumphal arches and a wheel of fortune. The fireworks of the "Two Italian Brothers" were targeted specifically for American audiences, who required no knowledge of the Italian language to enjoy the show. It would take a full century before a regular, viable Italian-American musical and theatrical presence took hold in New York City.

Italian-American immigrant theatre begins in New York City. In 1808 Italian American playwright, Lorenzo Da Ponte, in order to facilitate his teaching of Italian, adapted little comedies and short plays to be performed in his home by his twenty-four American students at Columbia University. These pieces were adaptations of works he had done earlier in Europe and purposefully didactic, as opposed to being solely entertaining or original. The true title of "first" Italian American playwright goes to political refugee Joseph Rocchietti, in 1842, for his *Ifigenia*, the first extant, published Italian American play, and written in the style of classical tragedy. This play, too, was read aloud by his students as an exercise in the study of Italian. But Rocchietti's agenda is to uphold the principles of democracy and republicanism and overcome the tyranny of bigotry. Other playwrights that emerge, only after 1870 with the mass migration, write an entirely different story when the first amateur phase of this vital ethnic theatre truly emerges, with the waves of Italian immigrants pouring into this country, bringing both the performers and audiences necessary for theatrical entertainments.

The average immigrant was a male, ex-agricultural worker from the south of Italy, unskilled, uneducated and unattached, discriminated against by the mainstream of American society, and often exploited as an underpaid laborer, sometimes even by his own countrymen. He was either unmarried or had in Italy a family, which he came here to support. The 20 or 30 percent that returned to Italy seasonally had no desire to assimilate themselves into their new surroundings, even had they been welcomed to do so. They retained their regional speech, their social and religious customs, their eating habits, etc. and congregated in communities that allowed them some free expression. Hence, the "Little Italies" of America.

All these factors contributed to creating an original theatrical expression: the Italian-American immigrant theatre of New York City. Its audi-

ences were the displaced men and women of Italy, and they were hungry for entertainment, recognition, a support system and social intercourse — all emotional needs which the theatres and the nightclubs helped to satisfy. The Italian immigrant community, located in tenement "Little Italies" throughout the city, supported itself through a network of fraternal and benevolent associations that often sponsored dances, concerts and lectures to celebrate holidays and benefit social causes in New York City and in Italy. Soon amateur theatrical clubs evolved. The earliest and most prolific prototype is the Circolo Filodrammatico Italo-Americano (The Italian-American Amateur Theatre Club), which mounted the first Italian-American production, the Italian play *Giovanna Marni*, on October 17, 1880 at Dramatic Hall on East Houston Street.

During the nineteenth century, a great variety of dramatic forms and entertainments were essayed on the stages of the Italian-American theatre. Italian and European writers were introduced to immigrant audiences, many of whom had never before experienced the theatre or the classics of literature. They heard the plays of their homeland and other European theatres spoken, if not in Italian, then translated into their own Neapolitan, Sicilian or other regional dialects. They heard the familiar operatic arias and duets, known by most Italians, in their local bistros. Audiences created their own stars, their own playwrights. The Italian-American experience furnished the subject matter for original plays written by Italian immigrant playwrights. Among them, Eduardo Migliaccio, known as Farfariello, made the Italian-American immigrant the hero of his dramatic creations; Riccardo Cordiferro, the pen name for the journalist and political activist, concerned himself in his plays and philosophical writings with the social conditions of the Italian immigrant.

The women in the theatre also enjoyed a freedom and an outlet for creativity that was not shared or available to their sisters who played out their lives in the more traditional domestic roles. Many women became writers, directors, entrepreneurs in their own right, as well as popular actresses and singers.

By 1900, the community had produced the major forces that created the theatre of the ensuing decades: Antonio Maiori, who introduced Shakespeare to his immigrant audiences in his Southern Italian dialect productions; Francesco Ricciardi who held sway as the Prince of Pulcinellas in the nightclub arena; Eduardo Migliaccio, whose stage name "Farfariello" means "Little Butterfly," and who created the unique art form — the

Italian immigrant character sketch; Guglielmo Ricciardi, who created Italian-American theatre in Brooklyn and went on to a successful career in the American theatre and cinema; Antonietta Pisanelli Alessandro, who started in New York City, performed in Chicago and then went on to create single-handedly, the Italian-American theatre of San Francisco; and many, many more. Many professional liaisons, marriages and business partnerships took place between these major families, creating a strong theatrical network in later years. More often than not, children in these families started their careers early and continued the family theatrical tradition for as long as there was a theatre to nourish them.

Financial problems were an ever-present worry for these young companies. Groups appear and, with equal facility, disappear. The more stable theatre companies tried everything to "make a go" of business: they would flourish one year, only to have a lean year next, and so might go on the road to try new audiences, sometimes returning poorer than when they left; they would move to smaller or bigger theatres in the hopes of juggling finances to better advantage; they would change their fare, from the classics to comedy and vaudeville, or vice versa; nightclubs would as easily change ownership, renovate, bring in stars from Italy. Successful or unsuccessful as these attempts might have been, efforts to create theatre were constantly in force and constituted an enormous output of energy during the seventy-odd years of its existence in New York City. The names of the personalities involved in the theatre in one way or another number in the tens of thousands.

The abundance of theatrical energy spilled out over the city's boundaries with the effect that professional New York City companies were bringing professional theatre experiences to Italian immigrants who lived in rural and suburban areas. Most of the major figures—Antonio Maiori, his comic sidekick Pasquale Rapone, Guglielmo Ricciardi, Giovanni De Rosalia who created the comic halfwit "Nofrio," the itinerant actor and singer Rocco De Russo, Eduardo Migliaccio, Clemente and Sandrino Giglio, to name a few—made excursions out of town, to reach new audiences and get the most mileage out of their productions.

One effect of this theatrical migration was to inspire the formation of amateur theatrical groups in other cities. During the 19th century, several amateur groups existed in New Jersey, Boston, and Philadelphia. By the early 20th century there were over eighty amateur groups scattered throughout small and large cities all over the United States. Some were profes-

sional. But many followed the pattern already established by amateur clubs in New York: they formed either for the sole joy of performing theatre, or to raise money for worthwhile social causes. And they are often associated with some religious, fraternal or educational organization.

Of course, not all amateur groups outside New York City owed their existence to the example set by traveling professionals. The great numbers of new immigrants alone would have inevitably resulted in the emergence of new theatre clubs. But what is certain is that major performers from the city came in contact with actors outside and often used them in their productions, thereby creating temporary marriages between companies. New York's Francesco Vela actually taught at a drama school in Providence, Rhode Island. It is conceivable that New York's ready access to the latest printed scripts, songs and sheet music found their way to other cities via the traveling companies, thereby increasing the repertory of local amateur clubs. Riccardo Cordiferro, journalist and playwright brought scripts of his play *Lost Honor* to many places out of town.

The "road" made reporters out of some New York actors and directors. The actor playwright, Salvatore Abbamonte, sent in information about his activity in Asbury Park to *L'Araldo Italiano* as did the actor, Salvatore Melchiorri, when he performed in Chicago. Riccardo Cordiferro included frequent out of town notices in his radical newspaper *La Follia*. Many of the anonymous notices of productions out of town came from the pens of well-known New York personalities. Furthermore, many regional reporters, who may also have been actors and directors, reported to the New York dailies about shows in their towns and about their own local stars. The list of out-of-town reporters is a long one.

All this reportage demonstrates that New York City's Italian-American theatrical consciousness was not a parochial one. It included an awareness and sharing of the theatrical tradition with other immigrants, who no doubt went to the theatres in their respective cities for the same reasons Italian-American New Yorkers did: socializing, entertainment, and a support system in the difficult process of assimilation.

First and foremost, audiences came to the theatre expecting to be entertained. The hardworking laborers came to the theatre either alone or with families in tow, to escape the harsh reality of their lives, to be dazzled by the glamour of the costumes and the beauty of the performers, to be reminded of home by hearing familiar folk songs, ballads and operatic arias, to hear Italian spoken, as well as their own regional dialects, to

laugh at the antics of their own regional stock character of the *commedia dell'arte* tradition, to be stirred by the patriotic sentiments and grandeur of the historical dramas, to be moved by the emotions played out in the melodramas, and to be reassured by the well-ordered universe depicted therein. The average audience, we can safely say, was quite dispassionate, or at best, ambivalent, about whether a production was educational or socially relevant.

These concerns, instead, were voiced by the writers and directors. When Paolo Cremonesi and Giovanni Flecchia formed a company to perform for Hoboken's Italian immigrants, they called the group "The Club for Instruction and Entertainment" and also "The Study and Work Club." Salvatore Abbamonte called his group "The Club of Young Studious Italians," whose stated purpose was the propagation of Italian culture overseas as well as entertainment. Intentionally or unintentionally, Italian-American theatre did play an educational role in the life of the immigrant. The history, literature and culture of Italy were paraded across the stages of Little Italy. Furthermore, dramatic literature of other European countries was equally accessible and the actor and director, Antonio Maiori, introduced Shakespeare in dialect to Italian immigrant audiences. The gentle, humorous satire of Eduardo Migliaccio provided another type of education. Farfariello, the character he created, was a comic stock character — a *caratterista* in the tradition of the *Commedia dell'arte*, — only this character, instead of originating in Naples or Bologna or Calabria or any other Italian region, was a product of New York City's immigrant community and spoke a curious, new but familiar, regional dialect, Italo-Americanese. Farfariello was the typical newly-arrived immigrant, the bewildered greenhorn, trying to make his way in a strange and inhospitable country. Education was an incidental byproduct of Migliaccio's characterizations, or *macchiette*. "Pasquale Passaguai" showed the immigrant how to avoid being duped by thieves, while his parody of "Il Presidente della Società" cured many community leaders of their habit of wearing pretentious military uniforms at public functions. Migliaccio's creations in particular and the immigrant theatre in general, helped ease the tensions and anxieties of living in a foreign country, and indirectly helped the immigrant in the process of assimilation.

The task of education was imposed on the theatre by its more educated and literate observers and participants. It was not long before the literati of the day imposed yet another role on the immigrant theatre

— that of propaganda. The actor Salvatore Abbamonte told of "red" evenings of theatre, which included radical speakers, revolutionary songs, and plays on social topics. He claimed that, for love of the theatre, he too had become a revolutionary. His play, *Senza Lavoro* (*Unemployed*), dealt with a contemporary social problem. Theatre groups identified themselves by names reflecting their political leanings. New York City had La Filodrammatica dell'Unione Socialista (The Drama Club of the Socialist Union), while Paterson, New Jersey, the home of King Umberto the First's assassin Gaetano Bresci, was also the home of Il Teatro Sociale (The Social Theatre). Il Nuovo Club Democratico Italiano (The New Italian Democratic Club) was located in Washington, D.C. New Haven, Connecticut had La Sezione Socialista Italiana (The Italian Socialist Department) and New Castle, Pennsylvania had Il Circolo Socialista Enrico Fermi (The Enrico Fermi Socialist Club).

On the Italian-American stages, immigrant audiences were confronted with contemporary social concerns, among them the exploitation of laborers by American bosses and Italian *padroni*, the miserable living conditions of crowded tenement slums, corruption and social injustice. At the turn of the century the left-wing journalist, Riccardo Cordiferro, began writing what would become a formidable list of social protest plays. His dramatic monologue *Il Pezzente* (The Beggar) described the plight of the beggar. His drama *L'Onore Perduto* (Lost Honor), encased in the structure of domestic melodrama, examined the dishonesty of some Italian-American bankers and its tragic effects on the newly arrived immigrant. The play also touched, however lightly, on the emancipation of women, and was produced in many Eastern cities for Italian immigrant audiences. Even the regular professional theatres would sometimes put on productions of plays they described as "social dramas."

However significant these plays might have been, however satisfying their enactment may have been to the more educated members of the audience, they never achieved the popularity of the comedies, the variety shows and the classics of the European theatre. In the theatre at least, Cordiferro was no match for Farfariello, in terms of popularity and exposure. But in the years that followed, the class struggle became more desperate and the voice of reform more insistent, all of which was reflected in the theatre.

In conclusion, then, the progress realized by the Italian-American theatre of the 20th century was outstanding. First, the theatre made a

notable transition from an essentially amateur status to its predominantly professional phase; second, the time saw an enormous output of activity and the participation of thousands of theatre artists; third, theatre proliferated within Italian-American communities outside New York City, as far as California, partially as a result of traveling professional and amateur companies from New York City; fourth, a distinctly Italian-American language and literature developed; fifth, the theatre was responsible in part for the evolution and celebration of a uniquely Italian-American identity; finally, this new identity contributed, in the characterization of Farfariello, a new comic stock character or *caratterista* in the tradition of the *commedia dell'arte*. By 1905 despite the vagaries of artistic life, the Italian-American theatre had persistently, obstinately, devotedly and lovingly "arrived."

Throughout the first quarter of the 20th century, immigration statistics for these years reveal a steady flow of new immigrant arrivals from which emerged eager new audiences. The major impresarios were still actively engaged in production for the better part of these years: Maiori, Francesco Ricciardi, De Rosalia, Cremonesi, Enrico Costantini, Migliaccio, Gennaro Ragazzino, Rocco De Russo, the Marrone brothers, Mimi Imperato, Silvio Minciotti, Esther Cunico, Silvio Minciotti, Clemente and Sandrino Giglio. Their ranks were enlarged and infused with the energies of new recruits and entrepreneurs, among them: Ilario Papandrea, Angelo Gloria, Alberto Campobasso, Attilio Barbato, Gennaro Gardenia (father of Vincent Gardenia), Francesco De Cesare, Gino Caimi, Gustavo Cecchini, Rosario Romeo, Giuseppe Sterni, Ettore Mainardi, and many, many more, and a host of amateur clubs as well.

The immigrant community needed a theatre, and the Italian-American theatre needed an immigrant population to exist. Without it, the theatre went into decline. The new immigration quota laws of 1924 restricted the annual importation of new Italian immigrants into the United Stated to figure not in excess of 2% of the total number of new arrivals in 1890. The Italian-American theatre gradually began to see the effects of the restrictive quotas in their dwindling audiences. Furthermore, as the second and third generation of Italian-Americans became acculturated, they turned to the new and readily available popular forms of entertainment: radio, the movies, and eventually television. Giglio, into the 1940s, and Gardenia, into the 1950s, were two of the last holdouts. Some, like Guglielmo Ricciardi long ago, managed to cross over into American spheres.

Ester Cunico for instance, played Ernest Borgnine's mother in the film *Marty* (Delbert Mann, 1955), and the late Vincent Gardenia, who played in the Italian-American Theatre until the 60s, is still highly visible in television and films.

But the Italian-American Theatre is virtually non existent today. Even if large numbers of Italian speaking immigrants were suddenly to materialize, our modern technological age has manufactured other diversions, which assure that a popular immigrant theatre is now impossible. In the New York metropolitan area, Frizzi e Lazzi, the Olde Time Italian-American Music and Theatre Company revives some of the material created a century ago and tours out of town. But in general, if an Italian-American today speaks the lines of an Italian play on a stage somewhere in New York City, he or she is probably a college student studying the language of his or her grandparents. Until recently, the contemporary Italian-American playwright Mario Fratti, who writes in Italian and English and whose plays are performed all over the world, staged Italian plays at Hunter College, using as actors his students of Italian, in the tradition started by Lorenzo Da Ponte at Columbia University in 1808.

Around 1951, a retired impresario, advanced in years, was visited by a younger actor. The older actor asked of the younger: "Che se dice? 'O teatro che fa? Chi ce sta mo' 'ncopp' 'e scene?" (What's new? What's happening in the theatre? Who's up there on stage now?) to which the younger man replied: "Nessuno" (No one).

ITALIAN AMERICAN CINEMA

City Views: The Voyage of Film Images

Giuliana Bruno
HARVARD UNIVERSITY

"Every story is a travel story—a spatial practice."[1] Film is the ultimate travel story. Film narratives generated by a place, and often shot on location, transport us to a site. Sometimes, the site itself would move. This is the case of Naples, a city that has physically and virtually migrated. Exploring Naples in film, one discovers its bond to New York—a migratory tie, and a filmic *transito*.[2] Situated on the same latitude, Naples and New York are "parallel" places, in many ways adjoined. Several sociocultural dislocations link these two cities of motion, which are historically and geographically bonded by the cinema.

THE SPECTACLE OF CINE-CITIES

Not all cities are cinematic. Naples and New York are intrinsically filmic. Photogenic by way of nature and architecture, they attract, and respond well to, the moving image. They have housed the cinema from its very first steps, and have a shared history as cine-cities. The "filmic connection" between Naples and New York is an offspring of their being metropolitan thresholds. These restless visual cities are about motion (and) pictures. As harbor towns, they absorb the perpetual movement of the sea, bear the mark of migration, convey the energy of people's transits, and carry the motion of trade. No wonder the cinema insistently depicts them. They are architecture in motion, as restless as films. An urban "affair," produced by the age of the metropolis, film imparts the metropolitan *transito*, and its ceaseless speed. Naples and New York lend themselves to moving portraits of dark beauty. Inclined to the *noir*, they

[1] Michel de Cerreau, *The Practice of Everyday Life*, trans. Steven Randall, (Berkeley: University of California Press, 1984) 115.

[2] *Transito* (untranslatable in English in one world) is wide-ranging notion of circulation, which includes passages, traversals, transition and transitory states, and incorporates a linguistic reference to transit. See Mario Perniola, *Transiti: Come si va dallo stesso allo stesso* (Bologna: Cappelli, 1985).

portray the metropolis of the near future. Like the filmic metropolis of *Blade Runner* (Ridley Scott, 1982), they are dystopian cities. Always somewhat decayed and embedded in debris, these striking cities are never too far from an exquisite state of ruin. Cities in ruins, they exhibit the social contradictions, and show the high and low, side by side, in the architectural texture, making a spectacle of the everyday. Cities of display, they suit the cinema — the spectacle of motion pictures.

The particular spectacle produced by Naples and New York is street theater. Bonded by the continual motion of their streets, these inevitably lead one to the streets to watch the spectacle of their moving crowds. Their filmic image often reproduces this spectorial walk through town — an urban promenade. New York streets and Neapolitan *vicoli* (alleyways) have been attracting film-makers for what is now almost a century. The image of these cities, rooted in their street life, is unavoidably linked to the "mean streets." "Escape from New York" and from Naples, is often the message. Yet cinema, and visitors, continue to return to the scene of the crime.

Naples and New York are both tourist attractions, and a tourist's nightmare. Their very history is intertwined with tourism, colonization and voyage, and their relative apparatuses of representation. In many ways, their filmic image partakes in form of tourism: cinema's depiction is both an extension and an effect of the tourist's gaze. Repeatedly traversed and re-created by the camera, Naples and New York have produced a real tourism of images. Shot over and over again, these cities have become themselves an image, imagery, a picture postcard.

VOYAGE TO NAPLES, A GRAND TOUR

This, of course, has always been true of Naples, the ancient capital, especially renowned for Baroque art and musical life, and for its mix of high and popular culture. A major stop on the Grand Tour of Europe, the elitist touristic practice that preceded mass tourism, Naples was endlessly toured, represented, and pictured. Cinema has continued this type of journey, producing its own grand tour. The ultimate incarnation of the classic voyage to Naples is *Voyage to Italy* (1953-4), a film by Roberto Rossellini. In this filmic voyage, as in the Grand Tour, North meets South, and the voyagers' search — a descent — becomes an exploration of the self. Once in the southern environment, the senses erupt, cool equilibriums break, and events take place. A similar experience is described by Jean-

Paul Sartre in his letters. Narrating his voyage "down" to Naples, Sartre, as Rossellini, speaks of the city's physicality, finding that one is inevitably affected by the materiality of the place, "the belly of Naples" — A body-city.[3]

Before, and in conjunction with the cinema, images of Naples marked the history of visual arts. Naples was one of the subjects most frequently portrayed in the geography of *vedutismo*, the practice of view painting that was recognized as an independent genre in the late seventeenth century. The image of the city in painting, as in film, is forever linked to the *veduta*, and its representational codes. One wonders whether the Bay of Naples was made to be "pictured."[4]

Naples has been looked at so much that it can be torn out by over-representation. As the writer Thomas Bernhardt once said: "To see the Vesuvius, it is, for me, a catastrophe: millions, billions of people have already seen it."[5] Over-representation and the touristic picture of Naples become a real issue when we consider its filmic portrayal, especially in view of what Naples has been made to symbolize in the cinema. When depicted as folkloric and picturesque, the city becomes both a frozen and a serial image.

The image of Naples in film succeeds a long chain of representations, of which travel literature and the panoramic gaze are an essential part. To understand the connection of Naples to the cinema, one must contemplate the visual history of the city, and consider tourism one of its main motor-forces. The way film emerged in Naples makes this particularly evident. From the very beginning, film was a form of imaging, and a way of touring, the city. Early Neapolitan cinema participated intensely in the construction of "city views." There was even a genre devoted to viewing the city: It was called *dal vero*, that is, shot from real life on location. The first filmmakers, including Neapolitan ones, widely practiced *dal vero*, making short films entirely composed of street views of the city and its scenic surroundings.

[3] Jean-Paul Sartre, *Witness to My Life: The Letters of Jean-Paul Sartre to Simone de Beavouir 1926-1939*, ed., Simone de Beavouir, Trans., Lee Fahnestok and Norman MacAfee (New York: Charles Scribner's Sons, 1992). The commonly used expression "the belly of Naples" ("il ventre di Napoli") derives from a book by the female novelist and journalist Matilde Serao. See her *Il ventre di Napoli* (Naples, 1884).

[4] On Naples and Grand Tour see Cesare de Seta, "L'Italia nello specchio del Grand Tour," in *Storia d'Italia*, vol. 5 (Turin: Einaudi, 1982). On *vedutismo* and Naples, see *All'ombra del Vesuvio: Napoli nella veduta europea dal Quattrocento all'Ottocento* (Naples: Electa, 1990) (exhibition catalogue).

[5] Cited in Fabrizia Ramondino and Andreas Friedrich Muller, eds, *Dadapolis: Caleidoscopio napoletano* (Turin: Einaudi, 1989) 181.

Dal vero was an international phenomenon, and Naples became a well-traveled subject of the genre. An extension of nineteenth-century dioramas and panorama painting, *dal vero* speaks of cinema's penchant for "sightseeing." Like the urban spectacle of *flànerie*, the mobile gaze of the cinema transformed the city into cityscape, recreating the motion of a journey for the spectator.

Let us now see how this phenomenon of image-making was implanted in Naples, by touring the origins of cinema in the city, and exploring the migratory connection to New York, established in the early decades of film history.[6]

A PANORAMA OF NAPLES' EARLY FILM DAYS

> Naples is the only true Italian metropolis.
> —ELSA MORANTE

> [In Naples] building and action interpenetrate in the courtyards, arcades, and stairways . . . to become a theater of the new . . . This is how architecture, the most binding part of the communal rhythm comes into being here, . . . [in] the baroque opening of a heightened public sphere . . . What distinguishes Naples from other large cities is [that] . . . each private attitude or act is permeated by streams of communal life.
> —WALTER BENJAMIN

Home of the first Italian railway, Naples played a prominent role in the rise of another industry of movement: the motion picture industry. Cinema entered the Neapolitan world of spectacle in 1896, and quickly "set down roots." In 1906, the novelist Matilde Serao published a newspaper article entitled "Cinematografeide." The author of *The Belly of Naples* invented this word to name a new kind of virus, a turn-of-the-century epidemic—the cinema. It was attacking the body of her city:

> The last and ultimate expression of Neapolitan epidemics and manias, the *dernier cri* of success today is the cinema. Do you see a banner in front of a store? Do not even bother reading the sign. I can swear that it says "Cinema Serena. Coming soon." [...] Cinema reigns supreme, and prevails over everything!"[7]

[6] For an extensive treatment of this subject, see Giuliana Bruno, *Streetwalking on a Ruined Map: Cultural Theory and the City Films of Elvira Notari* (Princeton, NJ: Princeton University Press, 1993).

[7] Gibus, "Cinematografeide," *il Giorno*, March 30, 1906. Reprinted in Aldo Bernardini, *Cinema muto italiano*, vol. 2 (Bari: Laterza, 1981) 20-1. Gibus was Matilde Serao's pseudonym.

The city's arcade, Galleria Umberto I, served as the main site of cine-matographic activities. The implantation of cinema in the arcade was a product of Naples' metropolitan fabric. The arcade was the allegorical emblem of modernity, and, like the cinema, expressed a new urban cul-ture.

This center of commercial, artistic, and social transactions had trans-posed the spectacle of street life into modern terms. A place of *flànerie*, it had renewed the function of the *piazza* (forum), the traditional Italian site of *passeggiata* (promenade), social events, and transitory activities. It was precisely this new urban geography that functioned as catalyst for filmic ventures, together with the area surrounding the railway station. All were sites of transit, indicators of a new notion of space and mobility, signs of an industrial era that generated the "motion picture."

As the home of over twenty film magazines and of a lively film pro-duction, Naples was in the vangard of the silent film art's development. This "plebeian metropolis" — as Pier Paolo Pasolini called it[8] — established its own style of film-making. Predating the stylistic features of Neo-realism, it pioneered realistic representation opposed to the aesthetic of "super spectacles," then dominant in Italy. Neapolitan cinema, rooted in local cultural tradition, was of the street. Often shot on location, it cap-tured the daily popular culture and the motion of street life.

The three most prominent film companies were Dora Film, Lombardo Film and Partenope Film. All were family enterprises. Partenope Film was run by Roberto Troncone, an ex-lawyer, and his brothers Vincenzo and Guglielmo, an actor. Lombardo Film was a husband-wife collabora-tion between Gustavo Lombardo and Leda Gys, the star of all their films. Lombardo, an adventurous member of the middle class who had been involved in Socialist politics, later founded Titanus, one of Italy's most important production houses.

Dora Film was run by a woman, Elvira Notari (1875-1946), and was the most popular of the Neapolitan production "houses." The name and works of Italy's first and most prolific woman filmmaker, excised from historical memory, are today unknown. As head of her own production company (named Dora Film after her daughter), Notari made sixty fea-ture films and over one hundred documentaries and shorts between 1906 and 1930. She wrote, directed and participated in all aspects of pre- and

[8] Pier Paolo Pasolini, *Lettere luterane* (Turin: Einaudi, 1976). See, in particular, page 17.

postproduction and also trained the actors. Her son Edoardo, acting since childhood, grew up on his mother's screen, and her husband, Nicola, was the cameraman. Notari's extensive production, suppressed by Fascist censorship, ended with the advent of sound.

Elvira Notari's city films were particularly sensitive to women's conditions. Shot location in the *vicoli* of Naples, her (public) women's melodramas derived from the body of urban popular culture. These films, inscriptions of urban transit and panoramic vision, used documentary sequences of street culture and city views. Their narratives reproduced metropolitan topography, the motion of the *piazza* and the geography of the cityscape. Notari's melodrama of the street represented the "belly" of a metropolis, her *meter-polis* — her mother-city, as the word's Greek root suggests.

Notari's films were shown in Naples primarily at a theater in the arcade and endorsed by a passion for the urban travelogue. The Neapolitan film magazine, *L'arte muta* [The Silent Art], remarked in 1916 that film audiences expressed a demand for sightseeing, and expected cinema to satisfy their panoramic desire:

> A moving drama where passion blossoms, red as the color of blood, is produced by *Dora Film*, the young Neapolitan production house, whose serious artistic intentions are well-known. The film was screened at Cinema Vittoria, the movie house of the Galleria Umberto I. The expectations of the public attending this theater have been completely fulfilled: the suggestive drama develops against the enchanting panorama of the city of Naples.[9]

It was, then, the urban matrix of a (plebeian) metropolis that encouraged the circulation and reception of Neapolitan cinema. Naples had traditionally offered the spectacle of movement. Its intermingling of architectural styles created "a baroque opening of a heightened public sphere;" its fusion of dwelling and motion within "a theater of the new," provided a fertile ground for the development of cinema. As film was implanted in the cityscape, the cityscape was implanted within film. Thus transformed into a moving image, the city began to travel.

[9] *L'arte muta*, Naples, vol. 1, no. 1, June 15, 1916.

NAVIGATION FROM NAPLES TO NEW YORK

Elvira Notari's city films were circulated throughout Italy and beyond its borders. They were involved in an interesting process of cultural "migration": the plebeian immigration from Southern Italy at the beginning of the century included "moving pictures." A good portion of Notari's production of the 1920s reached the United States. Like other immigrants, the "immigrant" films by Elvira Notari also traveled by sea, often accompanied by the singers who were to perform the live soundtrack of her musical cinema.

Dora Film found an outpost in New York, a city with a strong Italian immigrant presence, many of whom came from the Neapolitan region.[10] Dora Film of Naples fulfilled the "American dream," becoming Dora Film of America and opening an office in New York City on 7th Avenue. The office functioned as the threshold of distribution. Notari's films circulated most widely among the Italian American community in New York and reached other North American cities such as Pittsburg and Baltimore, as well as South American countries such as Brazil and Argentina.

During the 1920s Notari's films were screened publicly and regularly in movie theaters in New York's Little Italy and in Brooklyn. Her films were widely advertised in the Italian American daily newspaper, and pompously announced as "colossal Italian cinematography," "directly obtained from Naples and exclusively distributed."[11] Ads were usually quite prominently displayed on the page, and larger than those for performances of *Aida* and *La Traviata* at the opera. Films, operas, and cultural events were mixed together with ads for leisure-time pursuits, vacationing and travel.

Notari's films were generally shown in New York soon after the Neapolitan release, and often before the Roman release. As New York was home to many Neapolitan immigrants, the speed of film "transferral" added a dimension of simultaneous communication to the historical and imaginary connection between the two cities.

When economic and censorial pressures increased in Italy, due to Fascist opposition to the Neapolitan "street cinema," revenues from the immigrant market facilitated the reproduction of these films. The immigrant

[10] See Thomas Kessner, *The Golden Door: Italian and Jewish Immigrant Mobility in New York City, 1880-1919* (New York: Oxford University Press, 1977); and Louise Odencratz, *Italian Women in Industry* (New York: Russell; Sage Foundation, 1919).

[11] See, for example, *Il Progresso Italo-Americano*, July 9, 1921 and Sept. 1, 1924.

connection ultimately guaranteed Notari's economic survival through the difficult 1920s, as well as the bypassing of censorship in the first decade of the Fascist regime.

The films arrived in the States with publicity material in Italian and English, including a printed program with stills, illustrations and a summary of the story. The immigrant films were often described in the poor English of a foreigner. The style of the illustrations recalls the jackets of popular novels, such as those by Carolina Invernizio, a female novelist whose work Notari adapted on to film.[12]

Like the readers of serial popular novels, the viewers of Elvira Notari's films were plunged into the realm of fantasy. The films often spoke of hardship in the popular milieu, and presented fantasmatic strategies of countertactics, as characters negotiated positions of survival in the socio-sexual order at the level of private and public life. They spoke of an experiential condition that their popular immigrant audiences probably knew quite well.

Female spectators were largely present among immigrant audiences.[13] For women, film was a type of leisure approved by society and family. Having replaced previous sites of social interaction, the movie theater had become a place of public acceptance. Film, like the novel, gave women the illusion of social participation, while offering the immigrants a sense of fulfillment of personal fantasies.[14] As a form of collective spectacle, film constituted a crucial means of social re-definition for the immigrants. It offered a terrain for negotiating the experience of displacement. As film scholar Miriam Hansen puts it:

> The cinema provided for women, as did for immigrants and recently urbanized working class of all sexes and ages, a space apart and a space in between. It was the site for the imaginative negotiation of the gaps

[12] Invernizio's novels were distributed in the States by New York-based Italian American Press, located at 304 East 14th Street in Manhattan.

[13] See Roy Rosenzweig, *Eight Hours for What We Will: Workers and Leisure in an Industrial City, 1870-1920* (London and NY: Cambridge University Press, 1983), in particular, pp. 190-215; Elizabeth Ewen, "City Lights: Immigrant Women and the rise of the Movies," *Signs: Journal of Women in Culture Society* 5.3 (supplement; 1980): 45-46: idem, *Immigrant Women in the Land of the Dollars* (New York: Monthly Review Press, 1985); Kathy Peiss, *Cheap Amusements: Working Women and Leisure in Turn-of-the-Century New York* (Philadelphia: Temple University Press, 1986); and Charles Musser, *Before the Nickelodeon* (Berkeley: University of California Press, 1991).

[14] This argument is developed by Judith Mayne, See her *Private Novels, Public Films* (Athens: The University of Georgia Press, 1988), in particular the chapter "The Two Spheres of Early Cinema."

between family, school, and workplace, between traditional standards of behavior and modern dreams.[15]

The success of Elvira Notari's narrative films among immigrant audiences can be explained in terms of a cultural negotiation between the changing domains of private lives that had been shaken by the separation from their native lands and milieus. Especially those who came from Southern Italian societies, where the *piazza* provided a communal private existence, experienced the shock of a fundamental separation between the private and public spheres in America. Cinema could provide them with an imaginary bond, constructed not only in the actual space of the theater, a site of sociability, but also, and especially, in the mental geography of reception.

Delving into an "ethics of passions," Notari's specialty was the public domain of private passions. At the level of imaging, experience, emotions, sentiments, sexuality—all elements of the private sphere—were heightened. Yet the emotional sphere was "publicly" displayed in the city's space: as part of the theatricality of Neapolitan popular culture, the private dimension would constantly become a social event, as the personal was staged in, and for, a public audience. These films thus triggered intense personal/social identification in the social milieu of the movie theater, offering a fictional reconciliation of the split between private and public.

Unlike the immigrants themselves, Notari's films did not travel on a one-way ticket. They completed a cultural and productive round-trip journey: at one end, the American success helped Dora Film to produce films in Italy during difficult times; at the other end, achieving the effect of a cultural travelogue, her films enabled the immigrants to return home. Elvira Notari's films in New York acted as a vehicle to the transformation of memory. In an age of mechanical reproduction, the status of memory changes and assumes spatial texture. Both personal and collective memories lose the taste of the Proustian *madeleine,* and acquire the sight/site of photographs and films. For immigrants, Notari's films substituted motion pictures for memory.

[15] Miriam Hansen, *Babel and Babylon: Spectatorship in American Silent Film* (Cambridge, MA: Harvard University Press, 1991) 118.

THE IMAGINARY JOURNEY FROM NEW YORK TO NAPLES: IMMIGRANT CINEMA

The filmic channel of communication Naples-New York led to an interesting development. Notari's viewers transformed themselves into producers. In the mid-1920s, groups of Italian American immigrants commissioned Dora Film to travel around Italy and make specifically customized short documentary films for them. These shorts were to portray the immigrants' place of origin, the *piazza*, homes, and the relatives they had left behind. According to film historian Vittorio Martinelli, Dora film produced about 700 of these peculiar travelogues and one feature between 1925 and 1930.[16]

Trionfo cristiano (Christian Triumph, 1930) was the feature commissioned by immigrants from Altavilla Irpina. The sponsors asked for a filmic account of the local saint (Pellegrino), who, like Saint Anthony, triumphed over (sexual) temptation. Apparently, a great many naked women performed as temptresses. Unfortunately, both the feature and the shorts appear to be lost or destroyed. If recovered, the immigrants' films would constitute a precious historical archive of a *transito*, of an Italy observed, (re)constructed abroad — both retained and lost. A cinematic suturing of gaps and differences, these films would be documents, agents, and sources of a *History*. Both a collective History and a personal story, they sustained and supported southern popular cultures displaced from Italy. The immigrant films constituted not only a representation of but also a representation by these subjugated cultures.

Why would Italian immigrants financially sponsor the shorts? The very nature of Elvira Notari's feature films — a fiction that made the "body" of the urban text present, as it documented sites and local physiognomics, both recognized and missed by the immigrant viewers — most probably triggered the spectatorial demand for panoramic "home" (made) films. This use of cinema foreshadows the role that moving images have played in the development of video technologies. The shorts functioned as memory snapshots in motion, to have, keep and replay ad infinitum. Before Super-8 and video, they linked cinema's public sphere with the private sphere. Interestingly, and in a way that diverges from the contemporary privatization enacted by the video apparatus, these films were

[16] Vittorio Martinelli, "Sotto il sole di Napoli" in *Cinema & Film*, vol. 1, Gian Piero Brunetta and Davide Turconi, Eds. (Rome: Armando Curcio Editore, 1987) 368; *La Repubblica*, January 29, 1981: 16.

not conceived as private events. They function as a personal archive of memories for a community.

The immigrant films were based on a fundamental paradox, in so far as they were travelogues *in absentia,* touristic traces of an impossible voyage. A film itself became a journey, a vehicle of a denied experience — a voyage, so to speak, back to the future, or in the future past. Not a mere substitute for, or a simple duplication of, an event, home movies for people who could no longer go home, whose notion of home was indeed made problematic by emigration, the immigrant films served a socio-historical function by the very fact of their being constituted as private films. The cinematic here and now abridged the immigrants' spatio-temporal distances: it enabled the immigrants to be there, where they no longer were, while remaining here, where they were not yet implanted. The imagery functioned as a shared collective memory while they were in the process of acquiring a new projected identity.

Documents of a cultural history and vehicle for its transcoding into another culture, Notari's films facilitated the process of migration of cultural codes. Participating in the evolution of the immigrants' intersubjectivity, they stimulated a cultural remapping. While her films continued to reach Italian American audiences, Elvira Notari herself never set foot in New York. As her son stated, she, "despite all invitations, preferred to stay in Naples and send her fans beautiful animated postcards."[17] America left and returned to her an image: it was a voyage of the imagination. A sequence from a hand-painted film shows a return of the "American Dream" in Notari's iconographic universe: a woman is playing a huge drum that bears the inscription "Jazz Jazz Hop Hop Whopee!"

CROSS-CUTTING BETWEEN NAPLES AND NEW YORK: A VOYAGE OF RETURN

Notari's venture had several effects of return. While her production ceased, the immigrant connection continued into the era of sound. Films about Naples and New York began to be produced in New York for the immigrant market. An example of this immigrant cinema is *Santa Lucia Luntana* (Harold Godsoe, 1931), also called *Memories of Naples* and in Italian *Ricordi di Napoli.*[18] The multiple titles speak of the hybrid status of

[17] Interview with Edoardo Notari, cited in Stefano Masi and Mario Franco, *Il mare, la luna, i coltelli* (Naples: Pironti, 1988) 160.

[18] A Cinema Production, Inc. (president S. Luisi); director: Harold Godsoe; cinematographer: Frank

this film, which has recently been recovered. The stories of Naples and New York, and their languages, intersect in this narrative of immigration.

The film begins in Naples. At the sound of Neapolitan folk music, the spectators are taken for a walk through town. The promenade includes street markets, the Galleria Umberto I and the *piazza* at the entrance of the arcade. Panoramic views of the city and its surroundings abound. City views in the style of *vedute* glorify Naples' renowned vistas. Editing and camera movement reproduce the motion of the city. The mobile gaze of the cinema establishes our presence in the flow of the city. We are comfortably touring the streets and looking at the cityscape. Then, suddenly, there is a jump cut.

In a fraction of time, the jump cut takes us away from Naples, and transports us to New York. In one shot we are in Naples, in the next shot we are in New York. No journey is shown. There is no space or time in between. The motion picture idiom provides the missing link. The experience of emigration is consumed in film editing. It is the void between two shots—an absence, a lack, an off-screen space.

The jump cut erases the pain of the separation, the hardship of the long journey by sea, and the difficulty of the journey into another culture. Suddenly we are in New York, and it does not look so different. A similar film-making style provides the continuity and contiguity that do not exist in reality. We are simply extending our metropolitan journey. As if continuing our promenade through Naples, we end up in New York.

With the moving image leading the voyage, we take another city tour. It begins with the New York skyline, as seen from the water, and proceeds with other metropolitan views. The motion of the city is the protagonist of the excursion. Sites of transit are emphasized as we survey the harbor and visit the railway station. All the way from vistas of Naples to New York's skyline, the cinematic gaze is a tourist's perspective.

From the aerial views of New York, we go down to street level, descending into the city, and enter a neighborhood. A street sign informs us of our whereabouts: East 115th Street. We are in the Italian neighborhood of East Harlem. Visuals and sound provide continuity with Naples. The street looks like an open market and functions like a *piazza*. The documentary style pictures the street market: as we hear the live sounds of the vendors, the camera lingers on the display of food. Everything speaks of

Zucker; studio: Fort Lee, New Jersey; producer: Angelo De Vito; music: Giuseppe De Luca.

Naples displaced.

In a modest apartment of this area, we are introduced to the protagonists of the story. They are a family of Italian immigrants, composed of an old and disillusioned father, two daughters and one son. Although the mother is dead, she has not left the scene. Her picture, framed on the wall, speaks of her enduring presence. She is the resident Madonna.

The story of *Memories of Naples* is remarkably similar to some of Notari's melodramas. The family dynamics are exactly the same. The film features a generational struggle between an old single parent and a daughter who transgresses socio-sexual behavior. The honest parent, a person of modest means, is also distressed by the actions of an unruly son, who even steals from the family. One of the children provides the consolation of proper conduct. As in Notari's films, the generational struggle speaks of the conflict between an older societal behavior and the demands of the new industrialized world. At issue is the place of woman in modernity, and her public role outside the confines of the home.

In *Memories of Naples,* this conflict is complicated by emigration. America, the New World, is the ultimate representation of modernity. Inhabiting this new "territory" has shown the daughters the way out of a restrictive female role. In the film's view, entering this dimension is quite perilous: by going to work, a good daughter encounters sexual harassment. *Memories of Naples* presents a much more traditional view than Notari's cinema, and is ultimately opposed to modern habits. In its opposition, it collapses different sets of concepts. By treating America, the new land (of immigration), as the New World, it also makes Italy, the old country, into a representative of the Old World order. This creates a false idea of Italy, and blurs other distinctions. The generational conflict turns into a clash of cultures, countries and languages. In the film, coming to America has ultimately corrupted the children, who are now, in all senses, estranged from the "universe" of their parents. The father utters bitter words against the new country, that has deprived him of his "youth, dignity" and even "the desire to eat." "America," he concludes, "is the land of gold and happiness, but for whom?"

Memories of Naples is by no means a singular case, and its typology was not a unique phenomenon. Interestingly, the world view of Italian-American film is found operating in other types of immigrant cinema. The forgotten world of Yiddish cinema, uncovered by J. Hoberman, presents several cases of family melodrama, with plot developers that re-

semble *Memory of Naples*.[19] These films made for the Jewish community also expressed conservative ideas on the family and New World, especially in the 1930s. A shared master narrative seems to link the Yiddish film to the cinema produced for the Italian immigrants. Furthermore, these two immigrant cinemas shared the same production facilities.

Sound had barely made its appearance when the film *Memories of Naples* was released in 1931. This film is quite remarkable for its use of language and of sounds in general. Specific street cries were recorded as emblems of the particular sounds of New York streets. The conflict between the Old and the New Worlds is interestingly conveyed by a triadic linguistic structure. In the semiotic universe of emigration, language is a barrier and a hybrid. The film makes simultaneous use of Neapolitan dialect, Italian and English, with varying degrees of mastery of letter as a second language. The intertitles are in Italian with simultaneous English translation, while the spoken language is, for the most part, Neapolitan dialect and English of poor immigrants. Most characters would go back and forth between the two, but there is a person who speaks no English at all. Untouched by the new language, the young man is viewed as uncorrupted. This uncontaminated character will turn out to be the family's savior. He will marry the good-natured daughter, and take her and her old father back to Naples.

Marriage provides the resolution of the story. Even the liberated "bad" daughter will end up marrying. No longer a bothersome worry, after the marriage she is literally dropped out of the film at an unknown New York address. As the rest of the family leaves for Naples, the dishonest son is left behind in the East Harlem apartment. This picture of mother/Madonna also remains, eyeing her son.

Five years elapse. An editing tie covers the distance, and reaches the characters who have returned to Naples. The old father, the couple, and their child are settled in a splendid Neapolitan villa, bought by the repented son, who eventually returned from New York to fulfill the family happiness. The film has now gone full circle.

At the end of *Memories of Naples*, having returned to Naples, we have returned to the beginning of the story—a teasing Neapolitan panorama. An immigrant film has satisfied the immigrants' desire and actualized an impossible voyage of return. This film pretends that emigration is like

[19] J. Hoberman, *Bridge of Light: Yiddish Film Between Two Worlds* (New York: Pantheon Books, 1991).

voyage: it too has a return destination. In every voyage, the final destination must coincide with the point of departure — home. That which is unattainable in emigration is realized in film. By way of cinema, emigration is transformed into a voyage (home). And, by way of cinema, the journey is completed. It is modernity's travel: the emigration of film images.[20]

[20] A version of this essay was published in *Napoletana: Images of a City*, Adriano Aprà, Ed. (Milan: Fabbri Editori, 1993), the catalogue of the film retrospective held at the Museum of Modern Art, New York, 12 November 1993 to 27 January 1994.

White Passion: Italian New Yorker Cinema and the Temptations of Pain

Giorgio Bertellini
UNIVERSITY OF MICHIGAN

> *To Robert Sklar, to whom I owe so much.*

> "What are you trying to prove?"
> Joey to his brother Jake La Motta,
> who wants to punch him.
>
> *Raging Bull* (1980)

In terms of reoccurrence of setting, narration, dialogues, and accents, the correlation between American cinema and the representation of Italians in America almost always passes through New York (Chicago is a distant second). It is a necessary set determined by the convergence of the history of the great emigration, socio-anthropological reflections on race, and the history of cinema on the other side of the Atlantic. Any overall consideration of Italian Americans in American cinema must, therefore, be based on urban toponomastics, whether true or metaphorical.[1] At the same time, given the basic racial connotations of American cinematographic culture, both before and after the move to Hollywood, New York also serves as a kind of ethological laboratory, for it is there that experiments in multiracial cohabitation, whether true or pretend, are found. The significant "scientific" questions posed by this early twentieth-century entwinement of film and race are: Who can become truly American? What happens to those who cannot because of their race? Recent historiographic debates on whiteness (America's fundamental, binary, racial dividing line), according to which Italians were either fully and legally

[1] For the toponomastics of Italian American cinema, see my essay "New York City and the Representation of Italian Americans in US Cinema" in *The Italians of New York: Five Centuries of Struggle and Achievement*, Philip V. Cannistraro ed. (New York Historical Society and the John D. Calandra Italian American Institute, New York, 1999) 115-28.

included (Tom Guglielmo) or only in an alternate and probationary manner (Matthew Frye Jacobson), are important, but only as a conceptual starting point, and not a conclusion.[2] Having accepted the range of solidarity and privileges that Italians could enjoy as whites, one still must clarify the delineations of a racial difference that is not the one of Anglo Americans or the one experienced by Latinos, Indians, Asians, Blacks, etc. It therefore becomes useful to concentrate on this racial "discarding," often voiced in terms of a not completely irredeemable anthropological and cultural inadequacy, and based on the idea of a criminality to which, according to American Nativists, many Italian immigrants seemed to adhere in an instinctual and ancestral way.[3] Before discussing ethnic groups, one must therefore deal with the notion of race and the fact that its semantic plurality is absent from the binary dynamics of whiteness. In addition, the concept of race has an older history than cinema, which is tied to eighteenth-century European thought and was not as obsessed with considerations of color.[4]

In this essay I wish to concentrate on an often neglected racial element that is a constant narrative and visual source for Italian American cinema.[5] Italians are often associated with forms of violence *against* others — Italian

[2] Tom Guglielmo, *White on Arrival: Italians, Race, Color, and Power in Chicago, 1890-1945* (New York: Oxford University Press, 2003) and Matthew Frye Jacobson, *Whiteness of a Different Color: European Immigrants and the Alchemy of Race* (Cambridge, MA.: Harvard University Press, 1998. For other opinions see Robert Orsi, "The Religious Boundaries of an Inbetween People: Street Feste and the Problem of the Dark-Skinned Other in Italian Harlem, 1920-1990," *American Quarterly* 44.3 (September 1992): 313-47 and James R. Barrett and David Roediger, "Inbetween Peoples: Race, Nationality and the "New Immigrant" Working Class," *Journal of American Ethnic History* 16.3 (1997): 3-44. For a recent general overview see David Roediger, *Working Toward Whiteness: How America's Immigrants Became White* (New York: Basic Books, 2005).

[3] For the Nativist, anti-immigration movement, see the classic study by John Higham, *Strangers in the Land: Patterns of American Nativism, 1860-1925* (New Brunswick: Rutgers University Press, 1955).

In the first part of this essay I do not refer to the notion of "ethnicity," preferring instead the concept of "race" because in modern vocabulary ethnicity indicates cultural (language and customs) and biological difference. At the beginning of the twentieth century national differences among the Irish, Jews, and Italians were instead laden with connotations based on differences of an anatomical-physiological nature, as seen for example in the frequent use of the term "blood." The break between biological and cultural considerations, for the most part, occurred in the 1960s at the time of the struggle for civil rights.

[4] See the ground laying work of George M. Fredrickson, *Racism: A Short History* (Princeton: Princeton University Press, 2002).

[5] In this essay I use the term "Italian American" when referring to cinematographic productions about Italians in America that are written and directed by filmmakers both of Italian American descent and not. I am convinced, in fact, that the work of Italian Americans owes a great debt to that of silent and early sound movies, which generally were produced, directed and interpreted by non Italians.

and not—as a result of an affiliation with the Mafia, temperament, or urban survival. Here, instead, I will concentrate on the violence *suffered* (or self inflicted) and on *the manifestation of pain* exhibited since the very beginning by Italian American film characters, and which remains a narrative and visual constant in their cinema. More than any other race or immigrant community, the Italian characters of urban America have been made the subject matter of suffering. They are the victims of a culture that demands their spectacular immolation in the name of the Law, the American Dream, and the dictates of morality and proper behavior.

Let us start at the beginning. From 1900 to 1914, more than three million Italians arrived in the United States passing through the "golden doors" of Ellis Island. Eighty percent of them stayed in New York, where two thirds of its population had ties to emigration, being first- or second-generation Americans. During this same period, movie production began in New York and in nearby Fort Lee, New Jersey. New York was also the main laboratory for experimentation in multiracial entertainment (from vaudeville to nickelodeon). When the mania for very low priced movies exploded (1905-6), the masses of immigrants were the perfect audience. Shortly thereafter, however, the movie industry aspired higher than the plebeian spectacles of vaudeville and burlesque. From its lofty perch, cinema became both moralistic and ethnographic. In mirroring the crime pages of the newspapers and the photography of Jacob Riis and Lewis Hine, American cinema explored the ghettoes of New York, where its more respectable audiences did not dare to venture, and told (and often invented) stories of injustice and perdition, but also of unexpected virtue among the exotic customs, passions and crimes of the Old World. This ethnographic and ethological climate gave birth to Italian American cinema.

The first examples of films centered on Italians focus on the concept of criminality and difference in morality and customs (amorous passion, artistic talent, and explosive and picturesque temperaments). The completely Italian story of the kidnapping of a little girl by the Mafia, *The Black Hand* (Wallace McCutcheon, 1906), is perhaps the ancestor of the gangster genre. But it would be erroneous to understand it solely as a model of active violence, namely, inflicted on third parties. If we look at little Maria and her pitifully anxious parents, the paradigm is also that of publicly suffered and exhibited pain. If we then look at films such as *The Violin Maker of Cremona* (D.W. Griffith, 1909), *In Little Italy* (D.W. Griffith,

1909), and *Italian Blood* (D.W. Griffith, 1911), the dominant theme is the suffering of the Italian characters in terms of love, sorrow, maternal abandonment, and jealousy. Nowhere does the narrative dénouement appear to interrupt the manifestations of unstable, extremely vulnerable, and often anguished emotions that, in the modern American context obsessed with the pursuit of happiness, indicate primitive customs and anthropological residue.

When the negro-phobic blockbuster *The Birth of a Nation* (D.W. Griffith, 1915) opened, a moment that also coincided with the film industry's move from New York to Hollywood and feature-length films, Italian American cinema underwent an important transition. Its characters acquire dramaturgical and racial elasticity: they no longer are solely preconfigured Mafioso, impulsive or simply picturesque characters. In concert with a less deterministically scientific climate, but more closely tied to social environmental influences, the cinematographic characters interpreted by George Beban (the actor-director known as the imper-sonator par excellence of Italians) exhibit a first ever "pathetic" humanity. *Pathos*, coincidentally, is one of the preferred terms of contemporary reviews of his films. Victims of avoidable tragedies and never rectified judicial errors, as in *The Italian* (Thomas Harper, 1915) and *The Sign of the Rose* (Harry Garson, 1922), these characters exhibit totally unprecedented forms of receptive and emotive intimacy. Rodolfo Valentino's sheik and tango dancer of only six years later will evoke sensuality and desire without too many accusations of miscegenation, thanks to the doors opened by tear jerker sufferings of the asexual Beban.[6]

Meanwhile, the increase in female movie audiences coincided, as if in a virtuous circle, with a greater presence in Hollywood of very talented scriptwriters with strong contracts (Sonya Levien, Anita Loos, Frances Marion, Jeannie Macpherson, and June Mathis). Many of their films fea-tured women who were often socially marginalized or protagonists of passionate or forbidden love affairs. These heroines were either immigrants or the daughters of immigrants (halfway between a picturesque Europe and a redeeming America), or were Italians residing in their homeland, such as Mary Pickford in *The Love Light* (Frances Marion, 1921). When these women emigrate, New York's topography structures their search for freedom and love within the framework of assimilation, resistance,

[6] I discuss this point in "Black Hands and White Hearts. Italian Immigrants as Urban Racial Types in Early 20th Century American Cinema," *Urban History* 31.3 (2004): 374-98.

and new femininity.[7] Between the end of the first and the beginning of the second decade of the twentieth century, the theme of individual suffering in these tenement dramas was delineated within the context of an intense re-examination of these types of relationships, and thus implied much more than a pure and simple rising to power of the New Woman. Interlaced with all this was also the formation of the New Man, who was defined, enriched and certainly not weakened by a completely new capacity to suffer and not hide his pain. This transformation set in motion new romantic equilibria and was made possible thanks to the co-optation of new and possibly dissonant and controversial models of masculinity that were often linked with non-native racial identities.[8] Valentino was the foremost example of this process. He was the protagonist of stories set in a very wide range of exotic locations, from Argentina to the deserts of the Middle East to imperial Russia. The stories all shared an extremely sensual (almost masochistic) vulnerability composed of wounds, corporal punishments, sentimental sacrifices, and emotional fragility—all ingredients that, in the end, made Valentino attractive to his female co-leads and the public.[9] His sudden death in August 1926 resulted in an idealization of his "passionate" attributes (i.e., pathos), even if racist reviews persisted, and was often combined with contradictory accusations of animalistic instinctiveness, homosexuality, or even impotence, and submission to his second wife, the headstrong and very ambitious Natasha Rambova.

After the death of the star figure of Valentino (which will rise again a half century later with another fragile and very sensitive dancer, John Travolta), the Italian American of cinema remained an urban, city ghetto

[7] For example, *A Woman's Honor* (1917) tells the story of an Italian girl who, after being raped in Naples, finds love and justice in New York in the arms of an Italian lawyer. Similarly, *The Ordeal of Rosetta* (1918) is the story of parents who have disappeared, and of revenge and apparent suicides, set in Sicily and Manhattan, while *Who Will Marry Me?* (1919) mixes social class differences with forced marriages, set in the open air markets of Little Italy. With regard to the latter, see the essay by Giuliana Muscio, "Girls, Ladies, Stars: Stars and Women Screenwriters in Twenties America," *Cinegrafie* 13 (2000): 177-220.

[8] Valentino's most famous movies are: *The Four Horsemen of the Apocalypse* (Rex Ingram, 1921), *Blood and Sand* (Fred Niblo, 1922), *The Sheik* (George Melford, 1923), *Monsieur Beaucaire* (Sidney Olcott, 1924), *Cobra* (Joseph Henabery, 1925), and *The Son of the Sheik* (George Fitzmaurice, 1926). I have written about Valentino's vulnerable masculinity, as opposed, for example, to Mussolini's Roosevelt-type maleness, in "Duce/Divo: Displaced Rhetorics of Masculinity, Racial Identity and Politics Among Italian Americans in 1920's New York City," *Journal of Urban History* 13.5 (2005): 685-726.

[9] As eloquently demonstrated by Miriam Hansen in *Babel and Babylon: Spectatorship in American Silent Film* (Cambridge, MA.: Harvard University Press, 1991) which, however, does not include a discussion in terms of race.

character. This happened while real Italians were beginning to move, always as a homogenous group, towards the suburbs, Brooklyn, Queens and the Bronx. But the movies did not take much notice. During the Prohibition and the Great Depression, there were familiar stories to tell, familiar typologies to consolidate.

During the 1930s, we see the crystallization of the urban gangster with his animal instincts, rough or foreign accent, and inevitable downfall. His ambition for success is very American, a sign of the dirty conscience of the American Dream, as explained by Robert Warshow almost sixty years ago.[10] The gangster's social deviance, frequently expressed in racial terms because it is viewed as instinctive and irrepressible, must, however, be punished: defeat, often bloody and imbued with lacerating family drama, is inevitable. But ideologically, everyone understands what it means to want to make it. "The World is Yours" says the neon sign that Tony Camonte in *Scarface, Shame of a Nation* (Howard Hawks, 1932) stares at from the window of his room. And we join in the staring, despite his social and sexual perversions.

What we notice in these movies, from *Little Caesar* (Mervyn LeRoy, 1931), *The Bowery* (Raoul Walsh, 1933), *Fury* (Fritz Lang, 1936), *Underworld* (Oscar Micheaux, 1937), *Angels with Dirty Faces* (Michael Curtiz, 1938) to *Each Dawn I Die* (William Keighley, 1939), is not only the show of brute force, but also the protagonist's final punishment by violent death or humiliating imprisonment. They are events that humanize gangsters by depicting them as the black sheep of American society and the sacrificial lambs of post-1929 capitalism, viewed with cynicism and disappointment, and which for decades will continue to choose Italian Americans for ritualistic immolation, both in movies and on television. In the sentimental dramas of Frank Capra and Gregory LaCava, we see the painful humanization of the protagonist who is symptomatically caught up in stories of misadaptation and social displacement. Written and interpreted under a badge of racial invisibility, meaning without Italian American casting or characterizations, this cinema will expand to encompass everyman protagonists from the American heartland such as those played by James Stewart.[11]

[10] Robert Warshow, "The Gangster as Tragic Hero," in *The Immediate Experience* (Garden City, NY: Doubleday, 1962) 130. The essay was originally published in 1948 in the *Partisan Review*.

[11] For the conflict between personal success and social conformity, see *The Age of Consent* (Gregory La Cava, 1932) or *Mr. Deeds Goes to Town* (Frank Capra, 1936).

During the "noir" period, the Italian American diegetic propensity for suffering assumes the forms of profound moral confusion and unredeemable existential aloneness that result in a deep and receptive liking, even when they border on masochism.[12]

It happens with both cops and criminals, as in *Cry of the City* (Robert Siodmak, 1948) and *Kiss of Death* (Henry Hathaway, 1949), which support the feeling that a terrible wrong has been committed against very vulnerable Italian Americans, and in *Knock on Any Door* (Nicholas Ray, 1949) and *From Here to Eternity* (Fred Zinneman, 1953).

In other cases, the aloneness emerges due to the asphyxiating familism of Italian domesticity, as in the masterpieces *House of Strangers* (Joseph Mankiewicz, 1949), with the loud Edward G. Robinson and Richard Conte, and *Marty* (Delbert Mann, 1955), with Ernest Borgnine in the role of the desperate, unmarried butcher who, only at the very last moment, rebels against family and social pressure. In both cases, salvation comes in the form of a woman who is not from the neighborhood, who is not Italian, but who is fascinated by the protagonist's great frailty, not by his strength. We see the same dynamic in the very beautiful *Love with the Proper Stranger* (Robert Mulligan, 1963), where the loneliness of Steve McQueen and Natalie Wood is totally Italianized, and caused by their oppressive families and a pregnancy. It is not a coincidence that during this same period the most potent Italian American female figure is that of Anna Magnani in *The Rose Tattoo* (Daniel Mann, 1955), where she is the perfect exemplar, in her face and bearing, of a protagonist consecrated to physical suffering and spiritual anguish.

The 1950s in Hollywood are the years of the young and alienated anti-heroes (besides Steve McQueen, Marlon Brando, Montgomery Clift, and James Dean), of the more than familiar model of defenseless masculinity. Italian American film characters portray isolation, exclusion, and, above all, defeat both in life and, increasingly, in the boxing ring.

[12] On this point see Jonathan Munby, *Public Enemies, Public Heroes: Screening the Gangster from "Little Caesar" to "Touch of Evil"* (Chicago: University of Chicago Press, 1999). In the 1940s and 1950s the emotional, moral, and psychological dissonance of Italian American gangsters in trouble also extends to the figure of those who investigate them. Symptomatically, the stories' set is always the city — as the movie titles explicitly indicate: *The Naked City* (Jules Dassin, 1948), *The Street With No Name* (William Keighley, 1948), *City Across the River* (Maxwell Shane, 1949), *Dark City* (William Dieterle, 1950), *Where the Sidewalk Ends* (Otto Preminger, 1950), *The Asphalt Jungle* (John Huston, 1950), *The Naked Street* (Maxwell Shane, 1953), *The Big Heat* (Fritz Lang, 1953), *While the City Sleeps* (Fritz Lang, 1956), *The Harder They Fall* (Mark Robson, 1956) and *The Garment Jungle* (Vincent Sherman, 1957), set in New York's garment manufacturing district.

The relationship between the worlds of boxing, criminality, and sacrificial gladiating is a constant throughout all post World War II Italian American cinema, beginning with *Somebody Up There Likes Me* (Robert Wise, 1956) with Paul Newman in the role of the irrepressible Rocky Graziano, and ending with the plebian and masochistic Catholicism of *Rocky* (John G. Avildsen, 1976), and the lascivious immolation in black and white of Jake La Motta in *Raging Bull* (Martin Scorsese, 1980) — two boxers famous for their capacity to sustain punches.[13]

During the 1960s and 1970s, the criminal, psychological, and domestic vulnerabilities are joined by those of class conflict and the persistent humiliation of belonging to the urban proletariat. Meanwhile, there is the struggle for civil rights, a source of tension and pride, which the cultural climate of the time no longer defined as racial, but as ethnic, thus excluding the biological differences reserved for minorities of color. The 1970s are superficially the moment of ethnic redemption, at times via the Mafia with Coppola's godfathers and at others via the world of disco with *Saturday Night Fever* (John Badham, 1977), with Travolta, the new Valentino. The protagonists, however, still exhibit ancient wounds and an intensive desire for revenge strongly correlated with the toponomastics of the city. It is no coincidence that Vito Corleone is gravely wounded at the moment when he returns to the Little Italy of his youth. *Saturday Night Fever* is all based on the physical and topographic props of the bridges that Tony, an outsider from Bay Ridge, must learn to cross in order to project himself on the social and cultural Empyrean of Manhattan — he will make it, but in the process, his face and his pride will be scarred.

For Scorsese, Italian humanity is, and remains, a Purgatory of perennial waiting for redemption, as in the two very explicit cases of *Mean Streets* (1973) and *Raging Bull* (1980), which are very different chromatically, but not religiously. This was already apparent in the very early bloody hymn to self-flagellation of *The Big Shave* (1967). But the self-destructive theme is also repeated in *Gangs of New York* (2002) and *The Departed* (2006) — with the Irish community linked to the Italian one through a similar relationship with blood, suffering, and death. The parabolas of ascent and self-flagellation pervade the very polished but still "religious," because infernal, *Goodfellas* (1990) and *Casino* (1995).

Suffering, both self and other inflicted, becomes a fundamental dra-

[13] On this point, see the essay by Jacqueline Reich in this collection.

maturgical element in more recent Italian American cinema, from the amputated hand of Ronnie (Nicolas Cage) in the fairy tale *Moonstruck* (Norman Jewison, 1987), to the romantic sufferings of *True Love* (1989), and the religious martyrdom of *Household Saints* (1993) — these last two directed by Nancy Savoca.[14] It is not necessary that the director be Italian American: the pathos of Italian Americans has, by then, been stamped into the genetic code of the characters whether they are stereotypes or not, such as the Bedford-Stuyvesant, Brooklyn pizza men in *Do The Right Thing* (1989), and/or secretaries overcome by interracial attraction and thus rejected by their Bensonhurst family as in *Jungle Fever* (1991), both directed by Spike Lee. The Mafiosos suffer in *The Godfather, Part III* (Francis Ford Coppola, 1993), *The Funeral* (Abel Ferrara, 1996) and in *Donnie Brasco* (Mike Newell, 1997), as they are prisoners of a dramaturgy that requires revenge.[15] But the bricklayers in *Mac* (John Turturro, 1992) and the cooks in *Big Night* (Stanley Tucci, 1996) also suffer both internally and externally, and are linked by a tragic and very painful inability to accept compromises in their pursuit of success. Much of Abel Ferrara's cinema, with scripts by the religious Nicholas St. John, is morally conditioned by vices, penitence, and addiction.[16]

As at the time of *The Black Hand*, the greatest suffering originates from inside the Italian American community. It can, for example, be the result of the ostracism the protagonist faces when having a love affair with a partner of color, as in the case of *A Bronx Tale* (Robert De Niro, 1993), *Two Family House* (Raymond De Felitta, 2000), and *Nunzio's Second Cousin* (Tom de Cerchio, 1997).[17]

At the end of the 1990s, in harmony with the times, Italian American characters confess their vulnerability on the psychoanalyst's coach, beginning with the comedy *Analyze This* (Harold Ramis, 1999), followed imme-

[14] Other movies that focus on the theme of love affairs, including interracial ones, and aspiring to urban adaptation, both within and outside the Italian American community, are *Baby, It's You* (John Sayles, 1983), *China Girl* (Abel Ferrara, 1987), *Married to the Mob* (Jonathan Demme, 1988) and *Mafia Kid* (Paul Morrisey, 1988).

[15] In the 1990s, the decade that saw the decline of the American Mafia, thanks to the efforts of the FBI, the parabola of ascent and descent of the gangster genre covers a wide range of film. Among the best known titles are: *The Freshman* (Andrew Bergman, 1990), *The Lost Capone* (John Gray, 1990), *Dick Tracy* (Warren Beatty, 1990), *Mob Justice* (Peter Markle, 1991), *Bugsy* (Barry Levinson, 1991), *Hoffa* (Danny DeVito, 1992), *Federal Hill* (Michael Corrente, 1994), and several television productions such as *Gotti* (1996), *The Last Don* (1997), and *Bella Mafia* (1998).

[16] Giorgio Bertellini, "Abel Ferrara," in *Dizionario dei registi del cinema mondiale*, Gian Piero Brunetta, ed., Vol. 1 (Torino: Einaudi, 2005) 620-22.

[17] On this point, see the essay by George De Stefano in this collection.

diately by *Analyze That* (Harold Ramis, 2002), with a weepy De Niro. And then, of course, we have *The Sopranos* (1999-2007), set in nearby New Jersey. The title of the series itself indicates a vulnerability premised on castration anxiety. In the Prozac episode, the mob chief Tony Soprano regularly meets with the Scorsesian Italian American psychoanalyst, Lorraine Bracco, and undergoes panic attacks, confessions of domestic abuse (received), and uncontrollable transference. But the whole cast seems overwhelmed with continuous suffering, doubt, and depression. The professional and domestic traumas of all of the characters, and their often awkward attempts to alleviate them, are perhaps what determined the series almost decade long critical and viewer success.

In this essay, I have tried to give an overview of the entire history of American cinema through the lens of a physical violence and pathos that are profoundly marked by prejudice and racial self-celebration. The violence and pathos are narrative topoi and entwined visuals. They mark a range of actions and passions tied to a generosity that is, at times, epicurean (in terms of food, sex, and friendship), but more often stoic, if not martyr-like, of both body and mind. It is a visual and narrative catalyst tied to the strong, white, racial positioning experienced by Italians in America at the beginning of the twentieth century. The persistence of New York as a necessary set has permitted the continuation of this racial positioning by placing it within familiar boundaries and has impeded total assimilation, meaning the loss of dramaturgical identity, at least in film. Even without total equality, the affiliation of Italian American characters with the white community has allowed for receptive relationships dictated by emotional solidarity (Beban), erotic intimacy (Valentino), anti-capitalistic complicity (gangsters), social class (boxers, workers and even dancers), family (wives and daughters), and therapy (patients and analysts). These relationships are articulated through a manifestation of pain (and pleasure) not always permitted to Apollonic Anglo American characters. It is not a coincidence that Italian Americans in movies can never leave New York (or its vicinity); and if and when they leave, all they can do is dream of going back home where they know they will be able, finally, to suffer in peace.

Translated from the Italian by Maria Enrico

Four Italian American Directors
on the Theme of their Ethnicity: 1990-2007

Robert Casillo
UNIVERSITY OF MIAMI

By general acknowledgement, the premier Italian American directors of the last four decades have been Martin Scorsese, Francis Ford Coppola, Brian De Palma, and Abel Ferrara. With the exception of De Palma, they are known in varying degrees for their preoccupation with their own ethnicity as a cinematic subject. Yet to judge from their total output post-1990, their interest in Italian America seems on the whole to have diminished, whether as a result of the exhaustion of their subject matter or of their entry, as assimilating ethnics, into what Richard Alba terms the "twilight of ethnicity." At the same time, their Italian American films of this period afford an often critical or pessimistic interpretation of the ethnic group, accenting its failings in a sometimes insightful, sometimes stereotypical fashion, or else charting, in an apparently fatalistic mood, the decline of the Mafia on the one hand and the dwindling of ethnicity on the other.

The third installment of Coppola's *The Godfather* series, *Godfather III* (1990) is his only major treatment of Italian America in the last two decades. Although rightly regarded as inferior to the first two installments, the film must be taken seriously as Coppola's final judgment on the Mafia, if not Italian America. After taking over his father's criminal family under circumstances he could not fully control, Michael Corleone has spent his life attempting not only to legitimate the family but to atone for his many crimes, including his brother's murder. A generous contributor to Catholic charities, the normally astute Michael is lured by swindlers into investing in a Catholic financial conglomerate and thus risks impoverishing the Corleone family. For all his hopes of divesting himself of Mafia connections, he has no choice but to defend the family against its new Italian and Italian American enemies: "Just when I thought I was out, they try to pull me back in." The continuity of the family is further threatened by

Michael's increasing age and debility, as well as his lack of a successor. That lack is supplied by the arrival on the scene of young Vincent (Andy Garcia), the illegitimate son of Michael's dead brother, Sonny Corleone. With his leather jacket and thuggish ways, Vincent reinjects into the family blood line many of the primal virtues and energies of its founding father, Don Vito Corleone—in short, a return to origins. This theme of revitalization and resurrection is underscored in the family's return to Sicily, as if attempting to renew itself upon ancestral soil. The dangers of such a project are suggested in the forbidden, incestuous romance between Vincent and Michael's daughter, Mary (Sofia Coppola). In any event the attempt at renewal fails, for not only does Vincent fail to protect Mary from lethal violence, but the family is drawn once more, by a seeming fatality, into the criminal cycles from which Michael had sought to extricate it. His comment on this state of affairs applies to the film as a whole: "I had tried to prevent this, but it is not possible in this world."

A major reason for this pervasive mood of fatality is the overwhelming accumulation of doublings, variations, and inversions within *Godfather III* of situations as well as lines of dialogue previously appearing in the first two installments. Reminiscent of Don Vito in *Godfather I*, who in the opening scene presides over his daughter's wedding, Michael greets well-wishers and supplicants amid a celebration honoring his membership in the Catholic Order of St. Sebastian. As Michael during his youth had attempted to reject his father's criminal family, so his own son Anthony (Franc D'Ambrosio) refuses to become a lawyer but instead chooses a musical career of which his father disapproves. Whereas Michael had been the black sheep at his sister Connie's wedding, wearing his army uniform rather than more appropriate formal dress, that role is now assigned to Vincent (Andy Garcia), Sonny Corleone's illegitimate son, inappropriately garbed in a black jacket typical of a young street hood. Like his father, Vincent is a hot-blooded type who uses the celebration as an occasion for womanizing. In a violation of the Southern Italian code of *omertà*, Vincent's mention of Joey Zasa's henchman's murderous practices calls to mind the young Michael's revelations to Kay Adams (Diane Keaton) concerning Luca Brasi, Don Vito's enforcer.

In *Godfather I*, Don Vito's worst enemies are present under a mask of amity: the Tattaglias, more muscle than brains; and Barzini, the mastermind behind the Tattaglias. In *Godfather III*, Altobello (Eli Wallach) and Joey Zasa (Joe Mantegna) correspond to Barzini and the Tattaglias respec-

tively, Michael Corleone being their hated rival. The mob summit meeting in *Godfather I* is paralleled by the hotel gathering in Atlantic City, where Zasa declares war on the Corleones, while Zasa's subsequent murder during a Little Italy street festival is foreshadowed in *Godfather II*, in the young Vito Corleone's murder of Fanucci during an earlier event of the same type. The puppet show, which appears in connection with Fanucci, anticipates the performance of *puppi siciliani* in the trilogy's final installment, during Kay's first visit to Sicily. In *Godfather III*, Vincent and the Corleone gunmen "go to the mattresses" in their war against Zasa, but now the phrase has greater piquancy, for besides performing the cooking duties assigned to Clemenza (Richard Castellano) in *Godfather I*, Vincent is also romantically involved with his cousin Mary, the daughter of Michael Corleone. After being stricken ill and hospitalized, the incapacitated Michael is protected by his nephew Vincent in a series of events reminiscent of Michael's coming to the aid of his father after his nearly fatal assassination. In yet another parallel, Luca Brasi is ordered by Don Vito Corleone to pretend to betray him to the Tattaglias so as to gain information; Michael tells Vincent to do the same thing in order to sound out Altobello.

First appearing in *Godfather I* as an ominous signifier of fatality, oranges figure likewise in the final installment. One sees them on the banqueting table at the Atlantic City meeting, as the underworld bosses are about to be massacred in a sudden helicopter ambush. Just before Michael Corleone has a diabetic stroke, his adviser-henchman Neri peels an orange. When Michael has a diabetic attack in the presence of Cardinal Lamberto (Raf Vallone), this being a reminder of his mortality, the cardinal gives him orange juice. When Altobello visits an assassin for the purpose of exterminating Michael Corleone, oranges are quite visible as they sit at table. As in the first two *Godfather* films, the frequent presence of Christian imagery, for instance the crucifix prominently visible in the hospital where the Corleones plot vengeance against Zasa, only underscores the immense disparity between Christian values and the underworld. In a famous scene in *Godfather I*, Kay comes to realize that she will be forever excluded from knowledge of her husband's business activities, and that his clandestine acts of violence must drive a wedge between them in their private lives. She experiences a renewal of the same perception during her visit to Sicily, all the more ironically because it is preceded by an apparent revival of her and Michael's long-buried love. And

finally, as in *Godfather I* there is the theme of the godfather's weakening authority and the passage of underworld power from the older to the younger man. As Michael Corleone's subordinates had kissed his ring upon his ascendance to power over the Corleone family, so Vincent receives the same honor when the enfeebled and declining Michael turns over authority to him. However, what is perhaps most interesting in this scene is the prominently displayed design on the wooden door as Michael and Connie (Talia Shire) leave the room following the ceremony. Consisting of a series of concentric circles, the design suggests a cyclical pattern of inescapable fatality, the constant doubling back to a point of originating violence. As Michael says in a different context: "Just when I thought I was out, they pull me back in."

What further adds to the film's atmosphere of fatality is its recurrent parallelism and blurring of the distinction between life and art as a result of which Italian America and, more especially, Sicily acquire the aspect of theatricalized worlds where characters can only play out in a distinctly operatic fashion certain familiar and preassigned roles (not infrequently stereotypes) in an endless repetition of the same motifs and situations. As in *Godfather I*, Johnny Fontane croons during the film's opening celebration; Michael's son Anthony eschews the law for a singing career and later sings a Sicilian song especially for his father; and the film concludes with a performance of *Cavalleria Rusticana* in Palermo. Although Anthony resists his father's career demand that he enter the law, he substitutes for it another distinctly "Italian" profession, namely singing. The leaded windows with their spider web designs at the opening portend the labyrinthine machinations to follow. The Madonna looking out toward Lake Tahoe calls to mind Connie's similar pose at the conclusion of *Godfather II*. Not only is Joey Zasa (Joe Mantegna) a showy Don Gotti-type gangster whose picture appears on the cover of gentlemen's magazines, but he is killed by Vincent in the disguise of a policeman, the murder taking place amid a street festival in which the other assassins wear hooded capes. The film's assorted acts of dissimulation, treachery, and poisoning, including a box of lethal cannoli, calling to mind the reference to cannoli in *Godfather I*, belong to the machinery of a staged, Gothic Italy. According to Michael's ex-wife, Kay, in an insulting remark, Michael stands "disguised by his church." The theatricalization of events culminates in Sicily, which Michael describes as "opera." In one scene he surprises Kay in the guise of a chauffeur and takes her on a tour of the island. Subsequently, in

Michael's ancestral village of Corleone they observe a puppet show, *Baronessa da Carini*, whose plot concerns a Sicilian father who murders his daughter on account of her love for her cousin — a situation closely reminiscent of Michael's relation to his own daughter. As a further instance of a theatricalized narrative, the lobby of the Palermo opera house on the night of the performance of *Cavalleria* is shown to contain a large-scale mock-up of the same building, so that the audience within the movie theater is watching a scene unfolding in an opera house which holds its double within itself — with the suggestion of an infinitude, a *mis-en abime* of dissimulation. In yet another example of doubling, the gunmen who protect the Corleone family during the performance are identical twins. Their primary adversaries include the assasssin Mosca (Mario Donatone), who disguises himself as a priest, and Mosca's son, who enters the theater by posing as a shotgun-toting extra in Mascagni's opera. Subsequently, he fills the chamber of his shotgun with real bullets and gives the signal to fire by imitating the bray of a donkey. After killing one of the twins, Mosca himself pretends to be dead and then uses a knife to murder the remaining twin. Nor do these events lack for analogues on stage, where knives and rifles figure in the spectacle. So too, an earlier scene in which Vincent grabs his crotch, an insult directed at Zasa, is echoed in the performance of the opera, as is Vincent's subsequent biting of Zasa's ear. When Vincent observes Tony, in the role of Turiddu, sink his teeth into his rival's ear, he smiles and nods approvingly, realizing that he has himself behaved as a true Sicilian male, and that Sicilian life and theatricality amount to the same thing.

Reinforcing the film's fatalistic mood is its no less pervasive cynicism toward human life and institutions, a viewpoint that confirms Leopardi's characterization of Italians as the most cynical of peoples. This note had been struck previously in *The Godfather* series, especially in the first installment, which Coppola, by his own testimony, used to illustrate his idea of the basic moral and legal identity of capitalism and the Mafia. Reflecting the knee-jerk leftist iconoclasm of the 1960s, Coppola's tendentious statement ignores the demonstrable difference between normal (and legal) entrepreneurship and a criminal organization which specializes in "protection" and extortion through the violent or forced creation of consumer demand. Nonetheless, *Godfather III* advances the same idea while extending similar charges of corruption to both the state and society. A witness to the political machinations of modern Italy, which he sees as

having changed not at all since the days of the Borgias, Michael Corleone opines that politics and crime are the "same thing," "*la stessa cosa.*" On another occasion he tells his devoted sister Connie: "All my life I've tried to rise in society. The higher up I go, the more corrupt it is." Nor does the Church escape cynical condemnation, for though Coppola acknowledges the possibility of a good man such as Cardinal Lamberto (Raf Vallone), whom Michael characterizes as a "true priest," the Catholic Church appears mired in financial scandals and updated versions of the sale of indulgences. Coppola's notion of the historical futility of Catholicism is intended to gain credibility in being assigned to the good cardinal who, on the occasion of Michael Corleone's first confession in thirty years, compares a stone's imperviousness by water to the impenetrability of the heart of man to Christianity.

If, as some critics would argue, Italian American cinema encompasses only films by Italian American directors on Italian American subjects, then one must conclude that, for the greater part of his career, Brian De Palma has been working outside the category. Yet, notwithstanding his having been sent to a Presbyterian School and raised as a Presbyterian, De Palma's parents were Italian American Catholics. Father Richard A. Blake convincingly argues for the presence of a Catholic "afterimage" in De Palma's works, that is, traces of a Catholic orientation which the director takes half seriously and half parodistically, but which he in any case is incapable of escaping or casting off. However, it is only in the recent *Snake Eyes* (1998) that De Palma has placed an Italian American at the center of one of his films. Besides conforming to and trading on stereotypes of the Italian American male, especially the policeman, the characterization of Santoro reflects the director's shrewd assessment of certain ethical failings and virtues, which various sociological commentators have identified as characteristically Italian.

The protagonist of De Palma's *Snake Eyes* is Richard Santoro (Nicholas Cage), a corrupt Atlantic City police detective of Italian American background who stumbles upon a conspiracy when the Secretary of Defense is assassinated during a heavyweight championship match. The mastermind of the conspiracy is Santoro's old friend Commander Kevin Dunne (Gary Sinise), a dissimulating naval officer who in the aftermath of the conspiracy aims to track down and execute a beautiful young woman (Carla Gugino) in possession of essential information. The characterization of Santoro probably owes something to De Palma's year-long ex-

perience of having worked on a script for a film version of Robert Daley's *Prince of the City*, which was ultimately filmed by Sidney Lumet. In preparing the script, De Palma spent considerable time interviewing the chief character of Daley's book, Robert Leuci, a New York policeman who turned informant so as to expose the illegalities and corruption of the elite New York City narcotics squad to which Leuci himself belonged.

The resemblance between Santoro and Leuci is evident in their great likeability and charm, sartorial exhibitionism, easy, self-indulgent immorality, and frequent abuse of their authority as police officers. In addition to carrying on adulterously, which he regards as thoroughly natural, Santoro (like Leuci) relies upon bribery and payoffs to support a lifestyle far beyond the means of an honest police detective. At one point Dunne suggests that Santoro customarily plants evidence as a favor to local policemen. He beats up people who owe him money, uses his badge to intimidate private citizens, admits to having shoplifted on occasion (lamenting only that he had nearly been caught), and proclaims himself "king" of Atlantic City, which he lovingly characterizes as his "sewer." When Dunne pretends to worry over his responsibility for the assassination (which he in fact masterminded), Santoro voluntarily plays the role of "spin-doctor," saying "I know how to cover my ass." He adds: "Go to confession later but don't bury yourself now" — a thoroughly hypocritical view of Catholicism which some observers might see as not uncharacteristically Italian American and which forms a motif in many Italian American films, especially those of the gangster type.

Santoro's shameless deeds and actions imply a nearly total lack of public virtues, and in this respect he conforms to one of the most common — and not altogether inaccurate — stereotypes of the Italian. And yet, as has also been noted by numerous other observers, including Stael, Stendhal, Barzini, Peabody, and Christopher Browning, Italians tend to combine a weak sense of public responsibility with an abundance of private virtues, a characterological combination which often enables them to assert their basic humanity in crisis situations. Such a description applies neatly to Richard Santoro. Following the assassination, when the media hounds have gathered upon the bloody scene, Santoro's presumably Italian American respect for family compels him to drive away the newsmen, as he will not allow the dead man's family to witness the scene of his gruesome death. He thus favors private feelings over the public's basically ghoulish "right to know." Even at the beginning of the

film, when he behaves so atrociously as a policeman, he proclaims sincerely his conscience and fidelity to promises made to friends. While it is true that he conspires to cover up Dunne's apparent dereliction of duty during the assassination, he does so out of a fervent sense of friendship and loyalty. When Dunne assumes that Santoro's attempt to intervene on his behalf must be motivated by some selfish motive, such as that of becoming the mayor of Atlantic City, an ambition to which Santoro had confessed earlier, Santoro tells Dunne quite convincingly: "You're my best friend. Loyalty is my only vice." Dunne remains unconvinced of the depth of Santoro's commitment, subsequently informing his accomplices that "he's only chasing this down because of the career opportunity." After tracking down the young woman whom Dunne plans to murder and learning from her Dunne's role in the conspiracy, Santoro still hesitates to impugn his friend, "one of the most honorable dudes on the planet." But later, when Dunne offers him a million dollars in exchange for the woman's life, Santoro refuses blood money at the cost of submitting to a tremendous beating. He does so, moreover, with the knowledge that he risks defamation in the press and the loss of his "connected life." Unlike most of De Palma's other films, in which the protagonist proves impotent in a crisis, and in which the female lead is subjected to torments which critics widely perceive as misogynistically motivated, Santoro rises from cynicism to heroism in saving the damsel in distress. This, though, does not save the film from a cynical ending, as Santoro's heroism by unexpectedly attracting attention to his previous corruption as a police officer leads indirectly to his indictment and the loss of his badge.

Scorsese's *Casino* (1995) represents the third and final installment of his "gangster trilogy," which includes *Mean Streets* (1973) and *GoodFellas* (1990). This trilogy in a somewhat loose fashion traces the trajectory of Italian Americans and more particularly the mob in a dispersive movement from the Northeastern ethnic enclaves of the first and second generations into the suburbs of the Northeast and ultimately into the entertainment and touristic centers of Florida, Las Vegas, and California—a pattern of assimilation which loosely parallels that of this third-generation director's brilliant career, which has carried him from Elizabeth Street in Manhattan's Little Italy to the summits of Hollywood success. As in his earlier Italian American films, Scorsese depicts his ethnic group and more particularly the mob as an embattled subculture struggling to

maintain its identity in the face of varying pressures, which in this instance include the law, reliance on non-Italian Americans, the erosion of ethnic identification and loyalty to the codes of neighborhood and Mafia, and the corporatization of activities formerly regarded as criminal. Temporarily, however, the mob reaps enormous profits through its unholy alliance with the state of Nevada, which can solve its fiscal crisis only by means of tax revenues derived dishonestly from casinos secretly owned and administered by the Italian American underworld. In the midst of this highly compromised and morally ambiguous situation stands casino manager Sam "Ace" Rothstein (Robert De Niro), whose role within the Mafia is simultaneously that of Jewish outsider and, owing to his special managerial and gambling skills, privileged insider. In the end, the criminal paradise of Las Vegas collapses not only through the corporatization of the gambling industry, leading to the exclusion of mob investors and general purgation of the Mafia from Las Vegas, but through violence and disorder within the underworld itself, brought on by a rash of widely publicized crimes, rivalries, and betrayals. All of this betokens the failure of Mafia traditions of loyalty and deference even as the impersonal world of business bureaucracy is taking over the gambling industry. The film embodies the internal disintegration of the Mafia in the figure of Nicky Santoro, an out-of-control gangster played by Joe Pesci. At the film's conclusion Rothstein's detached point of view toward his traumatic criminal past recalls the similar viewpoint of Henry Hill (Ray Liotta) in the final scene of *GoodFellas*. More subtly it suggests an analogue with the increasingly assimilated Scorsese's inevitable eloignment from his own ethnicity, in this case rendered indirectly through the perspective of the ostracized Jewish outsider. The ending of *Casino*, which portrays the old Las Vegas of the Mafia at the moment of its demolition, may also signal the end of Scorsese's directorial interest in Italian America, for as he states in a recent interview, *Casino* climaxes with the blowing up of the ethnic world in which he had grown up, and which, to judge from the nearly complete absence of Italian American subject matter in his work of the last decade, now seems to hold out to him little if any creative interest. Certainly one would hope otherwise.

Abel Ferrara's *The Funeral* (1996) portrays the Tempios, a small time Italian American criminal family seeking to come to terms with its criminal heritage in the midst of the Depression. The film casts a backward glance at an earlier phase of the ethnic underworld, which Ferrara had

already treated in *China Girl* (1987) and, to a lesser degree, *The King of New York* (1990). The murder of Johnny Tempio (Vincent Gallo) has brought together for his funeral the remaining Tempio brothers and their wives, including Ray (Christopher Walken), his wife Jean (Annabella Sciorra), Chezz (Chris Penn), and his wife Clara (Isabella Rossellini). At the heart of this film are concerns some of which figure crucially in Ferrara's *Bad Lieutenant* (1992) and which also appear in many of Scorsese's Italian American films, namely the opposition between violence and Christianity, the underworld as a mimetic system radically contrary to the Catholic ideal of the Imitatio Christi, and the virtual impossibility of Christian pacifism having the least restraint upon a subculture absorbed in an ethos of endlessly retaliatory violence.

As in Scorsese's films, Ferrara identifies as one of the chief sources of the imprisoning gangster ethos the alluring mimesis of the gangster icon, whose aura the aspiring gangster would claim or at least borrow for himself. Thus the opening scene of *The Funeral* depicts the ill-fated Johnny sitting in a movie theater watching (and no doubt thinking of imitating) Humphrey Bogart's portrayal of the hardened criminal tough-guy Duke Mantee in *The Petrified Forest* (Archie Mayo, 1936). Another gangster, Gaspar (Benicio del Toro), the Tempio's nemesis, is very much the "dapper Don type," meticulous and immaculate in his dress, this being the sartorial correlate of his cool unflappability in the face of any situation. He has almost certainly taken over this pose from the many movie gangsters to be seen in the films of the early 1930s. Such a concern for making a good impression in the gangster style attains ghoulish proportions when Ray addresses Johnny in his coffin: "You got a good break; you look better than you ever did." He implies that the gangster is never more impressive visually than when he takes on the cold remoteness and mask-like impassivity of death, than when he transforms himself once and for all into an unfeeling surface. It is as if this were the real end and object of the death-obsessed gangster's posturings—to leave an impressive corpse barely distinguishable from his living manifestation. Ray further remarks that the "funeral assistants will touch Johnny up the next day." It is also mentioned of the Tempio brothers' father that in committing suicide he had so marred his appearance that, to add to the shame of his suicide, he could not appear at his funeral in an open coffin. As in Scorsese, the vauntings and posturings of individual gangsters are not infrequently interpreted by envious underlings as provocations to dishonor

them, as when the lowly gangster Ghoulie, in the film's original script, defecates in the pocket of Gaspar's coat. Appropriately, the gangster pose is unmasked by the person who suffers from it the most, namely the gangster's wife, as witness Jean's bitterly disillusioned comment on Ray and his brothers. She and other women take such men for "rugged individualists," but this is mere "romanticism," as they are "ignorant" conformists to a warped masculine ideal.

In *The Funeral*, the Tempio family's propensity to retaliatory violence is owed chiefly not to the imitation of celluloid criminals but rather to its paternal legacy. Toward the film's opening Ferrara introduces as a flashback of Ray's what is probably intended to figure as something like the character's "primal scene," in which he recalls the initiation into violence which his father inflicted upon him, grotesquely describing the event as a "Bar Mitzvah." While Ray's two brothers look on to absorb the lesson of this staged scene, the father urges the pre-adolescent Ray to shoot a man seated bound and gagged before him. "If he lives he'll return to kill you," says the father, thus implanting the idea that neither trust nor forgiveness is to be expected from the family's enemies—a satanic inversion of Christian belief. After Ray kills the man, the father gives him the gunshell as a sacred token, a priceless thing. The passing of this inheritance of violence to subsequent generations of Tempio children is suggested in the earlier scene in which, as the time of mourning begins, the young boys of the family are ordered to stop playing guns on a staircase. There remains, however, the disturbing possibility that the Tempios' violence will ultimately be turned against themselves, as the father had committed suicide, while the volatile and mentally disturbed Chezz seems capable of the same irrationality.

The film's larger, encompassing thematic is one familiar to Scorsese's audiences, namely that between Christianity and the Southern Italian code of masculine honor, which also entails the subordination and submission of women. The ostensible Christianity of the Tempios is evident in the presence of a crucifix on Johnny's coffin as well as in Ray's kitchen. Crosses appear elsewhere along with holy icons and shrines in honor of relatives, these having a religious import for Southern Italians. Jean even prays at her household shrine of the martyred St. Agnes, whom she describes as the "patron saint of purity," and whose fate she takes as a reminder of what happens when a woman says "no." This remark reflects the bitter frustration of a college-educated woman who cannot but defer

to an overbearing husband whose lies, adulteries, and violent excesses she can neither effectively criticize nor control. Discounted and ignored as is typical of Mafia wives, she clearly regrets her marriage undertaken for deluded "romantic" reasons. Yet the main point of tension between Jean and Ray centers on Christianity, as she is exhausted and frightened by her family's legacy of violence and desires desperately for a religious solution. When a nameless priest (Robert Castle) appears at Johnny's wake, a mourner advises him that the family needs not the last rites but an exorcist. Subsequently Ray shows his disdain of the priest by dismissing him as an "asshole" and remaining in his car for the duration of his visit: "I'm not about to start with that stuff at this point," he tells Jean. She in turn urges her husband simply to "bury" Johnny and his "fights" along with him, yet he lies in promising to do so. Notwithstanding her concern that Johnny's enemies may "come after the kids," Ray is willing to risk it. When during the wake Clara speaks knowledgeably and appreciatively of the fine and costly food provided for the mourners, the priest turns away disgustedly and in parting delivers this weary homiletic: "The only way anything can change is if this family has a total reversal of heart—not just going to church but the practical atheism all of you live daily." Jean rejoins that her family believes in God, but the priest insists that it is not enough, to which she replies that a miracle may be necessary, whereupon he urges her to pray for herself as a way of preparation for grace. Although not lacking in a certain dramatic power, this scene exhibits a thematic discursiveness and underlining which Scorsese is generally careful to avoid in his films, this being but one indicator of their superiority to those of Ferrara. In a later speech Ray blames his evil deeds on God with the argument that he has committed evil only because God has denied him the grace he needs in order to do good. His appallingly self-extenuating statement cannot conceal the fact that, in the terms provided by the priest, Ray has closed his heart to grace and therefore cannot receive it.

When at the film's conclusion the mentally disturbed Chezz kills Ray and shoots a bullet into Johnny's coffin before killing himself, one is to interpret his actions as the final working out of his father's legacy, although it is unclear whether the causes are biological or mimetic or both. In any case, Chezz's action puts an end to violence, which is what Jean and the priest had wanted, yet he does so not through a miraculous surrender of aggressive impulses, in accordance with Christian ideals of

brotherhood, but rather through their demonic negation, in a terrible act of fratricide. The implication is that neither Chezz nor Ray has left himself open to the redeeming descent of grace, but rather sees himself as hopeless and damned. At the same time, the violent and bloody conclusion of *The Funeral* carries a strong suggestion of fatality or inevitability and, in this sense, calls to mind *Godfather III*, in which the Italian American characters, try as they may, seem locked culturally and characterologically in a pattern of evil cycles beyond extrication.

of Steven Prince (1972) — two movies that feature both Scorsese and his family.

In essence, nostalgia is strongly present in the cinema of third-generation, Italian-American film artists. It's not the grandparents, who still embody the traditions of their land of origin; it's not the parents, who often reject it because of their intense desire to assimilate in the New World; it's the children who want to return to their roots and their ancestral homeland.

One who returned is Francis Ford Coppola with the beautiful episode in *The Godfather* (1972) when the young Michael (Al Pacino) takes refuge in Sicily after having killed McCluskey, a police captain (Sterling Hayden). Even in his case, nostalgia for the homeland is married (after all the plot's central theme in the segment is, in fact, a marriage — that of the future Mob boss with Apollonia, a local beauty) with nostalgia for Italian cinema. This can be seen in the cameo appearance by Franco Citti, which immediately recalls Pasolini and through him, metonymically, all Italian cinema. It is homage, using recognizable masks, that Coppola will repeat in the second part (Maria Carta, Angelo Infanti, Leopoldo Trieste) and in the third part of *The Godfather* saga. In this last part, Coppola gives us Citti, Raf Vallone as Cardinal Lamberto (an obvious reference to Pope Luciani) and Helmut Berger, a Visconti character par excellence, in the part of Keinzig (another obvious reference, this time to Calvi).

Coppola's nostalgia, however, is mainly found in his strong and at the same time tender portrayal of Italian-American settings. It is in his voyage à rebours to the Little Italy of the young De Niro (*The Godfather, Part II*, 1974) and its reliance on flashbacks, a technique later reprised by Leone (in *Once Upon a Time in America*, 1984). It is in Connie's wedding party in *The Godfather*, with Don Vito waltzing with his daughter (obvious homage to *The Leopard*) and a traditionally Sicilian song, "C'è la luna in mezzo 'o mare," performed with accompanying obscene hints about a fiancé's "talents." In *The GodfatherII* there is a little song "Avian u sciccareddu," sweetly sung by Vito Corleone as a young boy. It is in the rare occasions when Mamma Corleone speaks while dishing out pasta. And when the aged mother and even Al Pacino speak it, one hears Sicilian dialect in its most tender tones. In this use of the ancestral language, the nostalgia is heartbreaking.

There is a red wire that unites Coppola and Scorsese, and others of the same New Hollywood generation, and it consists of their Italian-

American roots and,, more precisely in the rapport between the American myth and the Mediterranean myth, between integration and a return to one's origins. There was a history of much prejudice against "Italians" when Coppola was at UCLA, preparing to become one of the foremost directors of the New Hollywood by studying the cinema of the founding "fathers" of Italian cinema, and that of its already well known "grand-children" (Bertolucci and company). Coppola's father, Carmine never made any headway in life—he was an anonymous flute player in Tosca-nini's orchestra. His "revenge" is therefore also on behalf of his family, of his father's frustrations, of his generation, and against anti-Italian taboos and racial prejudice. Coppola's oedipal battle against immigrant infe-riority complexes, Italian shame, violence, and death, is also a wholly American fight for survival. It is an updated American Dream. As did others of his generation, Coppola rediscovered his roots. He first used his family archives for the images and names of his father and mother: Car-mine and Italia (Italia is also the name of his sister, Talia Shire) appear in a brief cameo in *One from the Heart* (1982). This was followed by a more mature approach to Italian culture through cinema—Coppola is a great admirer of Bertolucci. And so there is a constant Italian presence in his films, in terms of narration, cast and crew. Italians are viewed, on the one hand, with the usual folkloric deformations (The Sicilian Mafioso, the virile and paternalistic man of honor, even the spaghetti that Coppola orders sent to the Philippines during the 1979 filming of *Apocalypse Now*) and on the other with admiration for their "humanistic" ability to com-bine poetics with technique. The result is the choice of Storaro (from Ber-tolucci) for *Apocalypse Now* and, earlier, of Nino Rota (from Fellini) for the music of *The Godfather*. Rota and Storaro, almost as if they were trade-marks, represent Europe. "Italian" also stands for marginalization and minority as Coppola displays an ambiguous attitude that vacillates be-tween absolution and condemnation. In The *Godfather, Part II* there is an actual anti-Mafia trial that ends in absolution. But there are also more generalized condemnations of "Italian Americans": of how they behave; their presumptions: their flashy clothes. They are voiced in the person of Senator Geary, when he tries to challenge Michael Corleone at the be-ginning of the film. Coppola, similarly to Puzo, does not reject popular stereotypes about "Italians." To the contrary, he exalts them. The Italian Americans of *The Godfather* are tender fathers and bloody assassins, re-spectful enforcers of clan morality and vigorous stallions. But stereotypes

become myths. And so Robert Duvall, Michael Corleone's stepbrother in the movie, visits the jailed boss Pentangeli, who has betrayed the Family, and suggests that he commit suicide. He doesn't say it explicitly but, in a rhetorical way, reminds the "traitor" of the deeds of the ancient Romans, whose honor remained unsullied if they committed suicide after a failed revolt.

Brooklyn resembles the Far West or the Roaring Twenties. In Coppola, the image of Italians becomes a condensation of myth and human ritual. This image is often associated with that of feasts in *The Godfather* saga but also, in an almost subliminal segment, in Coppola's very American *The Rain People* (1969), a small, extraordinary, early New Hollywood film. In a very brief flashback, the protagonist Natalie (her last name is Ravenna, which is both Jewish and Italian), for a moment, thinks back to her wedding, and — what a coincidence — to the tarantella that the newlyweds danced.

In essence, one could say that Coppola's relationship with Italy is identified with his oedipal one with his father Carmine, but also with a symbolic Father (including Cinema) that the director tries, ritually, to kill. I see this in the father figure of Kurtz in *Apocalypse Now* and in that of Vito Corleone (Marlon Brando, again) in *The Godfather*. Little wonder that Coppola is attracted to Bertolucci, who based his entire work on Oedipus.

In terms of the previous generation of film artists who felt the need to assimilate, and instead of nostalgia, relied on angry immigrant push and pull, Coppola exhibits a more detached sense of recovery, of rediscovery of roots. In his case, there is also a kind of Italian "complex" (of both inferiority and superiority) that caused him to be called "the Sultan of the Bay Area." It is a common symptomatology of those years and those generations: that of the persecuted and abused person, who nevertheless is still presumptuous and ambitious. A world in of itself that perhaps is typical of Italian-American "egocentrism."

CIMINO, TARANTINO, AND THE OTHERS

In the early Cimino, as in Coppola (particularly the early Coppola), one easily notes both egocentrism (as in his ambitious project *Heaven's Gate*, 1980) and nostalgia for Italy (even in film): *The Sicilian* (1987) besides paying homage to a mythical Italy, also pays homage to the country's cinema, and most of all to *Salvatore Giuliano* (Francesco Rosi, 1962). But

Cimino transforms Portella della Ginestra's red flags into folkloric and mythical icons, closer to Maoist banners than signs of historical philology.

Even more openly cinematographic is Tarantino's nostalgia for the cinema of the past. His passion for Italian 1970s crime stories is well known, and his cinephile references in *Kill Bill* (2003) are obvious when he heaps on Sergio Leone's topoi and Ennio Morricone's music. As with Coppola, therefore, but belonging to a different generation (a "fourth" one that of the Italian Americans) — Cimino ties his cinema to Italian cinema, with, however, a more self-ironic interpretation. If Coppola lived within Bertolucci's myth by imposing *The Conformist* (1970) on his crew and taking on his fundamental artistic collaborator (Storaro), Tarantino wallows in B and C movies and mixes together, in a post modern pastiche, different traditions and inspirations, as well as good and bad taste, but always under the banner of a historical memory of cinema that can be recycled, but only in a desperate manner.

Tarantino himself gives "official" credit to the many sources of his films. In the above mentioned *Kill Bill*, for example, the director makes many "confessions": the plain wood coffin used by Budd to bury the Bride was inspired by the ones in *A Fistful of Dollars* (Sergio Leone, 1964); Leone's first western is also the obvious source when Budd shoots the protagonist. *For a Few Dollars More* (Sergio Leone, 1965) is the inspiration for the Deadly Vipers taking turns beating the Bride (as happened to Lee Van Cleef and Clint Eastwood). *The Good, The Bad and The Ugly* (Sergio Leone, 1966) is the source for the opening scene of *Kill Bill* (both protagonists are barely alive and are about to be shot in the head). Sergio Leone, basically, is the great lost touchstone, the Italy–Roots par excellence, as metonomized by Great Cinema. Leone's Italy, furthermore, is very American in its febrile use of myth. All of which makes this Master — with his interest in genres, his use of spectacular stage settings and his constant debt to "classic" Hollywood — a quote/unquote "Italian American."

But Tarantino's inspiration goes beyond Leone: he also draws from so-called minor, "popular" and cult cinema. For example, again in *Kill Bill*, there is obvious borrowing from *City of the Living Dead* (Lucio Fulci, 1980): before dying, a woman sheds a tear of blood, just like Go Go

Yubari[4]. And Fulci's film itself, with its play on references and mirrors, is obviously a parody and a remake of American horror movies. So Tarantino plays with his Italian sources through a game of references that in the end results in a neo-baroque and apparently cold puzzle that, however, reveals a typically Italian-American "saudade" or yearning, and an "envy" (also in a psychoanalytical way, as if for a lost phallus) for the Roots that permeates all of his work. It is nostalgia for a long gone Land and an Age, but that need to be greedily reabsorbed, in a manner that is purposefully playful and infantile, with a focus that ranges from comics to martial arts, from swordplay to zombie splatter-horror. If Coppola, Scorsese and some early Cimino portray an Italian landscape sweetened by "old" films, Tarantino creates a digital and virtual one, born from a long ago filmic Father/Master/Godfather, who was killed and at the same time cannibalized.

The nostalgia theme can also be traced to other standard bearers of Italian-American cinema. Following are a few directors, films and simply actors and themes that evoke, through their body and stories, a golden age and land and a "Mediterranean" spleen that, directly or indirectly, echo Italy.

It's the spleen of Serpico, the Italian-American cop played by Al Pacino, of Santoro, the cop in Brian De Palma's *Snake Eyes* (1998), of Rocky Balboa, the out of it boxer whose desire to win is the vindication of a former immigrant, of John Travolta, the suburban dancer of *Saturday Night Fever* (John Badham, 1977) and of the maladjusted ex-convict played by Vincent Gallo in *Buffalo '66* (1998). It is the spleen and nostalgia of De Niro, actor and director of *A Bronx Tale*, for his childhood neighborhood and a time of origins. It is even, moving on to a later, perhaps "fifth" generation, the spleen of the protagonists of *Lost in Translation* (2003) directed by Sofia Coppola, an Italian American who has become more attracted to Japan and France than Italy (but let's not forget that as an actor, she embodied one of her father's most intense scenes: the melodramatic finale of *The Godfather III* on the staircase of the Massimo theater).

As for Robert De Niro, in particular, there is also a love for Italian cinema. Newspapers in April 2007 were full of articles on the "Italian" focus of the Tribeca Film Festival (which he created): Emanuele Crialese's

[4] It is not a coincidence that a tear of blood is also on the cover of the novel *Revolver* by a current (or former) "cannibal" [Italian literary movement] young Italian author Isabella Santacroce, who is strongly attracted to American narrative and scenarios.

film *Golden Door* (completely based on the theme of emigration), *The True Legend of Tony Vilar* (a "mockumentary" by Giuseppe Gagliardi on the true life of Antonio Ragusa, a singer from Calabria who emigrated to Argentina), Agostino Ferrente's *The Orchestra of Piazza Vittorio*, and even Paolo Cerchi Usai's cinephile *Passio*. Italy's flag flies over Tribeca say the papers, with De Niro at the center of this theme of nostalgia.

But there are many other echoes of Italy in the films of the New-New Hollywood. One can start with the brothers in *The Funeral* (Abel Ferrara, 1996) with its wake for Johnny Tempio who is killed when exiting a movie theater and continue on with other brothers, such as those of Niccolò Vitelli, the son of an Italian-American carpenter and builder in *Mac* (John Turturro, 1992). From Turturro's builder we move on to Stanley Tucci's restaurant in *Big Night* (1996): here too there are two brothers ("Primo" and "Secondo" Piaggi) and a nostalgic period setting of Italy and its myths (including culinary), of the 1950s, of a Golden Age of human dimensions that is Italian even when taking place in New Jersey. The term "nostalgic" could also be applied to Madonna's heavily Catholic symbolism, which made a brief and successful cinematic appearance with *Desperately Seeking Susan* (Susan Seidelman, 1985).

The examples are many, as we can see, and at times it is difficult to distinguish between the typical Italian-Americanism of a director (or actor) and a stylistic initializing (or dramatic "mask") that operates independently of any ethnic-cultural identity. But is it worthwhile to explore how much Brian De Palma[5] and Joe Dante, who are less explicit than others, owe to their long ago origins. And it would be worth it to analyze the acting of Ben Gazzara and Joe Mantegna, Nicolas Cage and Steve Buscemi, Joe Pesci and Al Lettieri, Danny Aiello and Danny DeVito[6]. There is a whole universe behind these masks that reveals a common background, be it comic or tragic, which shines a light on an anthropologically complex culture. Often Italian Americans hide behind last names that are above suspicion. I think of Murray Abraham (ignore the last name) and Susan Sarandon (whose family originates from Ragusa). I was in attendance at a meeting with Sarandon, who was being given a prize

[5] See Robert Casillo's essay in this collection.

[6] Add to these Penny and Gary Marshall (the children of an Italian American), Anne Bancroft (the daughter of Italian Americans), Mira Sorvino, Ray Liotta, Leonardo Di Caprio, Linda Fiorentino, James Gandolfini, Paul Giamatti, Marisa Tomei, Lou Ferrigno, Frank Langella, Alan Alda, Dom De Luise and Don Ameche. See also Bondanella's dedication in the above referenced book, in which the author has a very long list of "Hollywood Italians."

by a local association because of her descent, and I was able to confirm the importance of Italy to these famous people's creativity, and it certainly is not only because of their "Italianicity."[7] But perhaps Louise's journey (in the Ridley Scott film that immortalized Sarandon in our collective imagination, with her "leap into nothingness," and her strong evocation of a female and "feminist" identity) owes something to an Italian trip of her very own.

It is because "their voyages to Italy," as all voyages, are also psychoanalytical journeys within the human condition and within cinema; they are interior itineraries into the depths of the collective worlds of the imaginary and the unconscious.

Translated from the Italian by Maria Enrico

[7] I am referring to the conference and award "Ragusani nel mondo" [Ragusani around the world] held in August 2006 at the Palazzo di Donnafugata in Ragusa.

Dir–Actors Cut

Anton Giulio Mancino
UNIVERSITY OF BARI & UNIVERSITY OF MACERATA

> But when States are acquired in a country differing in language, usages, and laws, difficulties multiply, and great good fortune, as well as address, is needed to overcome them. One of the best and most efficient methods for dealing with such a State is for the Prince who acquired it to go and live there in person since this will tend to make his tenure more secure and lasting.... For when you are on the spot, disorders are detected in the beginning and remedies can be readily applied; but when you are at a distance, they are not heard of until they have gathered strength and the case is past cure.... The people are pleased to have a ready recourse to their Prince, and have all the more reason if they are well disposed, to love him, if disaffected, to fear him. (Machiavelli, *The Prince*, III)[1]

> "Now is the winter of our discontent made glorious by the sun of York"
> (Shakespeare, *Richard III*, Act I, Scene 1)

Over the last fifteen years, an increasing number of Italian American actors have chosen to become directors, and not only directors, and not necessarily directing themselves. This recurring phenomenon cannot be easily absorbed into the extensive and varied phenomenon of the actor-director in the broader North American film industry. There are not only two interdependent requirements (an actor on one side, and a director on the other), but in reality three (that is, to be Italian American). Putting aside the Italian American component, the discussion of an actor who becomes a director implies a concomitance and an unpredictable hierarchy of roles. If the actor's function is tied to the director's, then here is one example of a reciprocal bond. This reciprocity, however, is not always necessary. But if one takes apparently analogous examples of actors who are never, or only occasionally, the main characters in films that they have directed, then the actors enter into the category of the "director actors"

[1] TRANSLATOR'S NOTE: *The Prince*, Niccolò Machiavelli, *The Harvard Classics*, edited by Charles W. Eliot, Volume 36 (New York: P.F. Collier & Son, 1910) 10.

(this time without the hyphen): that is to say, the two professions do not automatically go hand in hand. Inverting the lexical polarity, in the category of "actor directors," it is worth noting the commutative characteristics: the difference between a "director actor" and an "actor director," without the unifying dash, becomes minimal and inconsequential. Quantitatively, this can be gathered by comparing the number of films directed with respect to those enacted, or vice versa. Qualitatively, it attains the specific weight of one against the other. Finally, if one discusses the "actor-director," one must intend to mean the actor who also directs one of his own films, following a necessary contingent or a convenience due to the actor's status. The act of directing becomes corollary to the actor.

Of interest here are the Italian American "director-actors." "Dir-Actors" consists of two terms in which the conceptual assimilation and assonance become reinforced and nevertheless restrained by the hyphen. The same hyphen would be used for the word "Italian American." In writing "Italian-American," the dash would unify and separate "Italian" pride (poetic or cumbersome symbol of a mythic-ritualistic past) and the acquired "American" component (expression of a mundane present). They are directors who consider being an actor — well-known actors, often stars — a "pre-existing condition" of sorts that is implicit, often undeniable, but ultimately not a determining factor in the production of the film. The determining factors are, for obvious reasons, the ethnic and sociological aspects of Italian Americans. In practice, they would be called "actors director-actors," since they usually oscillate between being "actors" on someone else's set or stage and being cathartically self-referential as "director-actors." The term "Dir-Actors," rather than being equivalent to "director-actors," is catchier, but above all, it results in being appropriate to the geographic-linguistic area to which they are held accountable. By and large, they are, or consider themselves to be, "total filmmakers."[2] Here we discuss Sylvester Stallone, Danny DeVito, Stanley Tucci, John Turturro, Robert De Niro, Steve Buscemi, Al Pacino, and Vincent Gallo. Stallone's *Paradise Alley* (1978), *Rocky II* (1979), *Rocky III* (1982), *Staying Alive* (1983), *Rocky IV* (1985) and *Rocky Balboa* (2007); DeVito's *Hoffa* (1992); Turturro's *Mac* (1992), *Illuminata* (1998), and *Romance & Cigarettes* (2007); De Niro's *A Bronx Tale* (1993); Tucci's *Big Night* (1993); Buscemi's *Trees Lounge* (1996); Pacino's *Looking for Richard*

[2] Jerry Lewis used the definition of "Dir-Actor" to title his autobiography: Jerry Lewis, *The Total Filmmaker* (New York: Random House, 1971).

(1996); and Gallo's *Buffalo '66* (1998) all possess another fundamental requirement. There is a fourth requirement, other than being an actor, director, and Italian American, which are requirements 1, 2, and 3. Rarely prolific, and for the most part independent (with the sole exceptions of Stallone and DeVito, who are the forerunners), they have made films (some but not necessarily all, as with DeVito, Tucci, Buscemi, and Gallo) concentrating explicitly on the relationship between themselves, the actors/characters, and their own or adoptive communities of origin on the margins of American society (Stallone, Tucci, Turturro, De Niro, and Buscemi). Or, they have made films in which the characters they play fall at least partially into this frame of reference (DeVito, Gallo, and Pacino). There are many other Italian Americans who could have been included in this list, such as Frank Sinatra and Ben Gazzara, followed (in chronological order) by Gary Sinise, Talia Shire, and Chazz Palminteri. (Palminteri would fall into the first category, not as a director, but as the actor playing the lead role and the author of the original play and screenwriter of *A Bronx Tale*). Specifically, they have made films that are not recognized under a strictly ethnic, and therefore technical, profile. Since the terms "ethnic" and "technical," in addition to nearly being anagrams, end up becoming intrinsic in this respect, the films of Sinatra, Gazzara, Sinise, Shire, and Palminteri, even though they belong to different time periods, likewise they do not fall into the frame of reference of this discussion. They, therefore, do not possess the fourth fundamental requirement.[3] We will not mention them, as we will neither examine films by these same "Dir-Actors" that are not in an Italian American setting.

For the first category of Italian American "Dir-Actors," being behind the film camera reveals cultural features as well as salient and unmistakable themes and styles. Directing the film besides writing the screenplay, if necessary (some also write the screenplays for their own films, others do not), has a precise value and meaning for an actor who identifies the historic-genealogical Italian heritage of his predecessors, relatives, friends, or casual acquaintances as his own. However remote, this represents an ideal bond of identification and expression. It also represents a value and one or more meanings, and refers nevertheless to a strategy for

[3] For the sake of completeness, we mention that two episodes of the television series *Columbo* were directed by Gazzara (*A Friend in Deed*, 1974; *Troubled Waters*, 1975), and have as an Italian American main character the famous lieutenant played by Peter Falk (who, contrary to popular belief, was not Italian American). As if it were not enough, the first of the two episodes has a plot that traces the set-up in Hitchcock's *Strangers on a Train* (1950), exactly like DeVito's *Throw Momma from the Train*.

existence rather than simple survival in that it bears on the paradigm of Italian American film. With this, it is understood to mean films about "Little Italy," the anthropological-relational space of Italian immigrants (and their descendants), who arrived in their adopted country en masse beginning at the end of the 19th century.[4] These newcomers not only arrived much later and were further behind other immigrant groups, but also arrived after the time when the United States was transforming itself from an agricultural country into an industrial giant. From the start, the Italian American community, comprised mostly of Southern Italians, found assimilation to be difficult, as it was crushed by the vice of poverty and cultural distance. Fundamentally, they were farmers by tradition who were forced to reinvent themselves as unskilled laborers especially in the building trade (one immediately thinks of *Mac*) and in industrial factories, which were concentrated in New York, Chicago, Philadelphia, Boston, and Pittsburgh.

Nevertheless, the similarities and differences will be carefully considered, beginning with the very first "Dir-Actor." Stallone's experience, which he officially debuts in directing *Paradise Alley* (1978), coincides with that of his followers, beginning with DeVito, and yet it is different in many respects. DeVito, in fact, crosses over into directing with *Throw Momma from the Train* (1987) nearly ten years later, without delving into the Italian American and matriarchal matrix of his character Owen's homicidal intolerance. In his following film, *The War of the Roses* (1989), he creates another important Italian American role for himself as the lawyer, Gavin D'Amato, but the role does not particularly characterize him in an ethnic sense. It is necessary to wait for *Hoffa*, for DeVito to "out" himself as an Italian American. It can be said that as an Italian American "Dir-Actor," despite the age difference, he is considered more a contemporary of Turturro; they both directed their Italian American films in 1992, which was the third for DeVito and the first for Turturro.

Stallone's film therefore remains an isolated case on the level of perspective. It operates within the ideological context of the Hollywood film industry during the second half of the 1970s, in which the losers and the poor are giving way to the winners in the successive decade. The first draft of the script for *Rocky* (1976), in fact, presented a much darker character that was psychically defeated. It was a sign of the times that were

[4] On this topic we limit ourselves to pointing out William Foote Whyte's *Street Corner Society: The Social Structure of an Italian Slum* (Chicago: University of Chicago Press, 1943).

changing nonetheless. In this way it was the real author—rather than the
expert John G. Avildsen—the then-unknown Stallone (as both the script-
writer and the unexpected main character), who corrected the shot that
transformed its anti-hero into a partial hero, powerful in his own "glory
in the defeat."[5] In the first film in the series, Rocky, heir to Rocky Mar-
ciano and Luchino Visconti's melodramatic main character in *Rocco and
His Brothers* (1960), loses the world heavyweight championship fight to
Apollo Creed (the African-American, Carl Weathers, who does not parti-
cularly represent his own community, equally disadvantaged, in that he
has a bright career along the same lines as Mohammed Ali's). But despite
his disfigured face and eyes, the anonymous "Italian Stallion," as he later
became known, is proud of the miraculous opportunity to be someone in
the ring for fifteen endless rounds. Andy Warhol's fifteen minutes of
fame have become boxing rounds, while in the following decade Turturro
relies on the same number of houses built and sold, or of successful
performances of his own play (*Mac* 1992 and *Illuminata* 1998), and Tucci
on the endless series of courses for an unforgettable dinner, but one that
is destined to come to an unfavorable end (*Big Night* 1986). If Tucci had
debuted as a "Dir-Actor" in Stallone's time, the two brothers who were
cooks and restaurateurs would have had a second chance. Instead in the
closing still shot of *Rocky*, it is well understood how the misfits of the
Seventies seem to be a distant memory because this young, down-and-
out, "spaghetti-eater" from Philadelphia already seems headed toward
(relative) success, leveling the field for many films of various genres
during those years, such as *Star Wars* by George Lucas (1977) and
Saturday Night Fever by John Badham (1978). In the middle of the Reagan
years, Stallone himself releases a predictably symptomatic sequel, *Staying
Alive*, where Tony Manero (John Travolta) becomes Rocky Balboa's clone,
where the choreographer resembles a coach, and the Broadway stage
resembles the triumphal boxing ring in the city of brotherly love. In
Staying Alive, the only film that he also produced, "Dir-Actor" Stallone
decided to offer this great opportunity to "his" Manero, and so he created
for himself an interesting cameo appearance. Stallone plays a street
hoodlum, who the tenacious dancer mistakenly bumps into while he am-
bitiously focuses on the show symbolically entitled "Devil's Alley," the
illusionary opposite of *Paradise Alley*. It concerns a hand-off delivery that

[5] This phrase was coined by John Ford and Peter Bogdanovich. See, Peter Bogdanovich, *John Ford*
(Movie Magazine Limited, 1967).

occurs through the symbol of continuity, although the original *Paradise Alley* had already presented the same scheme. So did the first *Rocky*, albeit on a more bitter note with a redeeming victory, that on the positive side only suggested the reunion of three Italian American brothers in the rundown New York neighborhood of Hell's Kitchen (precisely the polar opposites of *Mac* and *Big Night*). During those times, Cosmo, played by Stallone, was neither a fighter nor a mighty athlete, but rather the shortest brother. He did not have, by his own admission, the stature to fight in the ring. In four years' time with *Staying Alive*, the situation in Stallone's second directing attempt repeats itself, or more precisely, in the first of five sequels of *Rocky*, with *Rocky II*. The amateur, yet driven boxer from Philadelphia's Italian American underworld, is offered the chance to become a real winner and no longer simply a moral victor in the culture clash between those who are marginalized and those who are winners — between Italians and Americans. (We would also add between bit players and Hollywood stars.) It is 1979, but as it is easy to predict, the film "arrives" in the following decade and celebrates the limelight it had foreshadowed. Then however, having reached the top, Stallone must stay in the game and reaffirm this winning typology by increasing his investment in *Rocky III*. In *Rocky IV*, he transforms the boxer from humble Italian origins into a symbol of American political foreign policy still reflected along the lines of the Cold War versus the other empire, the Soviet Union. These are the rules for success, those of "the show must go on" (also articulated in *Staying Alive*), filmed during the period between *Rocky III* and *Rocky IV*). These are the rules that Stallone consistently embraces with Italian American enthusiasm and self-confidence that battles for survival, even contradicting himself, but firmly resolved to never give up. The spectrum is that of impending poverty, marginalization, and anonymity that has already been experienced. He has transformed himself from an "Italian-American" into an "Italian American" (the die is cast, and the hyphen is cast off). Or, he even becomes an "American" symbol: a hawk. He is the same person who, more or less at the same time, both acts in and co-writes the scripts for *First Blood* (Ted Kotcheff, 1983), *Rambo: First Blood Part II* (George P. Cosmatos, 1985), and *Rambo III* (Peter MacDonald, 1988). The wars, to be fought in a "galaxy far, far away" return in arrogance to examine this planet, and to be propagandized as fair, even those that are wrong, blundered, or distorted during the Sixties and Seventies. Stallone's parable does not stop. In this

way it arrives on the threshold of the nineties. But the enthusiasm of the previous decade is no more. *Rocky V* (1990) is directed from the start by Avildsen in order to recover the austere spirit of the series' prototype. Stallone, however, reserves the sixth round, *Rocky Balboa*, for himself. (The numeration has disappeared; perhaps the saga and the hero have reached the end of the line). Why yet another *Rocky*? And why go back to direct it? Perhaps there were no seasoned directors who would agree to it. However, these films should be examined; they are for Stallone truly labored and sweaty "rounds." The film titles flash like cards indicating the rounds of a boxing match. For as tired and as tested as the first Italian American "Dir-Actor" is, he continues relentlessly onward, pervading the character and the setting that he created.

This is the precise time period that ushers in the second generation of "Dir-Actors." A wall seems to separate them from Stallone, except for one of his films, which concerns them all. *Paradise Alley* is set in 1946, but the action is predated, beginning with the Sixties and Seventies, but also with Shakespearean times, the early twentieth century, and the Fifties. This shows that the trend of storytelling through the use of flashbacks was present from the very beginning and that Stallone confidently relied on it. It reflects on a world perceived as distant in time, memory, and consciousness. Being, living, or even only considering oneself to be Italian within an American framework that confuses, marginalizes, and validates, remains with the spirit; it is no longer a real, present condition but rather an ineffective emotional state. From Stallone to Gallo, following the chronological order of their directorial debuts, they are all assimilated Americans or Italian Americans, that is to say, no longer "Italian-Americans." The geographical and cultural distance can only surface in the form of internal malaise. Cinematically, this becomes a look back, a nostalgic and melancholy retrospective. Nor should we forget that 1946 is also the year when Stallone was born. Having reached the trinity of screenwriter, actor, and director with *Paradise Alley*, he declares between the lines of "being born," and of completely realizing himself both creatively and professionally. The author's personal details are allusively present in his style, and this most likely holds true for DeVito, Turturro, De Niro, and Tucci as well. If there are no misunderstandings about Stallone, imagine if there are any about Gallo, who titled his debut film with the place and birth year of his main character and alter ego, Billy Brown: *Buffalo '66*. It is another unequivocal way for Gallo to say "I," since he was born in Buffa-

lo, New York, albeit five years earlier. Perhaps his film does not directly deal with Italian Americans, but Billy's tragic and oppressive family ties and the ritual of meals consumed with his parents are based on an Italian food act as a link with several other films such as *A Bronx Tale, Mac,* and *Big Night*. Moreover, who are Billy's parents? His father is played by Ben Gazzara who sings like Sinatra, and his mother is Angelica Huston who is reminiscent of the Italian character in *Prizzi's Honor* (John Huston, 1985).

Even DeVito is an example unto himself. Although chronologically he fits into the group of "Dir-Actors" from the nineties, from the point of view of his work, he is inside the system and not outside, just as Stallone. Yet from the start Stallone, as does Turturro, De Niro, Tucci, Buscemi, Pacino, and Gallo focuses on Italian Americans, while DeVito waits for the appropriate time to do so. He camouflages himself within the folds of the biography of the controversial union organizer, who is in collusion with the mafia and pursued by Robert Kennedy. Why another film about Jimmy Hoffa? The prospect of another movie, more edifying than ambiguous, recalls *F.I.S.T.* (1978) directed by Norman Jewison but written by and starring Stallone. (Homage was paid to Stallone by selecting Armand Assante for the role of mafia boss D'Alessandro; Assante had already played the main character in *Paradise Alley*.) Compared to Stallone, DeVito adds a deep level of cynicism that leads him to choose Hoffa over Kennedy. But Hoffa, who is played by Jack Nicholson, and who is ever-mindful of the mafia killer in *Prizzi's Honor*, is so favorable to the "Dir-Actor" to the point that DeVito invents for himself the character of Bobby Charo,[6] Hoffa's right hand man. The film, therefore, is conceived in a thoroughly Machiavellian point of view. The imaginary character played by DeVito tells the story through flashbacks, and it offers the mafia and therefore all Italian American criminals (wherein lies DeVito's embarrassment of his origins), the last move. It is up to the rest of them to continue the dirty game. But first, Charo reconciles being Italian American, and allusively, even through intermediaries, he is an author. The following is taken from an exchange of jokes with Hoffa, to whom Charo is a sort of double, and to whom he has sworn loyalty:[7]

[6] TRANSLATOR'S NOTE: The character referred to in Mancino's text is named Charo. However, further research reveals that the character's name is in fact spelled Ciaro.
[7] TRANSLATOR'S NOTE: Dialogue excerpted from www.script-o-rama.com/movie_scripts/h/hoffa-script-transcript-jimmy-hoffa.html.

HOFFA: You fuckin' wops. You people. You cocksucker, why you wanna be born into a race like that?

CHARO: Bad judgment.

HOFFA: Fuckin' A. Well told. You go sit, look out the roadhouse, huh? The booth the meeting's supposed to be. Call the motherfucker. Tell me. Thing is, I'm not sitting here all day.

CHARO: I'll call him.

HOFFA: Leave me the piece.

CHARO: I'm gonna go naked?

HOFFA: You got the one at the roadhouse. What are you worried about? Get outta here. Do something for a living.

Hoffa's apparent contempt, as a product of DeVito's ruthlessly realistic direction and his fascination with those who are pure, brilliant, and unlucky as much as repulsive, superhuman, or subhuman characters, is mitigated by Charo's excessive desire to please, and from his complicity as a subordinate character reflected through DeVito the actor. The following exchange supports this:

HOFFA: Long time. You've been with me a long time, Bobby.

CHARO: What the fuck else am I gonna do?

What happened to the new generation of Italian American "Dir-Actors?" In the nineties, without sacrificing their eccentricity and mass appeal, they return to reflect on the defeats while freeing themselves from Stallone's relativism. From DeVito onwards it is no longer time for heroes. The obsessive and meticulous reconstruction of ethnic belonging, as much as it is supposed or accepted as true, counts more than the eventual redemption. What matters is the eloquence of the characters who failed, those who are idlers, neurotic, power-hungry, hyperactive, unfair, and unfaithful. Their endless conversations continue sideways nonstop, without a head or tail, but rich in dialect and cultural details. These details are not even standard Italian but regional, Southern Italian: Sicilians constitute the majority, but there are also the Abruzzesi and Neapolitans in *Big Night*. Moreover, the culinary, musical, theatrical, and cinematic repertoires are what matter. But above all, what counts is the idea of total control that "Dir-Actors," heirs to the *Commedia dell'Arte* and the romantic and nineteenth-century ideals of directing, exert over their (almost always) small films. Therefore what matters is the art of staging, which is conservative in an anthropological sense, and at times conserva-

tive in an ideological sense. Families, crews, casts, permanent theater companies or traveling theater troupes, patrons, clans, teams of professionals, groups of workers and staff members composed of friends and relatives (the Stallones and Turturros) are autocratic models of aggregation, collaboration, and organization. They consider what will or will not work, act, or perform inside the well-defined and self-managed perimeters, whether they are boxing rings, stages, domestic interiors, construction sites, Catholic churches, kitchens, public spaces, buses, ice cream trucks, or prisons. Through film, it is possible to define these areas and halt the centrifugal pull, power struggles, competition, team rivalries, marital crises, relationship issues, and everything that inevitably produces fission in the community of reference.

In *Looking for Richard*, Pacino, smiling, menacing, exuberant, governs the actors who he gathers around him and his disturbing character, giving voice to all—the critic, scholar, and historian as well as the interpreters who must decipher, re-read, and take ownership of the original Shakespearean play. The objective is to return the most performed Shakespearean tragedy to ordinary people:[8] Pacino is an Italian American and, therefore, he cannot exclude himself being interviewed, among the others, as a member of his community. It is necessary to examine the participatory essence of written text with respect to actors, as well as its theatrical and contemporary dimensions, circumscribed by the physical space of The Globe Theatre. In the process, the American actors may very well overcome their inferiority complex with respect to the British actors (disparities which lead to those between majority and minority, and also between an American macro society and an Italian American micro society). Fundamentally, the Duke of Gloucester, future King Richard III, and the Duke of Buckingham behave like gangsters. Like a reigning king, the "Dir-Actor" in turn must be able to hold everyone together, although fate reserves death for them both (a recurring theme of the films discussed here). He must be able to severely control everything and everyone. He must command the subjects-actors and dominate them. The "Dir-Actor" must be a demiurge; the actor in his turn must take back the stage, capable as no one else is to inhabit this vital and performative space, to understand his audience, to painstakingly prevent the dissolution of the group's identity, claiming the theme of fidelity—both a cross and a de-

[8] References to Shakespeare's *Richard III* are found in both *Throw Momma from the Train* and *The War of the Roses* by DeVito.

light—between the couple, marriage, family, even in the mafia sense. Following this reasoning, it means building houses in a certain way (*Mac*), ensuring that an African-American girlfriend knows how to make tomato sauce (*A Bronx Tale*), and in general rigorously and extensively cooking Italian cuisine (*Big Night*)—and staying as far away as possible from compromising with the adoptive country becomes an absolute principle. Possible failure is part of the danger in undertaking this ancient and noble profession. Not having a job, remaining alone without a companion and without children is the unfortunate fate of the immature main character Tommy Basilio in *Trees Lounge*, on which Buscemi (1996) personally chose to work. This failure from Long Island is the quintessential indolent Italian American who has stopped believing in a bright future, who does not know how to have an emotional attachment and can neither procreate nor pass down the secrets of his trade or wisdom gained during his dull existence; his existence as a drifting loafer offers no escape. Tommy allows himself to descend into being a regular customer at a bar, who is neither witty nor tragic, and where the only thing possible is to age slowly; once his sex drive falls off and the bar banter ends, all that is left is to become ill and sooner or later die. The present offers very few reassurances to Italian Americans. Buscemi is the most pessimistic of the "Dir-Actors" and in *Trees Lounge*, he mercilessly outlines the obstacles. Once the boundaries have been marked, leaving these small, unchanging worlds is an undertaking that is no longer worth the effort. The energy is lacking and everything is missing to take control of the situation and to begin to believe in the future again, and as it was in Stallone's first movie. The drive which once characterized Turturro has also declined. In *Mac*, the film is narrated through flashbacks, and in the penultimate scene told in the first person, Turturro stresses the particularly Italian American trait of exercising power over the things they have made themselves; whether it is a house, a son, or a film makes no difference. While leaving tangible traces of his "savoir fare," he is resigned to cement everything around him without being able to strengthen his family: having his two brothers quit is the price to be paid for having total control. In this case, the character also expresses the view of director-screenwriter:

> MAC: I have to check up on everything. Everything. I have to do everything. Everything. Every last thing I have to do. All of it. All of it. I have to do everything. Everything I have to do. All me. I have to do everything. All of it. Everything.

In the final sequence, the essence of handcraftsmanship is lauded, as well as the artistic and creative aspects of being a master mason and the sole proprietor of a family business. In the form of wisdom handed down from father to son, it also deals implicitly with a poetic statement typical of an Italian American "Dir-Actor":

> MAC: Do you see the finish?
> SON: Yes.
> MAC: That's care. It's someone who does not walk away. You can see that they took their time with it. I made that myself. We made it together, me and my brothers, from the ground up. In the past, when craftsmen were around, this is the way you had to be. Not like today. Today it's who ... knows how to talk who is respected. But before, it was who knew how to do. Instead of chitchatting. You needed to know how to do. And that person was respected. Beauty is knowing how to do. And doing it. Once you reach your goal, it's beautiful, it's nice. But what counts is doing.

These are "pearls" of elementary and cultural wisdom that echo those imparted to him by his deceased father, who returns to address his three sons again. Mac and his brothers should always bear the following in mind:

> FATHER: From a person's work you understand the person. Did they build Rome in a day? There are only two ways to do things: my way and the right way. And both of them are the same exact thing.

The poetic for Turturro, who in *Illuminata* even imagines directing a gossip orchestra in the theater's foyer, is also politics. The politics of the "Dir-Actors" to be (often) present in their own films is crucial. Their presence on the set or in the neighborhood is everything. It is the mafia boss Sonny, played by Palminteri in *A Bronx Tale*, who declares it as a reminder addressed to a young apprentice. Palminteri is the author *in pectore* of this Scorsese-esque film, as opposed to De Niro who is the official "Dir-Actor." The dual direction also affects the plot of the film, which shows the opposition between the high-ranking mafioso Sonny/ Palminteri and the blue-collar bus driver Lorenzo/De Niro. Both characters claim the right and the duty to steer Calogero in the right direction and therefore to teach him important life lessons. Lorenzo is his true father, while Sonny is a father-figure. They each give the boy different names: Lorenzo calls him Calogero (which is Palminteri's real

name; Chazz is the diminutive form), while Sonny, in keeping with following the shortest route offered by illegal means, rebaptizes him as "C." But it is also Sonny who articulates the basic principles of political realism, directly quoting Machiavelli. Machiavelli and Shakespeare both embody the sixteenth century, the period in which the conception of power becomes pragmatic, ruthless, and realistic. The sixteenth century also produces and spreads the *Commedia dell'Arte*. Sonny correctly paraphrases Machiavelli, but only in reference to his own territory in the neighborhood. But as it is already clear, in films by Italian American "Dir-Actors," this territorial control coincides with the territorial control of the production:[9]

> CALOGERO/C: You are always right. You're always right!
> SONNY: Eh, maybe. If I was, I wouldn't have done ten years in the joint.
> CALOGERO/C: What did you do every day?
> SONNY: There's only three things to do in the joint, kid: lift weights, play cards, or get into trouble.
> CALOGERO/C: What did you do?
> SONNY: Me? I read.
> CALOGERO/C: What did you read?
> SONNY: Ever hear of Machiavelli?
> CALOGERO/C: Who?
> SONNY: Machiavelli. He's a famous writer from 500 years ago. Availability. That's what he always said.
> CALOGERO/C: Availability?
> SONNY: That's right. Listen to me. You know why I live in this neighborhood? Availability. I want to stay close to everything ... because being on the spot, I can see trouble immediately. Trouble is like a cancer. You got to get it early. Otherwise it gets big and kills you. You got to cut it out. You're worried about Louie Dumps? Nobody cares. Worry about yourself, your family, the people that are important to you.

The political discourse continues:

> SONNY: That's what it comes down to: availability. The people that see me every day, that are on my side ... they feel safe because they know I'm close. That gives them more reason to love me. The people that

[9] TRANSLATOR'S NOTE: Dialogue excerpted from www.script-o-rama.com/movie_scripts/b/bronx-tale-script-transcript.html.

want to do otherwise, they think twice ... because they know I'm close.
That gives them more reason to fear me.

CALOGERO/C: Is it better to be loved or feared?

SONNY: That's a good question. It's nice to be both, but it's difficult. But
if I had my choice ... I would rather be feared. Fear lasts longer than
love. Friendships bought with money mean nothing. You see how it is.
I make a joke, everybody laughs. I'm funny, but not that funny. Fear
keeps them loyal to me. The trick is not being hated. I treat my men
good. But if I give too much, I'm not needed. I give just enough where
they need me but don't hate me. Don't forget what I'm telling you.

The lines of Machiavelli quoted by Sonny/Palminteri brings his speech to a
crucial point: the political definition of a minority community, regardless of
its configuration, is always on the defensive, just as the small Italian states
had to come to grips with foreign invasions in the sixteenth century. It is a
political idea intended as an existential opposition between friend and
enemy, between the insider/resident and the outsider/foreigner, which is
at the center of Schmittian theories derived from Machiavelli's strategic
approach to realism in conflicted terms, leading to war.[10] Italian Americans
become "Dir-Actors" to distinguish themselves in or from Hollywood;
however, they do so without approval and contrary to the laws of the mar-
ket, and using the same logic that caused the newcomers to resist the larger
American context, in which they arrived unprepared and disillusioned.
There are still many who recognize themselves to be different from the
others, from the Americans — those who usually make genial films. They
open themselves up using many actors, as if their conscience, recalling
Pirandello, were a piazza. It is a piazza that is open to all members of the
same community, but closed to those who are outsiders. Because the "out-
side" is a jungle where artistic autonomy is negotiated; it is an American
jungle received as a dowry from their ancestors.

Translated from the Italian by Giulia Prestia

[10] Carl Schmitt, *Le categorie del "politico"* (Bologna: Il Mulino, 1972).

Gender and Ethnicity in Italian/American Cinema: Nancy Savoca and Marylou Tibaldo-Bongiorno

Anna Camaiti Hostert
ROME, ITALY

In his *Introduction to Visual Culture*, Nicholas Mirzoeff explains the main characteristic of our society by emphasizing that the "focus on the visual as a place where meanings are created and contested" is due to the fact that the "world-as-a-text has been replaced by the world-as-a-picture." "Such world-pictures cannot be purely visual, but by the same token, the visual disrupts and challenges any attempt to define culture in purely linguistic terms. One of the principal tasks of visual culture, therefore, is to understand how these complex pictures come together" (7). Consequently, visual culture studies, so called *visual studies*, recognize that the "visual image is not stable but it changes its relationship to exterior reality at particular moments of modernity" (7). Visual studies is concerned with visual events in which information, meaning, or pleasure is sought by the consumer in an interface with visual technology, which is anything that will enhance natural vision, from paintings to cinema, to television and the Internet. This new emerging body of post-disciplinary knowledge comes from cultural studies, whose focus crosses the borders of traditional academic disciplines and concentrates its attention on the processes of formation of ethnic, racial, religious, and gender identities. Identity becomes more a problem to analyze than a solution, because it is continuously in progress changing its structure. In this sense, culture be-comes a tactic of knowledge, which studies the genealogy and the func-tions of everyday postmodern life. The definition of culture does not be-long to any one discipline but it concentrates on those moments in which the visual is an element of debate, contestation, and definition in terms of collective and individual identities.

Applying these principles to the analysis of the Italian American *dias-pora*, we will notice that, as Anthony Julian Tamburri states in his body of work and particularly in his essay "Italian Americans and the Media:

Cinema, Video, Television," the construction of the Italian/American identity shows the impossibility of deciphering it under a monolithic perspective. Furthermore, the criteria that supersede the formation of that identity seems to emphasize a debatable perspective full of internal and external contradictions that allow "to carry forward the debate" in a more constructive way especially under a visual point of view (2005, 305).

Keeping this perspective in mind, I will focus my attention on the conflicting aspects of the formation of Italian/American gender identities in the cinematography of Nancy Savoca, and I will compare it with a recent work of a younger woman director, Marylou Tibaldo-Bongiorno, who shows that those contradictions which produce pain, uneasiness, and suffering in the subjects who experience them, instead, turn to be an asset which makes American society a better place to live.

Nancy Savoca is mainly concentrating on portraying hyphenated identities, especially Italian, from a woman's point of view, but, following Tamburri's statement, she is always stepping in and out of these ethnic worlds in order to focus the audience's general attention on what I would call *transcultural* processes.[1] Gender is the key concept throughout which she analyzes all this *in fieri* process. If, as Homi Bhabha writes, "private and public, past and present, the psyche and the social develop an interstitial intimacy ... which questions binary divisions" and whose "in between temporality" will be the place of their narratives, then female subjectivity will always be represented as a hybridity, a borderline existence, a difference "within a subject" (254). Women inhabit that space and it is from there that they will tell their stories, showing the conflicts, questioning all dualisms, and "bridging the home and the world" (254).

Cinema, located by definition in a space of in-betweenness, is Nancy Savoca's preferred medium in which to narrate those stories that, as she says, "must be accessible to everyone," and it is also the privileged location from which to observe and describe the conflicts that arise from the conflagrating experiences of different ethnic worlds.

As she told me in a telephone interview:

[1] Tamburri in an old, and we can now say, avant-garde essay, "Italian/American Cultural Studies: An Emergence(y)?" (1996), addresses the question of ethnic literatures in the USA and their relationship to the dominant culture, coupling this discourse with an examination of postcolonial literature. His conclusion toward the creation of Italian/American cultural studies is that the differences between the several subaltern ethnic groups should be "grounded on equal terms through the exploratory lens of cultural studies—one thing that must take place both within and outside the Italian/American community" [324]).

In my family we all watched movies, we all loved movies, we all re-
peated the stories of the movies. When I was little and we lived in New
York, I always watched Italian, Mexican, Argentinean, and, of course,
Hollywood movies. For us it was like therapy because we went through
the problems of the characters like they were our own stories. There was
a connection between what happened to them and to us. Since that time I
knew cinema was a very powerful and a very strong medium capable to
portray the feelings of people. Also, in my family, everyone acted out
stories, especially women. If they had to tell you how someone walked
or acted in a particular situation, they would stand before the kitchen
table and would imitate the way she or he spoke, moved, cried, laughed
and so on.

Her films seem to embody a gendered perspective and portray stories
that emphasize the unheard voices of invisible fragmented subjectivities,
making — through the contradictory feeling and positions they occupy in
society — visible their bodies, without glamorizing them. As a woman, the
awareness of not belonging anywhere, as a permanent existential condi-
tion leads her in the direction of always going in and out from her ethnic
backgrounds. Savoca continued to explain:

When you are a woman, you live by definition in-between, your identity
is never *secure*, so to speak, you are not securely on one side or the other.
And my ethnic identity — my parents coming from two different cultures
being transplanted in a third culture — reinforces this insecurity. Being a
woman, as the outside culture, and being an independent filmmaker
keep me outside the mainstream of things and give me the ability to say
that I am never sure. I do not have an opinion that sounds like "I know
that is what it is." What I hate to do in the movies is to tell you what I
think, and that is the way you should see it. The reason why I make
movies, and I love making them, is not because I know something, but
because I don't know something. If I do not understand a particular
situation, that drives me crazy. I have to find out more about it and
explore it. To me it is much more interesting to say I want to know more
about something than to say "it is black and white and you have to stand
here," because this is never true anyway. To me, I like to say "it's all
gray, we better get in here and look around to see what's going on."

One of the things I find really interesting in having different ethnic back-
grounds — even though they are both Latin and have a lot in common —

and being born and raised here, is that all these differences are actually helping me. From my family, I have inherited this very emotional, dramatic, poetic, and unique way of looking at this culture from the outside, because they were immigrants and yet, being an American, I am an insider. When I go back to the country of my origins I realize that I have a lot of Americanism in me. The different cultures I have in me are so against each other that they create a tension that is actually therapeutic. There is this tension between, on the one hand, the Latin backgrounds—Italian and Argentinean—and on the other, the puritanical Anglo-Saxon way of living, which I have learned to except and to deal with. The result of this clash is not Italian, not American—it is a weird mix. The conflict comes because in those cultures, either Italian or Argentinean, there is more harmony, and when people from these countries come here, they experience a huge difference and they have difficult times in manifesting their emotions. A lot of Italian Americans, either performers or artists, have had that same cultural clash, and we work with it. Ethnicity is a plus, it always brings me back—even when the characters do not come from my background—to the stories I have heard from my parents. So I see it as something that makes me richer, brings into my stories the conflicts, which are at the heart of any drama, and allows me to the express the passion I have inherited.

We can see this even in the movie *24 Hour Woman* (1999), where the main character Grace, a TV producer, played by Rosie Perez, clearly a Latina, though it is never overtly mentioned, becomes unexpectedly pregnant. Her husband, a main performer in the show she is producing, is also trying to cope with being a father and an actor, leaning more toward the latter and leaving Grace alone to deal with the new parental condition. Her life dramatically changes, and she experiences how difficult it is for a woman to work and be a mother.

Women's social issues are very important to Savoca, as is shown in *If These Walls Could Talk*, a 1996 Cable-TV show, a trilogy on the theme of abortion spanning a forty-year period: 1952, 1974, and 1996. The feelings of Savoca's characters—usually expressed more directly and passionately by women, in many different ways—are, in fact, the leading motifs that introduce us to the plot, and give meaning to the other male characters and to their actions as it happens in the movie *Dogfight* (1991). The story, set during the Vietnam war, is of a young Marine who takes on an "ugly date" contest, a girl of Italian origins. That male-female relationship, seen

through the eyes of Rose (Lily Taylor) explains to Eddie how cruel that "game" was, all of which becomes a metaphor of a country that initiated a conflict with an emboldened attitude, and subsequently returned hurt and puzzled. The movie poetically mirrors the political environment of those years. Starting from the terrible and misogynist behavior of young soldiers who are leaving the day after for Vietnam, and who will all die except for Eddie "Birdlace" (River Phoenix), the movie becomes a critique of a boys club environment in which the war was initially a game, similar to the "ugly date" context, and in the end, becomes a bloodbath of wasted lives. Rose, the Italian/American girl, with her ethnic background, not casually chosen, becomes the *trigger* of a social and political critique of the American society in those times.

Both *True Love* (1989) and *Household Saints* (1993) originate from a gendered point of view and both deal directly with Savoca's Italian background. The first movie tells a story of a young Italian/American woman, Donna (Italian for woman, played by Annabella Sciorra), who, in preparing for her wedding, ultimately realizes she may not want to proceed. When she abandons her doubts, and the wedding celebration is in full swing, the time for taking pictures arrives. At that point, one already sees in the faces of the newlyweds the sorrow that will come up later. In a scene, which reminds us of the beginning of Scorsese's *Mean Streets* (1973), when the rituals of the Italian/American families take place on screen (baptisms, communions, weddings, funerals, and religious festivities like Christmas and Easter), all the relatives and friends make a wish for the married couple. The first we hear in Italian is "auguri e tanti figli maschi" (best wishes and [may you have] many sons), which reinforces the subaltern role women have in the traditional Mediterranean family and the macho stereotype about Italian men. The movie also depicts the new albeit slowly emerging mentality of a new generation of Italian/American women. There are different female characters here who not only have doubts about their respective roles, but who are also seeking new ways of expressing themselves and dealing with the contradictions they encounter along the way.

The second movie shows, as Savoca described herself, the three levels of spirituality: the first being the one of the grandmother, who asks God for something and will retaliate if she does not get it; the second, the mother Catherine, according to whom God exists yet there is no need to approach Him with petty problems; and the third, the daughter, Theresa,

who instead of asking what God can do for her and/or neglecting Him, poses the question how she might serve Him. Her answer is found in the daily, mundane tasks she can perform for others, which also indirectly implies, and Savoca confirmed it, the importance of social and political actions that can help other human beings. Here, religion becomes ingrained, as it is in Italian culture—a metaphorical tool that makes manifest gender roles, stereotypes, and cultural gaps that conflict with these women's daily lives in America.

At the heart of both films, there is the relevant theme of how to bring about social change without following the "rules," the stereotyped conventions, which set people, especially women, into fixed identities. Savoca discusses these issues starting from a gender/ethnic perspective, which both stem from her Italian background. From there, Savoca alternates, and it is from the power of feelings out of which she seems to re-emerge, illustrating not only the American situation, but also posing a global and old problematic question of social agency: What to do now? How to act in order to contest the rules of this male world, which create stereotypes? Of course, we do not have answers to all these important questions, but it seems that the power of images, and particularly the ones of cinema, can help shape our world in a direction we could not imagine before.

Tarantino's *Pulp Fiction* (1994) was a step forward, giving rise to a new generation of ironic filmmakers who accentuate the detachment from a past they no longer find threatening. In fact, they are able to make fun of the stereotype of the *mafioso*, *pizza*, *nonna*, and *tarantella* with a love of ancestral culture, whose traces they see in their own daily life.

This is the case of Marylou Tibaldo-Bongiorno who directed *Little Kings* (2003) in which she tells the story of three brothers who, for different reasons, live very complicated and contradictory personal relationships, especially with women. Already in the title we can detect a sort of irony from the denomination that the director, a woman, uses for the brothers, calling them "little kings." Dom, a teacher of biology in a local high school, where a student is madly in love with him, has an infatuation for his pregnant sister-in-law, Lori, with whom he goes to Lamaze classes in his brother Gino's place. He, instead, is engaged in a torrid, steamy affair with a lawyer who represents his construction company in labor negotiations. The third brother, Johnny, is in love with his teenage cousin with whom he is currently having sex. Dom is the only one who

knows everything about his brothers, both Gino's extramarital affair and Johnny's taboo relationship with their cousin. Dom is also the only one who seems to exhibit some semblance of sensitivity, almost serving as a maternal figure for his two brothers, which leads one to surmise that even the director has a particular affection for him. The turning point comes when Lori gives birth. Tibaldo-Bongiorno, with a crosscut editing, and in a very efficient and humorous way, shows us the heavy breathing of Lori in labor and her husband's orgasm while making love to his mistress.

The relationship between the brothers is strong, but at the same time rife with contrasts and contradictions. Gino, the most *macho* of the three, often uses his ethnic background to justify his behavior, while the other two either criticize directly, like Dom, or absolutely ignore it, as in the case of Johnny.

What struck me in this very clever movie is the irony, the sense of humor, which animates the affectionate and contradictory relationship among these brothers. At the movie's conclusion, after what seems to be a series of irreconcilable differences, they find solutions in very different ways to their problems both inside and outside the family, reconciling with the acceptance of their own ethnic origins. In this way, the film's finale also recalls Campbell and Tucci's *Big Night* (1996). These characters are no longer victims to exclusion, segregation, or discrimination from the cold Anglo-Saxon world. Furthermore, they are empowered by their positive changes as they demonstrate their overriding set of family values that makes them and their family more cohesive. Their emotions and passions, which once made them second-class citizens, now make them more responsible and responsive to others, as they are able to articulate their feelings without repressing their sensuality. They are also able, especially after confronting each other, to reach an interior equilibrium that contributes to improving the relationships among individuals, demonstrating a reversal of their roles and of their ethnic subaltern position. Let me conclude by saying that it is no casual coincidence that the artist who delivers this message is a woman.

Works Cited

Bhabha, Homi. *The Location of Culture*. New York: Routledge, 1994.

Camaiti Hostert, Anna. *Passing. Dissolvere le identità, superare le differenze*. Roma: Castelvecchi, 1995.

_____. *Sentire il cinema*. Firenze: Cadmo 2002.

_____. *Metix. Cinema globale e cultura visuale*. Roma: Meltemi, 2004.

Camaiti Hostert, Anna, and Anthony Julian Tamburri, eds. *Screening Ethnicity. Cinematographic Representations of Italian Americans in the United States*. Boca Raton: Bordighera Press, 2002.

Cartwright, Lisa. "Film and the Digital in Visual Studies: Film Studies in the Era of Convergence" in Nicholas Mirzoeff, ed. *The Visual Culture Reader*. New York: Routledge, 2002.

Chow, Rey. *Writing Diaspora: Tactics of Intervention in Contemporary Cultural Studies*. Bloomington: Indiana University Press, 1993.

_____. "A Phantom Discipline," in *PMLA* (October 2001): 1386-95.

Macrì, Teresa. *Postculture*. Roma, Meltemi 2002.

Mirzoeff, Nicholas. *Introduction to Visual Culture*. London & New York: Routledge, 1999.

_____. *Diaspora and Visual Culture. Representing Africans and Jews*. London-New York: Routledge, 2000.

_____. "Ghostwriting: Working Out Visual Culture" in Michael Ann Holly and Keith Moxey, eds., *Art History, Esthetics, Visual Studies*. Williamstown: Sterling and Francine Clark Institute, 2002.

Mitchell, William J.T. *Picture Theory: Essay on Verbal and Visual Representation*. Chicago: University of Chicago Press, 1994.

Mulvey, Laura. *Visual and Other Pleasures*. Bloomington, IN: Indiana University Press, 1989.

Shoat, Ella and Robert Stam. *Unthinking Eurocentrism: Multiculturalism and the Media*. London-New York: Routledge, 1994.

Tamburri, Anthony Julian. "Italian/American Cultural Studies: An Emergence(y)?" in *Through the Looking Glass: Italian and Italian/American Images in the Media*. Mary Jo Bona and Anthony Julian Tamburri, eds. New York: AIHA, 1994. 305-24.

_____. *Italian/American Short Films and Music Videos. A Semiotic Reading*. West Lafayette, IN: Purdue University Press, 2002.

_____. "Italian Americans and the Media: Cinema, Video, Television" in *Giornalismo e Letteratura tra due mondi*. Franco Zangrilli, ed. Caltanissetta: Sciascia, 2005. 305-24.

Director's Cut:
Italian Americans Filming Italian America

John Paul Russo
UNIVERSITY OF MIAMI

When we look at film with a so-called "ethnic" theme, how do we know when the ethnicity is intrinsic to the portrayal of the characters and the unfolding of the themes, and when it is, instead, mere wallpaper or appliqué around a more or less universal story about family, conflict, and change across generations? How do we recognize and differentiate, critically speaking, between a film that is about a family that is Italian American, and a film that could only be about an Italian American family? Contemporary Italian American directors have sought for authenticity in the presentation of ethnic patterns, trading on the now familiar profile: anarchic individualism, family and food, *bella figura*, the piazza, theatricality (opera), tough guy and mamma's boy, realism, immanentist Southern Italian Catholicism, death and memory, cunning, virtuosity, and sincerity—to name the more salient. Where non-Italian American directors such as Stuart Rosenberg in *The Pope of Greenwich Village* (1984), John Huston in *Prizzi's Honor* (1985), Norman Jewison in *Moonstruck* (1987), or Harold Ramis in *Analyze This* (1999) and *Analyze That* (2002) have rendered, with only minimal success, the ethos and iconicity of the group, Italian American directors have exhibited a cultural grasp and subtlety borne of closely observed experience, even while accounting for what Benedetto Croce called a stereotype's *granello della verità* (grain of truth). They have interpreted the early history of immigrant experience, gradual assimilation, and current status, whether living in Little Italies, or dispersed through the cities or the suburbs. Three films of the past decade or so—Helen De Michiel's *Tarantella* (1996), Penny Marshall's *Riding in Cars with Boys* (2001), and Marylou Tibaldo-Bongiorno's *Little Kings* (2003)—demonstrate "from within" the enduring power of ethnic archetypes.

The theme of De Michiel's *Tarantella* is familial memory centered in

the domus and preserved by women. In the opening scene Diana Di Sorella (Mia Sorvino), a professional photographer, is taking shots of skyscrapers in an empty concrete square when three children interrupt her, pleading that she take their picture. She tells them to stop bothering her. The hard-edged skyscrapers are symbols of modernity and will contrast with the small frame houses in Diana's old neighborhood. Similarly, the emptiness and silence of the square can be compared with the men playing bocce or a woman dancing the tarantella. The children represent the urban poor, exactly in the position of Diana's immigrant grandmother and mother on their arrival in America. Diana's brusque unwillingness to accommodate the children reflects upon her rejection of her past, her refusal to return to Little Italy, and her suppression of personal and familial memories, seen in flashback or, in an aesthetically sound decision, retold through a puppet show. Parenthetically, in *Underworld* Don DeLillo makes these contrasts between Phoenix, Arizona, and the Bronx, Little Italy, where he grew up.

The film tells the story of Diana's return to Little Italy, following her mother's sudden death (her father had died in her infancy). An only child, she had been too busy to appreciate the seriousness of her mother's illness and feels terrible guilt. Certain phrases recur in her voiceover: "strangers which they were and I am. A stranger with the Italian last name." Such a self-conscious statement of alienation could not have been said by Loretta Castorini (Cher) in *Moonstruck*. Loretta is a funeral home secretary (rather obviously, the death theme) and, in contrast to Diana, still lives with her parents, and insists on living with them if she remarries. Jewison does not examine the split between a specifically ethnic identity and a modern urban identity. Also, for him, the "Italian last name" is a source of broad humor: all the families have similarly funny sounding, complicated names (Castorini, Cammareri, Cappomaggi, the funeral home is Nucciaroni), implying that all Italians are the same: moonstruck, obsessed by love.

"How soon should I come?" Diana asks the family lawyer: so reluctant is she to return that she has to be told to come immediately, as if someone else should bury her mother. She rummages through her closet and finds a black dress. "Is this Italian enough?" she asks her bland, unemotional WASP boyfriend Matt (Matthew Lillard) — clearly a stereotype. "Do I shroud myself in mourning for the rest of my life?" After leading the funeral procession through the old streets, she prepares to clean out

the old house, playing her mother's old records: one hears Bellini's "Ah non credea mirarti" from *La Sonnambula* (Ah! I did not think the flowers would so quickly wither). She will soon be taking care of her mother's songbird, named Puccini, which has stopped singing. Going back to Joseph L. Mankiewicz's *House of Strangers* (1949), opera is common in films with Italian Americans, either for its passionate arias or its exhilarating rhythms of the life force: Rossini is omnipresent in *Prizzi's Honor*, which also has "Questa quella" from Verdi's *Rigoletto*; a long scene in *Moonstruck* takes place at the Met (showing *La Boheme*); Scorsese's *Raging Bull* has the intermezzo from Mascagni's *Cavalleria Rusticana*; the climax of Coppola's *Godfather III* contains two scenes (out of chronological order) from *Cavalleria Rusticana* at the Teatro Massimo, Palermo, and many more.

The physically and emotionally exhausting task of cleaning out the house is not abetted by Matt's arrival and they soon quarrel: "I'm going to explore this neighborhood," he barks, "and see if I can get a clue as to who you really are." But she is visited by her mother's comare, Pina Di Nora (Rose Gregorio), who presents her with a "dream book," a "journal" written in Italian by her grandmother and mother, and containing family history, recipes, pictures, and other mementoes, put together with extraordinary care—so much so that Matt asks, "Was your mother an artist?" Diana spurns the book, in its strange language, because she fears it holds nothing but old rules on how to cook, clean, and sew to be the "perfect little Italian girl." Yet the book exerts its aura: Pina reads from it during the film and Diana is won over to an understanding of her family past.

Far from being a superficial ethnic marker, Italian food in *Tarantella* symbolizes plenitude, the very opposite of Southern Italian *miseria* to which it is dialectically related. There are the large vegetable and bushy fruit gardens behind the house, the preparation of meals, the toasts and rituals of the dinner. Diana questions the time it takes; "you make time for what is important," responds Pina, who teaches Diana how to peel tomatoes *all'italiana* (by pressing a knife edge against the skin all around, then pulling it off). "So I understand that this is part of being Italian, but what about the other parts?" Diana questions, "Am I going to lose everything that I think I am if I try to put this Italianness into my life?" Pina does not respond directly; Diana needs a model, not categorical lessons, so Pina says, "did your nonna ever show you how to make crostoli?" Yes, she recalls: "that's Italian, hold on to that," says Pina. Diana

learns the secret of putting fragrant herbs (salvia, malva, oregano) under one's pillow to sleep. So close does Diana become to the quasi-magical garden—and by synecdoche, to the Italian past—that in one of the film's best scenes, Diana, insomniac, wanders into the garden where she falls asleep. Near the end of the film, Diana underlines what she has learned: *mangiando, ricordo* (when I eat, I remember). In *Godfather I*, Don Vito (Marlon Brando) dies in his fruit and vegetable garden. In *Prizzi's Honor*, Charley Partanna (Jack Nicholson, whose parents were Italian) prepares dinner for his father Angelo (John Randolph); but the direction is utterly perfunctory; the food is not integral to the film. *Moonstruck*, too, has the obligatory representations of food—local restaurant, family dinners, bakery. The dinner scenes fall flat. Ronny Cammareri (Nicholas Cage, an Italian American), a baker whose name sounds like the Italian word for waiter (*cameriere*), plays on the earthiness of bread, which becomes a metaphor for sex.

Perhaps to avoid the stereotype of the Italian woman as a life force, De Michiel makes Pina restrained, unsmiling, and sententious (there may be a bit too much of "the ancient wisdom of the Italians" in the script). Not uncritical of the past, she repudiates as "ridiculous" an apothegm in the dream book, "woman's silence is the honor of the house." How could we ever get to know each other if we didn't talk, asks Diana? "The curious monkey finds only trouble," another saying, reveals the anti-intellectualism of peasant culture. "Patience, obedience, respect, especially for the family" reads yet another lesson. Strolling through the streets, they hear a tarantella and see a woman dancing: Diana's first response is rejection, recalling weddings with "a bunch of old ladies dancing around in black." Pina corrects her, however, and says that *this* street dancer is not dancing the tarantella correctly. The dance itself is meant to remove the poison of the insect and of life itself, through a kind of dancing that is also a spiritual therapy. Pina urges Diana to be "down to earth": "touch and smell," "don't trust anything except what's in front of your eyes," "pull yourself through your life with your own hands." And "listen with your own heart." Apothegms are a part of films about Italian Americans by non-Italian America directors too, pointing to a folk cultural past.

The puppet episodes, which punctuate the film, tell a story of their own: Diana's grandmother Serena was prevented by her father from going to America. Instead, he married her off to a wealthy town bully, Barzalone ("big joke") who had made money in America and returned

with a big car, and planned to settle down. At this unhappy wedding, a schoolteacher, who admired Serena from afar, presents her with the dream book; De Michiel thus weaves together the contrasting themes of violence and artistic creation. When she has a daughter (Diana's mother), not a son, he is upset; later he beats and threatens her to the point where she retaliates by poisoning him (the tarantella theme) and running off with the child to America. "For a murder that occurred fifty years ago, for this, I have had to feel alone my entire life," cries Diana; "couldn't she have just loved me anyway?" Like the dream book, the puppet show expresses the high importance given to artistic creativity in the stereotype.

A deeply soulful aria from Wagner's *Lohengrin* (Act II, scene 2), sung in Italian, is playing when Diana enters her mother's bedroom. Like an operatic sleepwalker, she opens a drawer and takes one of her mother's slips, which she puts on, then takes out her mother's dress and lays it on the bed. On the soundtrack one hears the aria "Aurette a cui si spesso" (Breezes to which so often) but beginning with the second verse, "Now that delight has stirred me,/My joy I'll breathe to you." Diana replays it, dancing to it this time. In a surreal sequence, she approaches another bed, her mother's death bed, and kneels beside it; there is a crucifix upon the wall. Diana resurrects the spirit of the mother in her own self. "Death is the silence that goes beyond words: it is not to be feared." As she makes a vigil by the bed, one hears a thumping, like a drumbeat of death — the realtor Frank (Stephen Spinella) pounds a FOR SALE sign into the ground, the end of the era. Still, later, there is a repeat of the kneeling by the death bed, this time with Pina; the bodies of Diana's parents are shrouded, a sign of closure. Catholic ritual is made palpable not in a church, but in the home: the domus is sacred.

"I should have come back sooner," Diana tells Lou (Frank Pellegrino), the wise family attorney who has remained behind in the old neighborhood, "I missed out on a lot." "You did," he replies, "but at least you came back. It's not that bad now." Though the neighborhood and the people are changing, "it's just the natural progression of things, like it was when our families first moved here." Frank reminds us that the neighborhood is "mixed" and that there is a "Chinese" restaurant down the street. The film ends with Pina's death, as she rests on the beach, facing the ocean and looking out towards Italy; but this time Diana is present. "The years pass and women die," Diana says in a voiceover; "what do their daughters take with them?" She answers her own question in the

final scene. She stopped clearing out the house, but the new buyers are willing to take all the furniture, much to Frank's surprise. Leafing through the dream book, he asks Diana the same question that Matt had asked at the outset: "Was your mother an artist?" This time Diana has an answer: "I think so. We all are." So, Frank asks, is the book all she is taking? In the final words of the film, "Yeah, that's it."

That is all she needs, and it symbolizes the entire past, to which she will now contribute: and she may recall Pina's remark: "Remember to write from your heart and the rest will come through. Always cherish the book." The theme of the endurance of art has one last emphasis: as the old house appears on the screen, for the first time Puccini is whistling cheerfully.

Penny Marshall's *Riding in Cars with Boys*, based on Beverly Donofrio's captivating memoir (1990) of the same title, traces the life story of Beverly (Drew Barrymore), a teenager who becomes pregnant in the mid-60s, before oral contraception became common and before abortion became legal. This put a sudden end to her dream of going to college and escaping her environment, a lower middle-class mixed ethnic community of Wallingford, Connecticut. Her father (James Woods) and her mother (Lorraine Bracco) arrange for a quick wedding ceremony, give some financial support, and leave the rest to public housing; on her part, she struggles against her fate, attempts to balance night school with raising her son Jason, and puts up with her alcoholic, drug-dealing husband who eventually abandons her. At the film's end, in the mid-80s, Beverly has stopped blaming her parents, her background, her husband, and (worst of all) Jason (played as an adult by Adam Garcia), and has taken responsibility for her actions, to the point of apologizing to her son for her mistakes. Far from blaming him, she says he is the reason that she has become a better person that she would otherwise have been. (In the film the real Beverly and Jason Donofrio are extras at the wedding ceremony.)

While Donofrio's memor is thoroughly ethnic in its frame of mind, the film is oddly otherwise. Marshall's decision to cast Drew Barrymore in the principal role made for a Beverly that does not look like or act like an Italian American. Nor does James Woods. At least they do not, like Cher in *Moonstruck*, pretend to impersonate Italian Americans — they play their roles. Lorraine Bracco, on the other hand, is brilliantly successful in portraying an ethnic type, pointing out the lack in everyone else. Nor does Marshall appear to have intended a more broadly ethnic film. What seems apparent is that the ethnic stereotypes are fading in gradual

assimilation, which would be in keeping with conclusions of such sociologists as James Crispino and Richard Alba. Hence, to be Italian American in the suburbs of Connecticut is (almost) no different from being like any other hyphenated American or, for that matter, non-hyphenated American. Jason, who would be fourth or fifth generation Italian American, is thoroughly assimilated.

In Marylou Tibaldo-Bongiorno's *Little Kings* (2003), all the principal cast members are Italian American, which lends authenticity to the iconic representation of the clan. The film, which won the Palm Beach Film Festival Award for Best Feature and the Method Fest's Director's Award, is set in the New York metropolitan area and centers on three brothers. As "kings," they act like laws unto themselves, seizing their sensual pleasures and crossing moral boundaries in an almost anarchic way; as the derogatory "little" kings, they are mocked for pettiness and self-absorption within the extended family. Uttered three times at crucial moments in the film, the phrase "We're Italian" serves as a simple explanation, a badge of honor, a bad joke, an excuse, and finally an open question.

Each brother approaches a moment of personal and familial crisis. In his late twenties, Dom Santello (Dominic Pace) is a biology teacher at a Catholic high school in love with his pregnant sister-in-law Lori (Rita Pietropinto). As his name indicates, Dom is the main "king," the person who claims patriarchal authority; and, in that capacity, he is the narrator of the film as a whole. Gino (Mark Giordano), a year or two younger, is Lori's brash husband, a small-time contractor, who is besieged by unionizing workers and carrying on an affair with his labor attorney. As Dom says to Gino: "You know you're going to get in trouble, but knowing you, you probably won't." Johnny (Johnny Giacalone), the third "king," is still in college; he has come home for his mid-term break, having been visited by his seventeen-year-old cousin, Carlee (Robin Paul). They have fallen in love and spend much of the film trying to go to bed with each other, sometimes with family connivance, sometimes against it. In the end, each brother learns a lesson. Dom must put aside his love for his brother's neglected wife and resist the temptation from a female high school student. A new father, Gino must stop his cheating on, and verbal abuse of his wife. Johnny must take responsibility and marry his cousin who is pregnant. In each case the family (in particular, the mothers and wives, the "queens") wins out over the transgressions of the prepotent "kings." Appropriately enough, the film ends with a family ceremony: a shotgun wedding.

Stereotypical currents inform the film, often blending into one another: law vs. anarchy, sexuality, food, family, and religion. As with De Michiel, from the director's feminist viewpoint, Italian American masculine behavior exacts a heavy toll from the women in question. Nor are the women entirely absolved; their self-indulgence and refusal to accept responsibility are almost equally at fault for their predicament. Yet, far better than in *Prizzi's Honor* or *Moonstruck*, the film also examines the resilience of the family, its rituals of renewal, and its natural ability to help balance the equally natural tendency towards centrifugal individualism. The sound of breathing immediately establishes the feminine presence and the ideal of the family. Even as the film credits are unfolding, one hears Lori's deep breath exercises at a birth clinic; Dom is holding her, in the absence of Gino; he has been in love with her or thinks he is in love with her. Then she cries "Gino," much to Dom's annoyance, satirically undercutting his fantasy. Food is also essential in expressing the cohesiveness of the family. On first viewing, the preparation of a dinner seems chaotic, with everyone rushing about like Keystone Cops. On close inspection, however, the situation is in control: all the figures play their necessary part under the mother's watchful eye, and the proof is a sumptuous meal enjoyed by the entire family. This is, moreover, a wedding anniversary dinner for Dom's parents, celebrating a successful marriage. Tibaldo-Bongiorno well understands the significance of food: in a scene that depends on perfect timing the brothers are arguing loudly when suddenly Dom stops to let Gino taste the sauce he is making. All is stillness and silence for a second or two, the register changes to deep seriousness: Gino affirms it needs a little more time. Dom agrees, then the argument resumes.

If the family triumphs, individual characters often fall into the low mimetic category. Though Dom is taller and broader than his brothers, his size only seems to point up his ineffectuality. Stressed and finicky (what the Italians would call *pignolo*), he is continually associated with illness. He cannot prick his finger for a lab experiment for fear of blood; he faints at the birth of his niece; he suffers a head wound in a car accident. He ends up in the hospital at the end of the film when his "vampire" student Courtney (Tessa Ghylin) practices sympathetic magic upon him, his brother slugs him (believing wrongly that he has slept with Lori), and he feels nauseous from his moral misconduct. There are smaller details, as when he accidentally parks in the handicapped spot—and gets a

ticket. The film is strong on such details that add to the aesthetic coherence of the whole.

Religion informs numerous scenes, even via black magic. The two priests are Irish American, both by name and physical type. In the local church Dom confesses to the younger priest (Thomas Nelis), a family friend, saying that it has been one week since his last confession, indicating that he is a regular churchgoer. The priest vents his exasperation at his "incestuous" behavior, but at the same time he openly expresses his self-interest: he wants Gino's financial assistance for improvements to the church grounds. Father Connolly (Michael P. Moran), the high school principal, reprimands Dom for his sexual escapade with Courtney and fires him (he could have had him arrested for having sex with a minor). Father Connolly's lessons in morality to both Dom and Courtney carry conviction without pomposity; he is a practical man, holding a position of authority, involved in education, insisting upon the rules, troubled by the sexual anarchy of his biology teacher, but also forgiving—in sum, a solid representative of the Irish American Catholic Church.

Ethnic films of the kind we have been treating are a thing of the present, not of the past. The Hays Code of the 1930s and 40s made the representation of ethnic groups off-limits, with the exception of African Americans, and even there, restrictions were in force. The point was that a character was an American, not an ethnic, though frequently enough writers and directors found ways of slipping things past the censors. Today ethnic films are leaving a permanent record, but since non-Italian American directors fail lamentably to capture the Italian American experience, Italian American directors must relate and interpret, in the ethnic twilight, the various stages of assimilation.

Identity Crises:
Race, Sex and Ethnicity in Italian American Cinema

George De Stefano
NEW YORK CITY

> "I was never prejudiced towards anyone.
> I could never understand that in my neighborhood."
>
> —Chazz Palminteri, actor & screenwriter

Italian American neighborhoods not infrequently have been the sites of racial conflict and racist assaults. In such cities as Chicago, Newark, Philadelphia, and most of all New York, Italian Americans, mainly young males, have responded to what they perceived as African American threats to their territorial dominance with acts of violence.

During the 1980s, two particularly notorious racial crimes occurred in predominantly Italian American sections of New York. In 1986, in the Howard Beach section of Queens, a group of mostly Italian American youths attacked several black men whose car had broken down in the area; they chased one of the men onto a nearby highway, where he was struck by oncoming traffic and killed.

Three years later, in the Bensonhurst section of Brooklyn, Italian American young men surrounded several young black males whom they believed a local woman of mixed Italian and Puerto Rican ethnicity had invited to the neighborhood. The encounter ended with one of the blacks, a sixteen-year-old named Yusuf Hawkins, shot to death.

The Howard Beach and Bensonhurst incidents shocked not only New York City and the United States; these lethal assaults were reported and analyzed by media worldwide. The consensus of the commentary was that American racism is alive and well, and particularly among urban Italian Americans.

Organizations claiming to represent Italian Americans did not distinguish themselves in their response to these incidents. Defensive posturing, boilerplate denunciations of prejudice, and even silence took the

place of principled leadership.

Joseph Sciorra, a folklorist and Associate Director of Academic and Cultural Programs at the John D. Calandra Italian American Institute of the City University of New York, has written of being "deeply distressed by the excruciating silence emanating from the self-proclaimed leaders of the Italian American community" in the wake of the Yusuf Hawkins murder:

> I desperately searched for, but did not find, an Italian American of public stature who stepped forward in those early tense days to make an unequivocal repudiation of racism and violence, and to speak out against its manifestation in Bensonhurst. . . . A clear and authoritative Italian American voice was absent from the public sphere where the city's citizens could turn for understanding, resolution, and healing. The so-called leadership was struck by deep denial and paralysis.[1]

In contrast to the political obtuseness and discursive impotence of the "prominenti," several Italian American filmmakers have unflinchingly addressed race and racism, and the intersection of these categories with sexuality and ethnic identity.

In Robert De Niro's *A Bronx Tale* (1993), Raymond De Felitta's *Two Family House* (2000) and Tom de Cerchio's *Nunzio's Second Cousin* (1994), Italian American protagonists in urban, working class neighborhoods find themselves at odds with the prevailing racial and racist consensus of their communities. In each of these films, an Italian American male experiences a crisis that presents him with a choice: conform to oppressive tribal norms or refuse to abide by them. In each film, the protagonist makes the latter choice, with personal rebellion taking the form of a sexual relationship with a non-Italian American outsider.

Negative consequences ensue, including ostracism and alienation from their communities. But these men also gain from their rebellion, in moral education, self-knowledge, and personal integrity.

A Bronx Tale, adapted by actor-screenwriter Chazz Palminteri from his semi-autobiographical play of the same name, and directed by Robert De Niro, condemns both racism and organized crime. Palminteri plays Sonny, a neighborhood mob boss in the eponymous borough, and De

[1] "Italians Against Racism: The Murder of Yusuf Hawkins (RIP) and My March on Bensonhurst." Joseph Sciorra. *Are Italians White?: How Race is Made in America*. Jennifer Guglielmo and Salvatore Salerno, eds. (New York and London: Routledge, 2003) 193.

Niro is Lorenzo Anello, a bus driver trying to keep his impressionable son from falling under Sonny's influence. The film opens in the early 1960s, when Calogero (Francis Capra) is a nine-year-old living in an Italian American neighborhood in the Bronx. He happens to see Sonny shoot a man to death, in what appears to be a parking dispute.

When the police try to convince Calogero to point the finger at the shooter, the boy, who evidently has learned the rules of *omertà*, keeps his mouth shut. Sonny wants to repay the favor by offering Calogero's father, Lorenzo (De Niro) some easy work and extra cash. But Lorenzo is a proud man who scorns the Sonnys of the world, and he rejects the offer. To this working class hero, the real tough guy is the man who gets up every day and works to support his family, as he instructs his son.

But the smooth-talking and charismatic Sonny takes a liking to Calogero, and soon has him working the local bar, earning tips and running errands. Lorenzo discovers this and warns Sonny, "Stay away from my son!" in a confrontation that stops just short of violence.

The film's action jumps forward to the late 1960s, when Calogero — who now calls himself "C" — is a teenager. Despite his father's admonitions, C (Lillo Brancato) has become a part of Sonny's inner circle. But Lorenzo refuses to cede his paternal rights to Sonny, and the two men are still warring for the youth's soul.

On the verge of manhood, C faces a moral crisis. He has been hanging out with other Italian American youths, who represent the worst elements of the community. They are bigots and gangster wannabes, who mindlessly admire the unproductive and violent lives of their heroes. They've absorbed the benighted racial attitudes of the adults and reflexively regurgitate them. When C objects to an attack on black youths who were riding their bicycles in the neighborhood, another boy repeats his father's comment, "that's how it starts," i.e., the dreaded black incursion.

The histories of Italian Americans and African Americans have been marked from the start by competition and conflict over urban space and economics. Robert Orsi notes that Italian immigrants "moved into established black neighborhoods at the turn of the [twentieth] century in Philadelphia, St. Louis, Cleveland, and Greenwich Village, among other places; fifty years later, African Americans were displacing Italians in these same locations."[2] Italians also went into occupations that blacks had

[2] Robert Orsi, "The Religious Boundaries of an Inbetween People: Street *Feste* and the Problem of the Dark-Skinned Other in Italian Harlem, 1920-1990," *American Quarterly* 44. 3 (September 1992): 317.

dominated, such as barbering, restaurant work, brick working and other construction, and garbage collecting, in many instances displacing blacks.

Conflict became more common after the Depression era and World War II, as the two peoples competed with each other for "jobs, housing, and neighborhood power and presence."[3] Relations further worsened as the two largely urban groups found themselves jostling for economic and political power during the 1960s and 70s in the declining industrial cities of the North and Northeast. Conservative Italian Americans like Philadelphia mayor Frank Rizzo, a former police officer, and self-appointed community defender cum vigilante Anthony Imperiale in Newark, New Jersey, came to embody anti-black backlash with their hard-line, often racist "law and order" politics.

Animosities between Italian Americans and African Americans have exploded into open conflict, such as the battles over neighborhood and school integration that have been waged in cities like Chicago, Philadelphia, Boston, Newark, and New York.

A Bronx Tale unfolds in this historical context of racial strife, with young Calogero Anello caught in the crossfire. He is intelligent and sensitive enough to look askance at the motives and behavior of his peers, but he can't make a clean break with them; he hasn't yet the maturity to subordinate parochial neighborhood allegiances to a higher morality. His dilemma is only heightened when he meets and falls for a young black woman, Jane (Taral Hicks), while his friends are, at the same time, stirring up a feud involving her brother.

C's father, Lorenzo, for all his decency, disapproves of his son's budding romance with Jane. But Sonny, his gangster surrogate father, encourages Calogero to ignore Lorenzo's, and his community's, attitudes, and instead to follow his heart.

Sonny's disdain for convention is liberating for the boy, while his father's attitudes confine him. Some of the counsel Sonny imparts to C is just coldhearted mafia cynicism with a dash of Machiavelli — "It's better to be feared than loved," "You should do what you want because nobody cares about you anyway." But in this matter at least, Sonny is a better teacher than Lorenzo.

Sonny, in fact, literally saves C's life, when he prevents him from joining a bunch of his friends in a racist attack that backfires, with disastrous

[3] Orsi, 317.

results for the Italian youths, who end up burned to death by the incendiary device they'd intended to hurl at a gathering of black teenagers.

The complexity of Sonny's character — Palminteri plays him with a persuasive mix of menace and warmth — is one of the film's most original touches. Though Sonny makes his living outside the law and rules his neighborhood by instilling fear, he also can be wise and generous. He even is a somewhat poignant figure, lonely and lacking love in his life. He doesn't have any genuine friends. His men respect him, but any regard they might have for him is due to their dependence on him for their livelihoods. He has no family of his own, hence his attachment to another man's son.

Sonny sees C for the last time in his bar. Sonny's face lights up when he spots the young man. As he waves to C, he meets his death when he is shot point-blank by the son of the man he killed at the beginning of the film.

Robert De Niro contributes a solid and understated performance as Lorenzo Anello, a blue-collar Italian American of unyielding integrity, who struggles to support his family and to protect his son from the lure of illicit money. But his direction is more impressive. His years of working with gifted filmmakers, particularly his old friend Martin Scorsese, paid off: *A Bronx Tale* is well-paced, its pivotal moments expertly staged and dramatically compelling.

De Niro elicits effective performances from his young and green stars, Brancato and Hicks, as the Romeo and Juliet of the Bronx. The scenes between C and Jane in the first flush of puppy love have a sweetness and the halting, tentative rhythms of two kids from disparate backgrounds getting to know each other. De Niro, overall, demonstrates a sympathetic but unsentimental feel for the multi-ethnic working class milieu of the Bronx in the 1960s, and he evocatively uses period music, both African American and Italian American.

A Bronx Tale is a singular entry in the gangster movie canon in that it honors the genre's conventions — there's the remorseless violence, and much ethnic color, with characters named Frankie Coffeecake and Eddie Mush — while exuding an atypical "moral power," as child psychologist Robert Coles noted.[4] The film is unique in its depiction of racism and the mafia cult of male violence, as intertwined social evils that represent a

[4] Robert Coles. *The Moral Intelligence of Children.* (New York: Plume, 1998) 18.

terrible waste of human potential. "There's nothing sadder in life than wasted talent," is Lorenzo's favorite saying, which C has taken to heart.

The film's anti-racism theme derives from Palminteri's own experiences growing up in the Italian American Belmont section of the Bronx. The film's interracial love affair was based on his own relationship with a young black woman.

"I dated a black girl and I fell in love with her," Palminteri said in a 2002 interview.[5] "Well, you think you're in love when you're sixteen years old. We went together for some months and we just drifted apart. . . But we cared about each other. I was never prejudiced towards anyone. I could never understand that in my neighborhood. There was hatred for black people, and there was no hatred on my part. It bothered me. But being in the middle of it, as Calogero was, I always had to dance with both sides, because these were my guys. I grew up with them. I found that to be interesting. That's why I had to write about it."

Two-Family House, written and directed by Raymond De Felitta, is, like *A Bronx Tale*, a period piece, set in a working class Italian American neighborhood in Staten Island during the 1950s. The film's lead character, Buddy Visalo (Michael Rispoli), is a likeable working stiff who is profoundly dissatisfied with his station in life. He missed an opportunity to become a professional singer, but he still dreams of becoming a "saloon" singer, like Sinatra, in a saloon of his own.

He receives no encouragement from his sour wife, Estelle (Katherine Narducci). She is content to live with Buddy in her parents' home, a situation he loathes. (Their lovemaking must be quiet and restrained so as not to disturb Estelle's mother and father, a metaphor that extends Buddy's existential frustration to every aspect of his life, even the most intimate.) Whenever Buddy speaks of wanting to open his own tavern, she belittles him, noting that his previous business ventures all had failed. He is destined to work in a factory, she insists, and he should accept his destiny and stop pursuing futile dreams. Of Buddy's friends and neighbors, only affable Chip (Matt Servitto) encourages his ambitions.

But Buddy will not be deterred. He purchases the eponymous house, a dilapidated structure in need of complete renovation. First he must evict its remaining tenants, a grizzled Irishman and his young, pregnant wife Mary. When Mary (Kelly MacDonald) gives birth to a brown-skinned

[2] George De Stefano. *An Offer We Can't Refuse: The Mafia in the Mind of America* (New York: Faber and Faber, 2006) 240-41.

baby, racism rears its ugly head. And when Buddy falls in love with her, and the affair becomes common knowledge, a distraught Estelle berates him for going with a "nigger-lover."

If Buddy's yearning to rise above his dreary circumstances had perplexed his neighbors, his affair with a non-Italian woman who has borne a black man's child renders him an alien to them. Estelle and her friends offer him one last chance to rejoin the community, whose prejudices and stifling conformity he has spurned. She arranges a meeting with him, in a diner, with other local men and women on hand to support her. Though set in a Staten Island restaurant in the 1950s, the scene evokes Southern Italian village life, with a chorus of onlookers gossiping and passing judgment on a *disgraziato* who has violated age-old codes of proper behavior.

Buddy is dismayed to discover that his meeting with Estelle has become a public spectacle, a theater of marital discord. But he stays to hear what his estranged wife has to say. If he comes back to her, she says, she will tolerate his extramarital affairs, provided they remain discreet and do not cause scandal. It's not so much his infidelity that wounded her as the fact that he betrayed her with a "nigger-lover." Buddy, appalled and saddened, walks away from her, her disapproving witnesses, and his old life.

In the films of African American auteur Spike Lee, Italian Americans generally are depicted as congenital racists and contemptible losers. In what might be called Lee's Italian American Trilogy — *Do the Right Thing* (1989), *Jungle Fever* (1991), and *Summer of Sam* (1999) — the Italian characters are, with a few exceptions, bigots with a propensity for mindless violence.

De Felitta, though he portrays his characters as prejudiced, presents their attitudes as expressions of fear, insecurity, and insularity. Moreover, he shows that intolerance isn't somehow hardwired in Italian Americans, as Spike Lee seems to believe. Buddy Visalo, a good and decent man, is quite capable of rising above the provincial biases of his community; at the film's conclusion, he is living with Mary and her mixed-race son, whom he has adopted, in the Buddy's Tavern of his dreams.

Buddy's happiness does come with a cost. He is scorned and abandoned by his community and his friends; even once-loyal Chip deserts him. They all regard him as a fool who "threw his life away" in pursuit of an inexplicable dream, with an unacceptable partner. But as the film's narrator — who turns out to be Buddy's and Mary's son — informs us, his

parents remained happily married until their deaths, decades later. Cross-ing ethnic and racial boundaries, and defying those who patrol them has proved the route to a more fulfilling life than either Buddy or Mary otherwise would have had.

A Bronx Tale and *Two-Family House* are well-crafted films with com-pellingly articulated points of view and unequivocal moral stances. But for sheer daring, they pale next to Tom de Cerchio's short film, *Nunzio's Second Cousin*.[6] In just eighteen minutes, the director and screenwriter "confronts the questions of race and homosexuality, two seemingly taboo issues in the general community of Italian America, thus forming a tri-angle of issues of race, sexual orientation, and ethnicity."[7]

In the film's opening moments a gay male couple—an Italian Ameri-can and an African American—emerges from a bar late at night. They are confronted by a gang of young gay bashers who had been waiting for just such an opportunity: "Two fucking fruits just showed up on radar," one exclaims, adding, "Let's beat them back into yesterday" — presumably the past when white heterosexuals like him weren't affronted by such outrages as mixed-race homosexual couples.

But this all-too-familiar scenario—outnumbered gay men surrounded and attacked by a gang of young homophobic toughs—is reversed when the Italian American man produces a gun. A service pistol, to be exact: this "fruit," Anthony Randazzo, is an off-duty policeman. Brandishing his weapon, Anthony (played superbly by an eruptive Vincent D'Onofrio) unleashes a furious verbal torrent against the would-be attackers. "After tonight you're going to remember that the next time you decide to go out and fag-bash that sometimes fags bash back," he growls.

One of the oldest tropes in cinema is the gun as phallic symbol. But in this confrontation, the gun-wielding gay cop threatens one of the bashers with actual phallic violence. When the youth says that both he and Anthony are paisans from the same neighborhood, Anthony replies, ""You want to bond with me? Get on all fours and I'll stick my dick in your ass." This, according to Anthony Julian Tamburri, is "a particularly rich moment" that evokes the ancient Mediterranean cultural trope of

[6] *Nunzio's Second Cousin* is one of several short gay-themed films that comprise the anthology, *Boys Life 2* (1997)."

[7] Anthony Julian Tamburri. "Black and White: *Scungill'* & Cannoli: Ethnicity and Sexuality in *Nunzio's Second Cousin*," in *Italian American Short Films and Music Videos* (West Lafayette, IN: Purdue UP, 2002) 29.

penetration as the "ultimate sign of masculine dominance and privilege."[8]

In the traditional cultures of the Mediterranean, and to some extent even today, homosexual relations entailed a dominant man — who generally was married and a father, thus not "gay" in modern parlance — penetrating a "passive," usually younger partner. The penetrative partner exercises agency, a male prerogative, and thus retains his masculine identity. The man who is penetrated, however, is deemed less than a man and more like a woman, someone who has relinquished the male privilege of dominance in favor of feminine submissiveness.

This construction of homosexual relations prevailed in ancient Greece and Rome, and in the areas of Southern Italy known as Magna Graecia.[9] In today's Italy, it has been challenged and undercut by the emergence of a self-defined, politically and culturally activist gay community. Two structural developments that have eroded older discursive and regulatory systems that Foucault called "regimes of sexuality," also have brought change: urbanization, which enabled homosexually-inclined persons to leave the countryside and their traditional family cultures to find each other in cities, and the emergence of post-World War II consumer society, which further weakened the hold of religion and conservative morality and enabled the rise of a commercial gay scene.[10]

The penetrator/penetrated dichotomy, and its often invidious associations, no longer is the prevailing paradigm of same-sex relationships. (Truth be told, the actual behavior of same-sexers has always defied societal norms, even in Greco-Roman antiquity.) The gay sexual culture that emerged in North America and elsewhere in the Western world in the 1970s, in fact, championed versatility and condemned rigid roles as oppressive.

But role-defined sexuality persists, as is evident in contemporary gay culture. On Italian gay "cruising" websites, men who prefer to penetrate

[8] Ibid.

[9] It was the dominant conception in Republican Rome, which viewed same-sex relations, usually taking the form of an older man penetrating a youth, as a relatively exotic Greek practice. Under the Empire, homosexual behavior became more common and accepted, yet the active/passive dichotomy continued to hold sway. No less a figure than Julius Caesar was disrespected for being a passive partner of Nicomedes, the king of Bithynia; in the famous words of Curio the Elder, the polysexual emperor was "every man's wife and every woman's husband."

[10] Pier Paolo Pasolini lamented the fact that these changes had transformed the social construction of homosexual relations in Italy, from a purportedly traditional pansexuality to a sexual culture in which heterosexuality and homosexuality became the basis for dichotomous social identities.

call themselves *attivo*; those on the receiving end are *passivo*.[11] In North American gay culture, the preferred terms to express the sexual binary are the more neutral "top" and "bottom;" the former are prized and sought after, whereas the latter, being more numerous, are . . . competition.

The Italian American Anthony Randazzo is something of a cultural hybrid. He has inherited traditional Southern Italian attitudes towards gender and sexuality. His language, both verbal and physical, conveys masculine dominance; he is a true *maschione*. A "top." Moreover he is a police officer, a traditionally male occupation esteemed in working-class Italian America. But he also is a gay man who socializes in gay nightclubs, where he presumably dances with his boyfriend and quite likely engages in or appreciates the stylized, arch and often hilarious banter known as "camp."

Anthony, with his virile presence and sexual braggadocio, evokes a gay erotic icon, the "hot Italian cop" — usually mustached, muscular, and hairy of chest, presumably heterosexual, but sexually attainable under the right circumstances. Many pornographic stories and films have featured this fantasy figure.[12]

But this icon of gay pornography is problematic for gay men. Real policemen, Italian American and otherwise, historically have been agents of homophobic oppression, raiding gay bars, harassing gay men on the street, failing to arrest perpetrators of antigay violence and even abusing the gay victims. The watershed event of the gay liberation movement, in fact, began as a protest against police harassment, when, in August 1969, angry patrons of a Greenwich Village bar called The Stonewall Inn resisted a police raid on the establishment.

Anthony Randazzo is a reinvention of both the erotic icon and its real-life referent: the hot Italian cop as gay avenger, a figure of fantasy and

[11] The gay French writer, Renaud Camus, offered a harshly negative portrait of Italian homosexuality in his 1981 book *Tricks*: "One senses a stupid cult of virility tied to power, domination, even the humiliation of the other person.... Just as for the Romans of Antiquity, homosexuality is acceptable only when it is 'active,' that is, as a confirmation of strength, vanity, and superiority" (cited in Robert Aldrich. *The Seduction of the Mediterranean* [London and New York: Routledge, 1993] 205).

[12] Just as Italian American men constituted Hollywood's favorite ethnics in the 1970s, the Italian cop, and the working-class Italian American male in general, was a familiar figure in that era's gay porn, as well as in non-pornographic, "post-Stonewall" gay literature. "Frankie Olivieri," the Italian American transit worker in Andrew Holleran's celebrated 1978 novel *The Dancer from the Dance*, embodies the type: handsome and virile, but as his lover Malone, the novel's protagonist, discovers to his dismay, also oppressively jealous and possessed of a violent temper.

The Difficulty of Gender in Italian-American Culture: Gender and Ethnic Identity in *True Love*, *Little Kings*, and *Puccini for Beginners*

Veronica Pravadelli
UNIVERSITY OF ROME "TRE"

The status of female identity and subjectivity in Italian-American culture is a highly contested site, since any attempt to construct a degree of female autonomy necessitates reconsideration and critique of the symbolic function that both "family" and "community" play in such a culture. In the '70s, Women's Cinema envisioned new ways of representing the female experience, which in turn spurred new forms of female spectatorship. Broadly speaking, avant-garde feminist cinema became a political practice, since it not only produced counter-images vis-à-vis Hollywood representations of woman, but through formal and linguistic experimentation, it promoted a conscious, rather than unconscious, viewing experience. In other words, the process of identification activated by narrative cinema was broken in favour of highly reflexive strategies. Feminist avant-garde cinema indeed followed Laura Mulvey's famous indictment to destroy visual pleasure. In her concluding remarks of *Visual Pleasure and Narrative Cinema* (1975), she stated that only by "destroy[ing] the satisfaction, pleasure and privilege of the 'invisible guest,' and highlight[ing] the way film has depended on voyeuristic active/passive mechanisms"[1] can cinema rescue women from the position of the object.

While it is true that contemporary Italian-American women filmmakers strongly situate themselves within the precincts of narrative/genre cinema —but this is true of Women's Cinema in general since "narrative avant-

[1] Laura Mulvey, "Visual Pleasure and Narrative Cinema," in Laura Mulvey, *Visual and Other Pleasures* (Bloomington: Indiana University Press, 1989) 14-26, 26. On '70s Women's Cinema see E. Ann Kaplan, *Women and Film. Both Sides of the Camera* (London and New York, Routledge, 1983); Annette Kuhn, *Women's Pictures. Feminism and Cinema* (London: Verso, 1982); and more recently B. Ruby Rich, *Chick Flicks: Theories and Memories of the Feminist Film Movement* (Durham: Duke University Press, 1998).

garde film" has long been dead[2] — to some extent they still face similar concerns. Yet, in contrast to '70s and early '80s cinema, when *gender identity* was the key (and only) concern, Italian-American women's productions participate in what appears a global dynamic, since as a "minority group" they necessarily need to articulate gender identity in relation to ethnic belonging. It is in this context, I would contend, that we can look at Nancy Savoca's *True Love* (1989), Marylou Tibaldo-Bongiorno's *Little Kings* (2003), and Maria Maggenti's *Puccini for Beginners* (2007). In each film, the trajectory and the outcome of female identity and desire depend on the process of negotiation between gender and ethnic identity, between the ability to narrate the self, and psychologically separate from family and community, and the difficulty to extricate oneself from the traps of collective identity.[3]

CLAUSTROPHOBIA AND FEMALE SUBORDINATION: *TRUE LOVE* AND *LITTLE KINGS*

In *True Love* and *Little Kings* the Italian-American community is represented as a closed and autonomous world. Italian Americans seem to live in a "parallel" universe: no integration or contamination exists between "Americans" and "Italian-Americans." More specifically, the Brooklyn community depicted by Savoca in *True Love* is quite static and impermeable to change: to take just one example, the grocery store where Mike works, at the end of the '80s, is strikingly similar to the Santangelo shop in *Household Saints* (1993) during the '50s. While thirty years have gone by, the social function of the *salumeria* has remained constant. The store is a meeting place where the members of the community can gather; it is a staple in the formation of ethnic identity. But the neighbourhood is not simply static: for women and younger people, the closed world inhabited by the community is truly claustrophobic. Both Donna — the main protagonist of Savoca's film – and Lori — the major female role in *Little Kings* – are unable to rebel against traditional gender roles and behaviors and appear both visually and narratively trapped. The films are set on the

[2] On the contrary, documentary is still a major form of expression for women filmmakers. On feminist documentary see E. Ann Kaplan, *Women and Film*, cit., and Diane Waldman and Janet Walker, ed. by, *Feminism and Documentary* (Minneapolis: University of Minnesota Press, 1999).

[3] On these aspects in Italian-American women literature, see Roseanne Giannini Quinn, "'The Willingness to Speak': Diane di Prima and Italian American Feminist Body Politics" in *Melus* 28.3 (Autumn 2003): 175-93.

outskirts of New York, in anonymous suburbs where the signs and the icons of the big city, of modernity, are not visible. Donna and Lori move between the suburb and the kitchen: both working women, they are never shown—apart from a very brief episode in Bongiorno's film—in a working situation, while on the contrary, their male partners are introduced in their working context. Overall, in both films the main feminine space is the kitchen or more generally the "home": the spatial politics of the films are clearly gendered according to pre-modern parameters. As is well known, domesticity was a core element of the Victorian notion of *True Womanhood*, the dominant twentieth-century model of femininity, later questioned by the emergence of *New Womanhood*.[4]

In Savoca's film, visual claustrophobia is best exemplified by the "bathroom scene" during the wedding banquet: after Mike tells his newlywed that he is planning to go out with his male friends that same night, Donna rushes to the restroom, followed by her female friends. The young woman is crying profusely, as she cannot believe her husband's decision. Donna is sitting on the toilet, while her friends surround her first trying to understand what has happened then making an effort to console her. Framed in medium shot, the small group occupies the central area of the frame, while both sides are filled up by the pinkish walls of the restroom: the protagonist is visually cornered in a narrow spot, unable to move. Savoca repeats the shot when Mike joins Donna hoping to resolve the argument. Lastly, the affective distance between the two is visually rendered by framing Donna from a low angle on the threshold of the bathroom's door, and far away from Mike, who, closer to the camera, is shot out of focus. The scene exemplifies quite effectively Donna's condition or, better yet, it is the author's best comment on the status of romance and women within Italian-American culture.

In *Little Kings*, the relation between subjects and space is similarly claustrophobic, especially in the long episode of Gino and Lori's wedding anniversary in the first part of the film. The scene presents many close shots of faces and bodies: the hand-held camera moves nervously towards the object, then cuts and frames another character. Style somewhat breaks up the supposed unity of the family, by fragmenting the space and framing single characters. Like *True Love*, Tibaldo-Bongiorno's film moves be-

[4] On "True Womanhood" see Barbara Welter, *The Cult of True Womanhood: 1820-1860* in Michael Gordon, Ed. *The American Family in Social-Historical Perspective*, 2nd ed. (New York: St. Martin's Press, 1978 [1966]) 313-33.

tween the protagonists' private homes, in particular the kitchen and the livingroom, and the males' working places, Gino's construction firm and Dom's high school, and the neighbourhood's church. Thus, similarly to Savoca's film, *Little Kings* presents an autonomous world, founded on the basic values of family and religion.

Historically, comedy is the basic "genre of integration," to reprise Thomas Schatz's effective formula,[5] that is, a genre in which the human subject, through marriage, integrates him/herself in a social order whose rules s/he willingly accepts. In *True Love* and *Little Kings*, such a process is clearly questioned. Yet, male and female subjects do not show a similar attitude toward marriage as is often the case in comedy, at least in its most important sub-genre, screwball comedy. In these films, male characters consider marriage a sort of trap, the loss of freedom and the end of irresponsible behaviour, while women view marriage as the only available option. On the contrary, Donna and Lori's respective sole identities are that of wife (and eventually mother), and their desire is to spend more time with their husbands. Therefore, since men and women possess differing values and interests, whose relationship seems doomed to fail.

If we examine the films in the context of the history of gender relations in America, one can claim that in *True Love* and *Little Kings* the modern image of heterosexual relationships, what in the '20s social scientists and journalists called "companionate marriage," has not emerged. Companionate marriage implied "that young people ought to be friends and perhaps lovers before embarking on the serious matter of marrying." The new model of marriage contributed to the end of the large patriarchal family and championed a new form of family life: as Nancy Cott has argued, the modern family became "a specialized site for emotional intimacy, personal and sexual expression, and nurture among husband, wife, and a small number of children."[6] This latter aspect is particularly important to our analysis since it marks a fundamental difference between American and Italian-American cultures. Yet, one should not think that the "difficulty of romance" is just "an Italian-American matter": as one critic has pointed out, Hollywood comedy has represented the crisis of the heterosexual couple since the end of the '70s.[7] What is peculiar to

[5] Thomas Schatz, *Hollywood Genres* (New York: McGraw-Hill, 1981).

[6] Nancy F. Cott, *The Grounding of Modern Feminism* (New Haven and London: Yale University Press, 1987) 156.

[7] See Paul William, "The Impossibility of Romance: Hollywood Comedy, 1978-1999," in Steve Neale,

Savoca and Tibaldo-Bongiorno's works is that the woman's difficulty in voicing her feelings of dissatisfaction is caused by the ensnarement of family and community. It seems that what is at stake in both films is precisely the opposition between two models of male/ female relation and family life. I would argue that Donna's and Lori's desire for deeper commitment and connection with their husbands is, after all, a desire for the American model of heterosexual family life, while their husbands are content with the Italian-American version (or its cliché), since they are not ready, or able, to move beyond their prescribed gender roles and privileges.

It is important, at this juncture, to analyze in a more detailed fashion the structural function of family and community. While Donna is indeed the main protagonist of *True Love*, she consistently moves within the spatial boundaries of the family or community: the film shows effectively how any action, decision or gesture is sanctioned by a "collective eye." The formal structure establishes a strong continuity between character, family and community, and between public and private spaces. The narrative trajectory unfolds in the streets, in working places, bars and clubs, and inside Donna and Mike's family homes. The episodes are linked in a very effective way, since editing is quite fast and rather "nervous": therefore the film furthers a sense of continuity between outside and inside, public behavior and private feelings, the collective and the individual. Yet the film is also structured around a second theme, that is, an ongoing alternation between female and male episodes. Such a strategy clearly indicates the strong separation between men and women. Women and men tend to spend most of their free time with same-sex friends, since their psychic worlds have so little in common. However, male and female attitudes are not symmetrical: while Mike prefers to spend time with his buddies, Donna's sole desire is to spend each evening with her fiancé. For Donna, female friendship and affiliation are secondary, as she cannot enjoy herself; her primary desire and identification are as wife.

Female episodes tend to be set in domestic spaces, while male scenes usually take place in bars and working places. While the narrative is often linear, in many instances the separation between male and female world is furthered by cross-cutting.[8] For example, after Donna gets into an argu-

ed. *Genre and Contemporary Hollywood* (London: British Film Institute, 2002).

[8] On this aspect see also Edvige Giunta, "The Quest for True Love: Ethnicity in Nancy Savoca's Domestic Film Comedy," in *Melus* 22.2 (Summer 1997): 75-89, reprt. in Anthony Julian Tamburri and

ment with Mike, we see the young man at the grocery store talking with his employer, while Donna arrives home and finds her mother with female companionship. In the following scene a group of male friends watch a porno film in a bar, while in cross-cutting we see Donna at home with her friends, getting dressed for the evening. To conclude, the structure of gender separation subtending the film envisions an unbridgeable gap between Donna and Mike, between male and female desires, communication, and expectations. In so doing, *True Love* forcefully reverses all the gender paradigms of comedy.

In *Little Kings*, Lori's husband Gino has an affair with his lawyer and always makes up an excuse to work late. Even during the dinner party for the couple's wedding anniversary, Gino leaves home for a while to meet his lover. While we cannot equate Gino's deception and betrayal with Mike's behaviour, their relation to the women they profess to love is quite similar. For both, marriage strengthens family and communal ties, it allows the growth of the extended family. It is not, like Donna and Lori would like, the beginning of their own nuclear family. For the Italian-American male, the wife plays a role similar to that of the mother since they both sacrifice for the family stability. It appears that for the adult Italian-American male, marriage reactivates one's pre-oedipal tendencies and unresolved conflicts with the mother figure.

Since Italian-American culture and society are ruled by the non-verbal laws of the family (*Little Kings*) and community (*True Love*), the individual subject has little power to negotiate his/her identity vis-à-vis ethnic belonging. Obviously women pay the highest price. Savoca and Tibaldo-Bongiorno show that it is not possible, for men and women alike, to live "in between," to look for flexible identities, to negotiate one's attachment to and/or separation from Italian-American culture. One either accepts or rejects one's ethnic identity.[9] We should recall that when Donna starts doubting about her marriage, she says that if she called it off she would have to live far away from family and community. Even though she is not happy about her relationship with Mike she will nevertheless accept to stay within the community. In *Little Kings* Dom, the main protagonist, is presented throughout the film as a sensitive man, quite the opposite of

Anna Camaiti Hostert, eds. *Screening Ethnicity: Cinematographic Representations of Italian Americans in the United States* (Boca Raton: Bordighera, 2002).

[9] For an opposite view, see Camaiti Hostert's article.

his brother Gino, a sort of older and richer "Guido."[10] Dom is often depicted as a solitary and reflexive person, more interested in his personal feelings than in the role he is supposed to play: yet, in the end, he will remain in the family and will marry a woman he does not love.

Both films also show how Italian-American identity is shaped and strengthened through collective events and rituals such as weddings, births, and anniversaries, where family members cyclically renew their cultural belonging. *Little Kings* ends with the younger brother's wedding: Johnny marries his cousin who is pregnant. Thus, after Gino and Lori's baby, a second child will soon be born in the family. Similarly, Dom gets engaged to be married and accepts a job in Gino's construction firm: therefore his ties with the family are strengthened "forever." Even though the film has stressed the failure of Gino and Lori's marriage, the ending is very positive. Though some might recognize a light ironic tone, I am inclined to see the ending as a celebration of the Italian-American family. Notwithstanding some individual failures, the family unity seems stronger than ever. While it is true that through Dom's point of view the film criticizes Gino's macho attitude, Dom's concluding remark in voice-over, "We are Italians," is quite revealing. Throughout the film, the sentence had been uttered several times by Gino to indicate a sort of peculiarly "Italian" aggressive and boastful male behaviour. If Dom had never approved his brother's "Italian" attitude, his final words are in part ironic, but they also testify that his reflexive detachment toward his family is probably over. No female character could have voiced such a positive comment regarding her own family. Tibaldo-Bongiorno's strategy to choose a sensitive and kind male protagonist is very important. As Dom exhibits both male and female traits, he becomes a viable figure for female identification,[11] though he is incapable of criticizing or changing female subordination within the family.

[10] As Pellegrino D'Acierno has pointed out, "*Guido* is a pejorative term applied to lower-class, macho, gold-amulet-wearing, self-displaying neighborhood boys," a common figure in Italian-American culture and in the representations of Hollywood Italians in the American cinema. See Peter Bondanella, *Hollywood Italians: Dagos, Palookas, Romeos, Wise Guys, and Sopranos* (New York and London: Continuum, 2004) 70.

[11] One can recall here Miriam Hansen's famous thesis on Valentino. For Hansen, Valentino's dual nature was responsible for his immensely popular appeal to women. See Miriam Hansen, *Babel and Babylon: Spectatorship in American Silent Film* (Cambridge: Harvard University Press, 1991) 243-94.

PUCCINI FOR BEGINNERS AND THE CRISIS OF ITALIAN-AMERICAN IDENTITY

In *Puccini for Beginners*, Maria Maggenti's second film, the relation between gender and ethnic identity is entirely revised. Maggenti's work can be productively compared to Savoca's and Tibaldo-Bongiorno's films since, I would argue, its comment on female identity is antithetical to what has been previously discussed. Indeed, in *Puccini* the female protagonist, the young writer Allegra, rejects her ethnic identity, and is thus able to experiment with feelings of desire and gender identity. Allegra is a lesbian, though she also has a brief relationship with a young philosophy professor and, throughout the film, questions incessantly her own identity: the character's voice-over is a major reflexive device since it describes and explains the woman's affect and insecurities about sexuality. On the other hand, cultural identity has become a sort of façade, a surface material mediated by culture, rather than a lifestyle and a mode of authentic being. Maggenti uses opera, undeniably an Italian cultural form,[12] as a narrative element and a formal device in order to construct her own film and delineate her main character; on one hand Allegra loves opera and goes to see *Madame Butterfly* with her lesbian friends, on the other, the protagonist leads an "operatic" and excessive life since she runs from one lover to the other—from the male lover to the female lover, who in turn had previously been a couple—in the effort to hide her double life. Yet Allegra "is not an Italian American woman." She does not live in an ethnic neighbourhood, but in Manhattan, in the trendy area around Soho and the Village, the area that has been popularized in the last decades by minimalist artists, architects, photographers and fashion designers. Allegra is definitely "a New Yorker" even more than an American: she is witty and intellectual; she loves literature and philosophy and wants to be a writer; she is profound and serious, but she also loves to relax in her leisure time, taking a walk in the park, drinking coffee for hours, browsing through used books, and eating in trendy restaurants. A young, urban and liberated woman, Allegra's lifestyle and Maggenti's poetics remind us both of Woody Allen's comedies and HBO's *Sex and the City*. As we see Allegra and her three lesbian friends sitting and talking at a restaurant, we are reminded of many similar episodes in *Sex and the City*, when the four protagonists meet and talk about men and sex. In this regard, *Puccini*

[12] As Gramsci first pointed out. See his *Letteratura e vita nazionale* (Torino: Einaudi, 1964 [1950]).

for Beginners explicitly references the TV show, while offering, at the same time, a lesbian version.[13] Similarly, the film's ironic stance toward sexuality and love affairs is clearly indebted to Woody Allen's comedic style.

While Allegra faces the complex psychological dilemma of knowing if she is heterosexual or lesbian, her attitude towards the everyday is light and, to some extent, superficial. Allegra's "lightness of being" is beautifully rendered by on-location shots of bars and coffee places, parks, subways and trendy spots, bookstores and restaurants whose picturesque feel we may interpret as "typical New York." This atmosphere strikingly contrasts the claustrophobic working-class universe of the Italian-American community represented in Savoca and Tibaldo-Bongiorno. To some extent, in the Village, any young educated man or woman with an "artistic" thrust and just a bit of money, regardless of his/her ethnic, cultural and gender identity, can become a New Yorker. As Allegra goes through her search, her ethnic origin becomes irrelevant (and invisible). Therefore, if we read *Puccini* in relation to *True Love* and *Little Kings*, one can argue that female autonomy can be conceived only outside of family and community. And yet, there is no Italian-American identity outside of family and community: Allegra's New Yorker lifestyle is "another story." We are thus left with an irresolvable conflict. Savoca and Tibaldo-Bongiorno cannot reject their Italian-American origins since both the family and communal ties provide a deep affective and emotional stability and connection to others. Such a choice, however, is responsible for female subordination. To the contrary, in *Puccini* Allegra's relentless quest for new sexual relationships is also an attempt to fill a void and forget her loneliness: a single woman, Allegra has traded affective *dependence* for *independence*. While it is not clear to me how the conflict will be resolved, it seems absolutely necessary to envision new models for Italian-American female identity. Since Savoca's debut, Italian-American women filmmakers have been engaged in dissecting, via critical and reflexive strategies, the many forms of female subordination, thus renewing the scope and function of '70s women cinema. While change is indeed difficult, comprehension of the symbolic dynamics of Italian-American culture is an essential prerequisite for a different future and new way of being in the world.

[13] Interesting comments on *Sex and the City* can be found in Glen Creeber, *Serial Television: Big Drama on the Small Screen* (London: British Film Institute, 2004) 140-55.

"Ain't Nothing Over 'til it's Over": The Boxing Film, Race, and the *Rocky* Series

Jacqueline Reich
SUNY STONY BROOK

From its opening credits, Sylvester Stallone's 2006 film *Rocky Balboa* intends, to paraphrase the title song, to "take you back" to the series' original 1976 film. The familiar trumpet fanfare of Bill Conti's score, the titles in large block letters that pass across the screen from left to right, and the montage sequence featuring images of contemporary Philadelphia evoke nostalgia on several levels: nostalgia for the character of Rocky who had been absent from the screen for sixteen years; for the *Rocky* films as a subgenre of the ever-enduring boxing film, and for the glory days of Stallone's own faded film career. Inspired by the 1994 George Foreman fight with Michael Moorer, when the former regained the heavyweight title at the age of forty-five, the film's intention, according to Stallone, was to repeat the success of the first film and to prove that, in Stallone's words, "the last thing to age is the heart."[1] According to Leger Grindon, nostalgia and pathos are the constant characteristic emotions associated with the boxing film, which as a film form gives expression to multiple conflicts in American culture.[2] One of the issues boxing films often tackle, both directly and indirectly, is the racialization of American society, in particular the tension between white ethnic America and African Americans. Boxing films, in drawing on the extra-cinematic context of boxing's own history as a sport, have often featured Italian Americans as what Peter Bondanella has termed the *Palooka*: the loveable brutish fighter, who achieves success in the ring more with his sheer physical power rather than his artful style.[3] This emphasis on the strength of the white ethnic body and

[1] From the documentary, "Skill vs. Will: The Making of Rocky Balboa," Rocky Balboa DVD (Sony Pictures, 2007).

[2] Leger Grindon, "Body and Soul: The Structure of Meaning in the Boxing Film Genre," *Cinema Journal* 35.4 (Summer, 1996): 54-69.

[3] Peter Bondanella, *Hollywood Italians: Dagos, Palookas, Romeos, Wise Guys, and Sopranos* (New York:

its prominence in the boxing film has important implications for the representation of Italian American-ness in American cinema. Cinematic displays of muscled male bodies engage issues of race, gender and nationality, and the boxing films that feature Italian Americans are especially complicit in the articulation of a white racial identity at the expense of the African-American other. By focusing primarily on the first and the last films in the series, *Rocky* (John Avildsen, 1976) and *Rocky Balboa* (Sylvester Stallone, 2006), I show how the *Rocky* series rewrites racial tensions in order to create sympathy (Grindon's pathos) for the white ethnic, and how little has changed in this cinematic representation over the past thirty years. Moreover, I aim to answer this question: if, as many critics rightly contend, the first *Rocky* film created a narrative of masculine and ethnic redemption for post-Vietnam, post-Watergate, and post-affirmative action Bicentennial American, what does *Rocky Balboa* say about race, gender, and class in urban American in the 21st century?

From cinema's earliest days in the late nineteenth century, boxing proved an attraction for both filmmakers and spectators, despite the sport's marginal legal status in the United States. These early films consisted of filmed sporting events and helped increase the growing sport's popularity.[4] In American cinema, while there were many silent feature films about boxing, the genre flourished, according to Grindon, after the 1930s, when, up until 1942, over seventy boxing films were produced and released.[5] Films such as *The Champ* (King Vidor, 1931) and *Kid Galahad* (Michael Curtiz, 1937) mythologized the populist fighter as New Deal hero, in Aaron Baker's words, and, despite being primarily set in urban spaces, advocated a rural utopian vision of American society.[6] Other periods in which boxing films flourished were from 1946 to 1956, which revealed the darker side of the sport in such films as *Body and Soul* (Robert Rossen, 1947), *The Set-up* (Robert Wise, 1949), and *The Harder They Fall* (Mark Robson, 1956). During both these periods (especially the latter), films featured Italian American boxers as sympathetic protagonists who were often caught between the tensions of the old and new world,

Continuum, 2004) 92-131.

[4] Luke McKernan, "Lo sport nel cinema muto/Sport and the Silent Screen," *Griffithiana* 64 (October 1998): 80-141, here 84-97. See also Dan Streible, "A History of the Boxing Film, 1894-1915: Social Control and Social Reform in the Progressive Era," *Film History* 3.3 (1989): 235-357.

[5] Grindon, 65.

[6] Aaron Baker, *Contesting Identities: Sports in American Film* (Urbana: University of Illinois Press, 2003) 100-40.

such as in *Golden Boy* (Rouben Mamoulian, 1939). Much of the Italian American presence in boxing films is due to the history of boxing itself, which sported champions in different weight classes. The stories of Rocky Graziano, Jake La Motta, and Rocky Marciano have been told in countless films, including *Somebody Up There Likes Me* (Robert Wise, 1958), *Raging Bull* (Martin Scorsese, 1980), and *Rocky Marciano* (John Favreau, 1999).

Just as in these biographical films, many other boxing films take their cues from the history of boxing as a sport and address, either explicitly or implicitly, issues of race, class, gender, and national identity. Sociologist Kath Woodward notes how the history of boxing "is marked by social exclusion and processes of 'othering' especially through racialization, ethnicization and gender differentiation."[7] The fights of Jack Johnson, Joe Lewis and Primo Carnera, among others, played on racial stereotypes, racist fears, and national eugenic supremacy.[8] These racial tensions found cinematic correspondence in early silent cinema, which, according to Dan Streible, in turn revealed anxieties about race, class, and gender: approximately one third of all filmed prizefights before 1915 featured an African-American versus a white boxer.[9] Although much of post-code Hollywood cinema tried to bury these tensions, independent films such as *Body and Soul* openly problematized the powerlessness of the black boxer in light of the sport's endemic corruption and its ties to organized crime, and later films such as *The Great White Hope* (Martin Ritt, 1970), based on the story of Jack Johnson, made the racial tensions explicit.

In terms of the representation of race, gender and boxing, the *Rocky* series of six films is simultaneously progressive and regressive. As is widely known, the backstory of the *Rocky* film is, like its narrative, a Cinderella story. Sylvester Stallone, inspired by the Muhammed Ali/Chuck Wepner fight, wrote the film's script in a little over three days. The film's backers didn't want Stallone to star as the title character, and the film went on to capture the Academy Award® for Best Picture in 1976, beating the more pessimistic competition *Network* (Sydney Lumet), *All the President's Men* (Alan J. Pakula), and *Taxi Driver* (Martin Scorsese).[10]

[7] Kath Woodward, *Boxing, Masculinity and Identity: the "I" of the Tiger* (London: Routledge, 2007): 5.

[8] Jeffrey T. Simmons, *Beyond the Ring: The Role of Boxing in American Society* (Urbana: University of Illinois Press, 1988).

[9] Dan Streible, "On the Canvas: Boxing, Art, and Cinema," *Moving Pictures: American Art and Early Film, 1880-1910*, eds. Nancy Mowll Matthews with Charles Musser (Manchester, VT: Hudson Hills Press, 2005) 111-116.

[10] Daniel J. Leab, "The Blue Collar Ethnic in Bicentennial America: *Rocky* (1976)," *American History/*

This optimistic vision of Bicentennial America, with its feel-good story of the working-class and the American dream, has inspired a variety of critical interpretations. Lynn Garafola integrates the film within the genre of the working class films of the 1970s, with their message of nostalgia for traditional values that Italian Americans have come to represent in film: honor, chivalry, respect, and patriarchal domination. Others, such as Clay Motley, see masculinity in *Rocky* as a metaphor for the search for meaning and authenticity in the post-Vietnam era, in which Rocky's "going the distance" symbolizes the "recapturing" of the traditional values of virility and strength. Victoria Elmwood, on the other hand, observes how the white man shows the Black man the lessons of material exploitation and leads him back to the true roots of boxing, and how the black masculinity is in service to white remasculinization. [11]

What is somewhat astounding is that all of these points of view can easily be applied to what one can only presume to be the last installment in the series, *Rocky Balboa* (2006). The film begins not with the traditional montage of Rocky's previous victory but rather with a fight featuring Rocky's future nemesis, Mason "The Line" Dixon, who is played by the reigning light heavyweight champion Antonio Tarver. At this point, the sixty-year old Rocky has lost his beloved wife Adrian and has a one-sided relationship with his son Robert Jr, (Milo Ventimiglia), now trying to make it in the financial world away from his father's looming shadow. Rocky lives squarely in the past, a fact metonymically represented in the Italian restaurant he now owns, Adrian's, where he entertains diners with stories of his fights. With him, as always, is his brother-in-law Paulie (Burt Young), who, during a tour of their old haunts marking the third anniversary of Adrian's death (the pet shop, Mickey's old boxing gym, his apartment, and the empty lot where the ice rink once stood), tells Rocky that he is "living backwards" and that it's "time to change the channel." A final stop at the Lucky Seven tavern reunites him with Marie, the girl whom he tried to save in the first film and responded with "Screw you, creepo." Dixon, on the other hand, is tired of fighting boxers who pose little chal-

American Film: Interpreting the Hollywood Image, eds. John E. O'Connor and Martin A. Jackson (New York: Ungar, 1979) 257-72.

[11] Lynn Garafola, "Hollywood and the Myth of the Working Class," *Radical America* 14.1 (Jan-Feb 1980): 7-15; Clay Motley, "Fighting for Manhood: *Rocky* and Turn-of-the-Century Antimodernism." *Film & History* 35.2 (2005): 60-66; Victoria Elmwood, "'Just Some Bum from the Neighborhood': The Resolution of Post-Civil Rights Tension and Heavyweight Public Sphere Discourse in *Rocky* (1976)," *Film & History* 35.2 (2005): 49-59.

lenge to him but make him an extremely wealthy man. One day, a fictional ESPN series "Then vs. Now" features a computer-simulated fight between Rocky Balboa and Dixon, with the panel of judges calling Rocky the more experienced fighter and predicting his hypothetical victory over Dixon. The computerized Rocky emerges victorious, much as Rocky Marciano did in a simulated fight against Muhammed Ali in 1970. The media picks up the story, and Rocky begins to contemplate a return to the ring. Dixon's manager, L.C. Luco, convinces him to pursue a fight with Rocky to rebuild his tattered image. Billed as "Skill vs. Will," the fight occasions a reconciliation between father and son, the continued rehabilitation of Marie's biracial son, Steps, and the developing friendship between Marie and Rocky. It also provides a forum for the classic training montage sequence, complete with beef carcass punching. During the Las Vegas fight, Rocky gives Dixon a run for his money, and although Dixon ultimately emerges victorious in a split decision, Rocky goes the distance, as he did in the first film. The film ends with Rocky bringing roses to Adrian's grave, telling her, "Yo, Adrian, we did it."

Rocky Balboa came on the heals of a twentieth-century mini-revival of the boxing film, not only in terms of quantity, but also quality: *Ali* (Michael Mann, 2001), *Million Dollar Baby* (Clint Eastwood, 2004) and *Cinderella Man* (Ron Howard, 2005) are among the critically if not financially successful boxing films of the past five years. Perhaps not coincidentally, boxing as a sport has declined in terms of its popularity, mostly due to the absence of a charismatic figure at the top, such as George Foreman, for instance, or Mike Tyson, who makes a cameo appearance in the Stallone film. The casting of key players in the sport, including Tarver and fight promoter Lou DiBella, the fight's Las Vegas setting (with audience footage from the December 2005 Bernard Hopkins/Jermain Taylor fight), the press conference featuring today's preeminent sportswriters, and the use of Jim Lampley and the HBO team to call the fight all add to the veracity of the film's criticism, and perhaps attempt to diminish the potential ridiculousness of the sixty-year old Rocky/Stallone returning to the ring. It also sparked a revival of Stallone's sagging career. Stallone's desire to return to a proven formula and to the character with which he was so closely identified is not surprising, given the traditional trajectory of actors primarily known for their muscular bodies, whose extracinematic identities are tightly fused to their fictional characters. In interwar Italy, Bartolomeo Pagano's individuality was inseparable from Maciste; in

the 21st century United States, Arnold Schwarzenegger (aka the Governator) relied on the cooptation of lines from his films to sell his political message.

Despite its contemporary setting, the film's tone is decidedly nostalgic: Rocky's longing for the past (Adrian, his boxing career, his family), the series' nostalgia, the innocence and success of the first film, and Stallone's melancholic recollection of the glory days of his career. In evoking that nostalgia, however, the film treads into the same problematic racial territory as the original: the Italian American ethnic becomes the stand-in for white America, as he teaches the uppity African-American man how to be both a true American and a real man. The film foregrounds Rocky's Italian American-ness from the beginning, shooting a scene at Philadelphia's famous Italian market as he buys the supplies for his restaurant. Shot in a montage-like fashion, the sequence juxtaposes shots of Rocky comfortably interacting with the merchants and the fresh produce, cheese, meat and fish with photographic stills of the multi-racial clients, merchants and bystanders. In this poly-ethnic melting pot, Rocky's sheer physical dominance, enhanced by low-angle shots and strategic key lighting, foregrounds his whiteness.

Like his forerunner Apollo Creed, Mason Dixon is a fighter corrupted by material culture, although here he is more a pawn in the system. Managed by the greedy white promoters DiBella and L.C. Lucco (A.J. Benza), he is cut off from his grimy gym and former trainer, the humble Martin (Henry G. Sanders), who tells him: "You've got everything money can buy, except what it can't: pride." The colors black and white dominate the scenes in which Dixon appears on screen: his magnificently large white house, the white baseball cap he wears, and the antiseptic whiteness of his new training facility (as opposed to his origins in Mark's grimy studio) contrast with dark shadowy lighting which infuses Dixon's body. The two venues in which the audience sees the ESPN television show speak to the divide that exists between affluent white and Black society in contemporary Philadelphia, as envisioned in the film: the brightly-lit, predominantly white Irish pub where Robert Jr. sits with his analyst friends, and Dixon's house, which, despite its enormous windows, remains predominantly dark and shaded. Clearly, the darkness is an allusion to Dixon's moral dilemma, but still remains racially coded.

The fight sequence–the traditional third act of the *Rocky* series–completes the lesson Rocky has to teach Dixon: that what matters is heart,

pride, and respect, not material gain. Despite being filmed in high definition tape and employing more special effects (black and white footage, slow motion, color tinting), the ten-round bout incorporates many of the standard cinematic devices of previous Rocky films (the early knockouts, the comebacks, the Bill Conti score) and proves, again nostalgically, that computer simulations can never substitute for the real thing. The fact that Stallone and Tarver did not carefully choreograph the fight but actually sparred, often brutally, in the ring, adds to the reality effect.

In addition, the character of Marie harks back to the nostalgic, if not reactionary, representation of women in the first film. Just as Rocky, through his love, transformed Adrian from a mousy, asocial spinster into beautiful, adoring future wife, so does Marie blossom under Rocky's patronage: he rescues her from the now decrepit Lucky Tavern and gives her a job hostessing in his restaurant and mentors her troubled son. Her metamorphosis is physical as well as financial: she begins to dress more fashionably, wears make-up, and straightens her wild hair which she fashions into a stylish ponytail. During the fight sequence, she is not included in Rocky's support team, as is her son, Paulie and Robert Jr., but rather remains, as Adrian did, in the audience, a spectator rather than participant in the drama.

Philadelphia remains an essential presence, even character in the film. Although the film features traditional shots of the city's skyline and other famous landmarks, including the Philadelphia Museum of Art, most of it takes place in Rocky's old neighborhood, which is clearly marked as urban, crime-ridden slum. Its population, however, is decidedly white, a noticeable contrast to contemporary Philadelphia, whose poor population remains predominantly African-American. According to the US Census Bureau 2000 estimates, of the 20% of Philadelphians living in poverty, 42% were African American. In 2004, out of a total of 2004 homicides, more than 80% of the victims were African American.[12]

Hence, the return to the question posed at the beginning of this essay: what does *Rocky Balboa* have to say about race, class, and gender in twenty-first-century America? In an attempt to resuscitate a drowning career, Stallone has opted to hark back to the roots of the series, with the erasure of thirty years of women's efforts towards equality with men, a

[12] Rogelio Saenz, "Beyond New Orleans: The Social and Economic Isolation of Urban African Americans," Population Reference Bureau, www.prb.org; The Philadelphia Inquirer 2006 special section on Violence: http://www.philly.com/ inquirer/special/violence.

stereotypical portrayal of the African American male, and the exaltation of the sympathetic Italian American boxer as sacred vessel of the American Dream. Although clearly attempting to infuse his film with a sense of authenticity and realism, he has literally whitewashed the texture of contemporary Philadelphia, creating a serviceable melting pot united by its love for a local, albeit fictional, hero, and erasing the economic and social reality of one of the United States' most racially polarized cities. In this nostalgic evocation of the past, the character of Rocky, and, I would argue, Italian Americans in general, represent traditional American (read white) "family" values. In resuscitating a character who embodies the solid, moral principles of honor, pride, loyalty and family, *Rocky Balboa* harks back to an ethos which, from *The Godfather* (Francis Ford Coppola, 1972) on, Italian Americans have literally embodied on the big and small screen. In the pendulum of representations from progressive to conservative, the emphasis on the usual values of family, honor and sacrifice *all'americana* is more conservative today than it was in the 1970s. Italian American cinema has made great leaps forward, and with *Rocky Balboa*, Stallone has taken several steps back. One can only ponder what he will do with his next project as actor/writer/director: *John Rambo*, slated for release in 2008.

Italian American Cinema:
Between Blood Family and Bloody Family

Ilaria Serra
FLORIDA ATLANTIC UNIVERSITY

Emigration was a disgrace for the Italian family, a curse that weakened its unity and crumbled its foundation. One hundred years after the Great Migration — and some forty-plus years of healing that started in the 1960s — the family returns in full strength to dominate the cinematic imaginary of Italian Americans through the grandchildren of those same immigrants' film production: Martin Scorsese, Francis Ford Coppola, Stanley Tucci, Nancy Savoca, John Turturro, Alan Alda, and others. Their choice is explained by the semantic weight of the nuclear family as the *locus belli*, the site where ethnic and emotional fights both begin and end. The family is still one of the most preferred among possible symbolic themes that provide fodder to storytelling: we are in the midst of "symbolic ethnicity," where ethnic identity is not simply handed down and unquestioned, but chosen and re-chosen by each individual who reinforces and/or rejects some of its various aspects.[1]

Italian Americans have always been represented by the image of the family as far back as the first American films, and the Italian American family constitutes one of the most persistent stereotypes.[2] The first feature-length

[1] Self-presentation of Italian Americans deliberately chooses the family image with which to identify. Three chapters of the documentary *Little Italy* (Will Parrinello, 1995) are devoted, in one way or another, to the family. In the chapter entitled "Table as Temple," the table is depicted as the family's sacred space; in "Passion Has Us," we see a quick passionate montage of hugs and kisses Italian-style; and in "Power Not Authority," the mother figure is said to possess power, but not authority (which is reserved for the father). For a comparative study on the institution of the family in different American ethnic groups, see Mindel, Habenstein, Wright, *Ethnic Families in America*. Here, the sociologists agree in indicating the changes in the structure of Italian American families that took place over time, while they still maintained their relative solidity and unity (cfr. Lalli, Michael, "The Italian American Family"). Such *unity* is one of the words that are most often used in the self-description of Italian Americans, according to Susan Kellogg ("Exploring Diversity in Middle-Class Families").

[2] It is not by chance that an important — if dated — essay by Daniel Sembroff Golden concentrated on the family as ethnic metaphor: "The Fate of *La Famiglia*: Italian Images in American Film." In this essay, Golden maintains that the newly arrived Italian American filmmakers (the essay was written

movie with an Italian American protagonist, *The Italian* (Thomas Ince, 1915), ends with a family-based twist: Beppo renounces vengeance on his enemy's son when he sees the child he is about to kill, gesturing like his dead child. Paternal love is therefore stronger than Italian American thirst for blood. In similar fashion, at the beginning of the sound era, mothers appear in all their shapely weight: from the witchy "Ma" Magdalena in *Little Caesar* (Mervyn Le Roy, 1931), to the wild Anna Magnani in *The Rose Tattoo* (Daniel Mann, 1955), to the possessive mother of *Marty* (Delbert Mann, 1955). The distance, in some respects, is quite short from the mother of Marty-the-butcher to the mother of Marty-the-filmmaker.

THE SCORSESE FAMILY

In recent times, a new era of Italian American cinema has been inaugurated by the arrival, *en masse*, of the grandchildren of immigrants who have become active producers of culture and are quite comfortably situated within the American social fabric. In their storytelling, they look to the family as their safety net, the nerve center of relationships, and the world in which conflicts and reflections on identity take place. The young Scorsese, having recently graduated from film school at New York University, is content at placing the camera in front of his chatting and theatrical parents in order to create a solid documentary of gleaming *italianità*. *Italianamerican* (1974) offers an hour-long examination of ethnic reflections based on the genesis of a new identity — *Italiananamerican* identity — without hyphen and without capital letters: a single word in which two cultural essences merge smoothly, but not always easily. The film portrays the fusion simply through the depiction of a father and a mother, a plentiful table, a living room with its very nice couches still covered in plastic, and the mother's recipe for tomato sauce (greeted with a standing ovation at the film's opening). Thus, the Scorsese family becomes an *exemplum* of ethnicity.

Martin and Catherine Scorsese are the protagonists of another Italian American documentary, Marylou Tibaldo-Bongiorno's *Mother Tongue* (1999). In this film, in seven interviews, *italianità* is found in the strong, umbilical relationship of famous Italian American sons and their mothers (Rudy Giuliani, Robert Viscusi, John Turturro, and Martin Scorsese

in 1980) have lost their "consolatory family" and have become part of the American "lonely mass." In reality, as we shall see in this essay, it was not so.

among them). Catherine, Scorsese's mother, moreover, appears in many of her son's films, almost as if the filmmaker were taking advantage of his position of fortunate son in order to represent the seemingly orphaned young men of his movies, from J.R. in *Who's that Knocking at my Door* (1968) to the cousins Charlie and Johnny Boy in *Mean Streets* (1973), to the degenerate son and husband, Henry Hill in *Goodfellas* (1989). In Scorsese's fictions the family evaporates in order to leave space for the gangs.

BLOOD FAMILIES AND BLOODY FAMILIES

The Corleone family is the Italian American family par excellence. *The Godfather I and II* (Francis Ford Coppola, 1972, 1974), two huge successes that some Italian Americans find difficult to stomach, transform the blood family into the Mafia family through the use of the fairy-tale model of "a king who had three sons" (and a fourth son, Tom Hagen [Robert Duvall] adopted by both the blood family and the Mafia). The criminal plot eventually develops through fratricide; Michael, the young godfather, becomes a true monster when ordering the death of his brother, Fredo. At the same time, Vito, the old godfather, affectionately surrounded by the old Mafia family, with its perverted moral sense, dies as a doting grandfather, playing with his grandson among tomato plants. His death gives way to the new, lonely godfather who closes the door in his wife's face, as witnessed in the last scene of *Godfather I*. Nonetheless, the die is cast: the romantic Mafia family has become a solid piece of the American imagery.[3]

The dichotomy between the two types of families reappears in movies such as *Goodfellas* and *A Bronx Tale* (1993) by Robert De Niro (based on Chazz Palminteri's autobiographical play). In *Goodfellas*, Scorsese creates a narrative and visual parallel between the two families by cross-editing the group of husbands with that of their wives. These two groups counterpoint and complement each other: the Mafia wives, with made-up haggard faces, spend ill-gotten money on fake nails, while, on the other side, the violent, alcohol-filled husbands continue their own criminal business

[3] Through a strange irony, we might owe it to the defensive action of numerous Italian American associations overly concerned with their public image; for the word Mafia is never even mentioned in the movie, substituted instead by its surrogate "five families," yet the film succeeds in inextricably binding the notion of Italian family with Mafia "family." Clement Valletta suggested that, for Italian Americans, the insistence on the family in *The Godfather* might provide a vicarious satisfaction for a personal need to obtain justice, as well as a space for emotions in a world that is increasingly more impersonal. On the ambivalent charm of the Corleone family, see Barbara Grizzuti Harrison, "*The Godfather II*: Of Families and Families."

in a bar. These women (directly transposed from Nick Pileggi's memoirs) are fundamental for the Italian American criminals who reserve Fridays for their mistresses, while keeping Sundays sacred for the family and the barbecue. In *A Bronx Tale*, in turn, Robert De Niro aptly portrays the polarity between blood family and criminal family, by highlighting young Calogero's dilemma, divided between an honest, seemingly boring father (De Niro) and a dishonest, charming surrogate father (Palminteri). The clash between the two fathers implies a life choice, and it is resolved only in front of the mobster's coffin.

TV gangster Tony Soprano is the latest Mafioso with a strong family support system. The Soprano family is not only a decorative element in the show, but it is a staple of the episodes' narrative, and, presumably, the very reason of its success. Starting from the first episode (which the critics regard as an hour-long feature film), Tony is introduced through his relationship with his wife, wearing a bathrobe and eating breakfast; his interaction with his children who snub his enthusiasm for the ducks in the pool; and in conflict with his maniacally dependent mother, Livia. His mother will, nevertheless, try to kill him some episodes later, as well as his uncle a few years after Livia's failed attempt, thus demonstrating the fragile seams and the powerful evocative duality of the bloody-blood family. According to David Chase, director of *The Sopranos* (1999-2007), "the only place to go [after Coppola and Scorsese's gangsters] was the private life."[4] The presence of the Soprano family has been considered one of the reasons for the success of the show: it facilitates the spectator's identification with the characters, transforming Tony Soprano into a common man, and offering a series of interesting and independent female figures.[5]

FAMILY, CRADLE OF ETHNICITY

The other function of the film family is to protect the hearth of ethnicity, enclosed within the house's walls. Its lars are the grandparents, the most revered and venerated figures. Grandmothers and grandfathers have a fundamental importance in the Italian American imagery, perhaps because the protagonists of Italian American media production are the

[4] As quoted by Peter Bondanella in *Hollywood Italians* (314). The book includes an excellent critique of the TV show.

[5] I refer here to the analysis of the TV show in Regina Barreca's edited volume *Sitdown with the Sopranos*.

grandchildren. As a motif, both in literature and in film, these grand-children look back to their grandparents in order to find the secret, the essence of their ethnicity. Those grandparents, who arrived from a far-off land with cardboard suitcases, have become strangers to the subsequent generations. They have been forgotten, together with their foreign language, especially the second generation that tried to defend itself against American prejudice, precisely by distancing itself from its immigrant fore-bearers. Now, the grandchildren are left with only a few objects, some faded pictures, or a steamship ticket in order to recover the figures who have become mythical in their mystery.

In literature, the most famous great-granddaughter is Tina, in Helen Barolini's novel *Umbertina* (1979); she is an American student who walks the roads of Castagna in Calabria, in order to retrace the steps of her great-grandmother Umbertina. Parallel to Barolini's Tina is Diana Di Sorella, protagonist of Helen De Michiel's feature-length film *Tarantella* (1996). These young women attempt to recover the lost figures of their predecessors, with scarce information from their parents and few remaining objects (Giosue's "tin heart" for Tina, and a "Libro della Casa" for Diana). De Michiel describes Diana's quest for ethnic identity, an all-female search, as emerging from years of repression. Little Diana envisions her grandmother as a black-shawled, taciturn woman prone to numerous oppressive orders (Don't speak!; Be quiet!; Be good!; Don't ask questions!). Now, as an adult, Diana discovers the secret behind her grandmother's emigration in the "Libro della Casa," written by her mother in Italian, a language foreign to her. A bloody secret underlines the patriarchal repression of Italian women (Diana's grandmother had killed her violent husband and then escaped to America with her young daughter). The grandmother's story, now lost in the past, is represented through a clever cinematic device, with Sicilian wooden puppets (*pupi*). Such a choice is extremely efficacious: the past, drained of blood and life, consists of marionettes that would not move without a grandchild asking questions, and moving the strings.

In *Betsy's Wedding* (Alan Alda, 1990), the Italian family (or better, the colorful ethnic family) collides with the American family (or non-ethnic, WASP, gray, and flavorless). While the film's *Italianità* is diluted by the presence of the Jewish mother, the heart of the movie remains Italian thanks to the dead grandfather's occasional visits from the other world. The director Alan Alda (known also for the TV series MASH [1972-1983])

takes on the role of the young women's father who is often visited by his deceased father, the old Scannatanuzzo, who betrayed his own bloodline by Americanizing his name to Hopper. Ironically, it is Hopper/Scannatanuzzo who keeps alive the son's pride of his own difference, and he regrets to have worn an American mask, now disgusted by the many Mafia jokes made and/or recounted at his expense: "those sons of bitches stole my *italianità* from me." It is this grandfather who holds the keys to ethnic pride and the secrets of a lost culture, a culture he took with him to his grave, together with the lasagna recipe.

Another powerful and oppressive grandmother is Teresa in *Household Saints* (Nancy Savoca, 1993), a superstitious *strega* (witch) who makes life unbearable for her young daughter-in-law. Her entire old-world *Italianità* consisting of prayers, the blackmails of the household saints, and magic formulas uttered over the sausages, is metaphorically enframed by Teresa's tight chignon. Sociologist Marcus Lee Hansen's dictum — *that which the son wants to forget the grandson wants to remember* — is dramatically shown in Savoca's movie. When old Teresa dies, the daughter-in-law is liberated from a nightmare and subsequently paints the house in lively colors and hides all her religious objects in boxes. It is her granddaughter, also named Theresa, who fishes them out again, hangs up her grandmother's crucifix and saints, and becomes, so to speak, the reincarnation of her grandmother. Savoca aptly depicts the process of ethnic rediscovery with the apparition of old Teresa in the place of young Theresa who, in one scene, is frying sausages.[6]

FAMILY AS LOCUS BELLI

The family offers the perfect stage to visualize the conflicts between different ways to be ethnic. Brothers and sisters offer different modes of ethnicity in the horizontal sense: from *The Godfather*'s brothers to the four sisters of *The Amati Girls* (Anne DeSalvo, 2000), to the three tragic brothers of *Little Kings* (Marylou Tibaldo-Bongiorno, 2003) to the humorous thieves of brothers in *Trapped in Paradise* (George Gallo, 1994).

We immediately enter the symbolic realm when we see siblings struggle: the brother's fight conceals one man's struggle within himself, or the

[6] Noteworthy is a comparison between the craziness/sanctity of young Theresa in the movie and a psychological study on an Italian American family as described in *Transactions in Families* (John Papajohn and John Spiegel). Here, the psychological disturbance is tied to the process of adaptation of the family in an immigrant society.

confrontation among different parallel and discordant ways to be Italian in America. *Mac* (John Turturro, 1992) and *Big Night* (Stanley Tucci, 1996) offer the most interesting family portraits in this regard. The *fratelli-coltelli* ("brothers-knives," an Italian expression) in *Mac* represent two different approaches to Italian American identity: first-born Mac represents the traditional mode—that is, faithful to the father and the old ways, proud of manual work and sacrifice—whereas the younger brothers embody the more diluted, Americanized and indolent way. Coexistence is not possible, and the ties are neatly severed in the movie. Similar drama is recreated by *Big Night*. Here, too, two models of ethnicity come to terms: Primo emulates the rigid, old-style, anachronistic, way, far from any compromise, whereas Secondo is clearly the more accommodating, softened and bastardized manner of new world behavior. Their names say it all: first and second generation, first and second quality *italianità*.[7] Both movies glorify the nobility of manual labor, either in the world of construction or in the restaurant business. Both older brothers, loyal to the tradition, literally see themselves in the object of their work in meaningful passages of the movies: Primo looks at his face in the shiny lid of the pot, while Mac writes his name on the wet cement. Work is the principal expression of the good-willed Italian American, starting from the famous *jobba* of the first immigrants who were mainly unskilled workers, hired hands.[8]

THE COUNTER-FAMILY

The younger generation of Italian Americans suffers the same uneasiness that creeps through the rest of America, and working-class families show signs of moral and social decay. Several stories told by younger filmmakers speak about the degradation of the old monolithic family. *Brooklyn Lobster* (Kevin Jordan, 2005) is the story of a double failure, where business and marriage crumble together; *The Daytrippers* (Greg Mottola, 1996) tells the shock of a wife betrayed, which is shared by her entire family, who is literally squeezed together, between good and bad, in the same station wagon. Nancy Savoca portrays the disastrous wed-

[7] *Big Night* is one of the most beloved and discussed movies in Italian American studies. Among the other essays, see Anna Camaiti Hostert, "Big Night Small Days" in *Screening Ethnicity* (Tamburri, Camaiti Hostert) 249-58.

[8] Two Italian American novels centered on the immense pride in the work of immigrant hands are *Like Lesser Gods* by Mari Tomasi (1948) and *Christ in Concrete* by Pietro Di Donato (1939).

ding between Donna (the name hinting at the essence of femininity[9]) and the shop clerk Michael in *True Love* (1989). Common places, immaturity, and bad examples by the adults converge and ultimately condemn *in nuce* the two youngsters. The movie opens and closes with home video clips of scenes representing the ideal family, to be remembered as happy and smiling, filtered through the patriarchal lens of the father of the bride, but the spectator has already seen enough. We have entered the fragile heart of the newborn family and have witnessed the anti-romantic scene par excellence: bride and groom fighting in the ladies bathroom. The image that expresses all of Savoca's caustic and affectionate irony on the institution of matrimony is that which shows the bride—covered in white vaporous lace—sitting, enclosed in a stall, on a public toilet. Yet another female portrait of an anti-family is *Riding in Cars with Boys* (Penny Marshall, 2001), taken from Beverly Donofrio's memoir, where the sixteen-year-old child-mother, Beverly, fights to rebuild her life, between her studies, her son, and her drug-addicted husband, while living in suburbia. The circle of houses on a *cul de sac*, custom built for the movie set, are the only sign of an invoked solidarity in the disordered world of the 1970s.

Another Italian American family falls to pieces in suburbia—that of a dazed Billy Brown, the sweet and psychopathic protagonist of *Buffalo '66* (Vincent Gallo, 1998). His family is a mosaic in which fundamental pieces are missing. Released from jail, Billy goes to visit his family in the suburbs of Buffalo: a father who ignores him (Ben Gazzarra) and a fanatic mother (Angelica Houston) who loves football more than her son. "Ah, if you had never been born," she says reproaching him for making her lose an important game on the day of his birth; the day when the Bills won their one and only Superbowl championship. The decomposition of the family materializes in its cinematic decomposition: when Billy, his parents, and his pretend wife sit around the table to eat tripe, the camera substitutes one family member for the other. Thus, the picture is always missing a component. And it is not a shot-reverse-shot technique, the effect is emptiness and absence of the fourth member of the family: the family reunion is physically negated.

Raymond De Felitta's *Two Family House* (2000) is a different movie, an independent gem. Based on the life of the director's uncle, the movie delicately portrays the decomposition and resurrection of the ethnic family.

[9] Dawn Esposito, "The Italian Mother. The Wild Woman Within" in *Screening Ethnicity*, 32-47.

Buddy Visalo leaves his Italian American henpecking wife who criticizes his dreams and constantly counts his failures, as if she were reciting the rosary; with her, he leaves the entire suffocating Italian American community (which often appears as repressive in Italian American movies). He rebuilds his life with a young Irish woman and her biracial son. It is a social scandal, but also a chance of redemption. Italian blood is no more a guarantee for a happy unity: the rebirth, this time, takes place outside the family walls, under the sign of ethnic crossover.

CONCLUSIONS

Naturally, a considerable number of families continues to populate Italian American cinema. They are operatic families on the model of *Moonstruck* (Norman Jewison, 1987); the affectionate and noisy family of *29th Street* (George Gallo, 1991) with a mother who listens to opera while ironing; Danny DeVito's chubby wife appears for a minute, scarfing down spaghetti, in *Living Out Loud* (Richard Lagravanese, 1998), a movie where the *miscegenation* with the thin, blond American (Holly Hunter) is denied; the hypocritical, racist, grandmother-bewitched family of *A Wake in Providence* (Rosario Roveto, 1999), where the specter of homosexuality appears, as well as in the abject comedy of *Kiss Me Guido* (Tony Vitale, 1997) and in *The Daytrippers*; the Romeo and Juliet family feud over the best Yonkers pizza in *A Tale of Two Pizzas* (Vinnie Sassone, 2003), and the family broken up by invading mother-in-laws of *Italian Movie* (Roberto Monticello, 1993).

The predominance of the family as a narrative unit is part of a larger tendency in American cinema.[10] In the majority of Italian America films, however, the family is not only a cue for comedy or simple wallpaper, it is indeed a constitutive part of the narration.[11] Not only it is a beloved stereotype for many Italian Americans,[12] but it is a perfect narrative tool

[10] Dana Heller notes the deep importance of the family in the narrative discourse and writes that the family novel is everywhere because the family, in itself, is not to be found anywhere. The family exists not as a symbol of cultural unity, but as a concrete expression of "cultural description" (*Family Plots*). Sarah Hardwood arrives at the same conclusion after a study on cinema of the eighties and nineties, and speaks of a "moral panic" via-à-vis the family—a "sick" family that is nonetheless everywhere in American cinema (*Family Fictions*).

[11] In these films, Werner Sollor's concepts of *descent* and *consent* coincide: blood ties of descent coincide with the chosen loyalty to the Italian American identity.

[12] Numerous are the books, often printed by small printing shops, based on family stories. Many are books of recipes (e.g., the DePasquales, the Fantozzis, the Maccionis). On the theme of the Italian

because it offers a knot of *pathos*, feelings, and passions, which cinema wholeheartedly embraces. Also, it is a powerful ethnic element—the womb of ethnicity, either a protective or oppressive shell—that represents the duality of Italian American identity. Finally, it is a center of nervous irradiation with horizontal ramifications (brothers and sisters) and vertical upshots (grandparents and grandchildren), a source of infinite stories. It is the destiny of the Italian American family: to be destroyed by the migratory avalanche, ground up by the process of acculturation, but recomposed on the silver screen after three generations.

Works Cited

Archer, Robert A. The *Fantozzi/Petrick Family: Italian American*. San Angelo: Archer, 2001.

Barreca, Regina. *Sitdown with the Sopranos. Watching Italian American Culture on TV's Most Talked About Series*. New York: Macmillan, 2002.

Barolini, Helen. *Umbertina*. New York: Seaview, 1979.

Bondanella, Peter, *Hollywood Italians. Dagoes, Palookas, Romeos, Wise Guys, and Sopranos*. New York: Continuum, 2004.

Boykin, Rosemary DePasquale. *The DePasquales: from Italy-Sicily to Texas*. College Station: the Author, 1986.

Camaiti Hostert, Anna and Anthony Julian Tamburri, eds., *Screening Ethnicity: The Representation of Italian Americans in US Cinema*. Boca Raton: Bordighera, 2002.

Di Donato, Pietro. *Christ in Concrete*. Indianapolis: Bobbs Merril, 1939.

Golden, Daniel Sembroff. "The Fate of *La Famiglia*: Italian Images in American Film," *The Kaleidoscopic Lens. How Hollywood Views Ethnic Groups*. ed. Randall Miller. Englewood, NJ: Jerome Ozer, 1980. 73-97.

Hardwood, Sarah. *Family Fictions. Representations of the Family in 1980s Hollywood Cinema*. New York: Saint Martin, 1997.

Harrison, Barbara Grizzuti. "The Godfather II: of Families and Families." *The Dream Book*. ed. Helen Barolini. Syracuse: Syracuse UP, 1985. 121-25.

Heller, Dana. *Family Plots. The De-Oedipalization of Popular Culture*. Philadelphia: U of Pennsylvania P, 1995.

Kellogg, Susan. "Exploring Diversity in Middle-Class Families: The Symbolism of American Ethnic Identity," *Social Science History* 14.1 (Spring 1990): 27-41.

Lagace, Rita. *Italiano – A Taste of the Old World: the Mariano Family: a Collection of Recipes, Memories and Photographs of an American Family of Italian Heritage*. Miami: Lagace, 1996.

Lalli, Michael. "The Italian-American Family: Assimilation and Change, 1900-1965". *The Family Coordinator* 18.1 (Jan., 1969): 44-48.

Maccioni, Egi, Peter Kaminsky, Elizabeth Zeschin (ed.), *The Maccioni Family Cookbook: Recipes and Memoirs from an Italian American Kitchen*. New York: Stewart, Tabori & Chang, 2003.

American family, see also the Conference of the American Italian Historical Association, "The Family and Community Life of Italian Americans" (Chicago, 1980).

Mindel, Charles, Robert Habenstein, Roosevelt Wright, ed., *Ethnic Families in America: Patterns and Variations*. New York: Elsevier, 1988.

Papajohn John, John Spiegel. *Transactions in Families*. San Francisco: Jossey Bass, 1979

Tomasi, Mari. *Like Lesser Gods*. Bruce Publishing, 1948.

Valletta, Clement, "Family Life," in *Studies in Italian American Social History. Essays in Honor of Leonard Covello*, ed. Francesco Cordasco, Totowa: Rowman and Littlefield, 1975. 153-163.

Sound from The Cradle: An Image Journey of the Music of Italians in America in the 1990s

Simona Frasca
UNIVERSITY OF ROME, "LA SAPIENZA"

A pair of dirty Jordan sneakers. A sound system that blasts the indelicate and edgy music of Public Enemy. This is how hip-hop culture is both revealed and positioned in cinema. The 1990s began with *Do The Right Thing* (Spike Lee, 1989), a testament to the difficult actualization of the American melting pot ideal. The film presents an extraordinary social view that, among other things, reaffirms the simultaneously authentic and stereotypical nature of Italian Americans on the big screen. Lee's work is, furthermore, a formidable homage to music as a vehicle through which multi-ethnic conflict, the film's main theme, becomes explicit. Mookie, the character played by Lee, is a delivery man for Sal's Pizzeria. At one point Mookie gets into a verbal confrontation with Pino, Sal's son, and launches into a furious, rhythmically serrated list of anti-Italian epithets: "Dago, wop, guinea, garlic-breath, pizza-slingin', spaghetti-bendin', Vic Damone, Perry Como, Luciano Pavarotti, Sole Mio, nonsingin' motherfucker!" Pino replies in kind and the film cuts to scenes showing a chain reaction of a loafing Puerto Rican, a Chinese merchant, and an arrogant and obtuse beat cop, all at war with each other.

Through the eyes of the African American film director, we see how Italian Americans are identified in their social milieu at the end of the twentieth century, with the same cultural codes that existed at the time of the great Italian emigration: food and music. So, not very much has changed from their arrival in America at the beginning of the century. Ascription of Italians as "others" and the subsequent self-representation within the context of entertainment-cinema maintain these same identifying elements. Of extreme significance is the fact that music survived among all the "objects" carried in Italian émigré suitcases. It is the same music that, from time to time, emerges in cinema, and elsewhere, as a clear signal throughout the entire century. In those suitcases is "'O Sole

Mio," the Neapolitan song known in America and everywhere else as the "Italian" song par excellence. This is the very reason for the first great cultural misunderstanding in the history of Italian émigrés. The song, composed in 1898, accompanied Italians on the migratory adventure but it was in America that it became both a symbol of their ethnicity and a universal song—readapted in the Dean Martin and Frank Verna versions and counterfeited in Elvis Presley's "It's Now or Never." Thus the song, in cultured European terms, was reused as "art music"; that is, independent of its original context and ethnic identity.

This song by Giovanni Capurro and Eduardo Di Capua was born in Odessa on the Black Sea, almost as if in exile. Di Capua had gone there on tour with his father, an itinerant singer, and according to legend, when overtaken by a severe attack of melancholy, he set the words to Capurro's music. It is therefore difficult to prove that "O Sole Mio," recorded by Enrico Caruso in New York in 1916, is the pure and uncontaminated essence of a local musical culture, even if it were permissible to use such a definition for any musical tradition. "O Sole Mio," in fact, reveals its spurious nature from the combination of its dialect linguistic register and an exotic rhythmic pattern, the *habanera*, which does not belong to the Neapolitan tradition.

The song from its debut, therefore, seems to have been destined to a nomadic existence, ready to cast off the trappings of the city and culture that was its place of origin. In specific linguistic terms, this pliability translates into a negation of its main physiognomy as a musical document. In *Big Night* (Stanley Tucci, 1996), we hear an alien version of the Neapolitan song, now entitled "Love of My Life," sung by the Louis Prima –Keely Smith duo and another, nocturnal, intimate, jazz version performed off screen by Christine Tucci in Pascal's restaurant. It is amusing to hear how the song has been "disguised" using a composition technique that, while allowing the song to be recognized simultaneously, detracts from and updates the original version.

The above-mentioned adaptations of Capurro and Di Capua's song allow for several important considerations with reference to the concept of ethnic integration. The habit of using, in disguise, a song taken from a subordinate musical repertory extraneous to that of the dominant culture —as done with the American singers' adaptations of "O Sole Mio"—takes on double significance. It is not simply a case of "redoing" a famous song, but of transferring it into another socio-cultural context and trying to

make it intelligible to those who do not share its musical and linguistic code. For a song to be *popular*, a close emotional relationship must be established between its authors and the public. To be successful, song-writers must possess the exceptional capacity to capture the listeners' ears and cater to their tastes. When, for example, émigré authors appropriate a popular American song, they are declaring their double identity as both émigré and "American."[1] By taking on a musical document that is recognized in their new land, immigrants, on the one hand, actuate what Victor Greene defines as a close affective relationship between themselves and the public while, on the other, they intervene directly as authors of a translation and adaptation and give life to a *second* affective relationship by introducing the song into an unknown cultural context with consequent participation at a *symbolic* level in the émigré's integration into the new world. Greene wrote that recent medical research indicates that music is closely connected to the psyche, suggesting that musical patterns have a special ability to survive in the listener's conscious. A familiar piece of music thus has a strong conscious and subconscious hold on the psyche, to the point that people consider it a part of their identity. This result is defined as "brain music"[2]

This applies to émigrés attempting integration by subjectively using songs taken from the repertory of their new homeland, as well as citizens of that new country appropriating songs that do not belong to the dominant culture. In fact, by using their own aesthetic-expressive code, they enrich them with the values dictated by their acceptance of the new arrivals and the minority culture they represent.

Another song underwent an equally radical, "transubstantiationalist" transformation, one might say: "Maria Marì," a song that went from the Neapolitan songbook to join the history of Italians in America as an "Italian" song. This famous 1899 song by Di Capua, again, with words by the poet Vincenzo Russo, became immersed in the centrifuge of history and was transformed into a syncopated song halfway between boogie-woogie and Dixieland. The result is a totally de-structured composition, lacking

[1] This is the common early twentieth-century practice of using stock arrangements, whereby ethnic singers translated the words of famous songs into their own language. This practice allowed, for example, the famous sketch artist Farfariello to put into Italian/Neapolitan/English famous songs from the dominant culture, such as *Portame 'a Casa Mia*, a translation of the famous *Show Me the Way Home* by Irving King (1925). The same was done by Gilda Mignonette with *The Peanut Vendor* for her *Rumba delle Fragole*.

[2] Victor R. Greene. *A Singing Ambivalence, American Immigrants between Old World and New, 1830-1930* (Kent, OH: Kent State University Press, 2004) XVIII.

the deeper meaning of the original version. From an intimate, very sweet love song it becomes a humoristic contrivance based on a skimpy refrain that is the sole, moribund surviving trace of the original version. What remains of Russo and Di Capua's song is a trace of the sound that pursues it and, then in a rocambolesque way, loses the dialect's truth in a heavy mixture of nonsense and jive talk. The author of this extraordinary transformation and rebirth, in what could be called an anti-academic key, is once again Louis Prima. The career of this singer, born in New Orleans of Sicilian descent, belongs to the creation of one of the most important moments in the history of American popular music. He was one of the most eloquent and effective representatives of that harmonically complex genre known as jazz and its change into early rock and roll, and did so by using the alien element of his Italian musical heritage. Prima opened the door to entire generations of Italian American singers by providing a tremendous contribution in guiding the Italian inclination for melody to the realm of syncopated music. With him emerge crooners such as Dean Martin, Perry Como, and Vic Damone (see Spike Lee). After Prima, even if not exactly following in his footsteps, came the Italian generation of teen idols: Frankie Avalon, Fabian Forte, Bobby Darin, Annette Funicello, and Connie Francis, as well as the doo wop groups of Dion [Di Mucci] and The Belmonts evoked by Robert De Niro in his *A Bronx Tale* (1993) and Frankie Valle and The Four Seasons. Prima, therefore, negotiated the true musical integration of Italians in America. It is no casual coincidence that Prima is the great absent protagonist of Stanley Tucci's bittersweet comedy that focuses on the rapport between émigré Italians and their history, and their need to manufacture an entirely new identity. If, in fact, ethnic identity cannot be made less local, it can however be "relocated." The modalities of this phenomenon constitute the perimeter of its strident and painful process in *Big Night*. Tucci's film evokes the same fraternal conflict that was the theme of *Santa Lucia Luntana* (Harold Godsoe, 1931), one of the first movies with an Italian American setting.[3] It, too, was strongly tied (as is evident by its title, taken from the famous song by E.A. Mario) to the history of Italian-Neapolitan music.

These observations led to an obvious but not often articulated conclusion: that there was a golden age of Italian music in America, and it can be defined as such through its recovery in recent Italian American films,

[3] For an analysis of the film, see Giuliana Muscio, *Piccole Italie, Grandi Schermi* (Rome: Bulzoni, 2004) 256-60.

beginning with Martin Scorsese. It coincides with the creation of an Italian American identity that originates with Louis Prima and in the crooners who came after Bing Crosby. This august era (it reached its peak in a history made through deliberate self-representation rather than forced imposition), proceeded with results achieved thanks to the lessons learned from black music and doo-wop, in particular. By once again placing itself within the melodic sphere, the music produced during this phase is a combination of nostalgia and an Italian American style torch song.

In this way, the music recovered the late-Romantic elements of desperate and total love, of existential and solitary pain that began to characterize Neapolitan songs at the end of the nineteenth century. To Spike Lee's *Do The Right Thing* corresponds, ideally, four years later Robert De Niro's *A Bronx Tale*. Here, the music is the vehicle that—according to the musical medley technique used repeatedly by Scorsese in his sagas with Italian American settings, including *Casino* (1995) and *Goodfellas* (1990) to mention the most recent ones—immediately identifies the film's ethnic-social milieu. De Niro, as does Scorsese, uses a repertory taken from the golden age of Italian American music. *I Wonder Why* by Dion and The Belmonts gives way to *The Same Old Song* by Frank Sinatra. Dean Martin's *Ain't That a Kick in the Head* and Tony Bennett's *When Joanna Loved Me* reply. Throughout, we hear the best of black jazz, soul, and rhythm and blues: *Flamenco Sketches* by Miles Davis; *Hawg for You* by Otis Redding; *I'm so Proud* by Curtis Mayfield and The Impressions; *It's a Man's Man's Man's World* by James Brown; as well as the English beat pop of the Kinks and the Beatles and the evolved rock of Bob Dylan and Cream. De Niro's film presents two parallel stories: the objective one told through the language of images, and the subjective and interior one suggested by the language of music; and one does not always follow the other. Thus, at the end of the twentieth century, *A Bronx Tale* seems to open a breach within ethnic Italian American cinema and allows a return to reflections on "being Italian American." Such a self-reflective act seemed necessary because it represented a veiled desire, perhaps in order to underscore its authenticity, in order to reconsider the rarely deal with image of a somewhat resentful and violent Italian American. Here, De Niro and his confreres aptly employ those devices offered by the visually projected identification of cinematography.

Such cinematic imagery, faded now from overuse, has become custodian only of a truth that has had little regard for the real assimilation

journey of Italians in America. It is a route fraught with danger that not all Italian Americans are willing to take, because it implies a discussion of the underlying assumptions of a culture with which they identify but that too often relies on pure convention. A few years ago I interviewed Lawrence Tamanini about the programming on his "The Italian American Hour" radio show on WBCB in Levittown, Pennsylvania. I had the impression that I was talking with a person who was engaged in a form of cultural war against the widespread image of Italians in America. During the interview, Tamanini stated the following:

> The main genre of music that is played in my program would be jazz. Reason is, mainly the free expression it gives an artist. I have written to several Italian record companies but have never received any CDs from them. I listen to Italian jazz musicians since they are the artists that seem to be creating a fresher approach to jazz. Italian American artists such as Pat Matino, Joey Defrancesco, and Joe Lovano are played quite a bit but I stay away from the standard format that Italian Americans on the air play. They usually go with Sinatra, Martin, and Bennett. I love those folks but prefer to give airtime to up and coming artists first and foremost.[4]

With these touchstones of Italian American tradition, including Prima and a few others, all of Italian American music is sealed up and consigned to history. As Tamanini confirmed, it becomes very difficult to separate this musical imprint from the idea we all know as "Italian Americanness." Something similar applies also to "Neapolitanness," a concept that includes, among other things, aspects tied to a pronounced and specific musical imprinting that is at times conventional, but always palpitating. "Neapolitanness" and "Italian Americanness" coincided, from a musical point of view, for a certain period of time. Actually, one gave birth to the other but without staking any claims, as if it were a mother who, not being able to raise her children, hands them over to more capable hands. This allowed for the emerging of an imprecise and usurping concept of "Italianness" to the point that many Italian Americans have grown up with the mistaken impression that songs such as "'O Sole Mio" and "Maria Marì" were Italian.

The tradition of Italian American music acquired its adult form at the

[4] In *Alias*, a weekly insert of *il manifesto* (March 17, 2005): 12-3.

height of American popular music. The two repertoires grew together and subsequently the Italian American one made significant contributions to the American one. After all, this is the nature of American tradition. According to Adelaida Reyes, American musical culture is fairly recent and its musical life developed over a large area, since the United States is a country of immigrants. Consequently, there is not a single cultural "pedigree" with a mythical or provable origin, but an ever increasing number of them. People who come from different cultures and speak different languages set in motion a musical process of "Americanization," even if they continue to use the sounds and musical patterns of other countries.[5] This grafting is known to Scorsese who, when working on the sound tracks of movies such as *Goodfellas*, does not hesitate to mix together American rock and roll with Italian and Italian American songs. The same applies to his disciple De Niro. There is, in fact, a relationship between the two repertoires that may have been dictated by their close births: Dean Martin precedes rock and roll, which had its roots in the in-between genre: doo-wop, which, as mentioned, had a significant Italian American component. Doo-wop was a vocal harmony of African American origin that was popular in New York's Italian neighborhoods. De Niro portrays this very well in *A Bronx Tale*. Many working-class, first-generation Italian American families might not have had a television, but most had a radio. They did not listen to contemporary music at home; their parents' old Victrolas could only play 78 RPMs, and not the new 45 RPMs of their favorite groups. The kids chose doo-wop as their own form of social expression. It was music to entertain bands of teenagers who would meet after school on street corners and launch a melody of three, four, or five voices without the need for instruments. Using the old "a capella" genre with rock and roll rhythms was doo-wop's greatest innovation. The love songs, with their simple assonances and perfectly equilibrated harmonies, marked the beginning of a musical decade in which Italian American groups played a large part.[6] Scorsese's choices for the sound tracks of his films with Italian American ethnic settings are a kind of biography of the highest point of the Italian American tradition. The same can be said of Abel Ferrara's films, *The Funeral* (1996) and *King of New York* (1991).

[5] Adelaida Reyes, *Music in America: Experiencing Music, Expressing Culture* (New York: Oxford University Press, 2004) xi-xii.

[6] For more information, see Edward R. Engel, *White and Still All Right!: A Collection of "White Groups" Histories of the 50s and Early 60s* (New York: Crackerjack Press, 1977).

The debut of John Turturro as film director in the 1990s introduces a different current, that of the birth of the Italian American hybrid. His first film *Mac* (1992) is a return to the Bronx. The year is 1954. The context, once again, is that of an Italian family fighting for economic survival and social betterment. The film's sound track is not taken from contemporary music; there are no doo-wop or rock and roll groups to mark the musical scene. The plot focuses on the Italians' attempt to break out of a non-American multi-ethnic context, in which the presence of the dominant culture is barely glimpsed.

The music heard is almost completely from the past, with the exception of two brief musical appearances by Prima. It is the past of the Italian arrival in New York, a city that is cinematographically portrayed as the most "Italian" in America. Enrico Caruso, in his role as unparalleled opera tenor, sings "Di Quella Pira" from Verdi's *Trovatore* and the aria "M'Apparì Tutto Amore" from Flotow's *Marta*. It is worth remembering that this Neapolitan singer is the catalyst for a change in the average American's perception of Italian émigrés. He frees Italians from their sad and frightening status as subalterns, good only for violence and social disorder. The rest of the sound track consists of the folk repertory of Sicilian songs and a few authored ones ("Mamma" by C.A. Bixio) that contribute to the emphasis placed on social status of Mac's family.

One thing appears clear; Turturro's cinema music is much more than just an emotional coloring. In 2005, with *Romance & Cigarettes* this actor/director achieves his personal experiment in musical "cine-drama." In this film, despite the fact that he tries to avoid any open declaration of ethnicity, the truth astonishes and palpitates in its revelations. Signs of "Italianness" are spread throughout and coalesce in the sound track that uses, among others, Connie Francis's well known version *Scapricciatiello*, an authentic musical grafting that has become a true icon of the Italian American repertoire. The song is heard during the film's most amusing and perturbing moments when Kate Winslet (in the role of Tula), after a fiery sexual encounter with Nick Murder (James Gandolfini), performs an exhilarating and sensual "titty dance" for him on the bed, while singing in playback Pacifico Vento and Ferdinando Albano's song.

Turturro's musical choice shows him falling into the fascinating trap of believing a Neapolitan to be Italian. Most importantly, the choice is evidence of the director's desire for intimacy with regard to this profoundly hybrid musical repertoire. It leads to the idea that an Italian American

director who looks at Italian American music, in reality, is consciously asserting a feeling of solidarity with such music as a reflection and emblem of his/her ethnic culture or that, for the very least, that s/he is willing to confront it.

In essence, cinema seems to have contributed more than any other medium, to the founding of the Italian American musical repertoire expressed as gathering of homogenous aesthetic values. As Theodore Adorno and Hanns Eisler wrote, music represents the collective because its representation is made by its pathetic distance from the image.[7] Those values, however, have also functioned as a negative counterpart to the creation of a conventional imagination in which Italian Americans see themselves. With this music, the cinema discussed in this essay has made alliances, and rarely has the musical element acted in an alien, grotesque, or ironic way with regard to its cinematic counterpart. We are probably still in a phase of revanchism on the part of Italian Americans who are a little inclined to indulge in self-criticism. Emotional epics are still with us and music, when at the service of another language, as Adorno defined it, sharpens and emphasizes that language by requiring its ancient symbolic and undeniable value as unconscious accelerator of collective emotion.

Translated from the Italian by Maria Enrico

[7] Theodore W. Adorno and Hanns Eisler, *La musica per film* (Rome: Newton Compton Editori, 1975) 39.

Flesh and Soul:
Food and Religion in Italian/American Cinema

Alessandra Senzani
FLORIDA ATLANTIC UNIVERSITY

SET: A humble immigrant kitchen filled with votive icons and shaken by a persistent and obsessive beat.
SCENE: Juxtaposed close-ups of a ceramic Madonna and the fists of a middle-aged woman kneading bread.
CUT: Ritual distribution of the baked *calzone* to the children gathered at her table.
CUT: Male hands holding an iron bar start a dancing street fight on the notes of Little Richard's "Jenny, Jenny."
CUT: From the rhythmic fight, zoom in on the local stores and the sharp sound of the butcher's knife.

These are the first jarring shots of Martin Scorsese's film debut *Who's That Knocking at My Door*. Originally his Master's thesis at New York University, the film was shot in 1969 and, tellingly, begins with the director's mother and a pulse that foretells the tensions pervading a community strongly contained by patriarchal conventions and acutely aware that its cultural survival is entrusted to the hands of mothers. The initial sequence introduces key themes that will continue to mark Italian/American[1] films over the years: a keen eye for the rituals of the ethnic family — as they are performed and served on the family dinner table and at the Catholic altar — and an exploration of the repressed anger and violence contained in the Italian enclave and in American society at large.

Food and religion thus function as powerful lenses to reflect on conflicts linked to one's ethnic identity — torn between the pull towards assimilation and the resistance to shed one's ethnic roots. As James Kellner

[1] See Anthony Julian Tamburri's *To Hyphenate Or Not To Hyphenate,* for the use of the slash (/) in place of the hyphen (-), in order to reduce its implicit ideological gap.

points out, food on screen can only function as a metaphor because it cannot actually be consumed by the spectators. Yet, filmic culinary images can successfully — and paradoxically — challenge the predominance of sight over the other senses, reminding us of alternative paths to attain knowledge such as smell, taste, and touch. The image of food can recall tactile memories such as the odors of a long-gone place and home, introducing us to the diasporic experience and its ambivalence. Hamid Naficy well argues that the diasporic experience, while being fragmentary by definition, retains the potential power of (re)establishing connections among separate segments of one's life, thus (re)creating a sense of place and belonging. This "tactile optic" predicated on multiple spaces, temporalities, voices, bodies and senses is what defines the aesthetics of "accented cinema," a term Naficy coined for the films by directors living inbetween multiple cultures (28-29).

Beyond evoking localized and tactile memories, food and its rituals also serve as signifiers of ethnic survival, as Anne Bower's edited collection *Reel Food* well exemplifies. In keeping with the literature on symbolic ethnicity, Bower reminds us that sometimes a pot of tomato sauce on the stove represents the last trace of an ethnic identity that looses in corporality and hangs more and more loosely on symbolic rituals of a long-gone ethnic past. For Italian Americans, such practices are more often than not connected to Catholic holidays and rituals that dictate the calendar of their ethnic community. The smells from the ethnic kitchen mingle with the incense of the churches and the wax of the votive candles. The richly laden family dinner table is only steps away from the local altar and the pagan *penati*, the Roman patron gods of the storeroom with which many immigrants crossed the ocean.

The strong link between food and religion in the transmission of ethnic identity is further reinforced by the contradictoriness of their representation in the films by Italian/American directors. As illustrated in the first sequence of *Who's That Knocking at My Door* mentioned above, the rituals of the Catholic kitchen and church are often associated with the violence and resentment that boils in the ethnic community, constrained at the margins of the dominant society and often cut off from change. Cooking and praying function as cages for many Italian/American women, as well as for the Italian/American sons subject to the oppressing Law of the Fathers. In his article "*Cinema Paradiso*: The Italian American Presence in American Cinema," Pellegrino D'Acierno documents the cru-

cial role played by the family in Italian/ American cinema, which simultaneously celebrates familial ties and unveils the constraints of anachronistic patriarchal codes. As argued by Bower, cultural ties can be both renewed and challenged by the food served on screen (5) and, I would add, by the candles we choose to light up in cinema, to employ a Scorsesian metaphor of cinema as a church. A brief overview of the work by Italian/ American directors who have negotiated their ethnic heritage suffices to bring up the many contradictions that inhabit these texts filmed on the hyphen.

First, there is a clear demarcation between the second-generation Italian/American directors, particularly Martin Scorsese and Francis Ford Coppola, together with the independent and "damned" Abel Ferrara, and the third.[2] The *auteurs* of the second generation employed cinema as an allegory of the immigrant condition in American capitalism. In *The Godfather* (1972), Coppola explored the dark side of the American Dream, the corruption of American politics and Catholic institutions through the metaphor of the Mafia. With the now legendary Corleone family, Coppola aptly represents the duality of familial ties, showing the violence that can sometimes cement them and result from them (Santos 210). Banquets and religious ceremonies in this cinematic Mafia triptych are transformed into opportunities to carry out murder and illegal business: from the request of revenge pronounced during Connie Corleone's wedding, to the Catholic baptism of Anthony Vito Corleone and the juxtaposed blood baptism of the father, and finally up to the corrupted practices inhabiting the Vatican corridors and the bank offices, where food often serves as an instrument of death.

Differently from Coppola, Scorsese leaves behind such romanticized Mafia "men of honor" and prefers to clinically observe and represent the religious tribulations of his metropolitan mean streets, where his characters redeem their sins, as Charlie—actually in Scorsese's own voice—reminds us at the beginning of *Mean Streets*. In his tetralogy on Italian/ American gangsters (*Who's That Knocking at My Door* [1969], *Mean Streets* [1973], *Goodfellas* [1990], and *Casino* [1995]), Scorsese allegorically represents the apotheosis and inevitable descent of the greedy neighborhood

[2] Frank Capra and Vincent Minnelli are the names that made the first generation of Italian/ American directors famous, although they rarely dealt with their ethnic roots in their films. The second generation counts among its *auteurs* Francis Ford Coppola, Martin Scorsese, but also Brian DePalma and Michael Cimino, who contributed to the New Hollywood that emerged from the 1960s crisis.

bosses, whose ultimate demise takes place—not accidentally—in the ca-
thedral of American consumerism, Las Vegas, which Scorsese transforms
into a modern Lourdes, where money can wash away all your sins.[3]

Interestingly, the theme of "gaining paradise and losing it through
pride and greed" (Scorsese 200) in Scorsese's tetralogy is accompanied by
a gradual retreat of the Italian/American cuisine, both in terms of the
physical space of the kitchen and of the ethnic and religious rituals that
mark food preparation. While *Who's That Knocking at My Door* starts off
with the mother kneading bread, and *Goodfellas* represents the imminent
demise of Henry Hill through his hectic and desperate attempt to simul-
taneously cook up a luxurious dinner for his brother and conduct a drug
affair, in *Casino*, we never see the characters approach the kitchen stove.
Restaurants, diners and lifeless kitchens dominate this last descent, where
the consumption of food is replaced by capitalist consumption.

The doomed Mafiosi in *Casino* resemble the infernal characters who
populate Ferrara's films, the director who, together with Scorsese, dealt
most explicitly—and arguably obsessively—with the religious dilemma
plaguing the Italian/American and modern soul. Ferrara, with the contri-
bution of his screenwriter and theologian Nicholas St. John, has consis-
tently explored with merciless lucidity the carnal impulses of the Catholic
soul. His films rarely focus on food as a mediatory tool between the
sacred and the profane, preferring instead to directly tackle the corrup-
tion of the human flesh.[4]

If Ferrara and Scorsese represent the quintessence of a certain allegori-
cal cinema, the new generation of Italian/American directors seems more
concerned with the everyday life of middle-class Italian/American fa-
milies. Religion serves to convey an authentic and ethnic flavor to the as-
similated group. Characters still religiously make the sign of the cross
every time they pass by a church or mention a deceased relative or their

[3] See the brilliant essay by Robert Casillo in *Screening Ethnicity* about the pariah of Scorsese's cinema.
Here he explains why Las Vegas as the site of the mafia families' ultimate demise should not be seen
as accidental. As he illustrates, the rituals of gambling are closely linked to a God that can administer
good or evil unpredictably. Following Rene Girard's arguments on ritual, Casillo reminds us that its
function is often to control and contain violence, which is the essence of the sacred and of its duality
(163). According to Casillo, *Casino* "depicts a miniature version of the sacrificial crisis, in which
violence proliferated unpredictably as society descends to those promordial [sic] antagonisms from
which, according to Girard, ritual, like gambling, derives" (184).

[4] See Rebecca West and Silvio Danese for a detailed analysis of the role of religion in Abel Ferrara's
cinema. West also explores the analogies and differences between Scorsese and Ferrara, with their
extreme aesthetics and their reflections on masculinity.

mother; however, the directors do not make us privy to their moral and religious dilemmas, as we grew accustomed to with Coppola, Scorsese, and Ferrara. Similarly, the Italian/American cuisine gradually looses in visibility. While Coppola and Scorsese dwelled longingly on the richness of the Italian/American dining table, which served both ritual religious reassurances and cold vendetta dishes to the community, the new directors prefer sitting in restaurants and depicting solitary and tasteless dinners.

When cooking and food take center stage, they usually serve to explore issues of authenticity, reinforcing or challenging one's ethnic roots. Two films that have been the object of ample analyses both in Italian/ American studies and in the "food genre" literature are *Big Night* (Stanley Tucci, 1996) and *Dinner Rush* (Bob Giraldi, 2000. The two newly immigrated brothers, Primo and Secondo in *Big Night*, and their failed attempt to establish their restaurant of "true" Italian cuisine introduce us, as Anna Camaiti Hostert points out, to the dilemma of authenticity and the pressures to conform to an ideal of ethnic purity. Primo nourishes a certain religious idealism in his approach to cooking (Kellner 128), interpreting food as a mediatory tool to come closer to God. For this reason, food needs to be cherished and protected from contamination, which for Primo rhymes with Americanization. Secondo, on the other hand, attempts to negotiate his brother's purist position with the opposed capitalist and pragmatist approach of the rival restaurant owner Pascal, who rejects any attachment to the "authentic" Italian cuisine and responds only to the Law of Profit. As Hostert suggests, the film seems to argue that "perhaps maintaining one's own roots should go hand in hand with the flexibility of experimentation" (257).

Dinner Rush depicts, instead, a successful gentrification of a popular Italian/American *trattoria* in a refined nouvelle cuisine restaurant in New York City. The young chef Udo Copra seems to owe his refined taste and culinary ability to his Italian/American roots; yet, his hybrid and upper-class cuisine has wandered far away from the popular Italian/American dishes. Not surprisingly, Chef Ugo does not share the religious idealism of Primo in *Big Night*; he is fully assimilated in the New York upper-class and consumerist scene, conscious that a name ending in a vowel and a Mafia murder at his restaurant table are not a source of shame any longer, but rather opportunities for profit.

The scents and anguishes of the early allegorical movies of Italian/

American cinema have been largely diluted. While the 70s directors focused on the dialogues and conflicts of two cultures still in the process of acquaintance, the new fully assimilated Italian/American directors face issues of authenticity, and the need to (re)discover and (re)invent their ethnic heritage. What seems to be passed on from the previous generation in these two films is a tendency to confer the cutting knife in the hands of all-male chefs. Indeed, Coppola and Scorsese have often confined women in the *domus,* but they rarely recognized them any cooking mastery.[5] In their films, it was the bosses who prepared and seasoned the red sauce while planning the next move;[6] they taught us how to cut garlic as thinly as possible from their prison cell. Ethnic heritage and customs were men's business as clearly exemplified in *The Godfather III,* (Francis Ford Coppola, 1993) where Sonny's natural son teaches the young Mary Corleone the secrets and arts of the Italian/American kitchen.[7]

The younger Italian/American directors, possibly not to face such ambivalent heritage, seem to be less interested in analyzing the Catholic soul and the food that nourishes it. Beyond the two above-mentioned

[5] Scorsese honored his mother and her cooking talent in the beautiful documentary *Italianamerican* (1974), where he sets out to document how his mother made the red sauce. Yet, in his films, we rarely see women cooking.

[6] In Mafia films, the tomato sauce and its redness function as polysemous signifiers of strong passions and of the blood that is sacrificed in the metropolitan jungle, where the excesses in the kitchen mirror the excessive violence, greed and consumerism. Moreover, the tomato sauce also acts as a connective tissue of the different ingredients, often overshadowing the individual flavors and differences. As we will see, in recent Italian/American women's films, directors prefer to draw attention to the singular tastes, trying to strike a balance where no one ingredient dominates the others. This is true for the sausage recipe in Nancy Savoca's *Household Saints* (1993) where the Italian grandmother teaches her daughter-in-law the significance of harmoniously and carefully blending together all the ingredients, so that each can be tasted in its own right, as well as in Helen DeMichiel's *Tarantella* (1996), where the director frames the necessary ingredients for a pasta dish as in a *natura morta,* a still life that wants to celebrate the genuine, basic ingredients of most Italian recipes.

[7] This initiation to Italian/American cuisine and to sexuality is evoked in *Federal Hill* (1994) by Michael Corrente. Nick is a modern *guido,* i.e. the stereotypical Italian American who is good-looking but whose working-class status is derided by his flashy clothes, a sort of heir to the 1970s Tony Manero. Nick is a small drug dealer who sells to the rich pupils attending Brown University, among whom Wendy, an attractive blond student in art who is about to take a trip to Italy for study. Nick is able to seduce her with his cooking talent, which he demonstrates by preparing an "authentic" pasta dish with the ingredients he buys from the local Italian stores. Despite the class gap, Nick seems to successfully impress even Wendy's upper-class parents when he takes them out to dinner in a refined Italian restaurant, where he orders food in Italian—with a variety of dishes unusual for the typical Italian/American dinner on screen—and chooses one of the best wines of Northern Italy. The film reinforces many of the stereotypes about Italian/American men—among which a difficulty with language, a pervasive criminality and homophobia; however, it differs in that this modern *guido* can actually speak Italian and seems to know more of his ancestors' country than most of his predecessors.

films,[8] marital miscomprehensions, gender, and familial conflicts coupled with the desire to abandon the ethnic enclave appear to be the most recurrent themes for the new directors. Italian/American men in emotional crisis, questioning their masculinity emerge in all the genres explored by this new generation, with a noticeable increase in romantic comedies. Greg Mottola in *The Daytrippers* (1996), for instance, introduces us to the Malone family during an agitated breakfast that rapidly turns into a family complot on how to find out whether the husband of the older daughter is cheating on her. The scene is shot from a lower angle that keeps the plates full of scrambled eggs and bacon in the foreground, and conveys the impression of characters trapped in a space too tight for them. The shot creates a sense of constriction that is reinforced in the next scene when Mottola packs us along with the Malone family into a small car for the whole day/film. The sense of claustrophobia is thus heightened and reflects the enmeshed family relationships. We are made to share the constant attention of the stereotypical Italian/American mother, always inappropriate, overbearing, and excessively curious. After a long and increasingly irritating wait, the Malone family finally traces the husband and discovers that he is indeed cheating on his wife, but with another man. Betrayal and homosexual relationships are not here demonized,[9] but rather represented as a sincere identity crisis, a questioning of

[8] A yet different look on the food industry and its meaning for Italian/American families is offered by the recent film debut of Kevin Jordan with *Brooklyn Lobster* (2006). The film tells the story of a lobster farm in Brooklyn, not so much focusing on the art of cooking and notions of ethnic and artistic authenticity, but rather on the survival of the small family business. Few scenes, if any, serve in front of our eyes cooked and luscious dishes; many are, instead, the close-ups of raw fish—either dead or alive, or on the brink of perishing just like the family farm. Indeed, the film reflects on economic conflicts and pressures for a small, family-operated business in contemporary corporate USA. The director thus prefers emphasizing the difficulties and skills related to the job of lobster farming rather than to the art of cooking. Fish is depicted as a means of survival; it is respected and praised as a product and tool rather than as food—not accidentally no one in the Giorgio's family can actually stand eating crustaceans. While offering a fresh representation of an Italian/American family, the film also "pays its debts"—and humorously so—to the "Fathers" of Italian/American cinema and the mafia genre, tricking us in some scenes by employing its typical conventions, just so as to surprise us. A scene can serve as example here: in the parking lot of the restaurant late at night, we see Michael, the restaurant owner's son, in a black coat meeting up with Tommy, one of the workers in the farm, about an unclear business deal he has to offer. They stand in front of Tommy's car discussing the mysterious proposal in the middle of the night, like two gangsters closing an illegal deal. Yet, when the camera enters in the trunk, it reveals that we couldn't be more wrong: there in front of our eyes there is no stack of illegal money, guns or dead boy, but just innocent—although eerie-looking—lobster-shaped buns that Tommy thinks could be a great selling good in the farm store. Certainly a disturbing offer with these fake lobsters seemingly staring at us, but not one Michael cannot refuse—and the name there seems quite appropriate as well.

[9] Tom Di Cerchio has explored the still oppressing homophobia in the Italian/American community of Cicero in Chicago in his short, *Nunzio's Second Cousin* (1994). In the film, he uses food as a tool to

one's sexuality and desires, which had been trapped and suffocated by the cage of the Catholic and Italian/American marriage.[10]

The Catholic holy union seems to be on shaky ground in *Two Family House* (Raymond De Felitta, 2000) as well; here Buddy, a worker with an entrepreneurial spirit, faces the constant diffidence and lack of confidence of his wife and the Italian/American community, who are hostile to any change and attempts at independence. Buddy finds a confidant and eventually a lover in his Irish tenant, Mary, a young girl married to an older friend of her father. Her escape from a constricting marriage comes with the birth of her child, whose black skin clearly signals his being conceived outside of the Church sanctified union, and relegates her to an outcast status in the community. As so often in literature and cinema, food functions here as a courting and seduction tool when Buddy introduces Mary to the pleasures of a well cooked plate of pasta with Chianti. The film points to the constriction of an ethnic community that distrusts change and of a marital institution dictated only by conformism to tradition. However, while the films portrays the extra-marital affair as an oppor-

address the intersections between sex, violence and anger in the tensed familial and ethnic relationships of the neighborhood. I refer to Anthony J. Tamburri's essay on the film for a detailed semiotic analysis of the short and the multiple meanings cooked up in the family dinner represented. In this context, I would like to mention *Kiss Me Guido* (1997) by Tony Vitale as well, where the stereotypical *guido*, Frankie, ends up sharing an apartment with a gay actor in Greenwich Village. The beginning of the movie is a panoramic shot that displays right in front of our eyes all the standard Italian/ American stereotypes, which in the film are mostly associated with Frankie's brother Pino: machismo, homophobia, Catholicism, and misogyny. The movie specifically addresses the cinematic heritage of Italian Americans with Nick often quoting lines from various Scorsese's movies, such as *Goodfellas* and *Raging Bull*, films that address issues of masculinity and violence. Like these films, *Kiss Me Guido* draws our attention to the constraints of the Italian/American community, its being set apart from the rest of society and still tied to a patriarchal culture that oppresses the new generation. This sense of entrapment is clearly evoked in the first scene shot in Frankie's pizza shop, where the camera is set inside the pizza oven. The viewers can glimpse the events happening on the screen only when Frankie opens the oven, to be thus shut out again when he closes it. The image clearly thematizes the sense of exclusion and the narrowness of view that excessive traditionalism in ethnic communities often cause.

[10] Extra-marital affairs are also at the center of John Turturro's last feature film, *Romance and Cigarettes* (2005) where Nick Murder (played by *Sopranos* actor James Gandolfini, as his name in the film seems to humorously suggest, as well as the initial sequence in the car that reminds us of the TV series credit titles) has an affair with the provocative and outspoken Tula. The betrayal soon discovered by the women in the family is punished with solitary and burnt dinners; abandoned by his wife Kitty and daughters, Nick feels disoriented and suffers a heart attack because of liquorices indigestion. He then finds out that he is terminally ill, and the women in the family accept him back on the wife's terms. Their relationship gradually recovers as well, relying on the past years of intimacy and confidence. Ironically, the last act of love performed by Kitty is to threaten her husband with a kitchen knife; an instrument that can easily remind us of the knife that Scorsese's mother Catherine innocently delivers Joe Pesci in *Goodfellas*, a domestic weapon to kill a Mafia-made man. Here, however, it is the woman who hilts the knife and uses it to instill a healthy fear, a feeling that helps to remind Nick that he is still alive.

tunity to break free from communal ties and reach one's own self-fulfill-ment, it still retains a certain Catholic-Christian *ethos*, in its emphasis on compassion. By the end of the movie, the sinners Mary and Buddy have managed to open their own bar, where all are welcome, indifferent of sta-tus, roots, or gender, like in a church.

While these new Italian/American directors timidly reconsider gender roles within the Italian/American community and family, Italian/Ameri-can women filmmakers are forcibly reclaiming an alternative (hi)story for food and religion as the means often used to marginalize and subject women in the ethnic home. In *The Milk of Almonds,* Louise DeSalvo and Edvige Giunta remind us that food is at the center of power relations in the domestic Italian/American setting (1). As mentioned above, women have been doubly marginalized in Italian/American cinema: trapped in the kitchen, but deprived of their cooking talents ascribed to the men of the house. In advertising and in films by non-Italian/ American directors, we have grown accustomed to the Italian/American woman dressed in black, always busy behind the stove, and angered at her sons who betray her by going out to restaurants for their sustenance. Yet, most male Italian/American directors erased the Italian/American woman from this last stronghold altogether.

Filmmakers[11] like Nancy Savoca and Helen DeMichiel are (re)appro-priating these domestic spaces and turning them into sites where the pa-triarchy of the Italian/American community can be unveiled and criti-cized. Simultaneously, they do not hesitate to celebrate the mute resis-tance of the many Italian/American women who have been silenced in the backstage of Italian/American cinema.[12] In her first feature film, *True Love* (1989), Savoca depicts the wedding preparations of two young Italian Americans from the Bronx. The film juxtaposes the Italian/Ameri-can male world that dominates the streets of the neighborhood and the

[11] Interestingly, Anne Bancroft—the famous Hollywood actress, who is rarely identified as an Italian American because she was soon forced to change her ethnic name, Anna Maria Italiano, to make it in the film business—directed one feature film, *Fatso* (1980), where she chose to tell an Italian/American story focused on our relationship with food—possibly a statement of ethnic affiliation in the last stages of her career. See Steve Zimmerman and Ken Weiss for an analysis of the film (58-60).

[12] The ambivalence in the relationship with food and domestic rituals, as well as the (re)claiming of the stories, voices and experiences of the silenced grandmothers unites Italian/American women directors with writers and filmmakers of other ethnic backgrounds. As Marvalene Hughes observes, for instance, food—and specifically "soul food"—plays a crucial role in the reconstruction of an African/American identity that wants to give visibility to the women forgotten in the kitchen (272-80).

women's constriction in claustrophobic kitchens. As Giunta argues in her article "The Quest for True Love," Savoca does not romanticize the domestic setting; on the contrary, she unpacks its contradictions and conflicts in order to directly confront the patriarchal rituals that have always oppressed Italian/American women. Savoca reclaims her power behind the camera; she gives voice to the many Italian/American women struggling to break free from the stifling roles imposed by the fathers and priests of their community. The film depicts the Catholic marriage as a ritual that contains not only Italian/American women, but also men, since its patriarchal Catholic rituals do not respond to the aspirations and needs of a new generation. The film starts and ends with a home movie — first the engagement party and finally the wedding. The initial smiles and excitement give way to the empty and formal smiles of the newlyweds who, by the end of the film, look trapped in a frame that does not fit them, but which they do not know how to leave or inhabit differently. They cannot escape such overwhelming traditions and they are doomed, even in their dreams and desires, to regress into conventional narratives and dominant gender roles. She dreams of a fairy tale wedding symbolized by the blue potatoes served at the dinner, and he understands fun only in terms of a guys' night out drinking. In this film, men are always wielding a camera, framing, and staging the action, directing Donna and Michael according to an outdated script; Savoca, however, asserts her control of the camera eye, making viewers aware of the powerful constrictions and anachronism of the patriarchal rituals forced upon young Italian Americans (Giunta 264, 269).

In *Household Saints* (1993), Savoca revisits the Italian/American neighborhood to explore, in greater depth, the role of religion and Catholic marriage in the marginalization of the women. The film tells the story of how the Santangelo sausages have come to possess miraculous powers; the story spans three generations of Italian/American women, Carmela, Catherine, and Teresa, and recounts their struggle to claim visibility within their patriarchal community. As Rebecca Kuhn observes, in this film the women are the ones in control of the community's religious and spiritual traditions (36); it is their memories and gestures that keep the rituals alive. Grandmother Carmela, representing the first generation of immigrant women, lives her life according to a mixture of pagan and Catholic beliefs typical of Italian Catholicism (see Verdicchio and Gardaphé). Her conformism to old rituals, beliefs, and dogmas together with her authorita-

tive management of the Santangelo house traps the young daughter-in-law, Catherine, who is more attracted to the shiny pages of American fashion magazines than the shiny pots and pans of the Italian/American kitchen of her father and husband. She will find her voice and position within the family and community only once Carmela passes away; for Catherine, the mother-in-law's death signifies a break from the Catholic rituals and pagan superstitions containing women in the family. Finally in charge of her house, Catherine stores away Carmela's old paraphernalia and religious icons, turning her home into the perfect American household she loved to contemplate in magazines.

Yet, her mother-in-law's spirit continues to inhabit her life and sings back to her the famous recipe for the Santangelo sausage that Catherine is now responsible for making. Her Americanization and assimilation is thus already compromised and is further questioned when her daughter surprisingly becomes a fervid Catholic. Teresa takes her grandmother's religious icons out of the closet again, and asks to become a Carmelite nun; a desire her father denies. Such refusal leads Teresa to serve God as Saint Therese of Lisièux who transformed daily tasks into holy services; her religious fervor finally thrusts her into the hands of a young university student, Leonard, who knows how to exploit her beliefs. When he starts giving orders to her, she feels "a sense of freedom" similar to the feeling of "floating out of your body," described by the saint hagiographies she so eagerly devours. She thus subjects to Leonard's will, certain that it is also God's plan for her. Savoca clearly establishes a connection here between the patriarchal family and the Catholic Church, two institutions where the Law of the Fathers controls the women.

Teresa's Catholic fervor will lead her to death, but in her last vision we can notice a change. Her very last dream is about playing pinochle with God, Jesus, and St. Anne; once Teresa realizes that God is a cheater, she also discovers herself different from St. Anne who submissively plays to lose and please God; Teresa instead recognizes her desire to win her match against the Fathers of her beliefs. In *Household Saints,* Savoca celebrates the pagan beliefs on which the authority of Italian and Italian/ American women has relied for centuries, while simultaneously drawing attention to the need for reinventing and detaching them from the patriarchal traditions they have been part of. As Pasquale Verdicchio maintains, the film parodies the sanctity and the religious rituals that have oppressed women in the Catholic household, offering, instead, a heretic

feminist perspective (216).

We find a similar ambivalence between celebration and criticism of the religious, pagan, and domestic rituals that have been cooking in the Italian/American kitchen for centuries in Helen De Michiel's feature film *Tarantella* (1996). The film tells of Diane's trip back home after her mother's death and her journey of rediscovery. Back in her maternal house, Diane meets Pina, who will become her *comare* and initiate her to the rituals of the Italian cuisine and the struggles of the women in her family. Here, De Michiel aims at fusing a conventional linear narrative with Brechtian experimental intrusions. While the film fails to reconcile successfully the director's play with different genres, languages, and codes, it does offer food for thought and a tasting of possible deconstructive techniques that often find their source in the kitchen setting. De Michiel employs estranging elements in the attempt to challenge dominant stereotypes and narratives, and to voice those women's stories that have been erased from the official historical record. Thus, she intersperses the linear narrative with bits of Sicilian puppet's theatre to represent the grandmother's story, theatre-like re-enactments of Diane's childhood memories, and cuts to a non-localizable space and time where Diane impersonates the *contadinella* from Abruzzo, who proudly stands on the famous De Cecco pasta boxes. Preparing to pose within the frame of the pasta box with the help of the mother, Diane complains of the setting and clothes that do not let her breathe, drawing attention to the constant attempt to contain women in well-defined and limited frames.

In *Tarantella*, it is a woman, Pina, who teaches our protagonist—and the new generation of Italian Americans with her—how to appreciate the products of the Italian cuisine. Pina takes her class outside of the oppressive kitchen space into the open air of the home vegetable garden with its multiple scents and colors. As in the food films mentioned above, we find here a concern about authenticity and faithfulness to the ethnic tradition. However, Italian/American women filmmakers do no attempt to define and fossilize the multiplicity of Italian/American flavors and ingredients into one master recipe.[13] On the contrary, we could argue that we find in

[13] While writing this essay, I happened to read the "Dining In" section of the *New York Times* (February 21, 2007) and read Kim Severson's article on her trip back to Italy in quest of the true and authentic recipe for the family tomato sauce. Her research led her in Abruzzo, where she discovered that there is no such recipe among the dishes ordinarily cooked by her Italian relatives. Because of necessity, of adaptation to a new land and the products it produces, of contact and mingling with other cultures, the Italian/American cuisine has acquired a taste and flavor that differs greatly from

their approach an echo of Margaret Coyle's arguments that the quest for a true and authentic recipe can sometimes be read as an Americanization, in that it represents the attempt to codify and translate one's ethnic heritage into a mechanically reproducible good (46). Moreover, I would argue that such rejection of a master recipe also represents a rebellion against the religious dogmatism that has trapped the Italian/American family in anachronistic rituals. These women directors are (re)constructing their spiritual and ethnic identity out of the numerous ingredients, tastes, smells, and stories that their grandmothers are passing onto them. An ethnic heritage that is welcomed with the freedom and flexibility to mix its fragments into ever-new recipes, which benefit from the creativity of the individual cook. *Mangiando ricordo*—by eating, I remember—says Pina in *Tarantella* and Helen Barolini in *Festa*; these tactile memories served by young Italian/American women filmmakers in their films are an encouragement for viewers to create their own plate with the tastes they have come to learn and appreciate and with an added grain of curiosity and creativity.

Works Cited

Barolini, Helen. *Festa: Recipes and Recollections of Italian Holidays*. Madison: The University of Wisconsin Press, 2002.

Bower, Anne. L. *Reel Food: Essays on Food and Film*. New York: Routledge, 2004.

Hostert, Camaiti, Anna and Anthony Julian Tamburri, ed. *Screening Ethnicity*. Boca Raton, FL; Bordighera Press, 2002.

Casillo, Robert. "Pariahs of a Pariah Industry: Martin Scorsese's *Casino*." *Screening Ethnicity* 159-88.

Counihan, Carole, and Penny Van Esterik, ed. *Food and Culture: A Reader*. New York: Routledge, 1997.

Coyle, Margaret. "*Il Timpano*—'To Eat Good Food Is to Be Close to God': The Italian-American Reconciliation of Stanley Tucci and Campbell Scott's *Big Night*." *Reel Food* 41-59.

D'Acierno, Pellegrino. "*Cinema Paradiso*: The Italian American Presence in American Cinema." *The Italian American Heritage*. Pellegrino D'Acierno, ed. New York: Garland: 1999, 563-690.

Danese, Silvio. *Abel Ferrara: L'Anarchico e il Cattolico*. Recco: Le Mani, 1998.

DeSalvo, Louise, and Edvige Giunta, eds. *The Milk of Almonds: Italian American Women Writers on Food and Culture*. New York: The Feminist Press at CUNY, 2002.

Gardaphé, Fred L. *Leaving Little Italy: Essaying Italian American Culture*. New York: State University of New York P, 2004.

the Italian tradition. After an initial disappointment, Severson, however, starts to appreciate the fragments of her ethnic roots that have been reshaped and readapted in the new continent, mixed with other ingredients with different cultural flavors that contributed to create a new cuisine where the roots are still to be tasted.

Giunta, Edvige. "The Quest for True Love: Ethnicity in Nancy Savoca's Domestic Film Comedy" *Screening Ethnicity* 259-75.

Goldman, Anne. "'I Yam What I Yam': Cooking, Culture and Colonialism." *De/ Colonizing the Subject: The Politics of Gender in Women's Autobiography.* Julia Watson and Sidonie Smith, eds. Minneapolis: U of Minnesota P, 1992. 169-95.

Hostert, Camaiti, Anna. "Big Night, Small Days." *Screening Ethnicity* 249-58.

Hughes, Marvalene H. "Soul, Black Women, and Food." *Food and Culture* 272-80.

Kellner, James R. *Food, Film and Culture: A Genre Study.* Jefferson, NC: McFarland, 2006.

Kuhn, Rebecca. "Italian/American Women: The Home, Religion, and Theology in Nancy Savoca's *Household Saints.*" *VIA* 16.2 (2005): 31-44.

Naficy, Hamid. *An Accented Cinema: Exilic and Diasporic Filmmaking.* Princeton: Princeton UP, 2001.

Santos, Marlisa "Leave the Gun; Take the Cannoli: Food and Family in the Modern American Mafia Film." *Reel Film* 209-218.

Scorsese, Martin. *Scorsese on Scorsese.* David Thompson and Ian Christie, eds. Intro. Michael Powell. London: Faber, 1989.

Severson, Kim. "A Grandchild of Italy Cracks the Spaghetti Code." *New York Times* 21 February 2007, D1 & D6.

Tamburri, Anthony Julian. "Black & White, *Scungill'* & Cannoli: Ethnicity and Sexuality in *Nunzio's Second Cousin.*" *Italian/American Short Films and Music Videos: A Semiotic Reading.* West Lafayette, IN: Purdue University Press, 2002. 29-52.

_____. *To Hyphenate or Not To Hyphenate. The Italian/American Writer: An Other American.* Montreal: Guernica, 1991.

Verdicchio, Pasquale. "Unholy Manifestations: Cultural Transformation as Hereticism in the Films of DeMichiel, Ferrara, Savoca, and Scorsese." *Adjusting Sites: New Essays in Italian American Studies.* William, Boelhower and Rocco Pallone, eds. New York: Forum Italicum, 1999. 201-218.

West, Rebecca. "From Lapsed to Lost: Scorsese's Boy and Ferrara's Man." *Beyond the Margin: Readings in Italian Americana.* Paolo Giordano and Anthony Julian Tamburi, eds. Madison, Teaneck: Fairleigh Dickinson University Press, 1998. 198- 222.

_____. "The Land of Nod: Body and Soul in Abel Ferrara's Cinema of Transgression." *Screening Ethnicity.* 222-46.

Zimmerman, Steve and Ken Weiss. *Food in the Movies.* Jefferson, NC: McFarland, 2005.

Italian/American Briefs:
Re-visiting the Short Subject[1]

Anthony Julian Tamburri
JOHN D. CALANDRA ITALIAN AMERICAN INSTITUTE
QUEENS COLLEGE/CUNY

PART ONE

The short film—and I refer to that type of film well under sixty minutes in length,[2] be it a narrative fiction or documentary—is a cultural product that, until four decades or so ago, enjoyed good fortune with respect to being shown in many movie houses. Until the late sixties especially, when one went to the movies, there was often a short film of sorts, animated or real, that preceded the main attraction, providing numerous possible fora for such short narratives. This, we would all agree, is not the case today; for it is rare to go to a mainstream movie house and enjoy a prefatory short before the feature presentation. Today, very much in tune with the times, we are assailed by anywhere from five to fifteen minutes of trailers with a commercial mixed in every once in a while. Indeed, in some theaters the various trailers may take up to twenty minutes. This, of course, always makes one wonder when exactly the film is to begin and how the actual beginning time of the film jibes with what one sees in the papers or, when checking on starting times, is told over the phone.[3]

[1] For my use of the hyphen (-) instead of the slash (/), see my *To Hyphenate or Not To Hyphenate? The Italian/American Writer: An* Other *American* (Montréal: Guernica, 1991). For discussions on other alternatives to the usual hyphenated term, "Italian-American," see the following two cogent essays: Ben Lawton, "What is 'ItalianAmerican' Cinema?" *Voices in Italian Americana* 6.1 (1995): 27-51, and Luigi Fontanella, "Poeti Emigrati Ed Emigranti Poeti Negli Stati Uniti," *Italica* 75.2 (1998): 210-225.

[2] Edmond Levy writes that the Academy of Motion Picture Arts and Sciences tells us that shorts should be "less than thirty minutes" (See his *Making a Winning Short: How to Write, Direct, Edit, and Produce a Short Film* [New York: Henry Holt, 1994] 11). Given the tendency of commercial theaters to show films of at least 90 minutes, I believe we can surely consider those under one hour as a "short."

[3] On a related matter, one might also wonder if trailers themselves might not some day become their own form of art, as some critics have dared, though be it sarcastically, compared the trailer to its feature-length product. In this regard, an article in *Newsweek* tells us that one-third of the "500-person audience opted *not* to" stay for the film, viewing only the two-minute trailer of the then forthcoming *Stars Wars: Episode I – The Phantom Menace* (See Kendall Hamilton, "The Second Coming." *Newsweek*

Yet, in spite of the lack of venues for the short film, it appears to be very much in vogue. Moreover, unless the short film is commissioned for something special such as an anthology of sorts that will run as a feature presentation (e.g., *Boccaccio '70* [1970], *New York Stories* [1986], *Boy's Life II* [1998]), it is often the young filmmaker at the helm of the project; this is particularly true for the so-called young filmmaker who cuts her/his teeth on this timely production for an array of reasons, at the head of which we must list most obviously the economic factor. Numerous are the directors of these short films, finished products of which are often shown in small movie houses, off-beat theaters, and university theaters, if not also at the more competitive film festivals, be those festivals regional, national, or international. This last forum was, in fact, my introduction to *Lena's Spaghetti* (Joseph Greco, 1994) and *Nunzio's Second Cousin* (Tom De Cerchio, 1997) which I have discussed at length elsewhere,[4] as well as Dina Ciraulo's *Touch* (1995). I met these directors at the screenings of their films at the 1994 and 1995 Telluride Film Festivals, where they were each most gracious in providing me, soon after, copies of their films.

The brevity and conciseness of the short film indeed constitute some of its very appealing characteristics. Like the short-story writer, the ability of the short-film filmmaker to be both concise and inclusive is what draws the viewer/reader to the text and ultimately satisfies his/her curiosity. This, of course, would include the filmmaker's capacity of some semblance of character-development, which would prove essential in keeping the viewer's attention. Shorts tend to be highly visual; they tend to include more action with the storytelling relying "more on images than on dialogue" (Levy 11-12). Thus, the short-film filmmaker needs to develop a narrative strategy that is both economic in length and comprehensive in description, much in the same way the short-story writer has succeeded in writing in such a mode. This notwithstanding, the short film may often have a twist at the end, offering up a proverbial surprise ending.[5]

Such narrative success is evidenced by the six films I previously discussed in my *Italian/American Short Films and Music Videos*. The films included in that study run the gamut on the re-workings of ethnicity.

132.22 [November 30, 1998]: 84.). Indeed, Edmund Levy anticipated such a phenomenon when, four years before, he noted that "despite the fact that many excellent shorts are available today, they have been muscled out of the theater by promotional trailers" (3).

[4] See my *Italian/American Short Films & Videos: A Semiotic Reading* (West Lafayette: Purdue UP, 2002).

[5] See Levy's *Making a Winning Short*, especially chapter 2, "Defining the Short" (12-18).

Joseph Greco's *Lena's Spaghetti* is a wistful adventure into what I have shown to be a prime example of liminal ethnicity. There, he constructed a universal narrative of two persons' desire for friendship and companionship and, in so doing, succeeded in weaving into his narrative those ethnic signs that so clearly, once uncovered, comprise and thus exude a fundamental Italian American-ness.

In a similar manner, Madonna's narrative music video *Like A Prayer* also contains Italian/American ethnic markers that figure as liminal interpretants. As part of the background of this video's narrative, we saw that any well-informed reader with a semiosic sensitivity to Italian America may readily uncover in this narrative an Italian/American repertoire of signs. But this video also brings to the fore themes and motifs we found in other short films examined therein, those specifically concerned with issues of race and prejudice.

Race, indeed, constitutes a significant issue in a number of Italian/American short films. While it is true that films such as *The Godfather* (Francis Ford Coppola, 1972) and *Mean Streets* (Martin Scorsese, 1973) have shown the deplorable racist behavior of those individuals who populate these films, no Italian/American director has truly dealt upfront and in-depth with the issue in a feature-length film. The only filmmaker to deal with the issue head-on thus far has been Spike Lee in his films *Do The Right Thing* (1989) and *Jungle Fever* (1991). In the shorts I examined, instead, we saw that race figures prominently in DeCerchio's *Nunzio's Second Cousin* and Calleri's *Uncovering*. All three films—a fictional narrative, a music video, and a documentary—question the status quo of the relationship between whites (read, Italian Americans) and blacks. Race, that which has become, to some degree, an ugly stain in Italian/American history, to our chagrin, is here redefined. Similar to Patrick Gallo's perspective, these three filmmakers examine the race issue through a similar lens: eschewing the argument of *us against them*, all three films underscore instead the hopes and necessity of *us and them*.

Gender and sexuality, to continue, constitute the common denominators of Madonna's *Justify My Love* and, once again, *Uncovering*. Both films call into question the issue of woman and her ability and basic right to be able to choose, here couched in the personal issue of one's sexual choices. In *Uncovering*, one aspect of choice, which we must add to what we have said before, is also synonymous with freedom, and is manifested therein by the woman's black partner, as race-crossing is not necessarily a pre-

valent characteristic of Italian America. But *Justify My Love* also calls into question homosexuality, as at one point, we saw Madonna's partner transform ever so briefly into a woman. Homosexuality, of course, is what also lies at the base of *Nunzio's Second Cousin*, with race as the secondary, though indispensable, motif.

Each film in its own way offers a brief storyline that, while asking questions of its viewer, does not leave him/her hanging vis-à-vis information that might otherwise be considered fundamental to said storyline. Indeed, like many shorts, especially those made by younger filmmakers, these and other films made in the past twenty-plus years deal with subject matter such as sexuality, old and new family styles and strategies, youthful unrest, violence toward others, the search for direction, feelings of isolation, companionship, religion, new mores versus old, the possible loss of social guidelines, as well as other themes.

So much has been written on film in general. One need only peruse the innumerable bibliographic listings in any study to see how exhaustive the critical and theoretical production has been to date. However, with specific regard to the short film, the terrain is, for lack of a better word, quite barren indeed. Whereas in literary studies short fiction has enjoyed a good deal of critical and theoretical success, the short films seem to be a target of study only within the more specific and specialized studies of the so-called avant-garde cinema or the documentary. Yet, even here, careful attention to the brevity of discourse takes second stage, and notions of something we might consider to be specifically a narrative strategy of the short film is therefore left for us to ponder.

In addition to the people mentioned above, other names come to the fore. Chicago's Louis Antonelli's extensive award-winning experience with the short film is unknown to a majority of Italian Americans, be they members of the public at large or actual scholars of the artistic world of Italian America; his films have won countless prizes both in the United States and abroad. A second case involves the work of Helen De Michiel: now having ventured into the feature-length world of cinema with *Tarantella* (1995), De Michiel is another filmmaker who has proven to be most articulate with the short format. In addition, short documentaries both here in the United States and in Canada about the numerous Little Italies, if not the villages in Italy of the parents and grandparents of the filmmaker abound: Santo Barbiere, Anthony Fragola, Patrizia Fogliato, and Tony De Nonno are just a few names that come to mind in this category.

PART TWO

The three films I will examine more closely in this venue are *Che bella famiglia* (1994) by Diane Federico (a.k.a. Frederick), *Touch* (1994) by Dina Ciraulo, and *Tiramisù* (2002) by Len Guercio. Two of these three films speak to an array of the various themes we have seen in a plethora of both long and short cinematic productions dedicated to Italian Americana, albeit some in a more indirect manner: e.g., old world vs. new world, gender, working class, religion, family secrets, and, of course, *family*.

In *Che bella famiglia* the protagonist, ten-year-old Caroline Russo, is fascinated by her family history. Throughout this thirty-one-minute saga, we follow Caroline in her quest to unveil her family's secret: Who is the mysterious Immacolata? Is she truly the gangster/outlaw Caroline's big sister claims she is? Caroline's quest is stimulated by her school assignment to reconstruct her family tree. Clearly more visual than verbal, Caroline decides to do so through her drawings of what she knows about her family and Italian heritage.[6] But her teacher deems the project incomplete, and Caroline proceeds to query further her family's history and, in so doing, also digs out family artifacts. One of these is a photo of the mysterious Immacolata, soon deemed "gangster" and "kind of an outlaw." The name, coupled with her older sister's description, surely references a certain *coincidentia oppositorum*; for the "Immaculate one," we are told, is anything but, being the presumed gangster we believe she is.

This coupling of opposites arises throughout our visual journey. Caroline's visual family history at school, which detailed her Italian background, is juxtaposed to a classmate's family being Mayflower descendants. This difference in cultural heritage leads to the dichotomous binomial American-ness vs. Italian-ness. Caroline, we witness throughout the short film, is constantly negotiating her Italian heritage with her United States quotidian existence outside the family — a cultural pact of sorts that many bi-cultural people negotiate on a daily basis. Caroline, like many children of Mediterranean descent, walks a metaphorical tightrope in her wanting to fit in with their friends and, at the same time, remain loyal to their cultural heritage.

Through the father-daughter interactions, we also witness the gender

[6] Emphasis on the visual should not be overlooked; its self-referentiality, to a certain degree, evokes the visuality of the medium we are watching.

dilemma, as I have described it elsewhere,[7] often present in the Italian/ American family. Her father expresses a firm uneasiness with her drawings of such works as Michelangelo's *David*—a naked man in all his glory, so to speak—and prohibits her to continue. But his opposition to the naked is countered ever so curiously soon after by a horizontal scanning of the living-room wall that boasts, in all its glory, Botticelli's *Primavera*, under which, we soon see, is Caroline's father, Anthony, reading the newspaper in, what we might presume, is his favorite chair. This additional dichotomy of gender is too apparent to ignore; Anthony can sit under a well-lit and—pardon the pun—overexposed *Primavera*, but his daughter Caroline cannot practice her craft by copying such masterpieces as the *David*. This is, of course, further complicated by the difference in gender of the artistic subjects: the female nude can be the object of anyone's gaze, and in this case, especially the father's, whereas the male nude is prohibited from public view, a decision in this film made by the father figure, since none of the women we saw at the opening were truly disturbed by Caroline's subject matter.[8] Furthermore, in keeping in theme with the gender dilemma, this continual contestation between father and daughter is constantly mollified by the women around her: grandmother, mother, sister, and aunt.[9]

The old world/new world dichotomy exists in various, other forms throughout the film. The grandmother, in the States, reminisces about her dead husband, be it in her dreams as well as in the family's home movies, both in America and in Italy. The few dinner scenes offered reflect, I would submit, the presumed Italian table where wine and stories abound. And the grandmother, in conversation, speaks to her children and grandchildren in both Italian and English. More poignant, indeed, are those scenes reconstructed through "home movies" that the grandmother watches: they range from films of a ship departing, to those of her younger years in Italy, to, finally, scenes of two weddings, one that takes place in Italy and the other in the United States. This, too, I would submit, constitutes a comparison of cultures that underscores the overall notion of *coincidentia*

[7] See my "*Umbertina*: The Italian/American Woman's Experience" in *From the Margin: Writings in Italian Americana* (West Lafayette, IN: Purdue UP, 1991) 357-73; now in *A Semiotic of Ethnicity: In (Re)cognition of the Italian/American Writer* (Albany, NY: SUNY Press, 1998).

[8] The additional issue here is that the David's nudity is full frontal, whereas Botticelli's women in his *Primavera* are covered by drapes and the sort, especially in their pubic area.

[9] The female lineage in this regard is both vertical (direct), from one generation to the next (grandmother and mother), as well as horizontal (aunt and sister).

oppositorum vis-à-vis Italy and the United States. It is precisely the difference — i.e., the *oppositus* — that stands out here; the difference, I would add, not only between Italy and the United States, but indeed that too between Italy and Italian America.

Yet, the film revolves around that one characteristic associated so often with the Italian/American family, the much discussed (read, debated) notion of *omertà*, or, *don't wash your dirty laundry in public*. This is best articulated by Anthony, when, in reprimanding his daughter for discussing her family history at school, declares: "Watch what you say about your family at school or anyplace else!" The mysterious Immacolata — presumed "gangster/outlaw" — is the family's dirty secret. But more than shameful, we discover that Immacolata was indeed a woman ahead of her time in wanting to be the mother she *naturally* was. Thus, back when she was young, her desire to keep her son was deemed scandalous and, obviously for Anthony, shameful. For, Immacolata the museum manager had abandoned her husband and, as a consequence, lost custody of her infant son. Ironically, to be sure, Anthony held on to the old news clipping, which Caroline eventually finds and, to her delight, discovers that Immacolata, the talented artist and gallery manager, is actually her biological grandmother.

Finally, I would be remiss not to return to representations of the visual and, in so doing, the notion of self-reflexivity in *Che bella famiglia*. We already witnessed Caroline's penchant for the visual over the verbal. Furthermore, her discovery of Immacolata originates from a photo, not from any written document. Third, Immacolata herself is an artist who owns an art gallery, all of which places the visual in the forefront. Added to this, then, are the home movies present throughout the film. Such constant references to visuality surely underscores what we may readily assume is the obvious, that Federico's notion of filmmaking is one that situates the visual as a privileged mode of communication vis-à-vis the logos. In so doing, she puts the spectator on notice that there are things to come that may indeed be, etymologically speaking, significant, precisely because even though language may readily enhance the communicative act, it is neither totally independent of nor, indeed, superior to the visual.

Dina Ciraulo's *Touch*, conversely, is a film with minimal references both to notions of visuality and hardly any — indeed none, some might say — to Italian Americana. A fifteen-minute movie centering around a

piano lesson, the film seems to underscore class issues rather than specific ethnic traits: indeed, income and life-style come to the fore in this short film. While this is not clearly articulated by any of the characters, it is communicated through the various visual signs apparent throughout the movie: barren lawn vs. plush front yards, modest cars vs. fancier makes and SUVs, and, toward the end of the film, Anna's seemingly insignificant question about her father's watch, if it is in fact gold.

A young father drives his older daughter, Denise, to a piano lesson on, what we might presume, is a Saturday afternoon. After a few minutes of preparatory scenes at home — where the father gets dressed, the younger sister, Anna, brushes Denise's hair, we also see the base of a modest piano, a straw container with a hole in it, and a tattered booklet of Bach music, and Anna seeks out lose change in the sofa cushions — they all leave in their modest car, Anna and her father accompanying Denise to her lesson.

But there are a few seemingly insignificant scenes that are indeed poignant. First, Anna checks out one old photo in sepia tone of a young, female relative, an Italian so it seems, and then grabs from the same cabinet a small stature to take with her, a ceramic of, as it turns out, a young shepherd who carries with him a staff, horn, and lantern. Both the photo and the shepherd statue are polysemic signs, to be sure. However, as was possible with *Lena's Spaghetti*, one would not err, for instance, in considering them a type of semiotic of liminal ethnicity, something that was also characteristic of Madonna's *Like A Prayer*, which also contains Italian/American ethnic markers that figure as liminal interpretants, as C. S. Peirce would call them.[10]

Touch turns out to be a series of images, mostly external neighborhood scenes, that distinguish a working-class quarter from that of a more plush, well-to-do residential area. The distinctions are classical; for instance, a barren front yard of Anna's house is ultimately juxtaposed to the white picket-fenced yard of the piano teacher, where trees and flowers are fully in bloom, and a fountain, in the middle of one part of the large lawn, gushes water. As Anna's father's car proceeds to Denise's piano lesson, we see a crescendo of sorts of the various stages of development of at least three different neighborhoods: from the barren front yard and neutral white house of Anna's family to the increasingly more decorated

[10] Here, too, I refer the reader to my *Italian/American Short Films & Videos: A Semiotic Reading,* especially chapters one and three.

houses as they pass from one neighborhood to the next, arriving ulti-
mately at their final destination that is the quasi-pastoral two-story house.
In fact, as Denise enters through the gazebo-like gate, the camera, while
following her walking, moves right, changing its central focus from the
young girl to an entire scene of one side of the structure, placing Denise,
we see, on the margins of the screen, until she finally disappears through
the door.

In a sense, the piano teacher's house might constitute, for some, a se-
miotic recall of Pietro di Donato's Job, of *Christ in Concrete* (1939), that
which encompassed, and at times ominously, all things and all people
associated with Italian laborers. In the novel, class is one of the primary
themes, as the immigrants—members of a clearly sub-proletariat citizenry
—are powerless to make their situation better. The only way out is,
literally, to leave the old neighborhood—or, so it was believed for a good
portion of the twentieth century by many. In fact, we would be naïve not
to include the progeny of Italian immigrants as members of those who en-
gaged in what is proverbially known as "white flight."[11] Denise's physical
marginality on the screen, I would thus submit, is emblematic of her
family's current economic situation, one that is, to be sure, marginal to
the neighborhoods that she and her father must traverse in order to arrive
at the most lavish, which is where her piano teacher lives. Furthermore,
the piano, itself, is a semiotic reference to class insofar as what it is not: it
is not the accordion or mandolin, and the music is not the folk music so
often identified with the Italian American, rather it is the *ne plus ultra* of
classical music, Bach, the tattered booklet being one of the first signs we
as viewers see at the beginning of the film.

Thus, class figures as the overriding theme, trumping, to a large de-
gree, other issues including the more expected Italian/American reper-
toire. Instead, any overt allusions to Italian Americana are liminal at best.
I already mentioned the shepherd stature and the sepia-colored photo.
One might furthermore engage in a generous semiotic act in considering
Anna's name, for instance, an Italian sign *in potentia*; or, stretching still the

[11] Also menacingly ominous in this regard is Italo Calvino's short story "Marcovaldo at the Super-
market" (*Marcovaldo* [Turin: Einaudi, 1962]), in which a fantastical crane ultimately appears, sucking
up all the merchandise Marcovaldo and his family collected, when vicariously engaging in shopping
they could not afford to do. This, perhaps, is a more limited semiotic recall, for one who knows both
cultures, Italian and Italian/American. But the underlying issues are the same: class membership and
who cannot afford the so-called nicer things in life, not to mention, as in Marcovaldo's case, even the
necessities.

point, Anna herself is dark-skinned with black hair and eyes, physical characteristics typically associated with the Italian.[12] On yet another plane, indeed related, this film surely problematizes the issue of what constitutes that which we might consider an Italian/American sign. Some have already written on defining the Italian/American sign,[13] insisting for the most part in something apparent and thus convincingly significant, whereas, consequently, notions of subliminal ethnicity would fall by the wayside. While not steeped in "guns and garlic," to echo the title of Homer and Caputo's 1974 study of Italian Americans,[14] class surely brings us back to, among other places, literal and metaphorical Italian America of the twentieth century especially.

Leonard Guercio's *Tiramisù* (2002)[15] is a wonderfully ambiguous short film that, like *Touch*, plays on the polysemy of verbal and visual language; however, like *Che bella famiglia*, it is also chock full of apparent Italian/American signage, so to speak. Made in black and white, with the obvious intention to evoke a past era, one of a number in which "Mafia" comes to mind, we follow the story of a "don" whose power and influence can be clearly overwhelming.

Indeed, this is all we know throughout much of the film. The semiotic make-up of Don Camillo is based on a series of ambiguities that are, only at the very end of the film, fully *disambiguated*. To be sure, as the storyline unfolds the viewer is exposed to a series of visual and verbal signs that seem to lead to only one conclusion with regard to who Don Camillo truly is.

The opening scene is of a black Towne Car that drives slowly down a clearly ethnic, Italian/American neighborhood. The driver is a forty-something-year-old, dressed in a suit with dark glasses. The person he is chauffeuring is a sixty-something-year-old somber-type individual. Once

[12] In this regard, see *Are Italians White? How Race Is Made in America*, eds. Jennifer Guglielmo & Salvatore Salerno (New York : Routledge, 2003).

[13] See chapter one in my *A Semiotic of Ethnicity*, where I rehearse the various definitions offered through 1998. In the meantime, I would remind the reader of Robert Casillo's *Gangster Priest: The Italian-American Cinema of Martin Scorsese* (Toronto: University of Toronto Press, 2007), where he also rehearses various definitions of Italian/American cinema (passim).

[14] See Frederic D. Homer, *Guns and Garlic: Myths and Realities of Organized Crime* (West Lafayette, IN: Purdue University Press, 1974), co-authored by David Caputo, as indicated on the frontispiece.

[15] Screenplay by Albert Di Bartolomeo and Len Guercio. I would like to thank Len Guercio for a copy of the film and its screenplay, which has facilitated my transcription of dialogue and descriptions of episodes within the film.

they stop, the driver exits first and, vigilant of his surroundings, opens the car door for his passenger, whom we soon come to know as Don Camillo.

The "don" enters a caffè and is immediately greeted by a young woman (Maria), enthusiastically, "Ueh, Don Camillo, buon giorno," and she then kisses his hand and immediately yells to her mother in the back that "è arrivato Don Camillo!" (Don Camillo has arrived!). The young woman's mother (Lucia) comes out with a cake and offers it up to Don Camillo, who, in turn, mentions that he is off to an appointment in New Jersey. She, then, poised to wish him adieu, refuses to take payment. In return, Don Camillo replies: "Lucia, if ever I could help you, don't hesitate to ask." At this point Lucia does indeed ask a favor.

In the meantime, as the greeting of the young woman and subsequent conversation between her mother and Don Camillo proceed, there are two cuts of the camera to a couple seated at a table. The man twice nods with his head toward Don Camillo, as if to signal to his female companion that there is a "questionable" character who has entered the caffè. The second cut of the camera shows them leaving, as if, we might initially presume, it might not be prudent to remain.

But before going on, we should indeed revisit these opening scenes in order to unpack, as best we can at this point, the possible semiotics at play. Both visual and verbal references to organized crime, for sure the Mafia, seem to abound. The above-mentioned car, driver, and back seat occupant may all readily recall a "mafia-type" setting. This is then underscored by Maria's greeting—the kissing of the hand, especially—and her mother's subsequent conversation with Don Camillo. Of course, let us not forget the seemingly insignificant couple at the table near the window, who decide to leave, so it seems, because Don Camillo has now arrived. Furthermore, we cannot ignore Don Camillo's reference to New Jersey, where he has an appointment. *Tiramisù* appeared in 2002, three years after the debut of the much-debated HBO series *The Sopranos*, which, among other things, identified New Jersey as TV's fictive Mafia capitol. In this regard, Don Camillo's offer of help "if ever" Lucia needs his assistance, underscores yet another possible Mafia reference.[16]

[16] As the viewer proceeds at this point, s/he may surely have noticed one incongruent sign at this point. The Don, this seemingly powerful figure who belongs to a readily presumed world of organized crime, is named Don Camillo. For those not conversant with the history of children's literature in Italy, Don Camillo was Giovanni Guareschi's village priest, who was constantly at odds with the communist mayor, Peppone. As an anti-communist, he fought for righteousness and fair

The problem, we come to find out, is " . . . a delicate matter and [Don Camillo is] the only person who can help. Someone [he] know[s] very well refuses to marry [her] daughter. They have known each known since they were children. [Her] daughter is very upset. She pleaded with him but he refuses to be reasonable." Possible referents to this statement again fall into the category of organized crime; and Don Camillo's response falls right into place: "Don't worry. Leave it to me. I'll speak to him personally."

As the storyline progresses, we find out that the person who refuses to marry Maria is Tony Russo, presented to us as a casually dressed, young man in his late 20s. We first find him sitting at a desk, counting money and entering the figures into a ledger. The room has a simple desk and chair, no other furniture; and there are cans of paint, brushes, and other related paraphernalia strewn about. At one point, he places the ledger in a drawer from which he then pulls out a photo of Maria, on the back of which we read, "To Tony, You're always there for me! Love, Maria." As he places the picture back in the drawer, the phone rings; it is from Don Camillo, who proceeds to tell Tony that "[t]here's something [he] want[s] to talk to [him] about . . . it in person."[17] Tony and Don Camillo will meet up at Paulie Rossi's mother's birthday party.

Don Camillo arrives first, greeting everyone and then informing Paulie that Tony, seemingly a little "distracted," will be coming and he, Don Camillo, will want to talk to him "alone, if [Paulie doesn't] mind." Once Tony arrives, he and Don Camillo eventually speak, and the conversation that follows continues to conjure up referents to organized crime:

play for all involved, especially the downtrodden. Now, one might say that even the most canonical of cinematic dons (Don Corleone) fought for the downtrodden, only to be overwhelmed by changing circumstances of his world of organized crime. But the reference here to Don Camillo is too clamorous for us to ignore even at this early point in the film, and it thus immediately puts us on notice that something may indeed not be as we think it may/ought to be.

Guareschi's books of Don Camillo include: *Mondo Piccolo "Don Camillo"* (*The Little World of Don Camillo*, 1948); *Mondo Piccolo: Don Camillo e il suo gregge* (*Don Camillo and His Flock*, 1953); *Il Compagno Don Camillo* (*Comrade Don Camillo*, 1963); *Don Camillo e i giovani d'oggi* (*Don Camillo Meets the Flower Children*, 1969).

[17] The entire conversation seems to revolve around a presumed organized criminality, especially as Tony proceeds to describe his problem, which, in the end, he will be able to "handle": CAMILLO: "Everything all right?" / TONY: "Yea, why?" / CAMILLO: "You seem like something's on your mind." / TONY: "I've been having a problem with the collection." / CAMILLO: "What kind of problem?" / TONY: "Somebody's been stealing from us." / CAMILLO: "You need some help?" / TONY: "Nah, I can handle it." / CAMILLO: "Good. So you'll come to the party?"

CAMILLO: "You seem a little preoccupied."

TONY: "I told you I've been having a problem with the collection."

CAMILLO: "Anything else bothering you?"

TONY: "No."

CAMILLO (deliberate): "Good (sits, takes a sip of wine). My good friend Lucia tells me that you refuse to marry her daughter Maria. Is that right?"

TONY (sits, then answers carefully): "That's right."

CAMILLO (pauses then firm): "Listen, Tony. I don't care why—maybe you two had an argument or whatever. I'm asking you, here and now, to marry her. You two have a lot of history together. It's just not right for you to refuse her now."

TONY (resisting): "But . . . I . . . "

CAMILLO (insisting): "Look, I know the family and I know the girl's situation. Lucia told me Maria doesn't want anybody but you. So, I'm asking you to do the right thing. Otherwise, you set a bad example—*una brutta figura, mi capisci?*"

TONY (relenting): "Sì."

CAMILLO: "Good! Then it's set?"

TONY (capitulating): "Yes. Whatever you say, Don Camillo."

CAMILLO "Molto bene! (taps Tony on the knee) "Now let's enjoy the party (clinks Tony's bottle and smiles). *Salute!*"

The conversation consists of a classic series of signs that can readily refer to a situation of a pregnant young woman ("I know the family and I know the girl's situation") being abandoned by her boyfriend ("Lucia tells me that you refuse to marry her daughter Maria"). We also read the expected response from Don Camillo that, while articulated in a form of exhortation, is really a command:

> "Listen, Tony. I don't care why—maybe you two had an argument or whatever. I'm asking you, here and now, to marry her. You two have a lot of history together. It's just not right for you to refuse her now." [. . .] So, I'm asking you to do the right thing. Otherwise, you set a bad example—*una brutta figura, mi capisci?*"

Tony, as we see, agrees. The scene then switches to a crowded picnic table where Mrs. Rossi lifts Lucia's "masterpiece" of a cake out of the box. As she does so, we hear the beginning of "The Wedding March," and the scene changes to a wide shot of the interior of a church, from the perspec-

tive of the choir balcony, with Lucia escorting Maria toward the altar. There we also see, still from afar and therefore difficult to make out, three priests in the center, a maid of honor on the left, and the groom and best man in the right.

Once the scene switches again, we see a close-up of Tony, with a look of awe on his face, as if mesmerized by Maria's presence. The scene then switches to Maria walking down the aisle, smiling at those in her line of sight, left and right. It is at this time that a chink appears in the armor of the story the viewer may have been thus far weaving. For the groom is not Tony, as the camera switches to the groom and best man, two faces we see for the first time. Switching back to Lucia and her mother, we first see them approaching, when the camera shoots them again from the back, as they momentarily occupy the entire screen. Once the camera then scans for a broader image and the two women approach the altar, the visual and verbal signage we have amassed thus far is suddenly forced to undergo a change in signification. The camera then turns to the groom and best man, including one of the three priests, Paulie Rossi. Continuing its scan left, we now see that our other two presumed *Mafiosi*, Don Camillo and Tony Russo, are indeed priests themselves, Camillo a real Don Camillo of the Church.

At this point, there is a series of shots that now force us, the viewer, to re-evaluate our sign production. We first see a full screen close-up of the bride and groom; and in this regard, the verb "marry" assumes its transitive meaning of a third party performing the act, as Tony now marries Maria and her groom. Then, the scene switches to a scanning of the three priests, from right to left, ending with Tony. At this point, the camera switches back to the couple, as they kiss to seal their union. Switching back once more to Tony, the camera now scans upward, shifting Tony off-center, replacing him at the screen's focal point with the giant Christ crucified, an apparent message being that now we have two unions sealed, Maria with her groom, as well as Tony with the Church, having obviously chosen Christ over Maria. The final scene of the movie is once again shot from the choir balcony, and it comprises a perfect symmetry of bride and groom flanked by maid of honor and best man, all four standing in front of the trinity of the neighborhood priests.[18]

[18] How apropos that the "executive producer" of the film is listed as "Divina Provvidenza"!

PROVISIONAL CONCLUSIONS

Each in its own way, all the films mentioned and/or analyzed in this study transgress to one degree or another those traditional narrative formats we might readily associate with a more conformist discourse of the Italian/American filmmaker. The conventional themes of Italian/American history are revisited through a different lens, for which the history of Italian America is articulated through a plethora of different voices with a backdrop of film footage and, in some cases, still photographs that, in the end, constitute a unique narrative that is, like the United States, kaleidoscopic in nature. This, indeed, is what we learn from the new generation of filmmakers; that the nature of Italian America is a community of individuals, each with his/her own likes and dislikes, who share to a certain degree a similar culture and heritage, which in the end is perhaps the greatest challenge of all—the sharing of commonalities and its resultant transcendence of difference—not just to the filmmakers, writers, and the like, but indeed to every member of the community.

What each film has surely succeeded in doing is to offer to its viewer a new way of seeing Italian America and its many facets. In the end, each film uncovers its viewer's relationship to the internal and external dynamics of all the Little Italys as notions of race, gender, sexuality, companionship, family, and other issues come to the fore. In this sense, newness becomes the operative word as these filmmakers, each in his/her own way, have succeeded, at these various stages in their careers, in maintaining an artistic freedom that has allowed them to engage in different forms of a *sui generis* creativity. In so doing, they have, therefore, avoided at all costs falling victim to the shackles of both a thematic and formalistic tradition, appropriating, as we have now seen, a more liberating and expansive discourse.

Italian American DOC

Giuliana Muscio
UNIVERSITY OF PADOVA

The Godfather whispers in a muffled voice: "I made him an offer he couldn't refuse." The wild shirts that scarcely cover Tony Soprano's paunch and the kitchens filled with opera arias and the aroma of baked ziti. Such stereotypes about Italian Americans are totally rooted in the collective imagination that the political success of Nancy Pelosi or the presidential candidate, Rudolph Giuliani, seem to us — in our perception of our Americanized compatriots — to be anomalies rather than the rule. Our familiarity with Italian American culture is often derived from these troublesome stereotypes created by the American media. Viewers often know little or nothing about Italian emigration and cultural assimilation, except for what has been glimpsed in American cinema.

Documentaries, due to their assumed objectivity, anthropological curiosity, and unquestioned capacity for historical recreation, seem to articulate a more objective image of Italian American culture.[1] In reality, their very format pushes viewers to challenge stereotypes, particularly if they are made by Italian American directors combating old clichés with retorts such as: "We don't all belong to the Mafia" and "We are proud of our noble origins and traditions." The choral retelling of complex experiences, of traumas and dreams, and the anthropological description of rituals and behaviors overcome incorrigible folkloric tendencies and Hollywood-type generalizations. This happens thanks to revealing anecdotes and realistic details — beginning with Mamma Scorsese's tomato sauce recipe in *Italianamerican* (Martin Scorsese, 1974), the touchstone for Italian American documentaries.

Documentaries come in all formats: from historical to anthropological,

[1] As there are no bibliographical sources on Italian American documentaries, for this essay I have relied on "Documented Italians," an on-going series of film screenings organized by Dr. Joseph Sciorra at the Calandra Institute of New York, and on his accurate introductions, and the DVDs he so kindly made available to me.

from investigative to portraiture. An examination of some of those made by Italian Americans over the past fifteen years offers a more insightful configuration of this culture. What emerges is a fragmented identity having two constant elements: one, given, that Italian Americans strongly identify with the concepts of family and community; the other (which for us is perhaps unexpected) finds value in the concept of work. It could be said that the first element is a derivative of Italian heritage, while the second belongs to the American sphere, but is characterized by a dedication to artisanship. This latter concept stands for a devotion to one's profession, be it as an artist, actor, or chef (and, it should be added with a touch of irony, as a gangster). But it also represents the directors who search neo-realistic roots and Italian cultural traditions. It is an identity that operates on a multitude of levels that include typically Italic individualism and elements of class, gender, and occupation. Being male or female implies a difference in behaviors and role expectations within the Italian American community, just as statements made in an interview with an Italian American carpenter from Philadelphia will differ from those of an affluent vineyard owner from California. It is indeed essential to point out several dominant themes in this community, in order to connect with the fifteen million compatriots spread throughout North America who feel Italian yet also identify with a hyphenated identity, as the Americans say, one that uses a dash.[2]

To connect with this culture, one must know its history. Italian emigrants to North America were subjected to two interwoven types of discrimination: anti-Southern Italian and anti-emigration prejudice in Italy, and ethnic-racial prejudice in the United States. Historically, Southern Italian emigrants suffered from a weak sense of national identity: they were leaving an Italy that had only recently been unified and which, to date, has still not come to terms with many issues concerning its South. In addition, they were affected by a higher degree of anti-immigrant discrimination in America than Northern Italians.

Despised by the WASPs because of their dark complexion, their alien customs and traditions, and the media's frequent conflation of them with criminality, Italian émigrés to the United States were not defended by Italian institutions and intellectuals. While these factors impeded assimilation, it did, however, allow immigrants to preserve and transmit behaviors

[2] Rudolph Vecoli, *Negli Stati Uniti*, in *Storia dell'emigrazione italiana*, Piero Bevilacqua, Andreina De Clementi, Emilio Franzina eds., vol. 2, *Arrivi* (Rome: Donzelli, 2002) 55.

and values within the home: every family has a unique legend that, in some documentaries, takes the shape of a precious collective oral history.

These prejudices were the focus of *Pane Amaro* (*Bitter Bread*, 2007) a recent historical documentary made for RAI by Gianfranco Norelli that narrates the story of Italian emigration through the use of rare historical documentation.[3] Appropriately, the first part is entitled "Linciati o attentatori" (The Lynched or the Attackers). It tells of the lynching of eleven Sicilian immigrants to New Orleans in 1891, the largest mass lynching in American history. The second part examines the U.S. internment in prison camps of Italian American civilians declared "enemy aliens" during World War II. (These serious incidents of intolerance, and the traumatic shame associated with them, may well explain the lack of knowledge of the history of Italian Americans, both in Italy and the United States.)

Prisoners among Us: Italian Identity and World War II (Michael Di Lauro, 2003) covers the history of Italian Americans from the 1800s to present day. It tells the story of several Italian American politicians who demanded an apology from the U.S. government for the community's unjust treatment during 1942-45. In addition, the film seeks to uncover the rationale that prompted the "relocation" of Italians who were "relocated" in California or sent to prison camps. The documentary's goal, as stated in it's opening dedication, is to "learn from our mistakes," where the possessive adjective, "our," hints at the identity conflict embedded in the concept of Italian Americanism. It is not clear, in fact, if we should identify with the Americans who made a mistake in interning Italian Americans without due process, or with the immigrants who did not have the courage to protest their abuse. The cumulative historical research of Rudolph Vecoli, Sal La Gumina, Ben Morreale, and Jerre Mangione documented the New Orleans lynching, which, for the first time, linked a group of Sicilian dockworkers to the Mafia, followed by Sacco and Vanzetti's execution by the electric chair in 1927 after an unjust trial.[4] Viewed with political suspicion because of their association with anarchism, socialism, and unions, Italian immigrants did not have the full support of the Catholic Church, which was historically Irish controlled in

[3] Norelli's film was shown by RAI Tre on January 29 and February 5, 2007 as part of the series *La Grande Storia*.

[4] See also the recent documentary *Sacco and Vanzetti* (2006) by the non-Italian American director Peter Miller. In this film, traditional material is interwoven with letters and poems by Sacco and Vanzetti read by John Turturro and Tony Shalhoub.

the U.S. and thus had little tolerance for the processions and rituals typical of Mediterranean faith. Also, the Catholicism and dark complexion of the Italians did not escape the attention of the Ku Klux Klan in New Jersey, where a farming community was set upon with clubs and rifles in 1923; the robust farmers reacted with such vigor that the attacks ceased.

The Italian community remained isolated and defenseless. Residents underwent a strong identity crisis, particularly among first generation Italians who did not speak English, dreamt of returning home, and consequently did not want their children to attend American schools for fear of losing control over them. Parents worried they would forget their ties with their heritage, which was not an abstract "far away homeland" but a tiny village oftentimes remembered through a faded postcard saved as if a religious relic. The passage from regional identity to an Italian identity occurred with the call to nationalism by Gabriele D'Annunzio and Benito Mussolini, which penetrated Italian American newspapers and radio in the 1930s.[5] Even the New Deal appreciated the modernizing experience of Fascism and its new corporative project. Having been recognized by the regime as "Italians abroad" and no longer as shameful rabble, Italian Americans acquired a hyphenated identity that was approved of on both sides of the Atlantic. Many leading figures contributed heavily to this Italian treasury, but this taking of sides resulted in their being identified with the Fascist regime. At the beginning of World War II, while many Italian Americans volunteered to enlist, others suddenly found themselves on the opposing side, and not by choice. Viewed with fear as possibly belonging to "fifth columns" and not accepted by large sectors of American society, Italian Americans were subject to nighttime searches by the FBI, had their radios and cameras confiscated, and were sent to internment camps or forced to move if they lived in "militarily sensitive" areas such as the West Coast. These events resulted in exclusion and intolerance, and this period in the history of Italian emigration to North America remains primarily in the domain of collective memory. Erased due to shameful feelings and unspoken due to pride and feelings of injustice, this history emerges from the many interviews that reveal families forced to move, children's education interrupted, families separated for long periods of time, and men (even famous ones such as the tenor Ezio Pinza) who suddenly found themselves in internment camps. Some com-

[5] Stefano Luconi, "The Voice of the Motherland: Pro Fascist Broadcast for the Italian-American Communities in the United States," *Journal of Radio Studies* 8.1 (Summer 2001): 61-80.

mitted suicide. Because Italian was considered the language of the ene-my, the mother tongue was abandoned (almost permanently), signs of cultural diversity were rejected, and many last names were Americanized or changed. I have devoted ample space to this documentary because it allows us to confront a crucial historical fact that is often avoided due to its complexity and the unresolved feelings associated with it. Forced Ameri-canization dealt a severe blow to Italian identity surviving in domestic spaces and in the private sphere of the family while it greatly weakened in the public sphere with the exception, possibly, of the world of enter-tainment.

Italian prisoners of war in America is the subject of *Prisoners in Para-dise* (2001) by Camilla Calamandrei, who interviewed Italian soldiers cap-tured in Africa during World War II and brought to the U.S. as prisoners. Some of these soldiers chose to reject Fascism, others refused to do so and, as a result, were subjected to rather harsh prison conditions. Several soldiers from the first group met Italian American women, married them, and decided to remain in the U.S. The powerful romanticism of these families' stories contrasts with the persistent traces of hostility toward im-migrants, a sentiment that the film does not hide.

Historical documentaries on Italian emigration to the U.S. have been well received by American public television and history cable channels in their various formats. Among the better examples of Italian documen-taries is the excellent series written by Gian Piero Brunetta and directed by Gianfranco Mingozzi, *Storie di cinema e di emigranti* (1988), shown on RAI during the 1990s. It belongs to the genre of documentaries on Italian Americans in the world of entertainment that is gathering momentum in the U.S. In these films, which occasionally indulge in self-gratification, a tone of defensiveness again prevails as they focus on the daily battles that associate Italian Americans with the Mafia. *Beyond Wiseguys: Italian Ameri-cans and the Movies* by Rosanne De Luca Braun (Steve Fischler, 2008) con-fronts the Mafioso stereotype in the very place that promoted or even created it, namely the world of cinema. It does so with interviews of Ital-ian American entertainment figures in an attempt to understand how they deal with their cultural identity. If, on the one hand, at a dinner of the Italian American Actors Guild they sing *Marinariello* and Italian music (from Mina to Pavarotti), on the other hand actors such as Marisa Tomei, Paul Sorvino and Michael Rispoli object to typecasting and take on the Italian=Mafia issue.

The origins of this stereotype can be traced through Thomas H. Ince's silent films, to an organized media campaign to associate gangsters with Italian Americans, to the famous line "Leave the gun, take the cannoli" from *The Godfather* (Francis Ford Coppola, 1972), when the assassins, having accomplished their task, leave a body in a car but do not forget to take a tray of pastries. This mixture of violence and humor, of childish brutality and respect for ancient codes has ensured the longevity of this stereotype. It is one that has been analyzed by historians and critics including Sal La Gumina, George De Stefano, Giorgio Bertellini, Antonio Monda, and Fred Gardaphé as well as by writer/directors such as Richard LaGravanese, Martin Scorsese, and David Chase (*The Sopranos*). Numerous actors have been interviewed about their family origins, including Jack Valenti (former president of the Motion Picture Association of America), who shares his experience as a pilot during World War II and having to bomb Rome. John Turturro talks about going to the movies with his family after the Sunday ritual of dinner. Nancy Savoca (who was forced to translate movie dialogues from English into Italian for her parents) says she adores Anna Magnani, also Susan Sarandon's favorite actress. We even discover that one of the most famous Native Americans in U.S. cinema, Chief Iron Eyes Cody, was in reality Espera DeCorti, a Sicilian. When it comes to Frank Capra and Frank Sinatra, the documentary insists on their political involvement and the fact that both men were accused of being communists during the Cold War. Sinatra, who with his role as Angelo Maggio in *From Here to Eternity* (Fred Zinneman, 1953) was the first Italian American to win an Oscar, also labored to promote racial tolerance.

According to *Beyond Wiseguys*, the Italian contribution to American cinema and entertainment is embodied in the humanity of the characters, the values inherent in the family and community, as well as in the creative imagination of artists such as makeup man John Caglione who worked with Al Pacino and states that he is "proud of being Italian." It should be noted that he does not say "Italian American."

The painful and complex emotions tied to the adventurous and humiliating experience of being an Italian emigrant is the subject of *The Baggage* (Susan Caperna Lloyd, 2001), which is a personal memoir depicting the director's family. We are introduced to the Capernas, who emigrated to the U.S. in 1922 and, similar to other Italians, they wanted to return to Italy, but stayed. The ghost figures of absent fathers, separations, worried

mothers, all of these issues affected family relationships, which were also complicated by a typically American anxiety to achieve success, coupled with a typically Italian feeling of uncertainty about the future. We encounter troublesome images and memories among the postcards of the ancestral village, faded photographs of grandparents, and in the 1950s home movies. One is a confession by the director's father of how, when he was two-years-old and on the ship bringing him to America, he almost threw his mother's bag containing all of their immigration documents overboard. It was more a projection of his mother's ambivalence towards the voyage than a childish impulse. This intense and disturbing film straddles the line between historical documentary and personal memoir, but it shares the sense of the tragic experience of the other films.

There is an implicit continuity between this film and the director's earlier documentary *Processione* (1989), which is dedicated to the Easter "mystery" celebrations of Trapani, Sicily, in which heritage is connected to the pain and mystery of the community undergoing these rituals, as represented by the image of a Madonna entirely dressed in black. For the most part, the directors of these documentaries are women, and it is not a coincidence. Emigration studies reveal that the sharpest cultural conflict in immigrant families centers on the daughters for whom patriarchal rules are restrictive, yet the familial ties remain strong, particularly at an emotional level, and often problematic.

The richest vein of Italian American documentaries belongs to the anthropological genre. To this belongs the work of Tony De Nonno, such as *Part of Your Loving* (1977) and *It's One Family: Knock on Wood* (1982). The first portrays a baker from Palermo, who emigrates to New York. He whistles "Mamma" and "Come prima," as he kneads, cuts, and shapes bread, all the while explaining the importance of every gesture. He says that he makes the same bread as did the ancients, but that it takes creativity. It's as if he were creating a sculpture. The same love for one's profession is found in a family of immigrant puppet makers, the Manteos, in *It's One Family*. The Manteos create and bring to life beautiful Sicilian puppets and put on shows in Italian in New York about traditional knight-errant Paladins.[6] These two films highlight a strong element in

[6] De Nonno recently also made a documentary on the rituals for the feast of Saint Paolino in *Heaven Touches Brooklyn* in July (2004), in which he follows the traditional processions of the Gigli of Nola and their American versions in Williamsburg, East Harlem and Massapeaqua—areas with large Italian American populations.

Italian American culture that is not obvious to those who are not familiar with Italian Americans: the importance of a job well done, particularly manual labor.

This same passion for artisanry emerges in *Dyker Lights* (Paul Reitano and Terrence Sacchi, 2001), which focuses on the Christmas lights adorning the gardens and houses of a primarily Italian American neighborhood in Brooklyn. Miles of flickering, colored light bulbs, gigantic moving Santa Clauses, and adults dressed up as cartoon characters transform the street into an amusement park, with dancing majorettes and Christmas choirs. For months, the men on the block get up at dawn to decorate their homes before leaving for work. The tradition is handed down from father to son, and every year the spectacle expands, all for the enjoyment of the children and people of New York who come to admire the displays. It may seem a manifestation of American kitsch, but its origins are revealed by the Christmas menus (the fish based dinner on Christmas Eve, the pizza and the *arancini*, and the desserts made of figs, raisins, and almonds) as well as by these unique artists' motivation, which is rooted in their concepts of family and, again, on the value of a job well done.

Of a more anthropologically complex and socio-politically incisive work is that of Marylou Tibaldo-Bongiorno, one of the more interesting directors of this generation (who ventured into fiction with the independent film *Little Kings* [2003]), who, to date, has focused primarily on documentaries. In *Mother Tongue: Italian American Sons & Mothers* (1999), with her husband Jerome, she interviewed Italian American mothers and their famous sons including: Scorsese, Turturro, Rudolph Giuliani, Pat DiNizio (Smithereens singer), the writer Robert Viscusi, and the actors Mario Giacalone and Carlo Capotorto (Paulie in *The Sopranos*). The film explores the mother–son relationship within these Italian American families, highlighting their gender-specific roles as well as the crucial role of mother in Italian American culture. The Bongiornos recently completed *Revolution* (2006), a film that straddles history and urban sociology in its investigation of the Newark riots, which were set off by the actions of some Italian American police officers and the unsuccessful (and violent) reaction by an Italian American mayor. Using interviews with Tom Hayden — then a young militant engaged in urban renewal projects — and other politically and socially committed individuals who witnessed the events, as well as discussions with historians, the film confronts this explosion of racial tension, one of the most violent in the 1960s, which erupted in a city

with a large Italian American population. As explained in several of the essays in this collection, Italian American racism towards blacks (and not only them) — a recurrent subject for Spike Lee — is connected to Italian American issues of identity. From being the victim of grievous ethnic prejudice, the community has, in fact, moved to the forefront of racial intolerance. As frequently happens, the recently assimilated become the most fanatical in defending their privileged status, and the most hostile towards anyone who threatens their recent conquest.

Tibaldo-Bongiorno's work belongs to the sphere of investigative documentaries that deal with matters of genre and race identification as ecological issues (her latest film confronts the problem of flooding in New Orleans and in Venice). She accomplishes this by adopting a socio-political point of view that does not allow for compromises with ethnic origins, but instead is based on the critical heritage that Italian socialism and trade unionism introduced to the United States.

Obviously, the anthropological reservoir of Italian American documentaries is rich with films about religious processions and rituals, an aspect of Italian American culture that appeals to the WASP imagination, which is so distant from large religious celebrations. These films might be considered a genre of their own; one that is rich in diachronic documentation and geographical range. There are early films showing statues covered in dollars, tourist-anthropological reports on religious feasts in Southern Italy, the San Gennaro festival in New York's Little Italy and that of Our Lady of the Assumption in Boston's North End. A peculiar film that is half documentary and half short movie, *The Blinking Madonna* (Beth Harrington, 1994) is dedicated to the latter ritual mentioned. The daughter of an Italian American housewife and an Irish public relations man, the Catholic Harrington evokes a mediatic moment of glory: her video tape of the Madonna statue opens and closes its eyes for an instant. She then recreates it within her own existence, as a child growing up in the suburbs and attending a parochial school run by ultra modern 1960s nuns, in the year when John F. Kennedy, the first Catholic U.S. president, begins his mandate. Using an easy-flowing montage of repertory movies, old photographs, segments of Hollywood movies, home movies, some (a bit sophomoric) docu-dramas with actors and with Bridget Jones' type humor, the director revisits her education and the impact of the late 1960s which led her to distance herself from Catholicism. Having moved to Boston's North End, a primarily Italian American and Catholic area, she

rediscovers the centrality of the family and mothers and, by extension, the cult of the Madonna. Among the many processions Harrington depicts during the segment dedicated to her neighborhood, one shot shows the Madonna who closes and reopens her eyes. The director re-examines the events that led to this unusual occurrence and offers some answers on the issue of miracles. While a bit too "televisiony," and with a narration that is a little too casual, the film however gives a sense of the self-critical capacity with which this generation of directors (and, above all, the women directors) re-examines its cultural heritage. They do not resort to victim pathos, but instead use the type of good-natured, bully-type humor (á la John Fante) with which Italian Americans view reality, including religion. Yet, they do so with an air of enlightened skepticism, and not through the interior torment of a Scorsese or a Ferrara.

The Catholics of the Boston diocese are also the subject of *Hand of God* (2007), an accusatory television movie by Joe Cultrera about his brother's sexual abuse as a boy by a Catholic priest. After a thirty-year silence, Paul Cultrera decided to speak out in an attempt to understand the extent to which ecclesiastical authorities were aware of this priest's behavior, and if there was a cover up. By putting up signs reading "Do you remember Father Birmingham?" in the various cities where this priest was stationed, Paul was able to collect a large number of similar accounts of abuse. Throughout it all, the director tries to maintain the feeling of unity and loving protection within his family, as well as a touch of humor.

As with the preceding films which analyze ties to the Catholic Church, but are rooted in the current experience of Italians in America, *Closing Time: Storia di un negozio* (Veronica Diaferia, 2006) focuses on the present through the closing of a founding place of Italian American culture: the Ernesto Rossi & Co. store on the corner of Mulberry and Grand Streets in New York that sold books, sheet music, and all kinds of objects. The store opened in 1902 and soon became the place where organ grinders went in search of sheet music and for émigré Southern Italian artists. It was a national monument (or better yet, an archive) of Italian American culture. In January 2006, real estate pressures on this very expensive area of the city forced the closing of the store. This young Italian émigrée's documentary follows the last month of the Rossi family ownership, the memories of its clients and neighbors, such as Mr. Paolucci who, forced to close his restaurant, leaves Little Italy in tears.

What we have is a young Italian woman who narrates, with the regret

of one who discovers a story that has come to its conclusion, the last chapter of the life of Italian American culture, the end of the true Little Italy now besieged by Chinatown and absorbed into Soho. While closing the recycled cardboard boxes, one of Rossi's descendants says with bitterness that "everything changes and that it is all due to money." It appears that Little Italy has become a bit like Venice, a theme park for tourists in a hurry, where culinary corruption is evidenced by misspelled menus, and cultural diversity (the merchandizing of the Mafioso stereotype) is embodied by posters of the Sopranos or the Rat Pack. The posters hang next to T-shirts that say, "Italians do it better," and it's true, for who better than us knows how to sell what we don't even know we own?

Italian American culture has emigrated once again. It has gone to the suburbs of New Jersey, to Tony Soprano's pool from which we can glimpse the home of Dr. Cusimano, who has assimilated to American culture, shedding all vestiges of Italian heritage.

Translated from the Italian by Maria Enrico

Tony, Ray, and the Others: The Italian American on TV

Silvia Giagnoni
AUBURN UNIVERSITY, MONTGOMERY

In an attempt to deconstruct the role and depiction of Italian Americans on television, one must begin with an examination of *The Sopranos* that, by virtue of its strong scriptwriting, propelled the medium of television to new creative heights. Equally important, the show clearly demonstrates that television audiences desire quality entertainment and are willing to pay money to view such productions that provide a form of collective therapy. What message is communicated about the value of invention and creativity in the media if we attack programs such as *The Sopranos*? TV that is not TV ("It's not TV, it's HBO" is the channel's slogan).[1] Television that entertains, but also allows us to reflect, on the one hand, about the "demasculization of the typical American male," as Fred Gardaphé observes (*Scene* 75),[2] involving the consequent *degeneration* of the new generation of gangsters in our collective imagination, while on the other hand, speaks to the experience of Italian Americans and their place in contemporary American society.

Today Italian actors and characters are omnipresent on American TV; the stereotypes that dominated Hollywood cinema in the 1930s, which portrayed Italians as "Other," and translated to the screen characters as dishonest, lazy, *fessi*, thus non-American, no longer exist. Today, Italian Americans have become "White," although remaining ethnic — and, thus, subject to stereotyping as other groups — and television, the dominant form of American entertainment, reflects the new role this ethnic group plays in society at large. From sitcoms to detective and crime fiction (especially investigative crime fiction, as a result of the overwhelming success of *CSI* and its spin-offs) to legal drama, we observe many Italian

[1] *The Sopranos* episodes are shot in film, not video, format, a fact that further enhances the cinema-effect of the show.

[2] Gardaphé writes: "Il maschio americano sta cambiando; questo è ciò che *The Sopranos* ci mostrano" (*Scene* 75)

Americans, with or without the hyphen.[3] This trend is exemplified by *E.R*'s Doctor Robert Romano, *Desperate Housewives*' Lynette Scavo and family, *Seinfeld*'s George Costanza, *Law & Order*'s Detective Joe Fontana, featuring Italian American actor Dennis Farina, or Vincent D'Onofrio as Detective Robert Goren, Major Case Squad NYPD chief in *Law & Order Criminal Intent*, and also Christopher Meloni as detective Elliot Stabler in *Law & Order Special Victim Unit*.

The starting point of any examination of this subject matter must begin with *The Sopranos*, precisely because of the show's important contribution to contemporary TV. As a result of the program, the academic discipline of "Sopranos Studies" has emerged within the field of Television Studies.[4] Moreover, after the conclusion of the acclaimed series,[5] *The Sopranos* achieved the status of cult TV and, since January 2007, has aired on "basic" cable station, A&E. While HBO commercials do not interrupt the episodes, A&E's business practices are quite different. An analysis of the many commercials that interrupt programming lists advertisements for *Rome*, whose DVD release is repeatedly promoted, and *300*, the ultra-violent movie on the Thermopiles battle.[6] The A&E channel specializes in epic films and documentaries, and reinforces the violence-power-mafia equation,[7] recently suggested by the Public Broadcasting System's *Medici: Godfathers of Renaissance*.

The Sopranos expands on the themes suggested in *The Godfather*, i.e. that Mafia and big business are governed by similar rules.[8] Among others, Dean DeFino (2004) furthers this idea in his essay, "The Prince of North Jersey," reflecting upon *The Sopranos* by way of Niccolò Machiavelli's *The Prince*, and interpreting the show as a study on the structure

[3] The hyphen is the linguistic sign that represents the ethnic condition. For a semiotic speculation on Italian/American ethnicity, see Anthony Julian Tamburri, *To Hyphenate or not to Hyphenate. The Italian/American Writer: an Other American*. Tamburri suggests we use the slash rather the hyphen for the adjective (Italian/American) and no diacritical mark at all for the noun (Italian American), thus, the two identities (Italian and American) are given equal importance.

[4] There is an Evangelical interpretation of the show: Chris Seay's *The Gospel according to Tony Soprano: An Unauthorized Look into the Soul of TV's Top Mob Boss and His Family*.

[5] Between April and June 2007, HBO aired nine episodes that the network had announced earlier that year to be the last ones of the series.

[6] The movie is directed by Zack Snider and is based on the graphic novel by Frank Miller.

[7] A&E is part of A&E Television Networks, group that also comprises History Channel and Biography Channel.

[8] Dr. Cusamano and his friends joke about Tony's criminal activities by paralleling it to the corruption of politicians and the similar *modus operandi* in the corporate world.

and retention of power. Specifically, the same techniques employed to control "the Family" are also utilized by efficient leaders in the corporate world today. In the *Sopranos* universe, there is no clear distinction between good guys and bad guys, contrary to the crime and legal dramas in which this difference is palpable. As DeFino suggests, Tony uses psychiatry as a technique to become a better Boss, one that "works" at the role one is called to play. At times, we sense that Tony is conflicted and "stuck," he cannot escape his world, but the focus of the action rapidly moves elsewhere. On the other hand, the gangster has to be somewhat romantic, engaging, charismatic, and should possess some degree of "angst," or else we would not feel empathy for him. We learn that Tony is depressed since the ducks stopped visiting his pool, an allusion to *The Catcher in the Rye*, specifically, when Holden Caufield wonders where the ducks go when the Central Park lagoon freezes.[9]

As critics, we are compelled to discuss *The Sopranos* since it is our task to attempt to understand what viewers enjoy and, in the end, to explain the relationship between audience consensus, aesthetics, and the reasons for success in the context of the historical and cultural evolution of the Italian American stereotype. However, *The Sopranos* is a show about a Mafioso family, with some proclaiming the triumph of the stereotype! They are wrong. The success of the TV series relies on the fact that *The Sopranos* is about two families: the ordinary one, comprised of wife and two children, with the typical problems of family life, and the extraordinary criminal one, sometimes exciting, often repulsive, and stressful, driving Tony to enter psychotherapy in order to overcome his panic attacks. Tony is seeking relief from his anxiety, as well as a solution to maintain his power and role as the Boss of the Family.

A gangster that goes to a psychiatrist for treatment! This behavior undermines the traditional figure of the macho gangster as Tony breaks "the code of silence" by sharing his feelings and disappointments with Doctor Melfi, a woman, to boot. Tony is a man who feels that he cannot live up to

[9] Chase has the ducks visit Tony's pool and then makes them disappear, thus depriving him of the occasional joy of this bucolic diversion in the seemingly protected space of his backyard. In so doing, Chase might have wanted to recall the teenager *par excellence* of post WWII American literature, Holden Caulfield, and to establish a parallel between the two. The passage I am referring to is the following: "I live in New York, and I was thinking about the lagoon in Central Park, down near Central Park South. I was wondering if it would be frozen over when I got home, and if it was, where did the ducks go. I was wondering where the ducks went when the lagoon got all icy and frozen over. I wondered if some guy came in a truck and took them to a zoo or something. Or if they just flew away" (18).

the myths of his generation, feelings that he articulates repeatedly, while reflecting upon the great strong and silent heroes, "like Gary Cooper." *The Sopranos* only scratches the surface of the human psyche and makes clever use of stereotypes in an attempt to stay true to reality.

Maurizio Viano has viewed Scorsese's cinema through Pasolini's *Heretical Empiricism* and reflects on the Italian American director's movie as capable of conveying "a certain realism." Indeed, Scorsese's films, and those of Spike Lee, suggest that we can explore stereotypes without exploiting them, but rather by illuminating them in contrast with others. Likewise, the characters of *The Sopranos* are like Brechtian "types" and David Chase shows us their external behaviors, but little of their internal morality. Moreover, Chase himself announced in 2002 that he would never write again for the show.

> I just think, Tony Soprano, guys of his ilk, they're not very reflective people, they don't do a lot, in reality. So, there's only so many stories, so much depth, that you can impart to a character like that and still stay true to realism . . . (Chase, cit. in Lavery: 237)

The dialogue and the stories portrayed in *The Sopranos* question Italian American male and female stereotypes. For instance, Chase uses the stereotype of the Italian American man as "mama's boy" ("mammone" in Italian) and creates a situation in which Anthony Jr,'s classmates disrespect his mom. Anthony does not respond to the insults; rather, he gets angry only when they make fun of him because he is overweight, reinforcing the negative stereotype of mothers and sons in relation to food and compulsive overeating. Tony shares with Dr. Melfi that he would like to hang out with more *Americani* but his belonging to the Mob—*not his being Italian*—prevents him from doing so. Tony reflects that Cusamano is Italian but more *Americano* because he is a doctor, thus a "cultured Italian," like Russ e Lena Fregoli, his mother-in law, Mary DeAngelis' family friends. However, when Meadow insists that as a family they should discuss sexual issues because "it's the nineties, and other families do so," Tony retorts: "Outside it may be the nineties but in this house it's 1954." Although Tony may not be an overt male chauvinist, he strives to play the role of one. Yet, indeed, by making that joke, he ends up perpetrating the stereotype.

Stereotypes are not simply accepted, they are revisited, shown, often through irony, as Peter Bondanella notes. On the other hand, David La-

very maintains that in order to enjoy the show, the spectator has to "come heavy,"[10] thus quoting the line of an earlier episode of the show in which Uncle Junior tells Tony to come back heavy (armed). The viewer has to have a rich intertextual knowledge from movies, TV shows, and books to fully appreciate the show. He or she has to know twentieth-century Western popular culture.[11]

As Robert Kolker reminds us, references to American cinema work in order to celebrate the medium as "they enrich the work by opening it out, making it responsive to other works and making others responsive to it" (187). "Tony and his boys" love, imitate, and frequently cite references from Italian American cinema. In "Guy Walks Into a Psychiatrist's Office" (II, 1), Pussy comes back from Puerto Rico and asks Silvio (Steve Van Zandt) to play Michael in *Godfather Part III*.[12] In turn, Paulie's car horn is the musical theme of *Godfather* ("Nobody Knows Anything" I, 11). By and large, such music recalls the intertext of Italian American cinema, as in the first episode in which Dion's song echoes *A Bronx Tale*.[13]

In "The Legend of Tennessee Moltisanti" (I, 8) Tony's henchman Christopher (Michael Imperioli) fantasizes about becoming a screenwriter of gangster movies. It seems that Christopher would rather write stories about gangsters than be a gangster. Henry Hill's (*Goodfellas*) childhood dream seems broken for Christopher before he had the possibility to live it out, a frustration that Christopher shares with the new generation of gangsters and seeks to overcome with drugs. Christopher is thus another character not able to live up to his own mythology.

We must acknowledge that some Italian Americans do not like *The Sopranos*. They think the program constitutes further manifestation of the media's negative stereotypical representations, i.e. Italians as "Mafiosi," to which they feel subjected as a group. Some Italian Americans, one might readily speculate, may not be capable of making fun of themselves.

[10] The reference is to the episode of the first series, in which Uncle Junior tells Tony to come back to him carrying a loaded gun ("come heavy next time").

[11] Just like few other TV shows or animated films like *The Simpsons* or *Family Guy*, *The Sopranos* requires the spectator to have a good knowledge of popular culture to better enjoy the text.

[12] Little Steven/Silvio is at his best when he plays Michael; among Silvio's favourite, most-quoted lines: "Just when I thought I was out, they pulled me back in" and "It was you Fredo."

[13] Like in Scorsese and contrary to Coppola, the music chosen by Chase is not original, as Bondanella notes. If Hollywood cinema often deploys music to reinforce the illusion of reality (reality effect), thus contributing to manipulate the spectator's reactions and often link themes to certain characters, in *The Sopranos*, like in the Scorsese' "*mean street* series," music is in the foreground (e.g. in the opening titles), defying the hierarchies that rule the traditional filmic experience (Viano 141).

In other words, they lack self-irony, a characteristic in which Italians generally take pride.

Indeed, here lies the conflict. In Italian culture, "I panni sporchi si lavano in famiglia," (literally, "dirty clothes are washed in the household"). However, *The Sopranos* do it on prime time TV. Italian American organizations such as UNICO National[14] and NIAF[15] are unable to distinguish different types of media representations and do not go beyond the equation "Italiano=Mafioso." For them, and for the Italian American critic and poet Sandra M. Gilbert, these products of collective imagery offend hard-working Italian Americans who contribute to make America with their honesty, creativity, and intelligence, qualities they deem Chase does not possess.[16]

In 1999, NIAF offered its Achievement Award to Matt Le Blanc for his performance as Joey in the mainstream TV show *Friends*, suggesting the dichotomy within these conservative organizations, which often praise "those who made it, period"; in other words "those who made it by exploiting the stereotype of the Italian Mafioso" (read Robert De Niro and the like) and reproach "the blasphemous ones," as Tamburri ironically calls them.[17]

As Bondanella underlines in *Hollywood Italians*, Chase has created a universe dominated by Italian Americans, the fifth largest ethnic group in the United States, whereas with the composite universe we find in *The Sopranos*, Italian American characters constitute the majority and, most importantly, set the rules. Contrary to Scorsese and Coppola though,

[14] The headquarter of UNICO National, "the largest Italian American service organization," as we read in the official website, is in Fairfield, NJ.

[15] NIAF stands for National Italian American Foundation.

[16] Jonathan Cavallero notices that whereas these organizations dislike *any* depiction of Italian Americans *as* gangsters, they do not criticize the food companies' attempts to appropriate and alter at will Italian and Italian American food, and thus create a distorted representation of cuisine and culinary practices through commercials (and we do know how discourses are *constitutive* of reality). The task of a constructive Italian American criticism and of a progressive cultural leadership has its difficulties and complexities, as Anthony Tamburri more than once has pointed out, and is sometimes exercised paradoxically by *The Sopranos*. One example is when Paulie, at a Starbucks (I, 2) comments on the exploitation of Italian products.

[17] It is worth noting here the controversy that preceded the awarding of the Italian Honorary Citizenship to Robert De Niro. Members of CARRES (Coalition Against Racial, Religious and Ethnic Stereotyping), that gathers over thirty organizations, among them UNICO, NIAF and Sons of Italy, were strongly opposed to the awarding for the reasons mentioned in the text and sent a letter addressed to the then-Presidente del Consiglio Silvio Berlusconi. On the other hand, NIAF wrote a letter to the actor criticizing him for having dubbed Don Lino in the highly controversial *Shark Tale*, produced by Steven Spielberg. The cartoon was criticised by most Italian/American organizations as offensive and harmful for kids.

these wiseguys are surrounded by other Italian Americans who work at a variety of different professions and are motivated by quite different values. This is a progressive move for Chase, since in order to fight stereotypes we need to diversify representations and avoid the exclusive association between one group and determinate professions and/or negative features.[18]

Returning to a discussion of Matt Le Blanc, in *Joey*, the *Friends* spin-off, the protagonist Joey Tribbiani goes to Los Angeles to pursue his acting career. Joey lives with his 20-year-old nephew Michael, son of his sister Gina, played by Drea De Matteo (Adriana, Christopher's fiancée in *The Sopranos)*. Gina is a single mother, and her son often tries to help her, as when he once convinces Joey to lend Gina money to open a beauty salon so that she can leave her job and her ill-mannered boss.

Gina is one of the "guidettes"[19] vividly portrayed in so many Italian-American movies (i.e., Annabella Sciorra's friends in both *Jungle Fever* and in *True Love)*: Adriana/Gina constantly chews gum, curses frequently, and talks about minutiae as if they were extremely serious matters. Adriana/Gina wears sexy outfits, and appears more stylish than the often ridiculous guidettes of the 1980s, perhaps a sign of a positive evolution of the stereotype.[20]

On the other hand, Joey is a "buffoon" and a "Latin lover," a "Romeo" as Bondanella calls this stereotype: naive and and perennially good-humored. He is one of many contemporary *Latin lovers* with a last name that ends in a vowel, handsome ("belloccio") but also jovial, like Robert Maschio, *Scrubs*'s piggish surgeon, or *NCIS*'s Anthony DiNozzo. Aired on CBS, *NCIS* is one of *Jag*'s spin-offs, both produced by Italian American Donald Bellisario, creator of *Magnum P.I.*

Regarding crime fiction, *CSI Miami*, unanimously recognized as the least successful of the three TV series, has Italian American actor David Caruso (already seen in *NYPD Blue)* as Horatio Caine. But it is surely in

[18] As Bondanella notes, in *The Sopranos* we find priests (Father Phil Intintola), psychiatrists (Jennifer Melfi, Richard La Penna, and Dr. D'Alessio), restaurant owners (the Buccos), hospital administrators (Barbara Giglione and Miss Antoniette Giacolo), plumbers (Mr. Ruggiero), feminist professors (Prof. Longo-Murphy), labor-union leaders (Dave Fusco and Bobby Sanfilippo), and real estate agents (Virginia Lupo).

[19] Guidette is the female version of "Guido," the stereotypical working class Italian American guy. Movies, such as *My Cousin Vinny* and *Summer of Sam* are populated by "Guidos" and "Guidettes."

[20] When FBI agent Daniela Ambrosio is required to become Adriana's best friend, a colleague asks her "How big can you make your hair?" In order to "pass as a Guidette (read Adriana's friends), she would need to be able to comb out her hair as big as them.

CSI New York, the show that features a post 9/11 multiethnic scenario, that we find a majority of Italian Americans. The protagonist Mac Taylor (Gary Sinise), was originally to be named Rick Calucci with either Andy Garcia or Ray Liotta in that role, but both of them "refused the offer" (Tintori 163). On the crime investigation crew, we also find Stella Bonasera, half Greek and half Italian, whose name is actually inspired by *The Godfather*'s Amerigo Bonasera.[21]

Looking for what Fred Gardaphé calls "Italian signs" among TV characters with an Italian last name becomes a rather difficult and depressing task. More often than not, there is nothing beyond the reference to "pizza" and "nonna," to paraphrase one of Tamburri's essays. In other words, the signs are frequently stereotypical, especially in comedies, since the genre plays on dominant values, expectations, and conventional behaviors. In *The Sopranos*, Italian American signs are constantly visible, while other TV series water them down significantly for less "sophisticated" tastes. TV comedies, the sitcoms specifically, cater to a generalist audience; thus the genre "must laugh at existing social relations in such a way that dominant and subordinate groups 'lighten up' and find pleasure in the world the way it is" (Artz, Ortega Murphy 111).

Sitcoms typically make use of humor to support the dominant ideology, thus reproducing hegemonic culture. Characters are predictable, sometimes true caricatures. For instance, in *Everybody Loves Raymond*, unquestionably the most "Italian American" TV show, we find the typical intrusive and annoying mother/mother-in-law, the daughter-in-law that cannot cook, and the conflicts that generally occur between the two. First aired in 1995, the multi-award winning CBS series features the protagonist Raymond "Ray" Barone together with his nuclear family composed of his wife, Debra, and three children. The other fixed characters are his brother Robert, a cop, and his parents Marie and Frank, who live next door and constantly invade the privacy of Ray's home.

Whereas in *The Sopranos*, Italian American linguistic expressions such as "agita," "gavoon," "capiche," "goomah" are the show's trademark — indeed, the TV series has triggered a real craze and has contributed to spread Italian American vocabulary beyond the traditional urban and ethnic contexts — in *Everybody Loves Raymond* the use of these words is quite limited. As a matter of fact, the protagonists do not speak with an

[21] Stella, orphan, does not know anything about her origins and was driven to work in the Crime Investigation Unit by her desire to understand more about her own past (Tintori 166).

Italian American accent. Italian origins are emphasized in other ways, as when the Barones go to the Italian American pizzeria, or when having an aunt visit from Italy, who, stereotypically, after hanging a crucifix on the wall, forces the entire family to sing along "C'è la luna mezzo'o mare."[22]

Although the sitcom is undoubtedly entertaining, it plays on the stereotypes at a very superficial level. In other words, it does not foster knowledge, but rather reinforces existing ideas. However, it does not exploit the stereotypes to the point of being offensive as this is a show that is aired by mainstream TV and, for obvious economic reasons (advertising investments), it cannot afford to offend any group, not even the Italian American; *Raymond* does not show that type of self-reflexivity on stereotypes that we find in the HBO series.

In another sitcom, *The War at Home*, we find an Italian American woman, Vicky, played by Anita Barone, married to a Jewish American, Dave Gold (Michael Rapaport).[23] First aired in September 2005, the sitcom is a product of the "politically incorrect" Fox programming, "squeezed" between *The Simpsons*, *Family Guy*, and *American Dad*. Vicky is a young mother who does not speak with an Italian American accent. References to her Italian background are subtle in a TV show that often discusses ethnic and racial issues in a provocative, and often impolite, manner."[24]

Finally, the references to Italian ethnicity are often "national-populist." Joey and Gina laughing about their mom's moustache plays on the stereotype of the Italian woman as hairy, unclean, wild, uncivilized, and more animal than human. Joey's Italian Americanness is *all* about these stereotypical references, and the character played by Le Blanc follows the cinematographic tradition of the Italians as "fesso," as Cavallero aptly points out.

In conclusion, contemporary Italian American have assimilated into American culture and on TV. Their representations oscillate between light entertainment that ultimately reinforces and reproduces certain stereo-

[22] In *The Sopranos*, the perception of Italians and Italy is filtered through the experience of Italian Americans, and, at times, may come across as stereotypical to Italian eyes. However, we need to take into consideration that both Chase's point of view and his Ideal Audience is the Italian Americans.

[23] Dave Gold is an absolutely non-politically correct character, similar to Thomas Dunwitty, the one interpreted by Rapaport in Spike Lee's *Bamboozled* (2000).

[24] In historical and cultural times in which depolitization and conservatism are dominant in the States, *The War at Home* articulates this new cultural hegemony. For instance, in the episode "High Crimes," Hillary (the daughter) goes out with an African American and Anita decides to invite the guy's parents for a barbecue. Dave feels attacked by the guy's father and fights back, insinuating that he was able to get into Yale thanks to affirmative action.

types (*Everybody Loves Raymond*) and the invention of *The Sopranos* that openly exhibits the various stereotypes, and, in so doing, angers that narrow-minded contingency of Italian America.

Works Cited

BOOKS/ARTICLES

Artz, Lee, Bren Ortega Murphy. *Cultural Hegemony in the United States*. Thousand Oaks, Calif.: Sage Publications, 2000.

Barreca, Regina. Ed. *A Sitdown with the Sopranos. Watching Italian American Culture on TV's Most Talked-about Series*. New York: Palgrave Macmillan, 2002.

Bondanella, Peter. *Hollywood Italians: Dagos, Palookas, Romeos, Wise Guys, and Sopranos*. New York: Continuum, 2004.

Bordwell, David and Kristin Thompson. Eds. *Film Art. An Introduction*. New York: McGraw Hill, 2001.

Camaiti Hostert, Anna, and Anthony Julian Tamburri. *Scene Italoamericane*. Roma: Luca Sossella Editore, 2002.

Cavallero, Jonathan J.. "Gangsters, Fessos, Tricksters, and Sopranos. The Historical Roots of Italian American Stereotypes Anxiety." *Journal of Popular Film and Television*. 32, n.2. Summer 2004. 50-63.

DeFino, Dean. "The Prince of North Jersey." *Journal of Popular Film and Television*. 32, 2. Summer, 2004.

Della Piana, Libero. "Are Italians the New Anti-Racist Front?" *RaceWire* On Line Magazine, October 2004.

De Stefano, George. *An Offer we Can't Refuse: the Mafia in the Mind of America*. New York: Faber and Faber, 2006.

Gardaphé, Fred. "Fresh Garbage." Regina Barreca, ed. *A Sitdown with the Sopranos. Watching Italian American culture on TV's Most Talked-about Series*. New York: Palgrave Macmillan, 2002. 89-111.

_____. "Capire il Gangster Italo/Americano: Un'azione di classe." Anna Camaiti Hostert and Anthony Julian Tamburri, Eds. *Scene Italoamericane*. Roma: Luca Sossella Editore, 2002. 57-77

_____. *Leaving Little Italy. Essaying Italian American Culture*. New York: State U of New York P, 2004.

Gilbert, Sandra M. "Life with (God) Father." Regina Barreca, ed. *A Sitdown with the Sopranos. Watching Italian American culture on TV's Most Talked-about Series*. New York: Palgrave Macmillan, 2002.11-25.

Kolker, Robert Philipp. *A Cinema of Loneliness: Penn, Stone, Kubrick, Scorsese, Spielberg, Altman*. Oxford; New York: Oxford UP, 2000.

Lavery, David. *Reading the Sopranos: Hit TV from HBO*. Ed. New York: Palgrave Macmillan, 2006.

_____. "Coming Heavy." *Pop Politics.com* http://www.poppolitics.com/articles/2001-03-03-heavy.shtml.

Nochimson, Martha. P. "Waddaya Looking' At? Re-reading the Gangster Genre through 'The Sopranos.'" *Film Quarterly*, 56.2: 2-13.

Pasolini, Pier Paolo. "The 'Cinema of Poetry,'" *Heretical Empiricism*. Louise K. Barnett, ed. Trans. Ben Lawton. Bloomington: Indian University Press, 1988. 167-186.

Pinkus, Karen. "Automobilisti del New Jersey!@#%*!" Anna Camaiti Hostert and Anthony Julian Tamburri, eds. *Scene Italoamericane*. Roma: Luca Sossella Editore, 2002. 273-288.

Rapping, Elayne. *Law and Justice as Seen on TV*. New York: New York University Press, 2003.

Salinger, J.D. *The Catcher in the Rye*. 1945. New York: The Modern Library, 1951.

Seay, Chris. *The Gospel According to Tony Soprano: an Unauthorized Look into the Soul of TV's Top Mob Boss and His Family*. New York: Jeremy P. Tarcher/Putnam, 2002.

Tamburri, Anthony Julian. *To Hyphenate or not to Hyphenate: the Italian/American Writer: an Other American*. Montreal: Guernica, 1991.

_____. *A Semiotic of Ethnicity: In (Re)cognition of the Italian/American Writer*. Albany: SUNY Press, 1998.

_____. Beyond 'Pizza' And 'Nonna'! Or, What's Bad about Italian/American Criticism? Further Directions for Italian/American Cultural Studies." *MELUS*. 28.3 (2003): 149-74.

Tintori, Angela. *CSI: Crime Scene Investigation*. Milano: Delos Books, 2006.

Viano, Maurizio. "Scorsampling." *Differentia*. Spring/Autumn 1994: 133-152.

FILMS & TV SHOWS

300. Dir. Zack Snider. Warner Bros. Pictures. 2006.

Analyze This. Dir. Harold Ramis. Warner Bros. Pictures. 1999.

Bronx Tale. Dir. Robert De Niro. B.T. Films Inc. 1993.

CSI. Crime Scene Investigation. Richard J. Lewis, Judy McCreary. CBS Productions. 2000-.

CSI. Miami. CBS Productions. 2002-.

CSI New York. CBS Productions. 2004-.

Desperate Housewives. Mark Cherry et al.. American Broadcasting Company (ABC) 2004-.

Everybody Loves Raymond. Philip Rosenthal et al. CBS Television. 1996-2005.

Friends. David Crane, Marta Kaufmann et al. Warner Bros. Television. 1994-2004.

Goodfellas. Dir. Martin Scorsese. Warner Bros. Pictures. 1990.

Joey. Shana Goldberg-Meehan, Scott Silveri et al. 2004-2006.

Jungle Fever. Dir. Spike Lee. 40 Acres & A Mule Filmworks. 1991.

Law & Order. Dick Wolf et al. Wolf Films. 1990-.

Law & Order Criminal Intent. Dick Wolf et al. Wolf Films. 2001-.

Law & Order SVU. Dick Wolf et al. Wolf Films. 1999.

Medici: Godfathers of Renassaince. Susan Horth. DeVillier Donegan Enterprizes Inc. 2004.

NCIS - Naval Criminal Investigative Service. Donald P. Bellisario. 2003-.

NYPD Blue. Steven Bochco et al. 20th Century Fox Television. 1993-2005.

Rome. Bruno Heller et al. HD Vision Studios. 2005-2007

Seinfeld. Larry David, Jerry Seinfeld. Castle Rock Entertainment. 1990-1998.

The Godfather. Dir. Francis Ford Coppola. Paramount Pictures. 1972.

The Godfather III. Dir. Francis Ford Coppola. Paramount Pictures. 1990.

The Sopranos. David Chase et al. Home Box Office (HBO). 1999-.

_____. "Meadowlands" (I-4).

_____. "Guy Walks Into a Psychiatrist's Office" (II, 1).

_____. "The Legend of Tennesse Moltisanti" (I,8).

_____. "From Where to Eternity" (II, 9).

_____. "An Army of One" (III, 13).

The War at Home. Rob Lotterstein. Acme Productions. 2005-.

_____. "High Crimes" 25 September 2005 (Season 1, Episode 3).

True Love. Dir. Savoca Nancy. United Artists, 1989.

WEBSITES
http://www.aetv.com/
www.foxcrime.it
www.imdb.com
http://www.isopranos.com/
http://www.unico.org/index.html

An Annotated List of Contemporary Italian American Cinema

Antonio Valerio Spera

The following compilation represents a modest attempt to delineate a filmography of contemporary Italian American cinema. For reasons of brevity, entries noting the work of Francis Ford Coppola, Brian De Palma, Abel Ferrara, Martin Scorsese, and Quentin Tarantino have purposely been omitted since their careers have been previously well documented.

STEVE BUSCEMI (New York; December 13, 1957)

Born in Brooklyn and raised on Long Island, Buscemi became passionate about acting in high school. After graduation, he worked for four years with the FDNY and studied acting at the Lee Strasberg Institute. His first appearance was in 1986, when Bill Sherwood selected him for a role in *Parting Glances*. Since that time, Buscemi has acted in more than sixty films, working with directors of the caliber of Robert Altman, Jim Jarmusch, James Ivory, and Robert Rodriguez. In 1990, with *Miller's Crossing*, Buscemi began his partnership with the Coen Brothers. Two years later he was part of the cast of Quentin Tarantino's *Reservoir Dogs* (1992). His performance in this film earned him an Independent Spirit Award. An important figure in the world of independent cinema, he was also in blockbusters such as *Con Air* (1997) and *Armageddon* (1998). His debut behind the camera took place with his short film, *What Happened to Pete* (1992), written, directed, and performed by him. His feature-length debut as director was with *Trees Lounge* (1996); he has also directed three episodes of *The Sopranos*.

DIRECTOR: *What Happened to Pete?* (1992); *Trees Lounge* (1996); *Animal Factory* (2000); *Lonesome Jim* (2005); *Interview* (2007); episodes of *The Sopranos* (*Mr. and Mrs. John Sacrimoni Request, In Camelot* and *Pine Barrens*).

ACTOR: *Tommy's* (1985); *The Way It Is* (1985); *Parting Glances* (1986); *Sleepwalk* (1986); *No Picnic* (1987); *Heart* (1987); *Arena Brains* (1988); *Call Me* (1988); *Kiss*

Daddy Goodnight (1988); *Vibes* (1988); *Heart of Midnight* (1988); *New York Stories* ibid., 1989); *Slaves of New York* (1989); *Mystery Train* (1989); *Bloodhounds of Broadway* (1989); *Tales from the Darkside: The Movie* (1990); *Force of Circumstance* (1990); *King of New York* (1990); *Miller's Crossing* (1990); *Life Is Nice* (1991); *Zandalee* (1991); *Barton Fink* (1991); *Billy Bathgate* (1991); *In the Soup* (1992); *What Happened to Pete* (1992); *Reservoir Dogs* (1992); *CrissCross* (1992); *Ed and His Dead Mother* (1993); *Twenty Bucks* (1993); *Claude* (1993); *Rising Sun* (Sollevante, 1993); *Floundering* (1994); *The Hudsucker Proxy* (1994); *Pulp Fiction* (1994); *Airheads* (1994); *Somebody to Love* (1994); *Who Do I Gotta Kill?* (1994); *The Search for One-eye Jimmy* (1994); *Living in Oblivion* (1995); *Billy Madison* (1995; uncredited); *Desperado* (1995); *Things to Do in Denver When You're Dead* (1995); *Fargo* (1996); *Black Kites* (1996); *Trees Lounge* (1996); *Kansas City* (1996); *Escape from LA.* (1996); *Con Air* (1997); *The Real Blonde* (1997); *The Wedding Singer* (1998; uncredited); *The Big Lebowski* (1998); *The Impostors* (1998); *Armageddon* (1998); *Louis & Frank* (1998); *Big Daddy* (1999); *Animal Factory* (2000); *28 Days* (2000); *Double Whammy* (2001); *Ghost World* (2001); *Final Fantasy: The Spirits Within* (2001; voice over); *The Grey Zone* (2001); *Monsters, Inc.* (2001; voice over); *Domestic Disturbance* (2001); *Deadrockstar* (2002); *13 Moons* (2002); *The Laramie Project* (2002); *Love in the Time of Money* (2002); *Mr. Deeds* (2002); *Spy Kids 2: Island of Lost Dreams* (2002); *Spy Kids 3-D: Game Over* (2003); *Coffee and Cigarettes* (2003); *Big Fish* (2003); *Home on the Range* (2004; voice over); *Who's the Top?* (2005); *The Island* (2005); *Romance & Cigarettes* (2005); *Paris, je t'aime* (2006); *Monster House* (2006; voice over); *Delirious* (2006); *Charlotte's Web* (2006; voice over); *Interview* (2007); *I Think I Love My Wife* (2007); *I Now Pronounce You Chuck and Larry* (2007).

ACTOR (television performances): *Miami Vice* (1986); *Lonesome Dove* (mini-series, 1989); *Borders* (1989); *LA. Law* (1991); *Tales from the Crypt* (1993); *The Adventures of Pete & Pete* (1994); *The Last Outlaw* (1994); *Saturday Night Live* (1994-2000); *The Sopranos* (2002-2006).

MICHAEL CORRENTE (Rhode Island, April 6, 1959)

He became enamored with film as a youngster, as a result of his father's high degree of interest in foreign films. In 1981, he graduated from the Trinity Repertory Conservatory in Providence; three years later he moved to New York and founded Studio B Theatre. He produced and directed more than twenty theatrical works, including *Federal Hill*, which was written and performed by Corrente in 1986 at the Sanford Meisner Theatre in New York. With the hope of realizing the film version, he became a scriptwriter for the film *Title Shot* (1989) by Bill Durkin. In 1991,

he directed the film *Providence*, which included Keanu Reeves among its actors. Having finally raised the money, he debuted with his feature-length *Federal Hill* (1994), which aired at the festival of Deauville. Subsequently, he made *American Buffalo* (1996), written by David Mamet, with Dustin Hoffman as lead, which won an award at the Boston Festival Film. Enamored with Peter Farrelly's novel *Outside Providence*, he acquired the rights for a dollar and co-wrote with the book's author and brother Bobby Farrelly, completing the film in 1999. He also directed *A Shot to Glory* (2000), a soccer-based movie with Robert Duvall as lead. In 2007 he made *Brooklyn Rules*, which brought him back to organized crime, the thematics of his debut film.

DIRECTOR: *Providence* (1991); *Federal Hill* (1994); *American Buffalo* (1996); *Outside Providence* (1999); *A Shot at Glory* (2000); *Brooklyn Rules* (2006).

ACTOR: *Title Shot* (1989); *Federal Hill* (1994); *Kingpin* (1996); *Shallow Hal* (2001); *Assassination Tango* (2002).

PRODUCER: *Tilt-A-Whirl* (1995); *Say You'll Be Mine* (1999); *Outside Providence* (1999); *A Shot at Glory* (2000); *I'll Sleep When I'm Dead* (2003; executive producer); *When Zachary Beaver Came to Town* (2003); *The Door in the Floor* (2004); *Corn* (2004); *Brooklyn Rules* (2007).

RAYMOND DE FELITTA (New York, June 30, 1964)

Son of the director Frank De Felitta, Ray began as an "indie" director in 1990 with *Bronx Cheers*, which garnered him an Oscar nomination. In 1992 he won the Nicholl Fellowship in Screenwriting, an international competition for young screenwriters sponsored by the Academy of Motion Picture Arts and Sciences. His debut in feature-length films occurred in 1995 with *Cafe Society*, presented a year later at Cannes. In 2000, he directed *Two Family House*, which won the public's award at the Sundance Film Festival, and also garnered him two nominations for the Spirit Award. His subsequent works, *The Thing About My Folks* (2005) and *'Tis Autumn: The Search far Jackie Paris* (2006), won, respectively, the public's award at the Santa Barbara Film Festival and the best documentary for the Kansas City Film Festival. A professional jazz musician, De Felitta has also recorded CDs, one of which, *Monday Morning Quarterbacks*, is a duet with Peter Bogdanovich.

DIRECTOR: *Bronx Cheers* (1990); *Cafe Society* (1995); *Two Family House* (2000); *The*

Thing About My Folks (2005); *'Tis Autumn: The Search for Jackie Paris* (2006); *Street of Dreams* (2007).

WRITER: *Bronx Cheers* (1990); *Cafe Society* (1995); *Two Family House* (2000); *The Thing About My Folks* (2005); *'Tis Autumn: The Search for Jackie Paris* (2006).

ACTOR: *Mad at the Moon* (1992); *New Rose Hotel* (1998); *Joe the King* (1999); *New York City Serenade* (2007).

ROBERT DE NIRO (New York, August 17, 1943)

Born to a family of noted artists, De Niro grew up in the Bronx. At the age of ten, he made his theatrical debut as the Lion in *The Wizard of Oz*. Having realized his propensity toward acting, his mother enrolled him at the age of thirteen in New York's High School of Music and Art and at sixteen he began seriously to study acting, at the Stella Adler Conservatory learning method acting with Lee Strasberg. He debuted Off-Broadway in an adaptation of Chekhov's *Bear*. His debut in film was in 1965, un-credited, in Marcel Carné's *Trois chambres à Manhattan*. Between 1965 and 1970, he acted in three films with a young Brian De Palma, *Greetings* (1968) *The Wedding Party* (1969), and *Hi, Mom* (1970). In 1970 Roger Corman directs him in *Bloody Mama*. Three years later, with his performance in *Mean Streets*, he began a long collaboration with Martin Scorsese. Subsequently, De Niro won two Oscars (Coppola's *The Godfather II* [1974], and Scorsese's *Raging Bull* [1980]). In 1993, he made his debut as a director with Chazz Palminteri's *A Bronx Tale*, and in 2006 he directed *The Good Shepherd*. In 2002, soon after the tragedy of September 11, he co-founded the Tribeca Film Festival with Jane Rosenthal as a response to celebrate New York City as a major filmmaking center and provide opportunities for independent projects under his direction.

DIRECTOR: *A Bronx Tale* (1993); *The Good Shepherd* (2006).

ACTOR: *Trois chambres à Manhattan* (1965; uncredited); *The Wedding Party* (1966); *Greetings* (1968); *Sam's Song* (1969); *Bloody Mama* (1970); *Hi, Mom!* (1970); *Jennifer on My Mind* (1971); *Born to Win* (1971); *The Gang That Couldn't Shoot Straight* (1971); *Bang the Drum Slowly* (1973); *Mean Streets* (1973); *The Godfather II* (1974); *Taxi Driver* (1976); *Novecento* (1976); *The Last Tycoon* (1976); *New York, New York* (1977); *The Deer Hunter* (1978); *Raging Bull* (1980); *True Confessions* (1981); *The King of Comedy* (1983); *Once Upon a Time in America* (1984); *Falling in Love* (1984); *Brazil* (1985); *The Mission* (1986); *Angel Heart* (1987); *The Untouchables* (1987);

Midnight Run (1988); *Jacknife* (1989); *We're No Angels* (1989); *Stanley & Iris* (1990); *Goodfellas* (1990); *Awakenings* (1990); *Guilty by Suspicion* (1991); *Backdraft* (1991); *Cape Fear* (1991); *Mistress* (1992); *Night and the City* (1992); *Mad Dog and Glory* (1993); *This Boy's Life* (1993); *A Bronx Tale* (1993); *Frankenstein* (1994); *Les Cent et une nuits de Simon Cinéma* (1995); *Casino* (1995); *Heat* (1995); *The Fan* (1996); *Sleepers* (1996); *Marvin's Room* (1996); *Cop Land* (1997); *Wag the Dog* (1997); *Jackie Brown* (1997); *Great Expectations* (1998); *Ronin* (1998); *Analyze This* (1999); *Flawless* (1999); *The Adventures of Rocky & Bullwinkle* (2000); *Men of Honor* (2000); *Meet the Parents* (2000); *15 Minutes* (2001); *The Score* (2001); *Showtime* (2002); *City by the Sea* (2002); *Analyze That* (2002); *Godsend* (2004); *Shark Tale* (2004); *Meet the Fockers* (2004); *The Bridge of San Luis Rey* (2004); *Hide and Seek* (2005); *The Good Shepherd* (2006).

DANNY DEVITO (New Jersey; November 17, 1944)

Born Daniel Michael DeVito, Jr., he is the son of a small business owner whose ventures include a diner, dry cleaning store, and billiard parlor. Having graduated from a Catholic high school, DeVito began working as a cosmetician in his sister's beauty salon. The following year he enrolled in the American Academy of Dramatic Arts deciding to become an actor. In 1968 he had a small role in Robert Clouse's *Dreams of Glass*. In 1969, he had his Off-Broadway debut in Pirandello's *The Man with the Flower in His Mouth* and continued his theatrical work with *The Shrinking Bride, Lady Liberty* and Ken Kesey's *One Flew Over The Cuckoo's Nest*, subsequently made into a film by Milos Forman in 1975. That same year, with support from the American Film Institute, he debuted as director with the short film *Minestrone* (1975), written and produced with his then future wife, Rhea Perlman. The next project, *The Sound Sleeper* (1977), a short, won first prize from the Brooklyn Arts and Cultural Association. The sitcom *Taxi*, which aired from 1978 to 1983 was a huge success and DeVito became famous, winning an Emmy Award and a Golden Globe for his role as Louis DePalma. In 1987, he directed his first feature-length movie *Throw Momma from the Train* and with his wife in 1992, he founded Jersey Films, which produced numerous successful television shows and films including *Pulp Fiction* (1994), *Get Shorty* (1995), *Man on the Moon* (1999), and *Erin Brockovich* (2000).

DIRECTOR: *Minestrone* (1975); *The Sound Sleeper* (1977); *Throw Momma from the Train* (1987); *The War of the Roses* (1989); *Hoffa* (1992); *Matilda* (1996); *Death to Smoochy* (2002); *Duplex* (2003); *Queen B* (2005).

ACTOR: *Dreams of Glass* (1970); *La Mortadella* (1971); *Bananas* (1971); *Scalawag* (1973); *Hurry Up, or I'll Be 30* (1973); *One Flew Over The Cuckoo's Nest* (1975); *The Money* (1976); *Deadly Hero* (1976); *Car Wash* (1976); *The World's Greatest Lover* (1977); *The Van* (1977); *Goin' South* (1978); *Swap Meet* (1979); *Going Ape!* (1981); *The Gong Show Movie* (1980); *Terms of Endearment* (1983); *Romancing the Stone* (1984); *Head Office* (1985); *Ruthless People* (1986); *My Little Pony: The Movie* (1986); *Wise Guys* (1986); *The Jewel of the Nile* (1987); *Throw Momma from the Train* (1987); *Tin Men* (987); *Twins* (1988); *The War of the Roses* (1989); *Other People's Money* (1991); *Batman Returns* (1992); *Hoffa* (1992); *Last Action Hero* (1993); *Jack the Bear* (1993); *Look Who's Talking Now* (1993); *Junior* (1994); *Renaissance Man* (1994); *Get Shorty* (1995); *Matilda* (1996); *Felony* (1996); *Space Jam* (1996); *Mars Attacks!* (1996); *Hercules* (1997); *The Rainmaker* (1997); *L.A. Confidential* (1997); *Living Out Loud* (1998); *The Big Kahuna* (1999); *The Virgin Suicides* (1999); *Man on the Moon* (1999); *Drowning Mona* (2000); *Screwed* (2000); *What's the Worst That Could Happen?* (2001); *Heist* (2001); *Austin Powers in Goldmember* (2002); *Death to Smoochy* (2002); *Duplex* (2003); *Anything Else* (2003); *Big Fish* (2003); *Family of the Year* (2004); *Christmas in Love* (2004); *Catching Kringle* (2004); *Be Cool* (2005); *Marilyn Hotchkiss Ballroom Dancing & Charm School* (2005); *Relative Strangers* (2006); *Even Money* (2006); *The OH in Ohio* (2006): *Nobel Son* (2007); *Deck the Halls* (2006); *The Good Night* (2007); *One Part Sugar* (2007); *Reno 911-Miami* (2007).

ACTOR (television performances): *Taxi* (1978-1983); *All The Kids Do It* (1984); *Saturday Night Live* (1980-1988).

TOM DI CILLO (North Carolina; August 14, 1953)

After graduating from New York University's Film School, Di Cillo decided to become an actor and after eight years of struggle, he began to work behind the camera as director of photography for Jim Jarmusch's *Permanent Vacation* (1982) and *Stranger Than Paradise* (1984), as well as the episode *Strange to Meet You* (1986), which was eventually included in *Coffee and Cigarettes* (2004). In 1991, he debuted as director with *Johnny Suede,* based on his own theatrical monologue that he performed in 1987. It is a bittersweet comedy that, in addition to introducing the likes of Brad Pitt, earned Di Cillo the Leopard of Honor at the Locarno Festival. In 1995 his second film, *Living in Oblivion,* with Steve Buscemi, won the screenwriting award at Sundance and best film prize at festivals in Deauville, Stockholm, and Valladolid. *Box of Moonlight* (1996), in turn, screened at the Venice, Toronto, and Sundance festivals. *The Real Blonde* (1997), which closed the Sundance Film Festival in 1998, satirizes the television world,

and again includes Buscemi, who is also in *Delirious* (2006), which won an award at the San Sebastiano Festival.

DIRECTOR: *Johnny Suede* (1991); *Living in Oblivion* (1994); *Box of Moonlight* (1996); *The Real Blonde* (1997): *Double Whammy* (2001); *Delirious* (2006).

GEORGE GALLO (New York; November 30, 1956)

Enamored with painting, Gallo thought he might work in the world of graphic arts. But after seeing Martin Scorsese's *Mean Streets*, he decided to dedicate himself to the world of cinema. In 1982, with eight hundred dollars in his pocket, he moved to Los Angeles and founded the production company Sweet Revenge. In 1986, he produced, with Danny DeVito and Joe Piscopo, Brian De Palma's *Wise Guys*, whose screenplay he had written five years earlier. In 1988, he worked on a script for Martin Brest's *Midnight Run*, which met with great success and from which a television series was born, and Gallo was executive producer. His debut as director took place in 1991 with *29th Street*, of which he was also screenwriter and producer. Having never abandoned his passion for painting, in 1990 Gallo won the Arts for the Parks Award for his Impressionist landscapes. In 1994 he returned to directing with a Capra-style film, *Trapped in Paradise*; and in 2006 he made *Local Color*, which explores the friendship between an old painter and a young artist.

DIRECTOR: *29th Street* (1991); *Trapped in Paradise* (1994); *Double Take* (2001); *DysFunktional Family* (2003); *Local Color* (2006).

WRITER: *Wise Guys* (1986); *Midnight Run* (1988); *29th Street* (1991); *Trapped in Paradise* (1994); *Vermin & Pestilence* (1995); *Bad Boys* (1995); *Double Take* (2001); *See Spot Run* (2001); *Bad Boys II* (2003); *The Whole Ten Yards* (2004); *Local Color* (2006).

VINCENT GALLO (New York; April 11, 1961)

The son of Sicilian immigrants and the second of three brothers, Gallo left home at sixteen, moving to New York. There he began to work as a musician with different bands that included The Good, The Plastics, and The Gray. He also entered the art world, as both a photographer and a sculptor collaborating with various important galleries. His film career began with the short *If You Feel Froggy, Jump* (1986). At the same time, he accepted numerous television roles and worked as a model for numerous designers including Calvin Klein. He first appeared in a film in 1981, the

year in which he was also in Edo Bertoglio's *New York Beat Movie*. Three years later, he won the award for soundtrack at the Berlin Festival for Eric Mitchell's *The Way It Is*, in which he also had an acting role. After some brief appearances in *Goodfellas* (1990), *The House of Spirits* (1993), and *The Perez Family* (1995), he began a collaboration with the French director Claire Denis, with the short *Keep It for Yourself*, the TV film, *US Go Home*, and the feature-length *Nénette et Boni* (1996). In the meantime, he took on important roles in Emir Kusturica's *Arizona Dream* (1993) and Alan Taylor's *Palookaville* (1995). Recognition came to him when, in 1996, he accepted a role in Abel Ferrara's *The Funeral*. And the following year he directed *Buffalo '66* (1998), for which he also wrote the storyline, screenplay, and sound track, and acted with Christina Ricci. At the same time, he directed numerous videos including *Going Inside* by John Frusciante and *Grounded* by My Vitriol. In 2003, he made his second feature-length film, *The Brown Bunny*, which created a bit of scandal at the Cannes Film Festival.

DIRECTOR: *If You Feel Froggy, Jump* (1986); *The Gunlover* (1986); *Buffalo '66* (1998); *The Brown Bunny* (2003).

ACTOR: *The Gunlover* (1986); *The Way It Is* (1986); *Doc's Kingdom* (1987); *Goodfellas* (1990); *Keep It for Yourself* (1991); *A Idade Maior* (1991); *The Hanging* (1993); *Arizona Dream* (1993); *The House of Spirits* (1993); *Angela* (1995); *The Perez Family* (1995); *Palookaville* (1995); *Nénette et Boni* (1996); *The Funeral* (1996); *Truth or Consequences, N.M.* (1997); *Hollywood Salome* (1998); *Goodbye Lover* (1998); *Buffalo '66* (1998); *L.A. Without a Map* (1998); *Freeway II: Confessions of a Trickbaby* (1999); *Cord* (2000); *Trouble Every Day* (2001); *Get Well Soon* (2001); *Stranded: Náufragos* (2002); *The Brown Bunny* (2003); *Gli Indesiderabili* (2003); *The Tulse Luper Suitcase, Part I: The Moab Story* (2003); *Moscow Zero* (2006); *Oliviero Rising* (2007).

JOSEPH GRECO (Hollywood, Florida; April 13, 1972)

A lover of magic, at fourteen he enrolled in the Society of American Magicians. Subsequently, he developed an interest in movies and while at Florida State University's School of Motion Picture, Television and Recording Arts, he made the short *The Ghost of Drury Lane* (1993), a documentary on a ghost that supposedly haunts the Drury Lane Theatre of London. The film won the best short award at both the Houston International Film Festival and the Fort Lauderdale Film Festival. His next project, *Lena's Spaghetti* (1994), also won the best short film awards at the

Columbus International and the Canadian International Film Festivals. After graduating, he worked with James Cameron on the *Titanic* (1997), while directing various theatrical works and several projects for the Walt Disney Company. In 2006 he shot *Canvas*, his first feature-length, which won three awards at the Fort Lauderdale Film Festival.

DIRECTOR: *The Ghost of Drury Lane* (1993); *Lena's Spaghetti* (1994); *Canvas* (2006).

KEVIN JORDAN (New York, January 19, 1974)

Born into a family of lobster farmers, he began his career in front of the camera, doing commercials and in the TV series *In the Mix* as well as in Randall Miller's movie *Houseguest* (1995). Subsequently, he studied at New York University's Film School where he was a Scorsese scholarship recipient and winner of NYU's Continued Excellence in Directing. After graduating, he worked for two months on the set of Scorsese's *Kundun* (1997). In 1999 he wrote, directed, and produced *Smiling Fish and Goat on Fire*, presented by Scorsese and winner of the Discovery Award at the Toronto Film Festival. After directing two shorts, *Feather Pimento* (2001) and *An Ode to the Writer* (2002), he shot the feature-length documentary *AntiTrust: Edison v. Laemmle* (2002). His autobiographical film *Brooklyn Lobster* (2005), with Danny Aiello as lead, was screened at the Toronto Film Festival.

DIRECTOR: *Smiling Fish and Goal on Fire* (1999); *Feather Pimento* (2001); *An Ode to the Writer* (2002); *AntiTrust: Edison v. Laemmle* (2002); *Brooklyn Lobster* (2005).

RICHARD LAGRAVANESE (New York; October 30, 1959)

After having attended Emerson College in Boston, he studied acting and experimental theater at New York University. He held a series of jobs that included traveling salesman, cabaret entertainer, and writer. Having obtained a contract from Disney, he wrote the script for *A Little Princess*, directed by Alfonso Cuaròn in 1995. His first accomplished screenplay was for David Greenwalt and Aaron Russo's *Rude Awakening* (1989). LaGravanese's career further developed with his screenplay for Terry Gilliam's *The Fisher King* (1991), which earned him an Oscar nomination. Such success led Steven Spielberg and Kathleen Kennedy to entrust him with the screenplay for Robert James Waller's *The Bridges of Madison County*, which Clint Eastwood directed in 1995. That same year, he debuted as a producer with *The Ref*, for which he also wrote the screenplay.

His directing debut was in 1998 with *Living Out Loud,* while in 2000, at the request of Julia Roberts, he wrote the screenplay for Steven Soderbergh's *Erin Brockovich,* for which he won the Las Vegas Film Critics Award for original screenplay.

DIRECTOR: *Living Out Loud* (1998); *A Decade Under the Influence* (2003); *Paris, je t'aime* (2006); *Freedom Writers* (2007).

WRITER: *Rude Awakening* (1989); *The Fisher King* (1991); *The Ref* (1994); *A Little Princess* (1995); *The Bridges of Madison County* (1995); *Unstrung Heroes* (1995); *The Mirror Has Two Faces* (1996); *The Horse Whisperer* (1998); *Living Out Loud* (1998); *Beloved* (1998); *Erin Brockovich* (2000); *Paris, je t'aime* (2006); *Freedom Writers* (2007).

PENNY MARSHALL (New York; October 15, 1943)

Carole Penny Marshall (Masciarelli) was born in the Bronx, the younger sister of director Garry Marshall and television producer Ronny Hallin. After studying in a private girl's school in New York, she studied at the University of New Mexico. In 1968, she debuted as an actress in *How Sweet It Is,* a film directed by her brother Garry. In the 1970s, she had roles in the series *The Odd Couple, Mary Tyler Moore, Happy Days,* and in the spinoff, *Laverne & Shirley.* Her debut as director was in 1979, when she directed an episode of the sitcom *Working Stills.* In 1986, she took over for Howard Zieff as director of *Jumpin' Jack Flash,* a comedy with Whoopi Goldberg. Two years later, she directed *Big* (1988) with Tom Hanks, experiencing remarkable success with becoming the first woman director of a film that superceded one hundred million dollars, a success she repeated with *A League of Their Own* (1992). Her film *Riding in Cars with Boys* (2001) was taken from the autobiographical novel by Italian American writer Beverly Donofrio.

DIRECTOR: *Working Stills* (1979); *Laverne & Shirley* (1979-1981); *Jumpin' Jack Flash* (1986); *Big* (1988); *Awakenings* (1990); *A League of Their Own* (1992); *Renaissance Man* (1994); *The Preacher's Wife* (1996); *Riding in Cars with Boys* (2001)

ACTOR: *The Savage Seven* (1968); *How Sweet It Is!* (1968); *The Grasshopper* (1970); *Where's Poppa?* (1970); *How Come Nobody's on Our Side?* (1975); *Movers & Shakers* (1985); *The Hard Way* (1991); *Hocus Pocus* (1993); *Special Delivery* (1999); *Stateside* (2004); *Looking for Comedy in the Muslim World* (2005); *Everybody Wants to Be Italian* (2007).

ACTOR (television performances): *Then Came Bronson* (1969); *That Girl* (1968-

1969); *The Feminist and the Fuzz*: (1971); *Evil Roy Slade* (1972); *The Crooked Hearts* (1972); *The Couple Takes a Wife* (1972); *Paul Sand in Friends and Lovers* (1974); *The Odd Couple* (1971-1975); *Let's Switch!* (1975); *Mary Tyler Moore* (1974-1976); *More Than Friends* (1978); *Happy Days* (1975-1979); *Laverne & Shirley* (1976-1983); *Love Thy Neighbor* (1984); *Challenge of a Lifetime* (1985); *The Odd Couple: Together Again* (1993); *Saturday Night Live* (1975- 1996).

GREG MOTTOLA (New York; July 11, 1964)

Gregory J. Mottola was born on Long Island and studied at Carnegie-Mellon University in Pittsburgh. While a student, he worked as an assistant producer on George A. Romero's set of *Day of the Dead* (1985). Subsequently, he studied cinema at Columbia University and made the short *Swingin' in the Painter's Room* (1989). The film was sent to Steven Soderbergh who, very much impressed, wanted to meet him. Having read his screenplay, *Lush Life,* Soderbergh recommended him for the workshop at the Sundance Film Festival. In 1992, he studied at Sundance, but *Lush Life* was considered a project that was too expensive. At the advice of Nancy Tenenbaum, he wrote the screenplay for *The Daytrippers* (1996), signaling his debut at feature-length films. It won the Jury Grand Prize at the Slamdance Film Festival and was presented at the Semaine de la Critique de Cannes.

DIRECTOR: *Swingin' in the Painter's Room* (1989); *The Daytrippers* (1996*)*.

DIRECTOR (television): *Undeclared* (2001-2002); *The Big Wide World of Carl Laemke* (2003); *Arrested Development* (2003-2004); *Cracking Up* (2004); *The Comeback* (2005).

CHAZZ PALMINTERI (New York; May 15, 1952)

Born Calogero Lorenzo Palminteri, in 1973 he began studies with Lee Strasberg at the Actor's Studio. Until the mid-eighties, while working as a bouncer, he acted in Off-Broadway projects including *The Guys in the Truck* and *The Flatbush Faithful*. In 1986, he moved to Los Angeles and appeared in various television shows, including *Hill Street Blues, Matlock, Sydney* and *Wiseguy*. In 1988, he wrote the monologue *A Bronx Tale*, which he staged in New York and in Los Angeles. Having seen the show, Robert De Niro decided to make a full-length film out of it (*A Bronx Tale,* 1993), for which Palminteri was both screenplay writer and actor. The following year his role in Woody Allen's *Bullets over Broadway* (1994) won him an Oscar nomination as best actor. His debut behind the camera took place

in 1999 with an episode of TV's *Oz*. In 2004 he debuted as director of the feature-length movie *Noel*.

DIRECTOR: *Oz* (1999); *Women vs. Men* (TV movie, 2002); *Noel* (2004).

ACTOR: *Home Free All* (1984); *The Last Dragon* (1985); *Oscar* (1991); *Innocent Blood* (1992); *There Goes the Neighborhood* (1992); *A Bronx Tale* (1993); *Bullets Over Broadway* (1994); *The Usual Suspects* (1995); *The Perez Family (Famiglia Perez;* 1995); *The Last Word* (1995); *Jade* (1995); *Diabolique* (1996); *Faithful* (1996); *Mulholland Falls* (1996); *Scar City* (1998); *Hurlyburly* (1998); *A Night at the Roxbury* (1998); *Analyze This* (1999); *Excellent Cadavers* (1999); *Stuart Little* (1999); *Down to Earth* (2001); *One Eyed King* (2001); *Poolhall Junkies* (2002); *One Last Ride* (2003); *Just Like Mona* (2003); *Noel* (2004); *Hoodwinked!* (2005); *Animal* (2005); *In the Mix* (2005); *Running Scared* (2006); *Push* (2006); *Little Man* (2006); *A Guide to Recognizing Your Saints* (2006); *Arthur et les Minimoys* (2006); *Body Armour* (2007).

NANCY SAVOCA (New York; July 23, 1959)

Daughter of Sicilian and Argentinian immigrants, Nancy Savoca was born in the Bronx. Having earned a degree at New York University's Film School, where she received the Haig P. Manoogian Award for the shorts *Renata* and *Bad Timing*, she worked as an assistant for Jonathan Demme and John Sayles. In 1989, she debuted behind the camera with *True Love*, the story of an Italian American marriage in the Bronx, and for which she won the Sundance Film Festival's Jury Grand Prize and a nomination for the Spirit Award as best director. Her subsequent films, *Dogfight* (1991) and *Household Saints* (1993), earned a best screenplay nomination for the Spirit Award; and for a while she subsequently dedicated her energies to TV, directing the series *Dark Eyes* and *Murder One*. In 1999 she returned to the big screen with *The 24 Hour Woman*, which premiered at the Sundance Film Festival, and subsequently shot the monologue based on the controversial Hispanic actress Reno, in *Rebel without a Pause* (2002). In 2003, she directed the movie *Dirt* which tells the story of an illegal immigrant from El Salvador who works as a housemaid.

DIRECTOR: *True Love* (1989); *Dogfight* (1991); *Household Saints* (1993); *If These Walls Could Talk* (1996); *The 24 Hour Woman* (1999); *Reno: Rebel Without a Pause* (2002); *Dirt* (2003).

GARY SINISE (Blue Island, Illinois; March 17, 1955)

The son of film editor Robert L. Sinise, he moved with his family to Highland Park, where he discovered theater in a high school production of *West Side Story*. In 1974, together with Terry Kinney and Jeff Perry, he founded Chicago's Steppenwolf Theatre Company. Steppenwolf's first productions were held in a church basement, but soon thereafter the company became one of the most important in the city, and Sinise directed several works including Sam Shepard's *True West*, which was also produced Off-Broadway with John Malkovich. In 1990 he debuted on Broadway at the Cort Theater with *The Grapes of Wrath*. His Hollywood directorial career began in 1986, when he made two episodes for the TV series *Crime Story*; two years later *Miles from Home* (1988) with Richard Gere, which competed at Cannes. His debut as an actor was in the film *A Midnight Clear* (1992). In that same year, Sinise combined his directing and acting talents in *Of Mice and Men* (1992), acclaimed by the critics and this, too, in competition at Cannes. In 1994 he earned an Oscar nomination as best supporting actor as Dan in *Forrest Gump* (1994). The following year, he won a Golden Globe and the Screen Actor Award for his performance in the TV movie *Truman*.

DIRECTOR: *Crime Story* (1986); *thirtysomething* (1989); *China Beach* (1991); *Miles From Home* (1988); *Of Mice and Men* (1992*)*.

ACTOR: *A Midnight Clear* (1992); *Mice and Men* (1992); *Jack the Bear* (1993); *Forrest Gump* (1994); *The Quick and the Dead* (1995); *Apollo* 13 *(1995); Albino Alligator* (1996); *Ransom* (1996); *Snake Eyes (1998); The Green Mile* (1999); *Reindeer Games* (2000); *Mission to Mars* (2000); *Bruno* (2000); *A Gentleman's Game* (2001); *Impostor* (2002); *Made-Up* (2002); *The Human Stain* (2003*); The Big Bounce* (2004); *The Forgotten (2004); Open Season* (2006)

ACTOR (television performances): *True West* (1984); *Crime Story* (1986-1987); *My Name is Bill W* (1989); *The Grapes of Wrath* (1991); *The Witness* (1992); *The Stand* (1994); *Truman* (1995); *Fallen Angel* (2003); *CSI: New York* (2004-2010).

MARYLOU TIBALDO-BONGIORNO (New Jersey; August 17, 1962) and JEROME BONGIORNO (New York; December 5, 1962)

A married couple, Marylou and Jerome founded their production company, Bongiorno Productions, in Newark, New Jersey. Marylou holds an MFA from New York University, where she received a grant of $75,000, with which she made her first feature-length *Little Kings* (2003).

Marylou wears the hat of director, whereas Jerome collaborates as co-screenplay writer, director of photography, and editor. In addition to their short documentary *Mother-Tongue: Italian American Sons & Mothers* (1999), which aired on PBS, they also directed and produced *Revolution '67* (2007).

DIRECTOR AND PRODUCER: *City Arts* (1995); *Split Screen* (1997); *Mother-Tongue: Italian American Sons & Mothers* (1999); *Rubout* (2003); *Little Kings* (2003); *Revolution '67* (2007).

STANLEY TUCCI (New York; November 11, 1960)

Having grown up in Katonah, he attended the State University of New York at Purchase and graduated in 1982. In that same year, he made his theatrical debut in the role of Colleen Dewhurst in *The Queen and the Rebels*. In 1985 Tucci debuted in the movies with *Prizzi's Honor* by John Huston. His career continued with numerous television roles that include: *Crime Story, Wiseguy,* and *thirtysomething*. After numerous appearances in features, Tucci made his debut behind the camera in 1996 with *Big Night,* together with Campbell Scott, and for which he was also screenplay writer with Joseph Troiano. The film won much acclaim at the Sundance Film Festival, and thus widened the road for Tucci's career, and two years later he directed *The Impostors* (1998). 1998 was also the year of his first Golden Globe, won thanks to his role in the TV movie *Winchell.* In 2000 Tucci returned to directing with *Joe Gould's Secret.* The following year, he won his second Golden Globe as best supporting actor in *Final Conspiracy* (2001).

DIRECTOR: *Big Night:* (1996); *The Impostors* (1998); *Joe Gould's Secret* (2000); *Blind Date* (2007).

ACTOR: *Prizzi's Honor* (1985); *Who's That Girl?* (1987); *Monkey Shines* (1988); *Slaves of New York* (1989); *Fear, Anxiety & Depression* (1989); *The Feud* (1990); *Quick Change* (1990); *Men of Respect* (1991); *Billy Bathgate* (1991); *In the Soup* (1992); *Beethoven* (1992); *Prelude to a Kiss* (1992); *The Gun in Betty Lou's Handbag* (1992); *The Public Eye* (1992); *Undercover Blues* (1993); *The Pelican Brief* (1993); *It Could Happen to You* (1994); *Mrs. Parker and the Vicious Circle* (1994); *Somebody to Love* (1994); *Jury Duty* (1995); *Kiss of Death* (1995); *Sex & the Other Man* (1995); *A Modern Affair* (1995); *The Daytrippers* (1996); *Big Night* (1996); *Deconstructing Harry* (1997); *Life During Wartime* (1997); *A Life Less Ordinary* (1997); *The Eighteenth Angel* (1998); *Montana* (1998); *The Impostors* (1998); *A Midsummer Night's Dream* (1999); *In Too*

Deep (1999); *Joe Gould's Secret* (2000); *Sidewalks of New York* (2001); *America's Sweethearts* (2001); *The Whole Shebang* (2001); *Big Trouble* (2002); *Road to Perdition* (2002); *Maid in Manhattan* (2002); *The Core* (2003); *Spin* (2003); *The Life and Death of Peter Sellers* (2004); *The Terminal* (2004); *Shall We Dance?* (2004); *Robots* (2005); *Lucky Number Slevin* (2006); *Four Last Songs* (2006); *The Devil Wears Prada* (2006); *The Hoax* (2006).

ACTOR (television performances): *Crime Story* (1987); *Miami Vice* (1986-1988); *Wiseguy* (1988-1989); *thirtysomething* (1989-1990); *Revealing Evidence: Stalking the Honolulu Strangler* (1990); *Equal Justice* (1991); *Murder One* (1995-1996); *Winchell* (1998); *Bull* (2000); *Conspiracy* (2001).

JOHN TURTURRO (New York; February 28, 1957)

He became enamored with cinema during his childhood in Brooklyn. After having graduated from the State University of New York at New Paltz, he won a scholarship to the prestigious Yale School of Drama. He was immediately noticed in regional and Off-Broadway theater, winning an Obie Award for his performance in *Danny and the Deep Blue Sea* in 1983. The film that signaled his first appearance on the silver screen is Martin Scorsese's *Raging Bull* (1980). From 1985 on, he began to obtain roles in important films such as Susan Seidelman's *Desperately Seeking Susan* (1985), William Friedkin's *To Live and Die in L.A.* (1985), Martin Scorsese's *The Color of Money* (1986) and Woody Allen's *Hannah and Her Sisters* (1986). In 1989, Turturro took on the role of Pino in Spike Lee's *Do The Right Thing*, which marked the beginning of a long artistic collaboration between the actor and the African American director. The following year, he was one of the actors in the Coen Brothers' *Miller's Crossing* (1990) with whom, in 1991, he won the Palm d'Or at Cannes for his role in *Barton Fink*. He waited until 1994 to return to the movies with *The Exterminator 2*. The same year he debuted on Broadway with *Death of a Salesman*. In 1992 he won at Cannes the Caméra d'Or for *Mac*, his debut as director. He continued his work behind the camera with *Illuminata* (1998), followed by the musical *Romance and Cigarettes* (2005).

DIRECTOR: *Mac* (1992); *Illuminata* (1998); *Romance & Cigarettes* (2005).

ACTOR: *Raging Bull* (1980); *The Exterminator 2* (1984); *The Flamingo Kid* (1984); *Desperately Seeking Susan* (1985); *To Live and Die in L.A.* (1985); *Hannah and Her Sisters* (1986); *Gung Ho* (1986); *Off Beat* (1986); *The Color of Money* (1986); *Five Corners* (1987); *The Sicilian* (1987); *Do the Right Thing* (1989); *Catchfire* (1990); *Mo'*

Better Blues (1990); *Miller's Crossing* (1990); *State of Grace* (1990); *Men of Respect* (1991); *Barton Fink* (1991); *Jungle Fever,* (1991); *Brain Donors* (1992); *Mac* (1992); *Being Human* (1993); *Fearless* (1993); *Quiz Show* (1994); *The Search for One-eye Jimmy* (1994); *Search and Destroy* (1995); *Unstrung Heroes* (1995); *Clockers* (1995); *Girl 6* (1996) ; *Box of Moonlight* (1996) ; *Grace of My Heart* (1996); *La tregua* (1997); *Lesser Prophets* (1997); *Animals with the Tollkeeper* (1998); *The Big Lebowski* (1998); *O.K. Garage* (1998); *He Got Game* (1998); *Illuminata* (1998); *Rounders* (1998); *Cradle Will Rock* (1999); *Summer of Sam* (1999); *Company Man* (2000); *O Brother, Where Art Thou?* (2000); *Two Thousand and None* (2000); *The Luzhin Defence* (2000); *The Man Who Cried* (2000); *Monkeybone* (2001); *Thirteen Conversations About One Thing* (2001); *Collateral Damage* (2002); *Mr. Deeds* (2002); *Fear X* (2003); *Anger Management* (2003); *Opopomoz* (2003); *Secret Passage* (2004); *Secret Window* (2004); *Perfectly Honest* (2004); *She Hate Me* (2004); *Romance & Cigarettes* (2005); *Quelques jours en septembre* (2006); *The Good Shepherd* (2006).

ACTOR (television performances): *The Fortunate Pilgrim* (1988); *Sugartime* (1995); *Monday Night Mayhem* (2002), *Monk* (2004-2005).

TONY VITALE (New York; 1964)

Anthony Neal Vitale was born in the Bronx. He began his career in the movies in 1991, when he worked for independent productions as location director. In the same year, he presented a one-act comedy at the Village Gate. Two years later, he wrote the second act, and in 1994 he developed a screenplay. During this period, Vitale continued to work as a gofer, with directors such as Paul Mazursky, Irwin Winkler, Hal Hartley, and Nick Gomez. In 1993 Robert De Niro chose him as an assistant for *A Bronx Tale* and entrusted to him the opening scenes. In 1997 Vitale found the financing to bring to the silver screen the screenplay he wrote three years prior, and which he also directed, *Kiss Me Guido*. In 2001 he developed from his film the sitcom *Some of My Best Friends,* for which he was screenplay writer and production supervisor.

DIRECTOR: *Kiss Me, Guido* (1997); *Very Mean Men* (2000); *Jungle Juice* (2001); *One Last Ride* (2003).

Translated by the editors

Contributors

EMELISE ALEANDRI's photographic histories, The *Italian-American Immigrant Theatre of New York City* and *Little Italy* are published by Arcadia. The first book in her multi-volume series on the Italian-American Immigrant Theatre is published by Edwin Mellen Press with more volumes soon to follow. *And the Apostles Shook: The Failure of an Ideal*, co-written with Dr. Gloria Salerno, is forthcoming. She has produced three documentaries: *Teatro: The Legacy of Italian-American Theatre*; *Festa: Italian Festival Traditions*; and *Circo Rois: Che Bella Vita!* She co-originated the nationally-aired TV show, *Italics*. Dr. Aleandri is Artistic Director of the Frizzi & Lazzi Music and Theatre Company. As a film actress, she created roles in Spike Lee's *Crooklyn* and *Summer of Sam*, and plays Eleonora Duse in *Penguins and Peacocks*.

GIORGIO BERTELLINI is Associate Professor, Screen Arts and Cultures and Romance Languages and Literature at the University of Michigan. Editor of *The Cinema of Italy* (2004) and co-editor of *Early Cinema and the "National"* (2008), he is the author of a monograph on *Emir Kusturica* (1996; 2nd edition 2009) and of various essays on race in silent film culture that have appeared in numerous anthologies and periodicals, including *Film History*, *Film Quarterly*, *The Velvet Light Trap*, *The Italian-American Review*, *Urban History*, and *The Journal of Urban History*. He is also editor of the forthcoming collection *Silent Italian Cinema: A Reader* and author of the book-length study, *Italy in Early American Cinema: Race, Landscape, and the Picturesque* (2010).

GIULIANA BRUNO, a Neapolitan, has been living in the United States since 1980. Professor of Visual and Environmental Studies at Harvard University, she is the author of numerous books, including the much awarded *Streetwalking on a Ruined Map: Cultural Theory and the City Films of Elvira Notari* (1993). Her book *Atlas of Emotion: Journeys in Art, Architecture, and Film* (2002), winner of the Kraszna-Krausz Book Award for "the world's best book on the moving image," was recently translated into Italian (*L'atlante delle emozioni*). Her latest book is *Public Intimacy: Architecture and the Visual Arts* (2007).

ANNA CAMAITI HOSTERT divides her time between Italy and the United States, where she teaches cinema, gender studies, philosophy, visual studies, and theories of identity. She has collaborated with RAIsat and the daily *il manifesto*. Her books include: *Passing: dissolvere le identità, superare le differenze* (1996), also available in English as *Passing: A Strategy to Dissolve Identities and Remap Differences* (2007); *Sentire il cinema* (2002); *Metix: cinema globale e cultura visuale* (2004). With Anthony Julian Tamburri, she is also co-editor of *Screening Ethnicity: Cinematographic Representations of Italian Americans in The United States* (2002), also available in Italian as *Scene italoamericane*.

ROBERT CASILLO is Professor of English at the University of Miami, Florida. He is the author of *The Genealogy of Demons: Anti-Semitism, Fascism, and the Myths of Ezra Pound* (1988), which was cited by the Gustavus Myers Foundation as an outstanding book on the subject of intolerance. In addition to having written extensively on nineteenth- and twentieth-century literature and culture, he is the author of the books *Gangster Priest: The Italian American Cinema of Martin Scorsese* and *The Empire of Stereotypes*. He recently completed the first volume of *The Italian in Modernity: Representations of Italy and Italian Americans Since the Renaissance* (co-written with John Paul Russo) as well as another book entitled *Italian Americans on Screen*.

GEORGE DE STEFANO is a journalist and cultural critic who writes for numerous publications including the *Nation*, *Film Comment*, and *Newsday*. His recent book is *An Offer We Can't Refuse: The Mafia in the Mind of America* (2006).

EMILIO FRANZINA is Professor of Contemporary History at the Università degli Studi di Verona. His main area of research is Italian mass emigration to Argentina, Brazil, and other locations in Latin America. His publications include: *La grande emigrazione: l'esodo dei rurali dal Veneto durante il secolo XIX; I veneti in Brasile: nel centenario dell'emigrazione (1876-1976); Merica! Merica!: emigrazione e colonizzazione nelle lettere dei contadini veneti in America Latina, 1876-1902; L'immaginario degli emigranti; Gli italiani al nuovo mondo: l'emigrazione Italiana in America, 1492-1942; Dall'Arcadia in America: attività letteraria ed emigrazione transoceanica in Italia (1850-1940); La storia altrove: casi nazionali e casi regionali nelle moderne migrazioni di massa.* His edited volumes include: *Storia dell'emigrazione italiana* (2 vol.); *Il fascismo e gli emigrati.* He is also a board member of the following journals: *Altreitalie, Studi emigrazione,* and *Italia contemporanea.* He is the founder and current director of the Archivio storico dell'emigrazione italiana.

SIMONA FRASCA earned a doctorate at Università di Roma "La Sapienza." Her field of research is social history of music (e.g., free jazz; early sound reproduction era; contemporary indie scene). In 2003 she was a Fulbright Fellowship recipient to the John D. Calandra Italian American Institute, CUNY. She has lectured in several European and American institutions and universities (CUNY Graduate Center; St. John's College, Oxford; Istituto di Studi Americani, Roma; DAMS, Laboratori del Dipartimento di Musica e Spettacolo, Università di Bologna). As a freelance music journalist, she writes for *Il Manifesto, Alias, Rumore,* and has published the first biography on Norah Jones, entitled *Norah Jones, Piano Girl* (Arcana, 2004). She sits on the board of the Radio Rai Archivio Sonoro della Canzone Napoletana. Her forthcoming book is entitled *Birds of Passage: la diaspora dei musicisti napoletani a New York* (LIM).

FRED L. GARDAPHÉ is Distinguished Professor of English and Italian American Studies at Queens College, CUNY and the John D. Calandra Italian American Institute. His books include: *Italian Signs, American Streets: The Evolution of Italian American Narrative; Dagoes Read: Tradition and the Italian/American Writer; Moustache Pete is Dead!; Leaving Little Italy;* and *From Wiseguys to Wise Men: Masculinities and the Italian American Gangster Figure.* He is editor of the Italian American Culture Series of SUNY Press and with Anthony Julian Tamburri and Paolo A. Giordano, a founding editor of *VIA: Voices in Italian Americana.*

SILVIA GIAGNONI is a Professor in the Department of Communication and Dramatic Arts at Auburn University in Montgomery, Alabama. She received her laurea in Communication from Università di Roma "La Sapienza" and completed a Ph.D. at Florida Atlantic University with a thesis on Christian rock and Evangelical culture. She also produced and directed a documentary with Eleonora Orlandi on Christian rock. Silvia's scholarly interests range from visual studies to problematics of identity (specifically, Italian American identity). Currently, Silvia is working on a nonfiction book about the farmworker community of Immokalee, Florida and a documentary about immigration.

STEFANO LUCONI teaches U.S. history at the Università di Roma "Tor Vergata" and specializes in Italian immigration to the United States. His books include *La "diplomazia parallela": Il regime fascista e la mobilitazione politica degli italo-americani* (Milan: Angeli, 2000); *From Paesani to White Ethnics: The Italian Experience in Philadelphia* (Albany, NY: SUNY Press, 2001); *Little Italies e New Deal:*

La coalizione rooseveltiana e il voto italo-americano a Filadelfia e Pittsburgh (Milan: Angeli, 2002); *L'ombra lunga del fascio* (Milan: M&B, 2004) (written with Guido Tintori); *The Italian-American Vote in Providence, Rhode Island, 1916-1948* (Madison, NJ: Fairleigh Dickinson University Press, 2004); *La politica dello scandalo* (Turin: L'Harmattan Italia, 2006); *La faglia dell'antisemitismo: italiani ed ebrei negli Stati Uniti, 1920-1941* (Viterbo: Sette Città, 2007).

ANTON GIULIO MANCINO is Professor of Semiology of Cinema and Audiovisual Studies at the Università degli Studi di Bari and History and Criticism of Cinema at the Università degli Studi di Macerata. He is the author of numerous volumes: *Angeli selvaggi: Martin Scorsese, Jonathan Demme* (1995); *John Wayne* (1998); *Francesco Rosi* (1998); and *Il processo della verità: le radici del film politico-indiziario italiano* (2008). He has edited numerous volumes: *Intervista: Sergio Rubini* (2000), and, with Gianni Volpi, *Giancarlo Giannini: il fascino sottile dell'interprete* (2002). He has also contributed to collections on De Sica, Hitchcock, Tarantino, Amelio, Placido, and numerous other directors and actors. His essays have appeared in journals and dailies such as *Cinecritica* and *La Gazzatta del Mezzogiorno*.

GIULIANA MUSCIO is Professor of Semiology of Film and Audiovisual and Theories and Techniques of Mass Communications at the University of Padua. She directs the program for the Master of Education Audiovisual and Multimedia (MEAM) in the College of Education Sciences. She earned a Ph.D. from the University of California, Los Angeles. She taught, as a Visiting Professor, Film Studies at UCLA, as well as American Studies at the University of Minnesota. Her main areas of study include: screenplay writing, history of American cinema, documentary, history of the media, and the relationship between media and politics. Her authored books include: *Lista nera a Hollywood* (1979); *Scrivere il film* (1982); *La Casa Bianca e le Sette Majors* (1990); *The New Deal and the Film Industry* (1996); *Marilyn Monroe* (2004); and *Piccole Italie, grandi schermi* (2004).

EMANUELE PETTENER is a professor of Italian Language and Literature at Florida Atlantic University (Boca Raton). He has published numerous essays and short stories in Italian and American magazines and journals. He has published a monograph on John Fante, *Nel nome del padre, del figlio, e dell'umorismo: i romanzi di John Fante* (2010) and edited a special issue of *Nuova prosa*, "Essere o non essere italoamericani" (2009). His first novel, in turn, *E' Sabato, mi hai lasciato e sono bellissimo*, was published by Corbo Editore in Spring 2009.

VERONICA PRAVADELLI is Associate Professor of Film Studies at the Università di Roma "Tre" (Italy). She received her Ph.D. in Comparative Literature/ Film Studies from Indiana University. At Roma Tre, she coordinates the Socrates Exchange Program (the European Student Exchange Program) for Film, Drama and Communication Studies. In addition to her many essays and edited volumes, she has authored the following books: *Performance, Rewriting, Identity: Chantal Akerman's Postmodern Cinema*, (Torino, Otto Editore, 2000), *Alfred Hitchcock. Notorious* (Torino, Lindau, 2003), and *La grande Hollywood. Stili di vita e di regia nel cinema classico americano* (Venezia, Marsilio, 2007).

JACQUELINE REICH is Associate Professor of Comparative Literary and Cultural Studies at University at Stony Brook. She received her Ph.D. in Italian from the University of California at Berkeley. At Stony Brook, she is a core faculty member of the Cinema and Cultural Studies program and its past director. She sits on the Humanities Institute Advisory Board and participates in the Graduate Certificate in Cultural Studies. In addition to her many essays and articles, she has authored the volume, *Beyond the Latin Lover: Marcello Mastroianni, Masculinity, and Italian Cinema* (2004), and co-edited *Re-viewing Fascism: Italian Cinema, 1922-1945* (2002).

JOHN PAUL RUSSO is a Professor of Classics and English at the University of Miami, Florida. He has published on the theory of criticism, ethnicity, and history of culture, and is currently completing a study, co-authored by Robert Casillo, on representations of Italy, Italians, and Italian Americans since the Renaissance, entitled "The Italian in Modernity." He is the recipient of three Fulbright Fellowships to Italy, most recently to the University of Salerno, and has been visiting professor at the universities of Palermo, Rome, and Genoa. He is co-editor of *RSA: Rivista di Studi Nord Americani* and book review editor of *Italian Americana*. His *The Future without a Past: The Humanities in a Technological Society* received the 2006 Thomas N. Bonner Award.

JOSEPH SCIORRA is the Associate Director for Academic and Cultural Programs at Queens College's John D. Calandra Italian American Institute. He is editor of the social science journal, *Italian American Review*. Sciorra is co-editor of poet Vincenzo Ancona's bilingual anthology *Malidittu la lingua/Damned Language* (Legas, 1990; 2010), the editor of *Italian Folk: Vernacular Culture in Italian-American Lives* (Fordham, 2010), and the author of *R.I.P.: Memorial Wall Art* (Henry Holt &

Co., 1994; Thames and Hudson, 2002). He has curated several exhibitions, including "Sacred Emblems, Community Signs: Historic Flags and Religious Banners from Italian Williamsburg, Brooklyn" and "'Evviva La Madonna Nera!': Italian-American Devotion to the Black Madonna." As the avatar "Joey Skee," Sciorra maintains the blog, "Occhio contro occhio," at www.i-italy.org.

ALESSANDRA SENZANI has completed her Ph.D. in Comparative Studies at Florida Atlantic University, Boca Raton, with a dissertation titled: *Women, Film, and Oceans A/Part: The Critical Humor of Tracey Moffatt, Monica Pellizzari, and Clara Law*. She holds a *laurea* in Interpreting and Translating from the University of Bologna and a Master's in English from Youngstown State University. She has published various articles on Italian/American literature and cinema in academic journals such as *VIA, Quaderni delNovento*, and *Postscript*.

ILARIA SERRA holds a *laurea* in Italian from the Università Ca' Foscari Venezia and a Ph.D. in Comparative Studies from Florida Atlantic University, where she is now Assistant Professor of Italian. She has published close to three dozen articles and essays in numerous journals and edited volumes. She is the author of two major books: *Immagini di un immaginario: L'Emigrazione Italiana negli Stati Uniti fra i due secoli (1890-1924)* (1997), *The Value of Worthless Lives: Writing Italian-American Immigrant Autobiographies* (2007), and *The Imagined Immigrant: Images of Italian Emigration to The United States Between 1890 and 1924* (2009).

GIOVANNI SPAGNOLETTI is Associate Professor at the Università di Roma "Tor Vergata" in Film History and Criticism. The author and/or editor of more than sixty books and articles dedicated primarily to Italian and German cinema, he also directs the quarterly film studies journal *Close Up* and the web journal *Close-up on Line*. Since 2000, he has been the Artistic Director of the Pesaro Film Festival, *Mostra internazionale del Nuovo Cinema*, and president of the AFIC (Associazione dei Festival Italiani di Cinema), the Association of Italian Film Festivals.

ANTHONY JULIAN TAMBURRI is Professor of Italian and Comparative Literature and Dean of the John D. Calandra Italian American Institute of Queens College/ CUNY. His latest books include: *Italian/American Short Films & Videos: A Semiotic Reading* (2002); *Semiotics of Re-reading: Guido Gozzano, Aldo Palazzeschi, and Italo Calvino* (2003), *Narrare altrove: diverse segnalature letterarie* (2007), *Una semiotica dell'etnicità. Nuove segnalature per la scrittura italiano/americana* (2010), and *Revisit-*

ing Italian Americana: Specificities and Generalities on Literature and Film (2011). With Paolo A. Giordano and Fred L. Gardaphé, he is contributing co-editor of the volume *From The Margin: Writings in Italian Americana* (1991; 2nd edition, 2000) and co-founder of Bordighera Press. With Giordano, he co-edited *Beyond the Margin: Readings in Italian Americana* (1998). Tamburri is past-president of the American Italian Historical Association (2003-2006) and of the American Association of Teachers of Italian (2008-2009).

VITO ZAGARRIO is Professor at the Università di Roma "Tre" and teaches for American University programs in Italy (NYU in Florence). He is the author of several books on both Italian and American cinema. His recent publications include *The "Un-Happy Ending": The Cinema of Frank Capra Between American Dream And American Nightmare* (2010); *"Primato". Arte, cultura, cinema del fascismo attraverso una rivista esemplare* (2007); *Overlooking Kubrick* (2006); *John Waters* (2005); *Cinema e Fascismo. Film, modelli, immaginari* (2004); and *L'anello mancante. Teoria e storia dei rapporti tra cinema e televisione* (2004). He has also directed three feature films: *La donna della luna* (1988), *Bonus Malus* (2003), and *Tre giorni d'anarchia* (2006), as well as several documentaries and TV shorts. In 1992 he received a David Award for the first HDTV film with the Eureka standard, *Un bel di' vedremo*. He has founded Italian film festivals in Rome and Ragusa (Sicily), and is one of the founding organizers of the Pesaro film festival.

Index

CPSIA information can be obtained
at www.ICGtesting.com
Printed in the USA
LVHW10s0018140918
590135LV00002B/8/P

9 780970 340368